Birds, Beasts, Blossoms, and Bugs

THE NATURE OF JAPAN

Harold P. Stern

Director, Freer Gallery of Art, Washington, D.C.

Birds, Beasts,

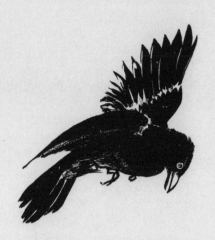

Blossoms, and Bugs

The Nature of Japan

Harry N. Abrams, Inc., Publishers, New York

in association with the U.C.L.A. Art Council and the Frederick S. Wight Gallery, Los Angeles

Library of Congress Cataloging in Publication Data

Stern, Harold P.
 Birds, beasts, blossoms, and bugs.

 Bibliography: p.
 1. Art, Japanese. 2. Nature (Aesthetics). I. Title.
N7350.S73 704.94'3'0952 75-46630
ISBN 0-8109-0708-9
ISBN 0-8109-9022-9 pbk.

Library of Congress Catalogue Card Number: 75-46630
Published in 1976 by Harry N. Abrams, Incorporated, New York
All rights reserved. No part of the contents of this book may be
reproduced without the written permission of the publishers

Printed and bound in Japan

Contents

Date Chart

Jōmon	?–c. 300 B.C.
Yayoi	c. 300 B.C.–300 A.D.
Kofun (Tumulus)	c. 300–552
Asuka Period (Suiko)	538–645
Nara Period	645–794
Early Nara Period (Hakuhō)	645–710
Late Nara Period (Tempyō)	710–794
Heian Period	794–1185
Early Heian Period (Jōgan)	794–897
Late Heian Period (Fujiwara)	897–1185
Kamakura Period	1185–1334
Namboku-chō	1334–1392
Muromachi Period (Ashikaga)	1334–1573
Momoyama Period	1573–1615
Edo Period (Tokugawa)	1615–1868
Early Edo Period	1615–1716
Late Edo Period	1716–1868
Modern Japan	1868–present
Meiji Period	1868–1912
Taishō Period	1912–1926
Shōwa Period	1926–present

Foreword

WERE ONE TO ASK, "How high can a bird fly?" I would respond "Into the sky." Should someone question, "Can a bug be beautiful?" I would suggest that the answer be sought in firefly lights, dragonfly wings, and grasshopper acrobatics. If there were a query, "Are flowers too ephemeral?" My answer would be "Brevity can be sweet and enhancing. It does in no way mar beauty, color, or fragrance." Were one to demand, "Are beasts to be feared?" I would retort "A dog's bark, a cat's meow, a lion's roar, a bullock's grunt, a monkey's chatter, a cow's moo, and a horse's whinny are but words. If one can speak, there is no fear. Beasts are graceful and strong."

Thoughts such as these have often flashed through my mind in the last few years. Nature in the form of living things is so very important, and yet only recently has mankind stopped to take inventory and look for ways of preventing the pillaging and total destruction of nature. The Japanese have always recognized the need for close harmony with nature. Exposure to the West and great industrial expansion have disturbed this relationship and in some instances even destroyed it, but at long last efforts are being made to stem the tide. To restore and reconstruct may not always be possible. We can review the past, however, in the wonderful record of the creatures of nature which the artists of Japan preserved in their works. This is the reason for this volume and the exhibition on which it is based.

It was originally my hope that the exhibition and book could cover, in depth, all periods and arts. I soon realized that concern for the objects, as well as space and budgetary limitations, made that goal unattainable. Thus I concentrated on objects in United States collections. The works of art contained in this volume are representative of a vast variety of materials, span of time, and range of artists. The creatures are but a small selection from nature's rich bounty in Japan. Though I am saddened that I was unable to attain my utopian dream, I was able to follow the developments of aesthetic traditions in Japan. Stylistic changes unfold, and though they establish Japan's love of and devotion to nature, they also reflect a close interrelationship between politics, economics, and aesthetics.

These works of art point to the enduring quality of nature. Though society underwent violent upheavals, nature's evolution has been very stately and slow. This volume is one of the first attempts made at viewing nature through the arts in many periods, media, and manners. My desire has been to make all viewers and readers aware of nature's importance in the arts throughout Japanese history, though especially from the Heian period on until modern times. May this create an awareness that birds, beasts, blossoms, and bugs are an essential part of any study of Japanese art. It is my hope that this study will also reveal the sensitivity of the artists and the stylistic changes they brought about, for both are valid and contribute to the total picture of life.

In the use of Japanese names in this volume, surnames always precede personal names.

Measurements for paintings illustrated in this volume are overall, and include the mounting as well as the painting itself.

Heian and Kamakura Periods

NATURE AND JAPAN sound alike to the initiated, and to these enlightened people they are synonymous. Since earliest times the artists of Japan have manifested an interest in the beauties of nature and it has played an important role in their daily lives. One must keep in mind that nature is sanctified in Japan. Part of Shinto, the native religion, embodies the worship of deified spirits cloaked in the mantle of nature, such as rivers, trees, and mountains. The second great religion of Japan, Buddhism, also imparts sacredness to nature. To the Buddhist, it is wrong to destroy even the tiniest blade of grass by trampling on it. Thus, all living and growing things are embraced by and become part of the deity.

The artist of the late Tumulus period, late fifth and early sixth centuries A.D., when *haniwa* were created, used natural forms. *Haniwa* were rings of clay no more than about a foot in diameter and usually less, which were topped with figures, beasts, or houses modeled of the same clay. Horses, barnyard fowl, deer, dogs, and monkeys were some of the subjects of these ritualistic sculptures. In the wall painting of the Takehara Tomb at Wakamiya-machi, Fukuoka prefecture, dating from the same period as the *haniwa*, horses were painted along with other elements on the rear wall of the funerary chamber. In addition, flanking the passageway in the antechamber of this same tomb, a fantastic bird and a tortoise are depicted. In all likelihood these equated with the symbols for the directions so common in early China and Korea. Thus one can see that nature themes were important even in this early formative state of Japanese art.

Traditionally, 552 A.D. is given as the date when Buddhism came to Japan. It was at this time that the King of Kudara presented to the Japanese court a gilt bronze image of Buddha accompanied by canopies. If they resembled those found at the Hōryū-ji, these hangings were embellished with phoenixes as well as angel-like heavenly beings known as apsaras. Probably metallic or cloth banners hung from the corners of the canopies, and almost certainly these had a floral and apsara motif. To further establish the nature theme in Japanese art at an early date, one need only examine a catalogue of objects from the Shōsō-in, the Imperial Repository. This treasury was presented in 756 A.D. to the Tōdai-ji in Nara by the Empress Kōmyō in memory of her husband, Shōmu (724–748). Included therein are many works of art decorated with bird and floral elements, as well as delicately drawn deer and other animals. The Shōsō-in objects have the richness, elegance, and refinement of T'ang dynasty (618–907) Chinese art. The impact of T'ang decorative style on Japanese art was so great that it continued to influence artists directly or through transmitted modification into modern times.

During the Nara period, which lasted roughly from 645 to 794, nature's role in art continued. It was, however, not the dominant aesthetic movement, for this was the period

when Buddhist art was flowering and the representation of deities in anthropomorphic guise was all-important. Birds, beasts, blossoms, and bugs did appear, but usually in conjunction with an iconographic work. The elements of nature were used primarily as embellishment and ornamentation. Few works of the Tempyō period have survived in which the sole theme is the four subjects to which this volume is devoted. Art in Japan was clearly being used for sacred pedagogical purposes.

It was actually not until the Heian period (794–1185), and the growth of secular forms of art, that nature themes appeared independently with any degree of frequency. Motifs of flora, fauna, birds, and insects continued to decorate items intended for sacred use or as offerings. However, the same themes were also used to decorate the handsomely crafted sheets of paper on which favorite poems of master poets of the age were written in flowing calligraphy. Such an example is the *Ishiyama-gire* fragment (No. 1) in this volume. Other uses were as illustrations for compendiums like the herbal titled *Yakushushō* (No. 2). We also know that textiles of the period used floral motifs. It is astounding that at this early date, the eleventh century, handscrolls were painted in which animals acted out human roles. These are the noted *Chōjū Giga* (Frolicking Animals) scrolls attributed to the priest-painter Toba Sōjō, Kakuyū (1053–1140). It is believed they were intended as a report on "The State of the Nation" and were a priestly warning to all to mend their ways. There is a great novelty about them and they set the pace for an entire school of caricature-like paintings or prints known as *Toba-e*, after

the so-called founder of the style. This innovation in Japanese art was most important because it signaled a break away from Chinese domination. It is one step in the growth and development of a national style which came to be called *Yamato-e*. This is literally translated as "Japanese pictures," for Yamato is another name for Japan. The Toba-e also contain characteristics—a strong sense of movement and action as well as humor—common in Japanese art from at least as far back as the eleventh century. A fragment from a twelfth-century *Chōjū Giga* scroll appears in this volume as No. 5.

Textiles with delicate floral patterns and metalwork decorated with arabesques, blossoms, and insects were not unusual in the Heian period. Lacquers and objects made for personal use were decorated with natural themes. The very fact that such pieces were personal tended to dictate detailed and delicate rather than bold decoration.

In the Kamakura period which followed, true control of the country rested in the hands of military figures like Minamoto Yoshiie (1041–1108) and Minamoto Yoritomo (1147–1199). The center of dictatorial control of the land was moved from Kyoto to Kamakura, where the ruling lords lived with their loyal retainers. Art of the Kamakura period took on the vigorous character of the age. Paintings often represented the struggle between Minamoto and Taira clans with bold directness and a narrative quality. Such is the case of the Yamato-e handscrolls, which flourished in a wave of nationalism resulting from the attempted Mongol invasions of Japan in 1274 and 1281. Handscrolls such as that depicting the *Tale of the Swift*

Bulls (Nos. 3 and 4) point to a marked and rapid development of the Japanese painting style. Artists endeavored to convey some sense of realism. The use of clearly defined outlines, with colors and washes confined within the delineated areas, was typical of the age. Even when heavy pigments were applied to fill in these areas, lines were usually drawn over them to strengthen and define the representation. The Kamakura artist consciously strove to put action into his work. This has always been an important feature of Japanese art and especially of the Yamato-e handscroll paintings.

The nature tradition continued in metalwork, lacquers, textiles, and ceramics. The flower tray for Buddhist rituals, known as a *keko* (No. 6), is extremely lovely. The cut-out pattern, with its chased and engraved design to which silver and gold have been applied, signifies a very high aesthetic and decorative tradition. The same can be said for the lacquered incense burner (No. 7). The stylization of the plovers and waves is vigorous and reflects the political climate.

Ink drawings and paintings had long played an important role in sacred art. Thus great numbers of sutras illustrated with sketches of the deities or their mudras (hand gestures) were produced. In addition, nature paintings in ink closely resembling those of Sung and Yuan dynasty China grew in popularity. The very lyrical *Plum Blossoms* (No. 9) in the Cleveland Museum of Art is evidence of the Chinese influence. Ink painters of the Kamakura period were establishing a set of precepts adhering closely to those followed in China. A vocabulary of brushwork was being built up, and though the ink paintings suggest those of China, the two would normally not be confused. To the Japanese artist, pattern and decoration were most important. If we turn to our theme, we find that the qualities of boldness, vigor, a narrative style, elegance, and decorative pattern have been contributed by the artists of each historical period.

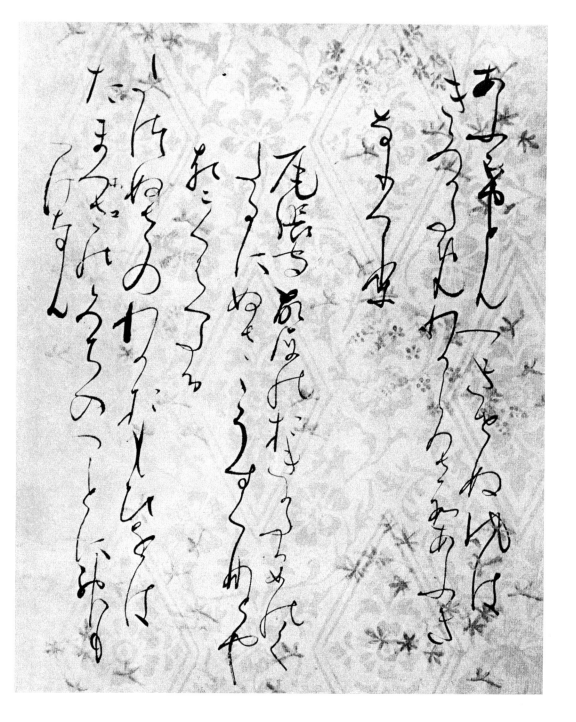

1. A Poem page from the selected works of Ki-no-Tsurayuki. Heian period, twelfth century. Ink, color, and silver on paper, 52 1/4 x 16" (132.7 x 40.6 cm). Seattle Art Museum

Since the earliest use of their written language the Japanese have demonstrated a great love for literature and the recording and documentation of it. This characteristic is reflected even today in that Japan is one of the greatest publishing centers of the world. Not only are the volume and flow of literature amazing; the aesthetics of the beautiful book, pamphlet, or tract has nowhere been more carefully refined and developed than in Japan.

Many beautiful collections of chronicles and poems were composed and assembled during the eighth century as confidence grew in the use of a written language. The *Nihongi* (*Chronicles of Japan*), *Kojiki* (*Record of Ancient Events*), and *Manyōshū* (*Collection of Ten Thousand Leaves*) are all evidence of this. One of the most elegant and sophisticated literary assemblages of the Heian period is that commonly known today by the name *Ishiyama-gire*. The collection of poems by the Thirty-six Poets, of which this page was originally a leaf, was treasured by the Imperial Household until 1549. At that time the Emperor Gonara gave the collection to the Hongan-ji in Kyoto, which in turn sold two volumes in 1929. Since the first Hongan-ji had been located at Ishiyama, the sheets from those volumes were called *Ishiyama-gire* (Ishiyama fragments).

These treasured decorated pages of poetry are indeed rare, and only four are currently outside Japan: the specimen shown here, an example in the Philadelphia Museum of Art, one in the collection of Mr. and Mrs. Jackson Burke, New York, and an unusual page executed in a collage method with

sheets of torn or cut colored papers in the Freer Gallery of Art, Washington, D.C.

The Seattle Art Museum page is covered by an overall printed lozenge pattern with a floral motif filling all but the double walls of the lozenges. Added to this design and tastefully embellishing the page are what have been at times termed birds, insects, and a small spray of delicate blossoms. These stylistically resemble motifs often found on finely decorated Chinese gold and silver of the T'ang dynasty. The ornamentation of the paper is done in silver and gray ink and has a sheen probably produced by the addition of mica and glue.

The calligraphy on this elegant surface is by an unknown scribe, who, to judge from the nature of the brush-work, must have been a master of consummate skill. The characters and *kana* (syllabary) done in ink complement the paper and are poems by the great master poet Ki-no-Tsurayuki (c. 884–946). The text has been translated by Professor John Rosenfield of the Fogg Art Museum, Harvard University, as follows: "Added to a gift of a fan sent to the Governor of Chikugo on his departure from the capital.

> A wind that will never fail
> Though you were to fan forever
> Such is my deep respect for you."

Professor Rosenfield tentatively translates the second poem as:

> "These paper offerings
> For the starting of your journey
> May the gods accept,
> And these my loving thoughts
> report to you,
> At every shrine along the
> spear-straight way."

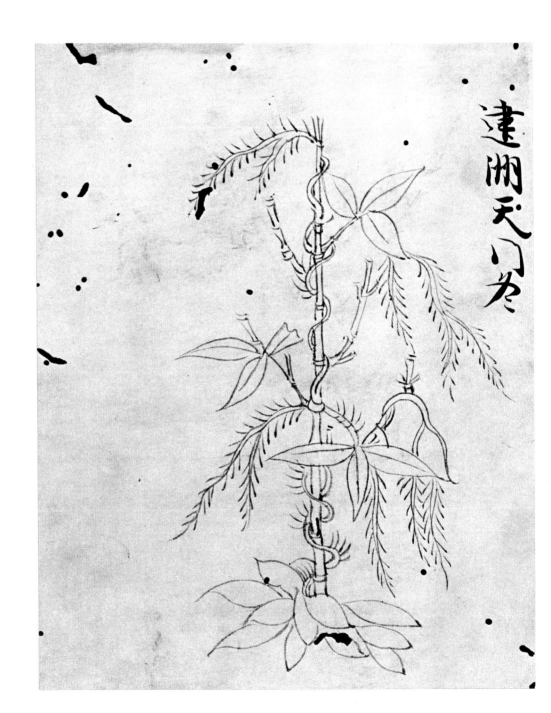

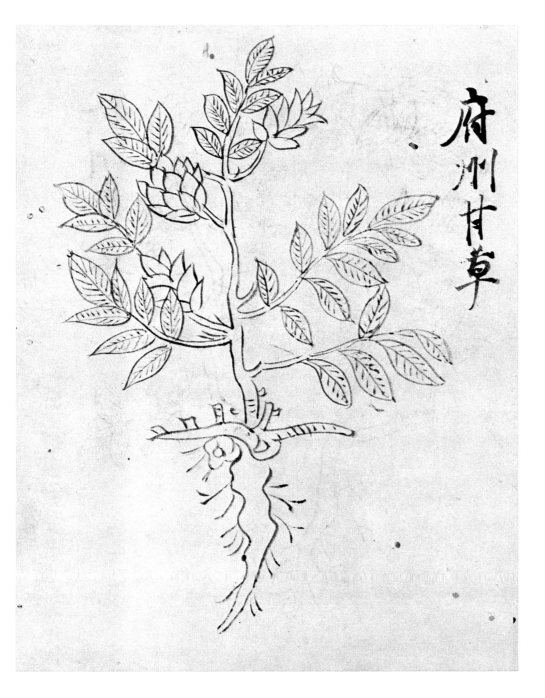

府州甘草

2. *Book of Medicinal Herbs*
(Yakushushō). Late Heian period, mid-
twelfth century. From the Hōbenchi-in,
subtemple of Kōzan-ji, Kyoto. Sumi ink
and red ink on paper, 6 5/8 x 5 3/4″
(16.8 x 14.5 cm). Fogg Art Museum,
Harvard University

Herbals and pharmacopoeias were an
early and popular form of depicting the
plant life of a land. These volumes with
illustrations of the plants useful in
sustaining and maintaining health were
very important works, and it is obvious
that because of their nature they would
be copied and proliferate. The tech-
niques employed in producing such
volumes were rather similar throughout
the world. In the Near East a parallel
volume of slightly later date than this
example was the 1224 copy by Ab-
dallah ibn al-Fadl of the Dioscorides
Materia Medica, one of the most noted
early treatises of this nature.

The *Yakushushō* (*Book of
Medicinal Herbs*) illustrated here is
based on a Chinese herbal. It was
copied by a monk of the Shingon sect
named Ken'i Ajari, who was active
from 1072 to 1145 and was associated
with a subtemple of the Ninna-ji located
on the western outskirts of Kyoto. It
is clear that this work closely follows
the Chinese original, for the text and
illustrations reproduce the Chinese
formula.

There appears to be evidence that
more than one hand was associated with
the copying of this work. Thus there is a
variety of calligraphy styles, and it is
possible that the plants portrayed are by
yet another hand, or hands. Some
thirty-one drawings can be found in the
book. In this volume, seven herbs are
discussed and illustrated. The two
shown here are 2a—asparagus (*t'ien
men tung*) and 2b—licorice root (*kan
ts'ao*). The plants are very simply drawn

in outline. The artist clearly sought basically to delineate the distinctive features of each plant: the veining of the leaves, root structure, and blossom. They were obviously swiftly drawn, perhaps as an exercise. He also placed beside them their proper names. The text accompanying each herb explains its usage and value. In addition to serving medicinal purposes, herbs were also used as part of the *goma* ceremony, in which aromatic herbs were ritually burned and offered.

The artist's concern for accuracy in his copy is a strong characteristic of Japanese art, and simple drawings such as these were to continue throughout its history.

3. *A Bull* from the *Shungyū E-kotoba (Tale of the Swift Bulls)*. Handscroll (fragment). Kamakura period, thirteenth century. Ink and slight color on paper, 41 3/4 x 19 3/4 " (106 x 50.2 cm). Seattle Art Museum. Gift of Mrs. Donald E. Frederick

4. *A Bull* from the *Shungyū E-kotoba (Tale of the Swift Bulls)*. Handscroll (fragment). Kamakura period, thirteenth century. Ink and slight color on paper, 45 1/4 x 23" (115 x 58.4 cm). The Cleveland Museum of Art. Purchase, John L. Severance Fund

Bullocks were the principal beasts of burden in Japan until relatively modern times. These sturdy animals with their broad muscular shoulders and stout necks were employed to move the trade of the land to and from the market. They were also used in the fields and to draw the carriages of all levels of society as they moved from place to place.

Paintings of these vital beasts were gathered together in scrolls such as the one to which these two fragments originally belonged. Similar scrolls portraying horses and grooms also appear to have been a common theme from the Kamakura period on. We know of prototype Chinese representations of horses in the Sung dynasty, but the Chinese artist generally did not concern himself with dignified portraits of animals other than horses, dragons, and tigers. In Japan, although the compositions are carefully structured, there has always been less formality in art. Perhaps because of this the Japanese turned to these individualistic and sympathetic portraits of bullocks.

These fragments were originally part of the same scroll, of which only ten sections have survived. In one, formerly in the Masuda collection, a youthful attendant stands beside the bullock. Normally the scroll is titled *The Ten Fast Bulls*, the title being from the copy depicting ten of these beasts on deposit in the National Museum, Tokyo. In this catalogue I have used "swift" rather than "fast," for in dealing with students I have found that they often associate "fast" with abstinence rather than with speed.

Each of these designs is a great masterpiece of animal painting. From the brushwork it is apparent that the Seattle and Cleveland works are by the same hand. Heavy masses of black and touches of brown form the bodies of the animals. The forms are all carefully contained within a skillfully drawn enclosure of lines. Some of these are dark, whereas others take on the appearance of reserve areas though in truth they are drawn. In both fragments the artist has used a device of shading to create the rounded and massive volume and musculature of the beasts. The tonalities of black, gray, and brown are most adroitly handled. The artist also contrasts the full and forceful bodies of the beasts with the extraordinarily delicately drawn hair of their tails.

The bullock in the Seattle Art Museum collection has its head lowered, with weight concentrated on its shoulders and forelegs. It stares at the ground and its horns turn downward; its rump protrudes and its hindlegs appear to be drawn in. One can speculate that it is either ready to charge forward or merely looking for some choice bit of food. In contrast, the Cleveland Museum of Art bullock is shown in movement. Its left foreleg is lifted and bent, and its other legs and raised head indicate its forward motion.

Both these paintings point to the skill of the Kamakura artist of Japan, who, working in the Yamato-e (Japanese) tradition, was able to impart character and movement to these important beasts. These paintings survive as two of the most treasured early animal paintings of Japan.

DETAIL OF PLATE 3 ▶

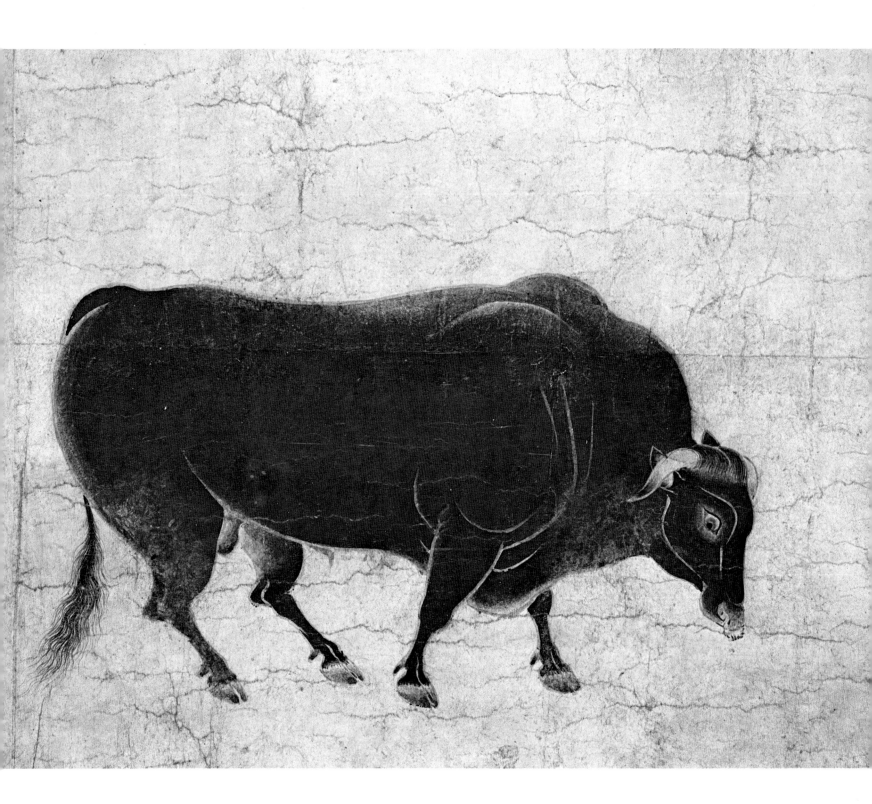

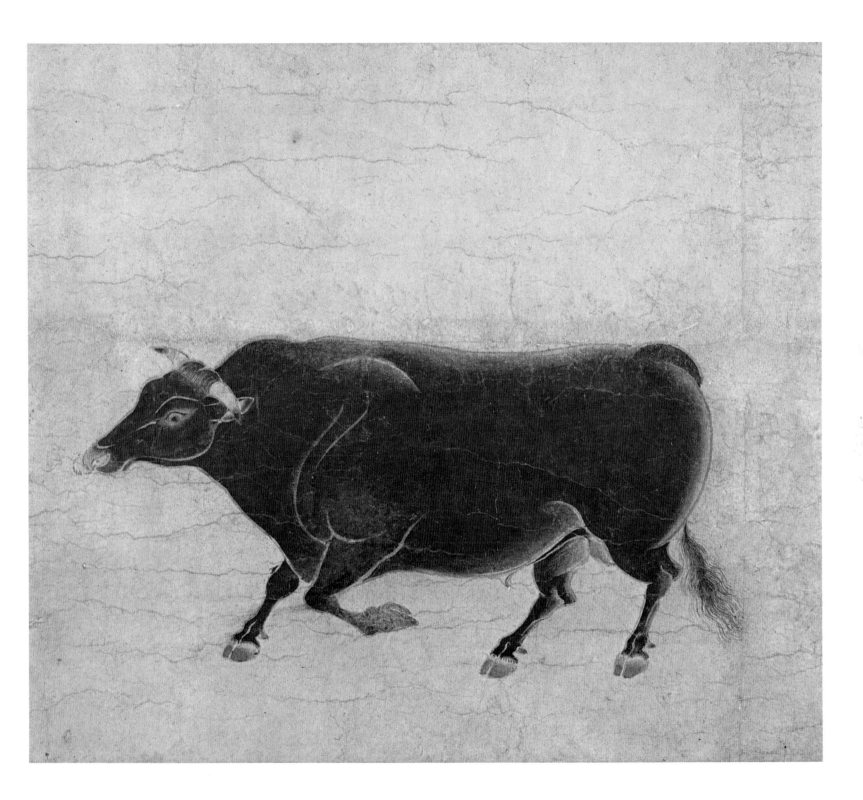

5. *Chōjū Giga (Frolicking Animals).* Handscroll (fragment). Kamakura period, thirteenth century. Ink on paper, 11 3/8 x 21 1/8" (28.9 x 53.6 cm). The Brooklyn Museum. Lent by the Guennol Collection

There are probably no better-known paintings in the world portraying animals acting in human roles than the series of scrolls titled *Chōjū Giga* and their fragments. The main body of paintings categorized under this name consists of four handscrolls believed to have been done by different hands and probably at varying dates. The most important of these is the first scroll, which is traditionally attributed to the brush of the priest-artist Kakuyū, more commonly known to us as Toba Sōjō (1053–1140). He was a priest of the Shitennō-ji and in 1131, prior to his retirement to the Onjō-ji, was made abbot of the Shōkongō-in.

The *Chōjū Giga* handscrolls which are in the possession of the Kōzan-ji, just outside Kyoto, have been interpreted as being a report on the state of the nation (Japan) in the twelfth century. They carefully document the frolicking and playful life and even report the lip service to, or mockery of, Buddhist ritual. Though they were probably intended as a form of protest painting or warning, I know of few works which in outward appearance are more joyful. These scrolls and the fragments believed to have been derived from them provide some of the earliest action cartoons to be found in Far Eastern art history. They explode with scenes that appeal to a permissive society—games, picnics, contests, etc.—but the artist who created these paintings intended them to be viewed by the public as warnings. The message was clear: "Stop all this, mend your ways, the day of doom is nigh!"

There is a great deal of controversy surrounding the dating of the various scrolls and their fragments. Research has even extended to the measuring of markings and pressure on the paper. The fragment lent by the Guennol Collection is a case in point. Though scholars have argued about it for years, few have been able to point to anything concrete placing it outside the Kamakura period. It is a charming subject, for it portrays a race. The racecourse at the Kamo River in Kyoto had been used for competitions since the fifth day of the fifth month of 1093. This depiction may well be a parody of such a race. We know that races took place at court prior to that time, and we know that even earlier racing was common in China, going back at least to T'ang times.

The scene shown here is very entertaining, for monkeys and a rabbit play the human roles, while a stag substitutes for a horse. Two of the monkeys wear the typical tall hats of Kamakura court officials. One has just been thrown by his steed and, in a rather disgruntled as well as battered state, rests on the ground. His friend holds on to his hat as he rushes along and tries to catch up with the bucking and galloping stag. The scene is filled with action: the gentle rising curve to the left of the composition, the running simian holding his hat, and the stag with five legs all clearly indicate movement. The stag is very angular, whereas the monkeys and rabbit are executed with a much more cursive brush. A minimum of line is used, and there is very little background or foreground to indicate the setting. But the story is clearly told, and today the *Chōjū Giga* paintings are among the most universally appealing in Japanese art.

In 1974 the Freer Gallery of Art in Washington, D.C. acquired an early Muromachi period copy of a scroll of the *Chōjū Giga* type that was formerly the property of the Ryūkō-in and carries its seal. It is known in Japan as the earliest datable copy of these paintings, and it is interesting to note that the section portrayed here also appeared in that scroll.

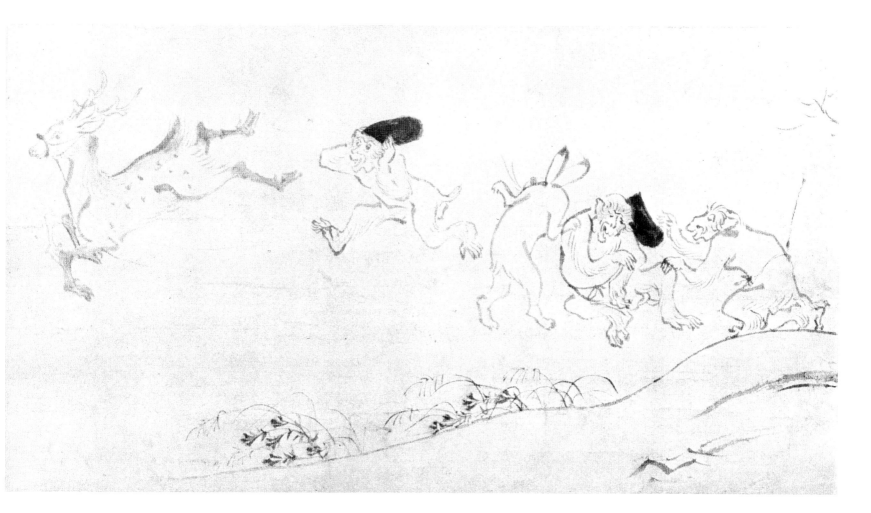

6. *Keko* (ceremonial flower tray).
Kamakura period, twelfth century. Gilt
bronze, diam. 11 3/8″ (28.9 cm).
Honolulu Academy of Arts.
Wilhelmina Tenney Memorial Fund,
1955 (2114.1)

As part of memorial services held in
Buddhist temples, there was a ritual
that involved the strewing of flower
—usually lotus—petals. This practice
we know goes back at least to the Nara
period; evidence of its common use at
that time can be seen in the 800-odd
bamboo baskets now preserved in the
Shōsō-in (Imperial Repository) in Nara.
 This particular example is one of
great beauty and rarity. It very closely
resembles the *keko* in the Jinshō-ji in
Shiga prefecture, which is registered as
a National Treasure. The tray is shaped
like a shallow bowl; except for the
narrow solid rim, the entire surface is
made up of a reticulated pattern of
legendary peony-like *hosoge* flowers
and tendrils. The imaginary *hosoge*
flower is very often associated with
Buddhist ritualistic items and was
commonly used as a textile motif.
 The pattern is one of great richness
and elegance, calling to mind the gold-
and silverwork of T'ang dynasty China.
The pattern is such that no matter how
one turns the tray the design appears
alive and in movement. To enhance the
cutout motif, the artist has chased and
incised into the metal fine details of the
flowering plant. He has then carried his
craft one step further by gilding and
silvering the tray so that it takes on ad-
ditional richness and three-dimension-
ality. On the bottom and decorated ex-
terior of the tray three small rings are
placed in a triangular arrangement. The
cords that supported the tray were at-
tached to these rings, and decorative
metal ornaments were suspended from
the ends of the cords.
 Few examples of cut-gilt bronze
metalwork exist that surpass or equal
the sumptuous refinement of this
twelfth-century flower tray.

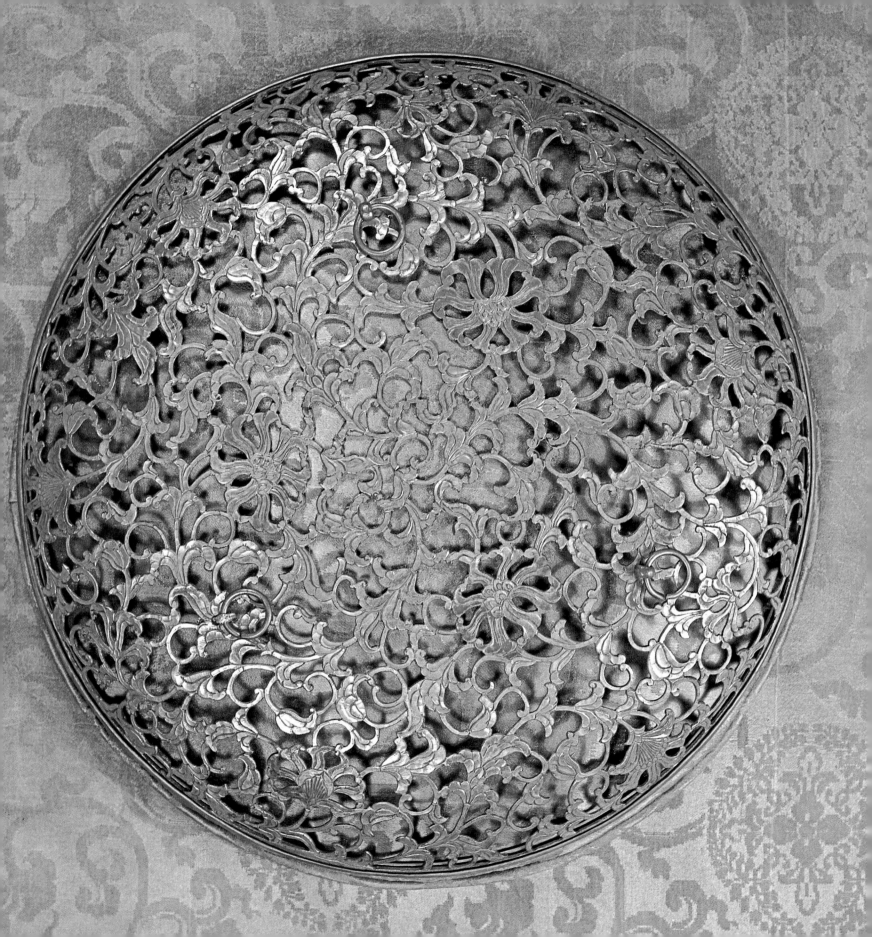

7. Incense burner. Kamakura period. Lacquer, 3 x 4 1/4″ (7.1 x 10.8 cm). The Cleveland Museum of Art. Purchase from the J. H. Wade Fund

The art of lacquer came to Japan at a very early date. We know that in the Suiko period (sixth century), control and skill were such that lacquer was employed as a covering layer for sculpture and for the surfacing and decoration of furniture and votive items. China and Korea served as the source of inspiration and instruction; however, the Japanese, as so often was the case, refined and developed the technique to new levels of expertise and excellence. Lacquer is a very sturdy and almost indestructible material. But it comes from the sap of the *Rhus vernicifera* plant and, to most people, raw lacquer juice is highly toxic, producing the same reaction as poison oak or ivy. This is one of the handicaps faced by the lacquer artist. To work in comfort and safety, he must be immune or develop immunity. A second hurdle in the path of the lacquerer is that the processes of fabrication and decorating are very slow and tedious. This is especially true if one is to produce delicate designs on lacquer in relief or in different colors. A third difficulty is that, unlike most other materials, lacquer must be kept in an environment of very high humidity in order to cure and dry properly. Facing these three hazards, Japanese artists mastered the material and have produced, right into modern times, works of incredible beauty.

This small incense burner is an early example of lacquer artistry applied to an object not designated solely for spiritual purposes. The incense burner is lobed and almost pouchlike, for the neck is narrower than the foot and banded with metal. The basic lacquer ground applied to the wood body is dark brown in tonality. Painted on the dark-brown ground is a motif very common in Japanese art, *chidori*, plover in flight. The birds are executed in gold lacquer and, though they are highly stylized, the artist has remarkably captured their swiftness and beauty in flight. Though the incense burner itself is formal and geometrical in shape, the birds on its surface are free, and dart here and there in all directions as they presumably skim over the surface of water. Although the basic formula for the birds is repeated, it is not slavishly echoed, and the plover have individuality and charm. The presence of movement and those two characteristics are typical of Japanese art through the ages.

The theme of plover in flight is much beloved by the Japanese; it appears not only in art but in literature. Plover occur in poetry found in the *Kokinshū* (*Collected Poems of the Past and Present*) of the tenth century, as well as in the *Manyōshū* (*Collection of Ten Thousand Leaves*), the earliest anthology of Japanese poetry. An amusing touch added to this rare and striking object, probably as a replacement at a later date, is the rounded bronze cover made to resemble open wickerwork. Because of this cover, the object, in addition to serving as an incense burner, resembles a hamper in which fish might have been stored. Little wonder that the plover fly so energetically around it!

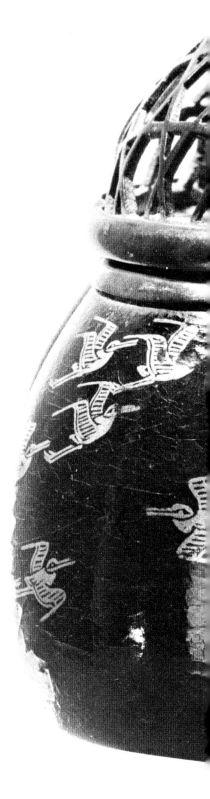

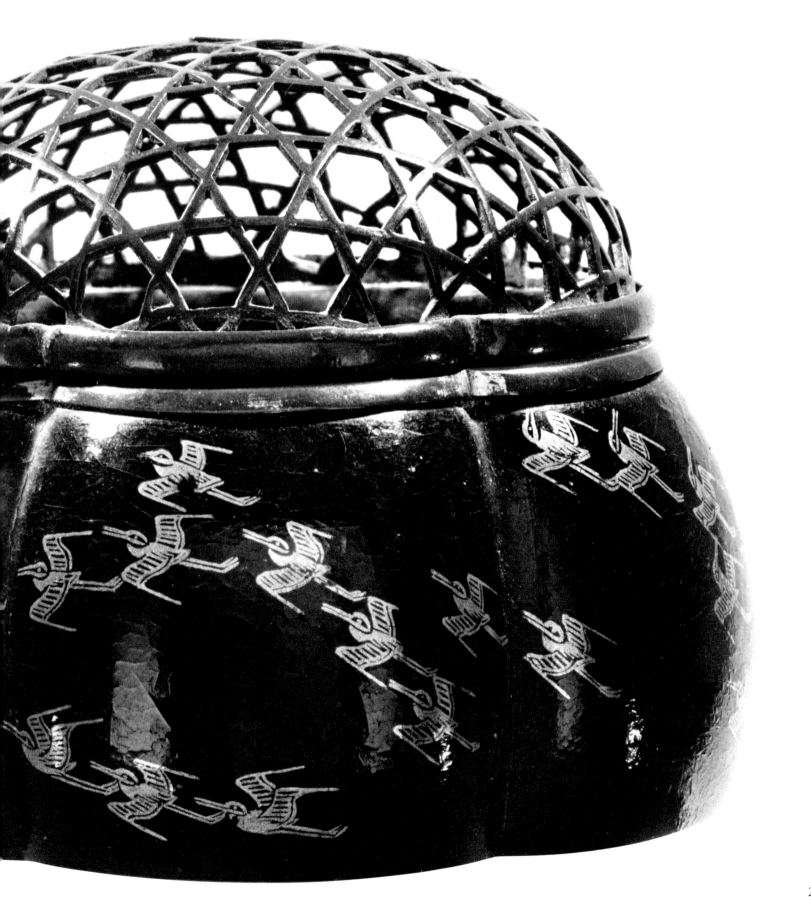

8. Mirror. Kamakura period. Bronze, diam. 8 1/2" (21.6 cm). The Cleveland Museum of Art. Purchase, John L. Severance Fund

One of the "Three Sacred Treasures" of Japan, along with a sword and a string of beads, is a mirror known as the *Yata-no-Kagami.* It is this mirror which is said to have been used to show her reflection to Amaterasu Ōmikami, the legendary sun goddess, and thus lure her forth from the cave into which she had retreated and return light and day to the world. A replica of this mirror still plays an important role in all imperial ritual and is kept in a sacred sanctuary in the Imperial Palace in Tokyo.

To the best of our knowledge, mirrors were introduced to Japan from China, where, many centuries earlier, artisans had mastered highly sophisticated bronze-casting techniques. Mirrors dating from the Tumulus period have been excavated. The Shōsō-in contains a good number of highly decorated mirrors inlaid with mother-of-pearl, which are rather rare. Mirrors produced in a purely Japanese style appeared in the eleventh century, during the Heian period; they are rather small and thin, with highly raised rims. Their backs were decorated with naturalistic elements such as plants, insects, and birds scattered over the surfaces in an abstract manner. Although using the same naturalistic motifs,

mirror decoration changed in the Kamakura period; the various elements were then organized to form more realistic, unified compositions. Thus landscapes appear on the backs of mirrors. At the same time, the typical Kamakura mirror, including its rim, became thicker than those of the previous period.

This handsome and sharply cast mirror is typical of those of the late Kamakura period. On its back is cast a design of a rocky island on which pine, bamboo, and a tortoise flourish. On the small flat island two cranes and a small pine tree are depicted, while in the upper portion of the composition, six plover fly through the cloudy sky. It is a very lyrical and symbolic composition,

for most of the elements depicted equate with longevity. The pine, bamboo, tortoise, and cranes are all felicitous symbols and carry the wish for a long life. The center knob is cast in the form of a tortoise. Mirrors with these basic decorative elements continued in popularity into the mid-nineteenth century; obviously they made wonderful gifts, for their decoration automatically conveyed tidings of long life and happiness.

The casting of this particular mirror is exceptionally crisp. The artist organized his design elements beautifully in the circular composition, with pine trees, birds, rocks, and waves all balancing each other. Joyous scenes such as this were often labeled "Island of Immortals."

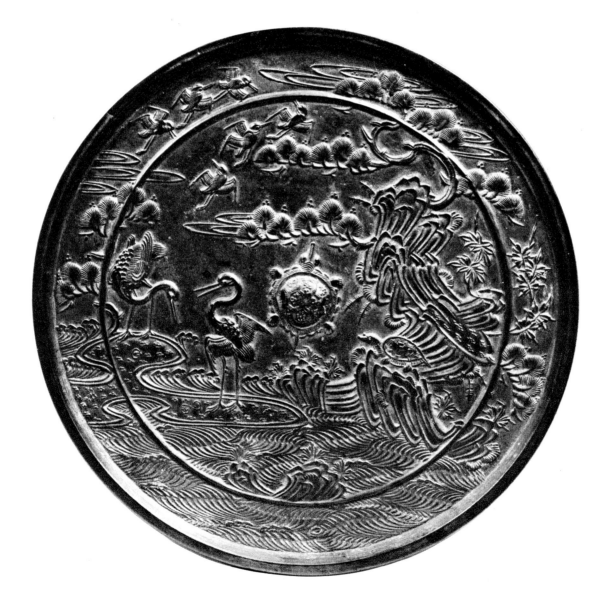

9. *Plum Blossoms*. Artist unidentified. Nambokuchō period, fourteenth century. Kakemono, ink on paper, 72 x 18 3/4" (182.9 x 47.6 cm). Seal: rectangular—not deciphered. The Cleveland Museum of Art. Purchase, John L. Severance Fund

The use of branches of flowering plum or a gnarled old plum tree as a theme for paintings was common from the fourteenth century on. The source of inspiration was once again China, where a long tradition of paintings of *Prunus* existed. Only recently my colleague Hincheung Lovell, Associate Curator of Chinese Art at the Freer Gallery of Art, researched this subject, and her very informative and instructive paper is about to be published in *Archives of Asian Art*. In this paper, Mrs. Lovell points out that the traditional innovator of the category of plum-blossom paintings in China was a monk named Hua-kuang Chung-jen (c. 1061–c. 1123), who is said to have created his designs by loading his wet brush with ink so that each stroke was absorbed by the fibrous structure of the paper. He avoided the use of outlines. Hua-kuang Chung-jen reportedly was fascinated by the shadows of plum blossoms cast by moonlight on his window, and was so inspired that he tried to capture that impression. There are two other styles; one ascribed to Yang Pu-chih (1097–1169), who relied on outlines for the flowers, and a second assigned to T'ang Cheng-chung (twelfth century), who worked in a reverse technique by painting in the background and leaving the blossoms and branches in reserve.

The branches of the plum which serve as the theme for the painting illustrated here are primarily done after the manner of Hua-kuang Chung-jen. A large branch and lesser shoots enter the composition from the bottom, and they cross and, at times, intersect each other as the artist employed them to create a very strong design. The young branches are composed of single strokes executed with spontaneity, so that, though the brushwork is forceful, one remains certain that the branches are limber and will move and sway with the breeze. Spotted along the edges of these branches are clusters of blossoms, whose petals and buds are made of small dots of light ink applied with a wet brush and absorbed into the receptive paper in the alleged Hua-kuang Chung-jen manner. However, the pistils, stamens, stems, and hulls of the blossoms are done with dots and lines of intense ink. The entire arrangement of these branches of *Prunus* is of great beauty and speaks of the symbolic nature of the tree. The plum is one of the "three friends" in Far Eastern art. It equates with longevity, for it blooms at the end of winter to signify the continuance of life. In this fine painting the branches reach in all directions and inform us that growth goes on.

In the lower-left portion of the painting, near the thickest branch, there is a seal. Unfortunately, it has not yet been deciphered, and the competent artist remains unknown.

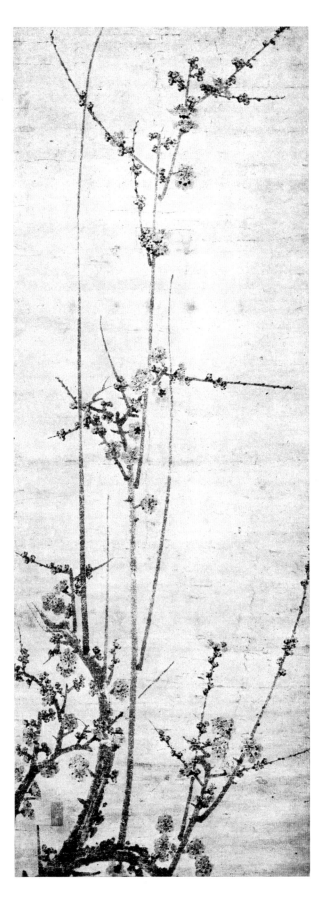

Muromachi and Momoyama Periods

ONCE JAPANESE ARTISTS gained competence in ink painting, they developed a general style which they refined and subdivided into schools, with each one having its own characteristics. The vitality of art in most lands is proportionate to the number of skilled artists at work and the support they receive from patrons and the masses for their finished products. In nature studies, the Muromachi period (1334–1573) saw the growth and flourishing of bird, flower, and animal paintings executed in ink. These in general were derived from Chinese prototypes, and the paintings are grouped together under the term *Muromachi Suiboku-e*, which literally means "ink and water paintings of the Muromachi period." The artists who produced these works were not only doing deocrative studies; they were also carrying out fairly accurate investigations of nature and recording pictorially what was known at that time.

The artists of the period soon learned to employ a variety of inks, papers, and silks. Knowledge of the characteristics of these raw materials was invaluable in producing lively and alluring paintings. It is also clear that many of the artists who produced ink paintings with nature themes were priests. It should not seem unusual to the layman that the great religious compounds of Japan were centers of culture. We are aware of the same phenomenon in the Western world—it was at the monasteries that one found the learned men. The interests of the Japanese priests extended far beyond the boundaries of religion and reached into the arts.

These same monks or lay fellows were very often the people who had traveled on religious pilgrimages or as official representatives of the central authority. Their journeys took them to China and Korea, and while there, they studied intensely and were exposed to aesthetic developments abroad.

The monks also were skilled in calligraphy and many went a step further, carrying their ability to write beautifully into the development of painting. Monks such as Shūbun (flourished in the first half of the fifteenth century) and Sesshū (1420–1506; No. 10) had traveled to China. Sesshū is known to have painted there, and though his paintings were allegedly lauded by the Chinese, he never properly acknowledged his full debt to Chinese art. In fact, it is reported he bemoaned the lack of competent painters on the mainland. If one examines Sesshū's paintings, however, one is rapidly convinced that if he had not had great exposure to the art of China he might have been a lackluster academic hack.

A monk's knowledge of art was not only attained by travel abroad. It was also acquired at home, because the monasteries were the great repositories for art. At this time war and battles were rife in Japan, and when one adds natural calamities to those made by man, it is astounding that any works of art survived. Again, like the churches and monasteries in Europe, those of Japan served as centers of sanctuary. The treasures acquired by missions abroad were safeguarded in temple storehouses. Much Chinese art of the

Sung, Yüan, and Ming dynasties was devoted to representations of nature. The Che school in particular was favored by Japanese who brought back paintings from China. This school was rich in artists who, in addition to producing landscapes, took delight in painting birds, flowers, animals, and insects into their compositions. Exceptionally popular was the artist Fa-ch'ang (Mu-ch'i; died between 1269 and 1279), who painted the *Dragon and Tiger* now in the Daitoku-ji in Kyoto. Monkeys and cranes were also his forte and numerous works attributed to his hand are found in Japanese temple collections. The Japanese artists of the Muromachi period also became acquainted with works by the artists Lü Chi and Li Tsai. The former master was especially noted for his large compositions of groups of birds and flowers set in rocky landscapes. In truth, it is difficult to establish much Sung dynasty influence on Japanese artists. The strongest impetus came from Ming works.

In addition to the Japanese interest in and curiosity about anything foreign, it must be pointed out that it was during the Muromachi period that Zen Buddhism established its greatest foothold in Japan. Natural subject matter had much appeal to Zen artists who sought simplicity and whatever was untainted by human toxicity. Thus works such as Shōkei's *Kingfisher Perched Above a Stream* (No. 11), Eii's *Hahachō* (*Crested Mynah Birds*; No. 15), and Sesson's *Grapes and Bamboo* (No. 16) came into being and were highly favored. Given the opportunity, readers might acquaint themselves with superb examples of Zen painting in Japan, such as the *Heron* by Ryōzen (active c. mid-fourteenth century) in a private collection, Kyūshū

Kyōkyaku's (active late fourteenth century) *Plum Blossoms* in the Masaki Museum in Ōtsu, or Gyokuen Bompō's (died c. 1420) *Orchid and Bamboo in Moonlight* in the collection of the National Museum, Tokyo. There are numbers of these paintings to be seen in public and private collections both in Japan and the United States. The Zen manner usually relied on the use of ink and an economy of line. The subjects were reduced to their essentials, and the so-called "bones" of their structure gleamed with brilliant light.

The Muromachi period also saw the development of bird, flower, and landscape screen paintings. Screens had been produced much earlier in Japan, so the format was not an unfamiliar one. The bird and flower screens and wall panels attributed to Sesshū (No. 10), Motonobu, or other Kanō and Unkoku school artists permitted a new dimension. Painting was no longer confined to very narrow and tight boundaries. The artist was now able to think in terms of large-scale compositions covering broad expanses. The challenges were many, for it was necessary to maintain the viewer's interest over a larger image area. This was often accomplished by the addition of color, which indicates an increasing search for realism as well as a love for the patterns created by the interplay of colors. Japanese artists had long mastered these skills.

An additional wonder of the Muromachi period was the establishment of the Kanō school of painting, which fused Muromachi Suiboku elements with the traditional Yamato-e and its related Tosa styles. It is incredible that this tradition, which commenced with the artists Masanobu (c. 1434–c. 1530) and his son, Motonobu (1476–1559;

No. 12), continued to flourish into the nineteenth century. The Muromachi period was thus a very formative one, for out of the Kanō and Muromachi Suiboku traditions many new styles were to break off and blossom.

Toward the end of the Muromachi period (late sixteenth century), many changes—political, economic, and cultural—were occurring in Japan. On the political side, the strong sway of the scholarly, Chinese-oriented, Confucian-flavored Ashikaga shogunate was drawing to a close. Economically, civil warfare had weakened and destroyed many once powerful daimyo. As their influence declined, so did that of their samurai and other retainers. But though power shrank, costs remained high—a familiar story even today. Pressure existed to maintain a front and not to lose face. Because of the cost, this further weakened that social class.

Merchants and purveyors of supplies and services for the daimyo and samurai grew in importance. Slowly but surely many of them became moneylenders to the formerly wealthy. A spiral of wealth increasing wealth was established, and with it came the craving by the newly affluent to copy the lifestyle of those they were economically displacing.

It is odd that in Japan, just as in the Western world, one might term this "the gold rush." The era is known as the Momoyama period (1573–1615). The number of patrons interested in art had greatly increased and competition among them grew. As in most ages, gold was a recognized symbol of wealth. It had always been employed in art in Japan, but now its use was widely expanded and techniques were popularized in which gold was placed over gold and various arrangements of cut, strewn, or shredded gold were applied to enrich a surface and enhance a design. Such is the case in the *Plum Blossoms and Poem Papers* screen (No. 22). In this instance the painted design is all-embracing; it hangs like a beautiful, pierced veil over the background.

It was during the Momoyama period that Oda Nobunaga (1534–1582), Toyotomi Hideyoshi (1536–1598), and Tokugawa Ieyasu (1542–1616), the triumvirate of great military generals who wielded dictatorial power, destroyed their rivals and united the country once again, bringing comparative peace.

Regardless of the many rapid changes occurring during this period, we must keep in mind that Japan is a land that has always revered tradition. This also applies to aesthetics, and thus branches of the well-established Kanō school were very popular. The Sanraku (1559–1635) *Wagtails* (No. 18) and *Horses Romping at the Beach* (No. 21) are but a small indication of the vigor of that school. Great numbers of artists claimed allegiance to it. In a similar manner, subschools sprang forth from the Muromachi Suiboku tradition, and these included the Kaihō line founded by Yūshō (1533–1615; No. 17), who took the Kanō style and softened it with Chinese elements. The Unkoku and Hasegawa schools, which both claimed a heritage from Sesshū, also took root and flowered in this period.

One of the major aesthetic achievements of the Momoyama period was the founding of the Rimpa school. The style of this school could almost be called a bouillabaisse, for into its formation went all sorts of elements that blended to form something of great taste and lasting beauty.

Rimpa was a highly decorative style that fused elements of the Yamato-e, Muromachi Suiboku, Tosa, Kanō, and Chinese traditions to create a new and distinctive school. Two artists, Hon'ami Kōetsu (1558–1637) and Nonomura Sōtatsu (first half of the seventeenth century), teamed together to produce works in which their genius joined. Tokugawa Ieyasu, the military ruler of the country, bestowed upon Kōetsu a plot of land at Takagamine outside of Kyoto, and Kōetsu developed this into an art colony. Painters, potters, lacquer craftsmen, calligraphers, metalworkers, paper makers, and wood carvers all assembled in this colony to work under the spell cast by Kōetsu, whose contribution to Rimpa can be seen in the simplicity and rustic nature of many of his designs. Sōtatsu, his collaborator, added experimentation with block printing and the use of rich, subtle contrasts of gold and silver, as can be seen in the fabulous *Deer and Poems* (No. 23) scroll in the Seattle Art Museum. The pattern of the animals is complemented by Kōetsu's calligraphy, and the rhythm of both elements creates a syncopated flow. Sōtatsu also revived interest in the narrative handscroll manner of painting, and thus in Yamato-e. The Rimpa school is also particularly noted for compositions dominated by handsomely colored groupings of flowers. Sōsetsu's *Flowers of the Four Seasons* (mid-seventeenth century; No. 25) is a fine specimen of this variety of Rimpa.

The Momoyama period was also very rich in ceramics, metalwork, lacquer, and textiles, and nature themes were often used to decorate these objects. The rise in the popularity of art among the masses brought ever-increasing pressure on artists to improve upon or add originality to their work. In the crafts, this also took the form of tasteful embellishment. Individuality was one of the criteria used in judging a work of art. Though it was very brief in span, in terms of aesthetic creation and contribution the Momoyama period glows richly.

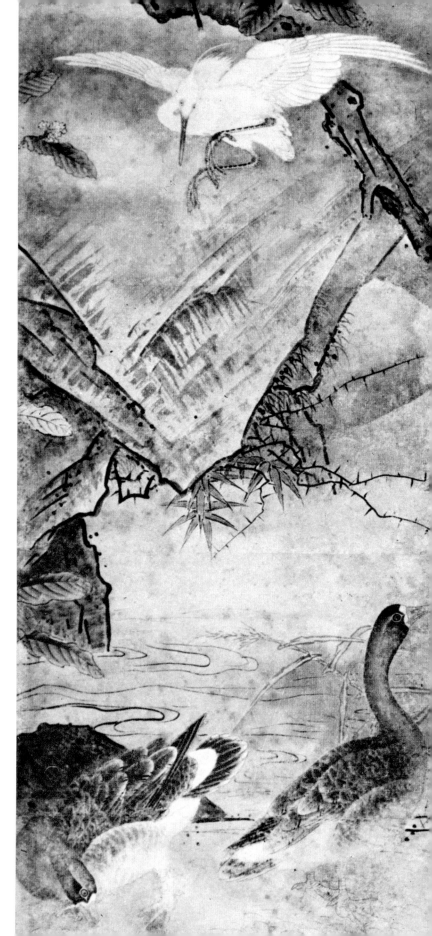

10. *Birds, Flowers, Reeds, and Trees on the River*. Attributed to Sesshū (1420–1506). Muromachi period, late fifteenth century. Pair of sixfold screens, ink and color on paper, each 70 x 12′ 3″ (177.8 x 373.4 cm). Asian Art Museum of San Francisco. The Avery Brundage Collection

During the Muromachi period numbers of screens were produced with assemblages of birds, flowers, rocks, and water as the theme. These screens were usually painted in pairs, and normally a basic formula was followed. In looking at such a pair of screens, one sees that the outer edge generally has a land mass from which emerges the trunk and branches of an old twisted tree, serving almost as a proscenium frame to mark the foreground of the composition. Large outcroppings of rock, as well as single boulders, also indicate the outer edges. The center of the composition usually contains a pond or stream, which in turn leads one's eye to a mountainous landscape in the background. Spotted throughout the quiet bucolic setting are rocks, reeds, flowering plants, and a variety of birds.

Bird and flower settings of this variety clearly were derived from later interpretations of Chinese works such as the hanging scroll of *Pheasants and Sparrows Among Rocks and Shrubs*, attributed to Huang Chü-tsai (933–993) of the Later Shu and Sung dynasties, in the collection of the National Palace Museum of the Republic of China,

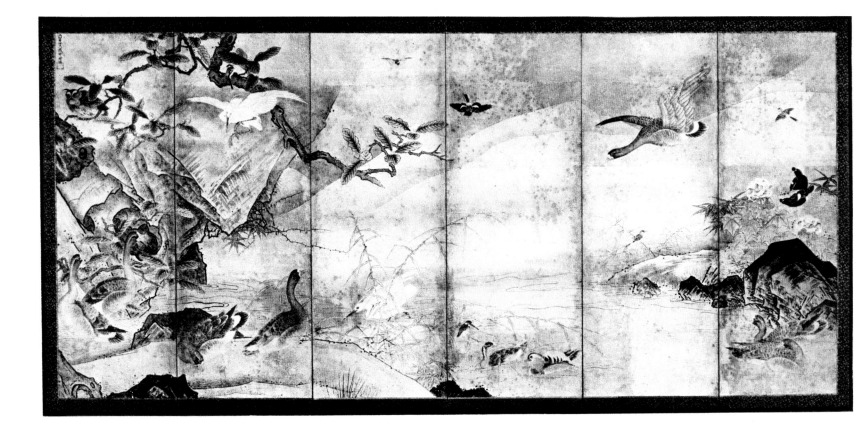

Taiwan. Numerous paintings of this kind were produced in the Sung dynasty, and the tradition continued in the Yüan and especially flourished in the paintings of the Che school of the Ming dynasty. This type of painting appealed greatly to the Japanese love of nature, and numbers of these scrolls found their way into collections in Japan during the Muromachi period.

The artist Sesshū (1420–1506) is often credited with having painted and promoted bird and flower screens. Sesshū had studied painting with

Shūbun and early in his career was attached as a novice to the Shōkoku-ji in Kyoto, where he studied under the pious Zen master Shunrin Shūto. He moved to Yamaguchi prior to 1463, and between 1467 and 1469, he traveled to Ning-po, China, and also to Peking. While abroad, Sesshū studied Chinese painting and although he professed a lack of satisfaction, he was greatly influenced by the art of the Che school, and especially of such artists as Li Tsai and Lü Chi. On his return from China in 1469, Sesshū roamed

about northern Kyushu, for civil war was rife in Japan, and between 1481 and 1484, he journeyed throughout the country, even into the north. After this spell of wanderlust he settled in the town of Yamaguchi, though he continued until his death in 1506 to make periodic visits to sites he wished to see.

Bird and flower screens such as the pair shown here are normally attributed to Sesshū, although to date scholars continue to argue as to whether or not he ever executed any paintings of this genre. The Freer Gallery of Art in

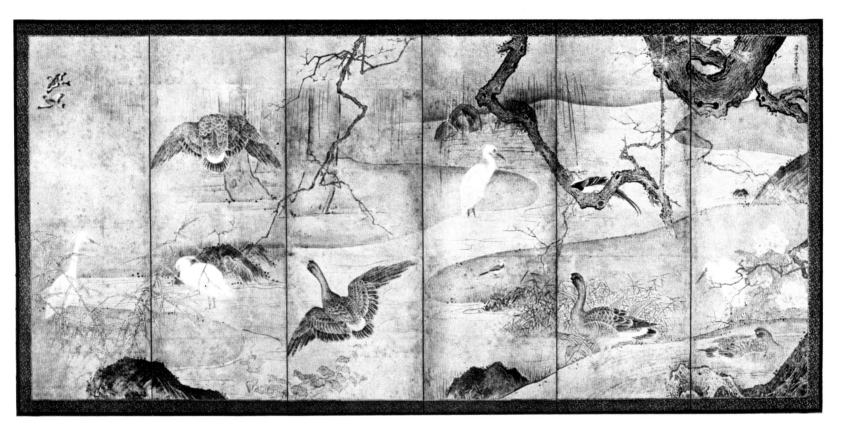

Washington, D.C., the Cleveland Museum of Art, and the Detroit Institute of Arts all possess examples, in addition to a number of specimens in Japan.

The pair of screens illustrated here have suffered a great deal with the passage of time. They have faded much, have been washed, show traces of heavy mildew and foxing, and have even been overpainted with additions to the original design. However, they remain a fine and typical Sesshūesque composition of his general time, though very unlikely as a work from his brush. On the right-hand screen a plum tree frames the composition and introduces us to a setting filled with egrets, white-fronted geese, a magpie, buntings, and sparrows. A peony blossoms on the right, while reeds grow on the left. The composition appears to be marred by willow branches that rather unexpectedly hang down from a cloud band. It is my own interpretation that these do not belong and were added either in whole or in part during a later restoration. The left screen is framed on the left by an outcropping of rocks and a chestnut tree and, on the right, by rocks and rose mallow plants. Again birds occupy the open space. Mandarin ducks, a kingfisher, white-fronted geese, crested mynahs, egrets, owls, and buntings appear to enliven the setting. The theme is typically a seasonal one, with the right screen representing spring and summer and the left autumn and winter. Both screens carry a signature that could be read Sesshū and are dated to 1496, the seventy-eighth year of his life. They also each carry a seal that was utilized by Sesshū, read Tōyō. It was screens of this nature that inaugurated bird and flower screen painting in Japan.

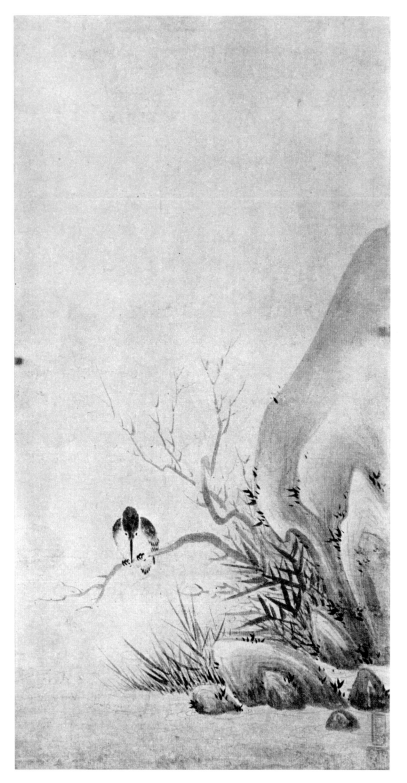

11. *A Kingfisher Perched Above a Stream.*
By Shōkei (died c. 1508).
Muromachi period, late fifteenth century.
Kakemono, ink on paper, 29 1/4 x 15"
(74.3 x 38.1 cm). The Cleveland
Museum of Art. Purchase, John L.
Severance Fund

The Muromachi artists of Japan, especially those who worked in ink, or ink and slight color, in the Zen tradition, produced works endowed with great calm and insight. If one searches deeply enough, one can usually come up with the symbolism of the subject matter and its link to Zen teachings. In this instance, the kingfisher is but transient and will not remain fixed, for soon it will spot its food, dive for it, and fly away. In like manner, the fish that will fall prey to the bird is also symbolic of change, a life that passes, and reincarnation. The solitary kingfisher sits perched on a branch of a barren shrub that struggles for survival beside a large boulder. Bamboo sprouts and reeds push forth from the stream that washes and erodes the rocks. The kingfisher is the center of focus, and to make it appear more so, the artist Shōkei has used ink of deeper intensity to delineate its form. The only areas of equal intensity are the clump of bamboo and small growths of an unidentified plant that cling to the rocks. The boulder itself is soft and not as jagged or angular as those depicted by such artists as Shūbun and Sesshū. The form of the rock is echoed in one of the branches of the shrub on which the kingfisher sits. Its head, long vertical beak, and eyes impart a vertical balance to the painting.

There is actually not a great deal known about the artist Shōkei. There is evidence that he was a Zen monk and that he was active in Kamakura, where he served as a scribe at the Kenchō-ji. While there, Shōkei may well have come under the influence of another notable priest–painter, Chūan Shinkō. Although we do not know the date of Shōkei's birth, we do know that in 1478 ne went to Kyoto, where he studied with Geiami (1431–1485). Shōkei spent two years in Kyoto, and they were obviously very rewarding. He was indeed privileged to receive instruction from Geiami, who, in addition to being an artist of great competence, was an arbiter of taste and adviser to the Ashikaga shogunate on matters regarding art and culture. While in Kyoto, Shōkei was permitted to study and, in a traditional manner, to copy the Chinese paintings in the shogun's collection. That Geiami, a recognized master, thought highly of Shōkei is documented, for prior to his pupil's return to Kamakura, the master presented him with a painting done by his own hand. During that age, this was considered a sign that one was accepted and respected. Shōkei returned to the Kenchō-ji, where he appears to have remained until 1493, when he again returned to Kyoto. He lived there, working in his studio, until his death.

Shōkei also used the name Kenkō, and we find him also using the name Keishoki, which is a combination of part of his name, *Kei*, and *shoki*, a scribe (the position he held at the temple). In the lower-right part of this painting are two of his seals. The upper, rectangular one reads Kenkō and the lower, square-shaped one reads Shōkei.

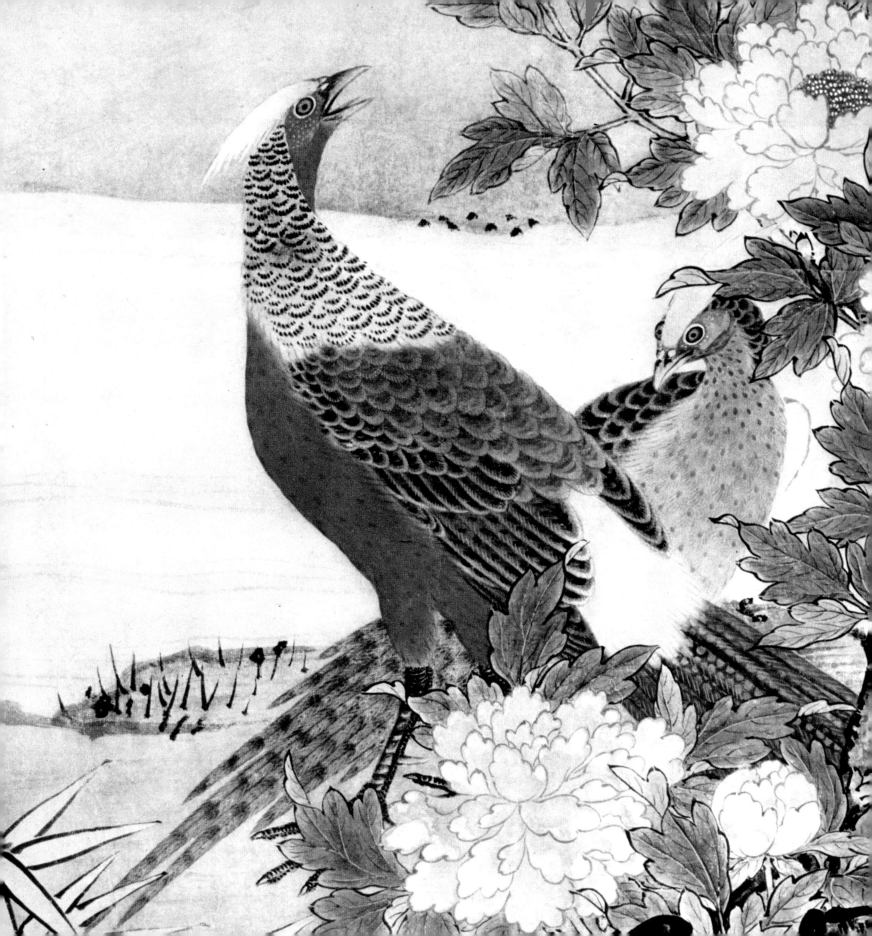

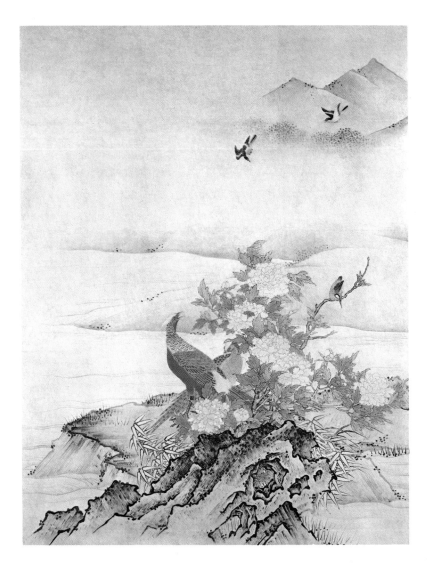

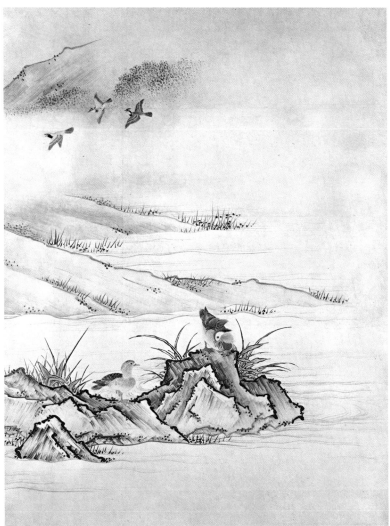

12. *Flowers and Birds in a Spring and Summer Landscape.* Attributed to Kanō Motonobu (1476–1559). Muromachi period, sixteenth century. Four *fusuma* panels mounted as kakemono, ink and color on paper, each 69 3/4 x 54" (177.2 x 137.2 cm). The Cleveland Museum of Art. Purchase, Leonard C. Hanna, Jr. Bequest Fund

We have already seen in No. 10, attributed to Sesshū, that such artists as he popularized bird and flower paintings in the screen format. The early examples that have survived point to a tendency for the artist to be fussy and to overcrowd his compositions. This does not imply that they were poor designs; indeed most of them are very carefully structured and of great beauty. The primary problem was something that affects almost every pioneer or experimenter who seeks to introduce something new; his enthusiasm leads him to include either too much or too little. It was such artists as Kanō Motonobu—who with his father, Masanobu (1434–1530), founded the Kanō school tradition of painting— who brought simplicity to these large compositions without impairing their sense of decoration and gorgeousness. This accomplishment is certainly evident in the four large kakemono illustrated here, which were formerly *fusuma* (sliding door panels) and are attributed to Motonobu's hand.

The justification for the attribution to Motonobu rests largely on the fact that the paintings are of the same approximate scale and type of composition as the thirty kakemono (which were also once *fusuma*) in the Daisen-in of the Daitoku-ji in Kyoto. The Daisen-in paintings also carry the Motonobu attribution, and though they relate very favorably to the Cleveland Museum of Art paintings, it is difficult to be dogmatic. There are slight stylistic variations, but I would hesitate to rule these superb designs out. Much of the argument rests on the treatment of the rocks, spatial effects, and brushwork. There seems to be no solution other than to attribute them to the hand of Motonobu.

The composition of these four paintings creates a superb continuous pattern. A glorious old peach tree rooted at the base of a rocky outcropping is the most evident feature of the

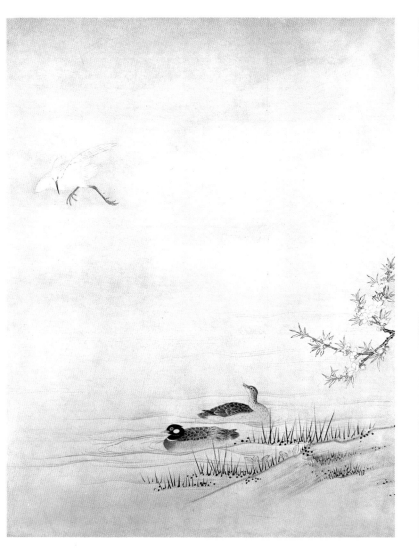

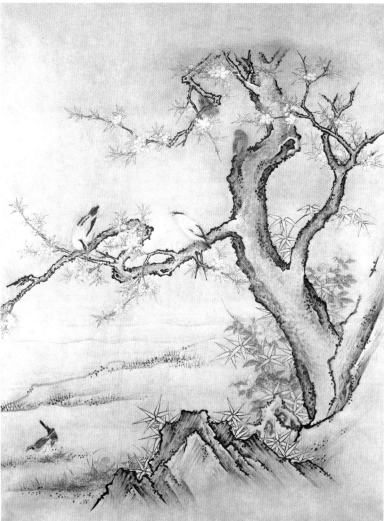

two right panels. Bamboo and a rose bush as well as dandelions soften the regularity and intentional hardness of the rocks. In typical Kanō manner, the rocks are built up of squarish elements, with diagonal striations placed on them to suggest form and depth. Scattered here and there, little dots of lichen sprinkle the rocks, trees, and even the grass, adding to the spatial relationship. In the tree rest two pairs of birds. The upper two have short parrot-like beaks, while the lower two, probably yellow orioles, have longer beaks and much more distinctive markings. On the ground, two buntings search for food.

In the stream leading to the typical mountain background a drake swims undisturbed while his hen looks at a flying snowy egret. In the third panel from the left, a mandarin duck and his mate pose on Kanō rocks jutting out into the water, and on the fourth panel two pheasants compete with their showy plumage as they rest beside a peony bush in full bloom. The artist has beautifully contrasted the broad and full-petaled blossoms with the exquisite plumage of the pheasants, thus creating a stimulating pattern. On a branch of the bush rests a kingfisher, while in the sky two buntings frolic before

pyramidal mountain peaks. Without question this set of paintings is important in addition to being beautiful and lyrical.

Kanō Motonobu, the artist to whom the paintings are attributed, was a very able painter who combined elements of Japanese and Chinese painting to create the Kanō style. This style fused the color and decorative sense of traditional Yamato-e with a reliance on linear elements, such as strong ink outlines, much admired by many Chinese masters of the Che school.

Motonobu, like his father, served as official painter to the Ashikaga shoguns

and was placed in charge of the artists' guild. He is reported to have married into the Tosa family and this may have awakened and stimulated his interest in the Yamato-e tradition, for Tosa artists were the protectors and inheritors of this trust. Motonobu was ambitious and he spent approximately fourteen years in decorating the fortified monastery of Hongan-ji at Ishiyama. He also worked for numbers of Zen temples. His aspirations are reflected in the scale of the paintings illustrated here and in others of his compositions. The school that he and his father created was to flourish into the nineteenth century.

13. *Birds, Pines, and Camellias Beside a Waterfall*. Attributed to Kanō Motonobu (1476-1559). Muromachi period, sixteenth century. Twofold screen, ink on paper: 67 x 68 1/2" (170.1 x 174 cm). Shinenkan Collection

We have already seen in No. 12 one type of treatment of the bird and flower theme which may be attributed to Motonobu; this is a second example. The composition is busier, and much more transpires in the limited space. Perhaps this is natural, but I do not feel it can be explained so easily. The first problem is that it is very possible that the two folds which compose this screen were also once sliding doors or part of a wall panel. If so, they represent but a small segment of an overall design and thus we cannot judge them. The typical, though also amazing, thing is that even when separated, each panel can stand alone as a worthy composition. It is rather uncanny the way Japanese artists were able to achieve this goal.

A group of dovelike birds stand on the bank of a stream and watch the water as it is violently churned by the force of a waterfall that feeds the riverlet. Waterfalls were often utilized, as can be seen in the Daisen-in paintings and in the Freer Gallery of Art landscape screen which are also attributed to Motonobu. Once again, this device was borrowed from the Chinese (Che school painters of the Ming dynasty); however, in the Japanese paintings the water takes on added turbulence. On the bank stand two old pine trees with vines entangled in their branches. The bark of the trees is carefully defined and gives a sense of roundness to the trunks.

The pine needles are delineated in varying intensities of ink, which adds to the sense of depth.

A camellia plant in full bloom grows behind a small hill to the rear of the pine trees, and the contrast of its foliage and blossoms adds to the creation of a decorative pattern in which Kanō school artists were much interested. The painting also portrays action, an element so much a part of Japanese art.

On the remains of a large snapped-off branch of one tree a bunting is poised, beak open, as though it has spotted a tasty morsel, while below another bunting sits with its bill open as though calling "Feed me." In the foreground, two additional birds make their presence known. The artist clearly shows that he has studied nature well and is sensitive, for one is aware of the birds' feathery nature and the suddenness of their movements.

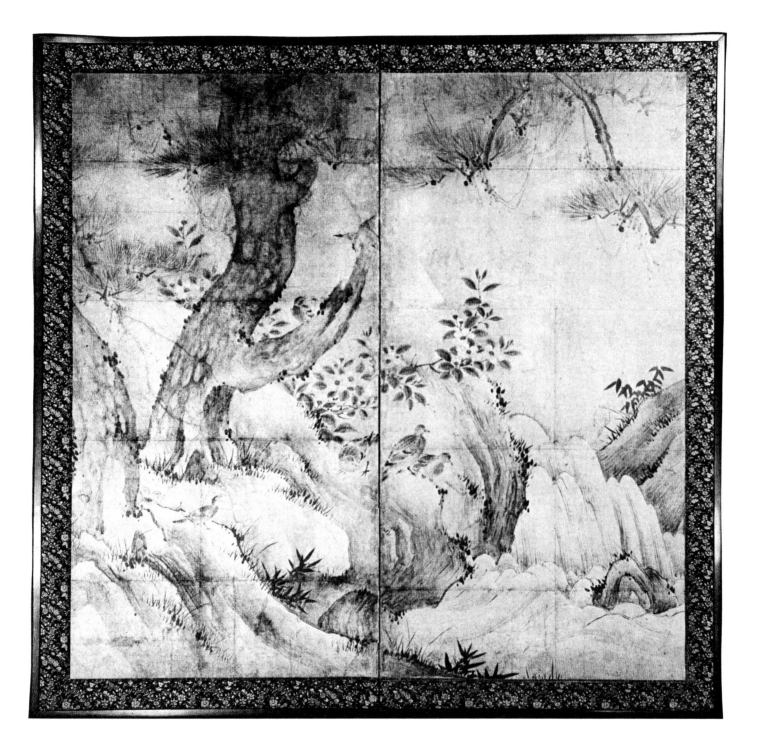

41

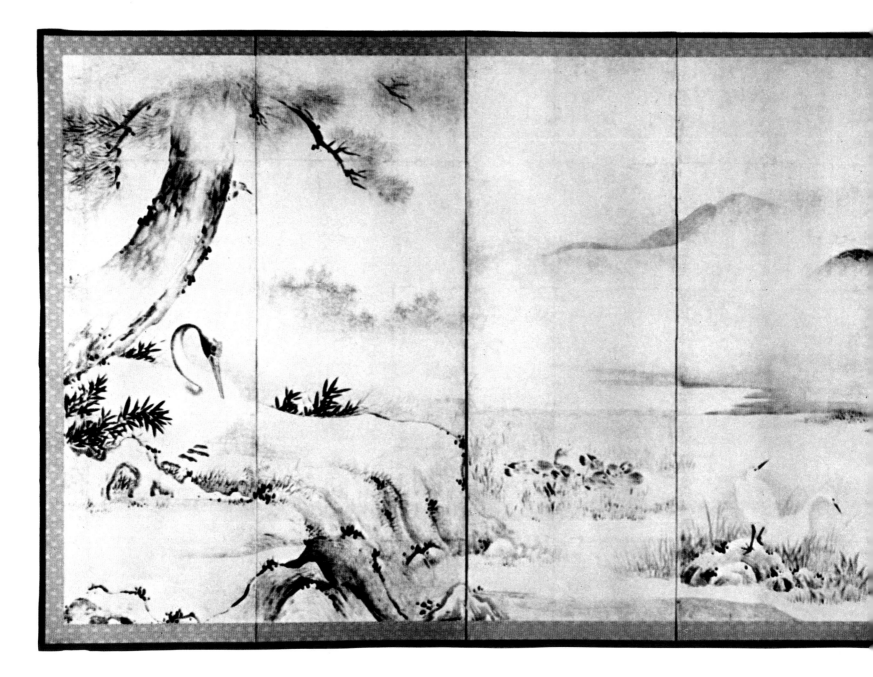

14. *Birds and a Marshy Stream.* Artist unknown. Late Muromachi period, sixteenth century. Sixfold screen, ink and slight color on paper, 69 3/8" x 12' 5" (176 x 378.4 cm). New Orleans Museum of Art. Gift of Mr. and Mrs. Frederick Stafford

Once again we return in the painting shown here to a less crowded, more spacious setting of birds in a landscape. There is no crowding, and the transition into depth is accomplished with great skill and subtlety, utilizing bands of mist, washes, and tonalities of ink.

It is quite obvious that this is the left-hand screen of what was once a pair, and it is my hope that someday its mate will appear and the two parts will be reunited. The design is a most appealing one; whether half, or whole, or panel-by-panel, each composition is worthy. As in Nos. 11, 12, and 13, the setting is a gathering of birds before a body of water. On the far left a large pine tree gracefully curves into the setting, its branches vanishing beyond the confines of the screen. Clinging to its trunk is a woodpecker and resting beside the roots of the tree embraced by bamboo is a magnificently painted graceful young crane. In the water and among the reeds of the marsh, groupings of two, three, and four ducks swim and rest. Above them a small bird, perhaps a kingfisher, dives toward the water, while in the center of the painting, two egrets search for food and take their ease in the quiet setting. Actually, one of the egrets twists its neck and looks upward at the commotion in the sky. In the background there are very soft rounded mountains and trees that melt into the mist.

The great problem with this painting is where to place it in the schools popular during the later portion of the sixteenth century. One might ask whether it is of the Kanō, Unkoku, or even Hasegawa school. In all likelihood, the first suggestion is more probable. We know Kanō Eitoku (1543–1590), grandson of Motonobu and son of Shōei (1519–1592), painted in this general manner. One need only study the sliding doors in the Jukō-in of the Daitoku-ji in Kyoto to realize this. Eitoku, however, relied on more angular and defined brushwork. The softness and lyrical flowing quality of the New Orleans Museum of Art painting make it unlikely that it is a work of his hand, but there is a strong probability that it is by a very competent pupil in his studio. Most artists of the day were exposed to the strong Kanō tradition. The competence in handling the spatial transitions leads me to think of Unkoku Tōgan (1547–1618), an artist who worked in the westernmost portion of Japan and who claimed to be the third-generation heir of Sesshū. A second possibility would be the Hasegawa school and its founder Tōhaku (1539–1610), who lost a battle with Tōgan when he claimed to be the fifth-generation heir of the Sesshū tradition. Tōhaku had exhibited great mastery in synthesizing nature and in sympathetically capturing the essence of birds, flora, and fauna. His work was less static and academic than that of the Kanō school. Taking all of these factors into consideration, I return to my belief that the screen illustrated here is a superb work done in the Kanō tradition.

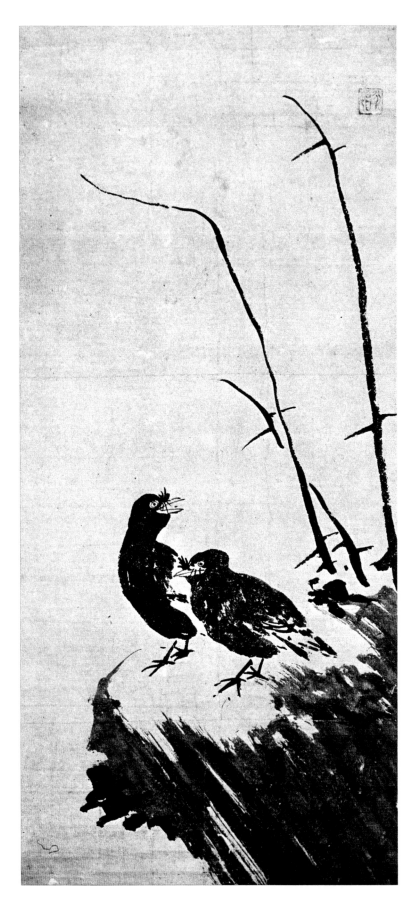

15. *Hahachō (Crested Mynah Birds)*. By Unkei Eii (active c. 1505). Muromachi period, sixteenth century. Kakemono, ink on paper: size overall, 65 1/4 x 10 3/4" (165.7 x 27.3 cm); painting, 31 x 14" (78.7 x 35.5 cm). Private collection

Not all painting of the Muromachi period was executed meticulously with great attention paid to detail. The paintings of Zen priests working in that tradition were often much freer, and were marked by an economy of line and direct statement. This is true of the two crested mynah birds, called *hahachō* in Japan, who stand on a rock beside a wintry thornbush. The birds are quite animated and are executed spontaneously with a minimum of brushwork. The artist has, however, given them character. One raises its head and opens its bill as it calls away. The second bird stands solidly on its two legs and ignores the noise made by its neighbor. By speedy and controlled application of ink the artist has made the birds appear rotund and defined different areas of plumage. The rock on which the birds stand is formed simply by a number of hastily applied diagonal brushstrokes. These give an appearance of being casually applied, but if one analyzes them one notes that they are arranged to give depth and to create the roundish platform on which the birds stand. The thorny shrub behind the rock repeats the diagonal thrust seen in the rock and aids in placing the birds in focus as the central theme. In general, the artist used a very intense mixture of ink.

There is some question as to the proper identification of the artist. In the upper right of the composition is a seal, read Eii. There was an artist named Unkei Eii who was active around 1505 and there are paintings which bear both the Unkei signature and the Eii seal. Unkei is thought to have studied in the Sesshū manner. In the history of Japanese painting titled *Honchō Gashi*, Unkei is reported to have been of the Tsuchieda family and to have used Shizan as a studio name. There is confusion and it is very likely that this person is not the same Unkei who used the Eii seal. In other discussions of Japanese artists, such as the *Gako Benran*, it is reported that Unkei dwelt at the monastery at Mount Koya. In the most famous biographical discussion of artists, the *Koga Bikō*, it is reported that Eii's active date as an artist can be fixed by the fact that he is recorded as having produced works in 1505 in a sketch-book of the Kajibashi Kanō family. Regardless of the uncertainty of the details of Eii's life, this work is endowed with great charm.

DETAIL OF PLATE 16 ▶

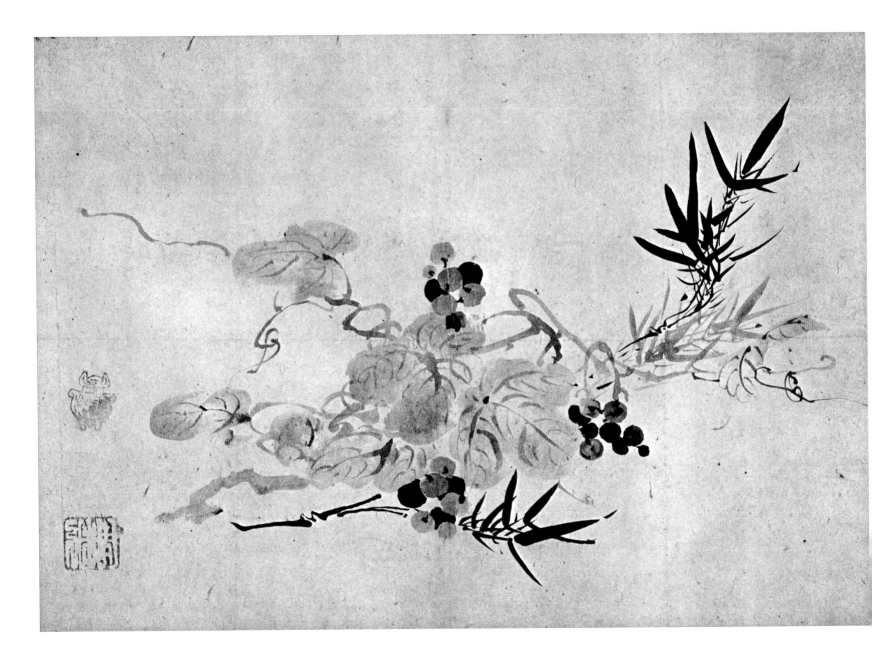

16. *Grapes and Bamboo*. By Sesson (1504–c. 1589). Muromachi period, sixteenth century. Kakemono, ink on paper, 45 1/4 x 22 1/2″ (115 x 57.2 cm). Collection of Dr. and Mrs. Kurt A. Gitter, New Orleans

It is known that still-life decoration existed in Japan prior to the Muromachi period, though it is only from that age that a number of truly competent painting examples have survived. They usually took the form of arrangements of flowers in a basket; Eii, the painter of No. 15, is credited with having produced such a work. The still life by Sesson shown here depicts stalks of bamboo and a branch broken off a grapevine, with leaves, tendrils, and fruit. It is a well-composed grouping of the two plants that differ greatly in nature, and is an unusual work of art. One might interpret it as symbolic of the two temperaments, yang and yin, the positive and negative principles of universal life. Artists in both China and Japan often endowed their work with contrasts which were emblematic of the two principles.

In this work the bamboo, though pliant, is painted with sure strokes that imply the directness of each segment. The leaves, in like manner, are bladelike. They come to a point, are tapered, and remind one of the swords that were so prized by the Japanese warrior; thus they equate with yang. The branch of grapes, on the other hand, is softer, rounded, and constantly changes direction as it twists and winds upon itself; it symbolizes yin. To add to the contrast, the artist painted most of the bamboo in dark ink, while much of the fruit, save for some lusciously tempting bunches, is done with lighter ink and washes. The ripe grapes are skillfully used to link the parts of the design. The work, though manifestly organized, displays great freedom and spontaneity.

Etoh Shun and Professor Tanaka Ichimatsu have directed their research and attention to the life of Sesson, the artist who produced this fine work. Sesson spent most of his life in the northern part of Japan living in the rural districts of Hitachi and Aizu. He was much influenced by the work of Sesshū, and though he was born only two years before Sesshū's death, he felt that he had inherited the mantle and represented the tradition. Thus he used the character for *setsu* (snow) as part of his name, as did Sesshū. It has become the vogue to refer to Sesson as eccentric but in truth there is little to substantiate that characterization. The artist was born in Ōta of Hitachi province in 1504, a member of the Satake family, which exercised feudal control over a large estate in that region. Rather than follow the family tradition, possibly because of intrafamily rivalry, Sesson became a Zen priest. The ateliers in the temples were natural resources for studying and copying art. Sesson became an itinerant priest–painter and by 1546 appeared in Aizu, where he taught painting to the feudal lord Ashina Moriuji; later he traveled to Odawara, which served as the center of the powerful Hōjō family, which controlled the Kantō region, but he did not spend the remaining days of his life there. After 1561 he headed back home to his favored north country, where he evidently remained until about 1589, the time of his death.

On this finely constructed still life of bamboo and grapes there are two seals. The upper one is shaped like a Chinese bronze vessel called a *ting*, and the characters enclosed by it read Sesson. The lower, square-shaped one reads Shūkei, another name used by Sesson. According to the research of Professor Tanaka Ichimatsu, the combination of these two seals without a signature would lead one to believe that the painting was a product of the artist's fifties.

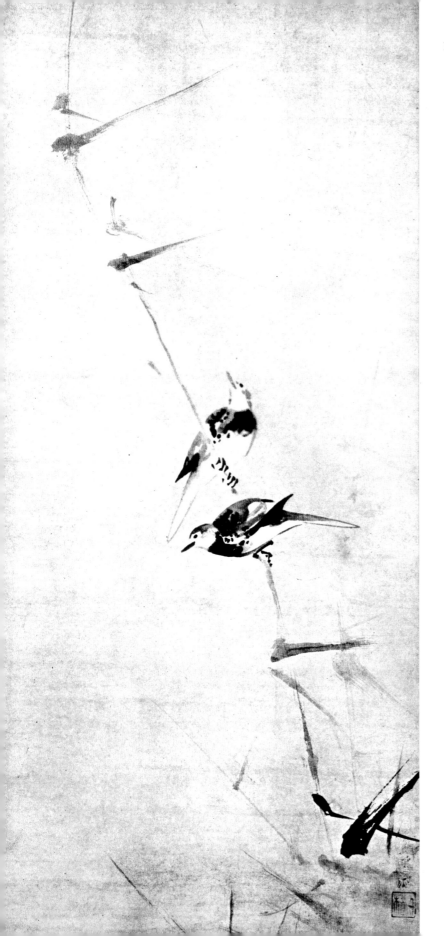

17. *Wagtails and Reeds.* By Kaihō Yūshō
(1533-1615). Momoyana period, late
sixteenth century. Kakemono, ink on
paper, 74 x 20 1/2" (188 x 52 cm).
Private collection

The artist Kaihō Yūshō, although well
rooted in the basics of the Kanō painting
tradition, was an individualist who
borrowed from his teachers and
developed his own style. It was less
academic and freer; especially evident
was Yūshō's use of softer values and
long, narrow, bold brushstrokes. These
call to mind the artist's earlier profes-
sion as a samurai for the Asai family of
Ōmi. After 1570, Asai Nagamasa
(1545-1573) was beseiged in Odani
castle by Oda Nobunaga (1534-1582).
Realizing that all was lost, he joined
with his father and two sons and com-
mitted suicide. It was only after this
that Yūshō joined the Tōfuku-ji and
studied painting with Kanō Eitoku
(1543-1590). Yūshō's work also
shows his exposure to the Chinese
Southern Sung painters Liang K'ai and
Yü-chien, whose work had come to
Japan and was much admired by Zen
masters.

He undertook the painting of many
large-scale projects such as the sliding doors
he executed for the Kennin-ji in Kyoto.

In the painting shown here, Yūshō
has portrayed two carefully, though
spontaneously, drawn wagtails clinging
to a rather thin reed. One looks down
while the other glances up, as though
sighting along to the top of the reed,
which curves slightly inward. Perhaps
this marks the point where the reed has
bent under the bird's weight and it is
seeking to reassure itself. This reed
and the others surrounding it are
painted in an almost haphazard
manner. The brush was set down and
raised quickly as it was drawn along to
form a point. Also, the pressure on the
brush was such that the hairs composing
it often divided, adding evidence of the
artist's spontaneity. There is nothing
out of place, and the design is minimal,
in the Zen manner.

Hidden among the reeds at the bot-
tom right of the painting are two seals.
The upper, rectangular one reads
Kaihō and the lower one reads Yūshō.
The style created by Yūshō was
followed by a number of pupils, including
his son, Yūsetsu (1598-1677), and is
known as the Kaihō school.

18. *Wagtails*. By Kanō Sanraku (1559–1635). Inscription by Genhan. Momoyama period, late sixteenth century. Kakemono, ink on paper, 54 3/4 x 17 1/2" (139 x 44.5 cm). Private collection

Two wagtails are the theme of this well-composed and rather unusual painting by Kanō Sanraku, who had been selected by Eitoku to succeed him as the fifth head of the Kyoto branch of the Kanō school. One bird is perched on a soft-shouldered slope of earth and peers down at a rock and the marsh grass growing in the water at the stream's edge. It appears that Sanraku first did the entire outline in light ink and then strengthened the design and tried to indicate the variations in natural coloration. The position of the wagtail, as shown here, is humorous, for the long tail feathers barely balance the rather plump little body. The earth on which the bird stands is painted in an unusual and fascinating manner. Not only did Sanraku use a variety of soft, light brushstrokes; he also used a technique called *tarashikomi*, which we have not seen applied much earlier than this, in delineating the earth. *Tarashikomi* is a technique that was used by Chinese artists and then copied by the Japanese. It consisted of applying ink or color and, while still quite wet, adding more ink or color. This would puddle as the two blended and natural random outlines would form as the ink dried. The technique is very tricky and difficult to master, and it actually was Sōtatsu, the painter of Nos. 23 and 24, who perfected the technique in Japan. The use of *tarashikomi* in this painting of wagtails helps to give form and texture to the soil. Sanraku punctuates this area with blades of grass painted in dark ink. In the distance tall blades of marsh grass done in light ink reach in from the left edge of the painting and direct the viewer's eye to the second wagtail, which is poised in the air. Its beak is open and it appears to be changing its direction of flight prior to settling on the ground. Placed between the two birds and balancing the tall marsh grass on the left is an inscription in the Chinese manner dealing with wagtails.

Kanō Sanraku was in a rather unusual position, for prior to him only artists who were born into the family succeeded to the mantle of the Kanō

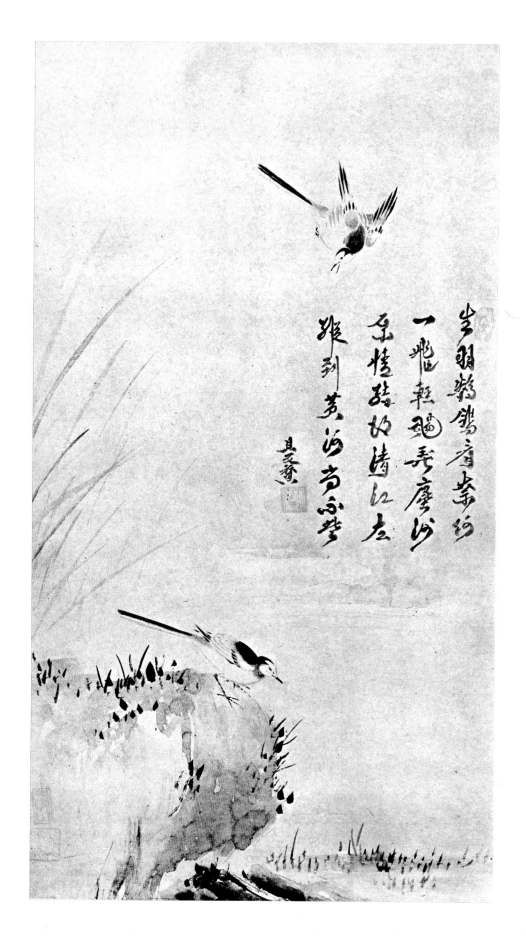

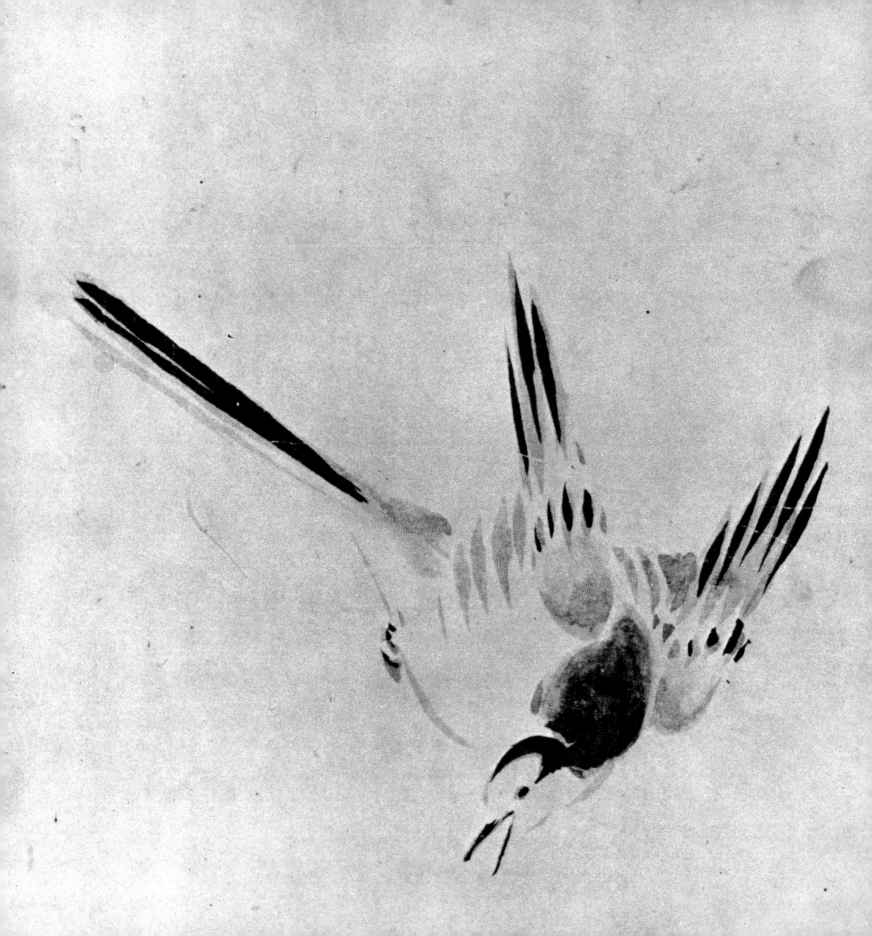

school. Sanraku was the son of a relatively unimportant warrior and painter, Kimura Nagamitsu. As a result of Nagamitsu's loyalty to Toyotomi Hideyoshi (1536–1598), Sanraku's talent was recognized and encouraged by this all-powerful military ruler and he was placed under Eitoku's tutelage. When Hideyoshi decided to decorate Fushimi Castle, which he built in 1593, he called upon Sanraku to help. The artist often found himself engaged in the painting of typical Momoyama interiors. This usually consisted of an entire room composed of decorated wall panels, or *fusuma*. Works such as the *fusuma* from the Shōshinden of the Daikaku-ji and the Tenkyū-in of the Myōshin-ji in Kyoto and the screen titled *View of the West Lake* in the Mary and Jackson Burke Collection, New York, typify the scale on which Sanraku is thought to have worked more often. Not only in size but in technique this painting of wagtails serves as a fine contrast to those other works, and reveals another facet of the artist's versatility and skill.

19. *Koma-inu* (lionlike dog). Momoyama period, c. 1600. Ceramic, Seto ware, glazed and gilded, h. 7″ (17.8 cm). The Detroit Institute of Arts. Laura H. Murphy Fund

The legendary creature known as a *koma-inu* is said to have first been brought to Japan from Korea. In Korea it was believed to have wolflike characteristics. The ideographs for Koryo, the dynasty that ruled Korea from 918 to 1392, are also read Koma in Japanese, and thus the term can be translated as Korean dog. Beasts of this nature in wood, stone, or ceramic were placed as guardians at each side of the entrance of Shinto shrines. They also were associated with Buddhist structures, but that connection waned by the fourteenth century. The beasts usually were of two types; one with its mouth open, like the Detroit Institute of Arts example, and the other with its mouth closed and a short horn on its head. The former was defined as a *shishi* (lion) and the latter as a *koma-inu* by the Emperor Juntoku when he wrote the *Kimpishō*, a treatise on court customs, about 1219–22. This documentation is ably reported by Professors John M. Rosenfield and Shūjirō Shimada in their magnificent catalogue of the Kimiko and John Powers Collection, titled *Traditions of Japanese Art*. In practice, the terms were interchangeable.

The *koma-inu* shown here is of ceramic and from the clay and the glaze applied prior to the gilding of the piece it can be determined that it is Seto ware.

During the Kamakura and Muromachi periods, Seto, which is located in present-day Aichi prefecture, was where the best ceramics were made. Kato Shirozaemon Kagemasa, also known as Toshiro, is traditionally said to have traveled to Sung dynasty China in 1223 along with a Zen priest called Dogen and to have spent approximately five years abroad. While in China, Toshiro studied ceramic techniques, and when he returned to his kiln in Seto in 1228 he tried to apply the knowledge he had gained on the mainland to glazed wares. This was the start of Seto ware, and through the years the kilns in this region maintained their position as one of the six ancient kilns and one of the most important centers of ceramic production in Japan.

A great variety of shapes and forms were produced by early Seto potters, including, as we know from excavations, lions similar to the one seen here. During the Muromachi and Momoyama periods, Seto ware was very much in demand, for the simple glazed ware was admirably suited to the cult of the tea ceremony.

The *koma-inu* shown here is in all likelihood a Momoyama period revival of the Kamakura tradition. The addition of gilding over the glaze should be studied further. It is either a later embellishment to an earlier piece or could be indicative of the Momoyama period tendency to opulence and grandeur. As this *koma-inu* is relatively small, it may also merely point to the desire for a gilt bronze by one who could not afford the real thing.

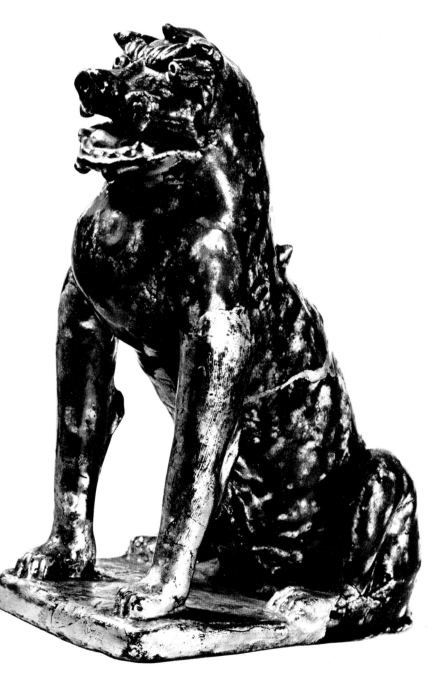

20. *Butterflies* (ornamental architectural studs). Momoyama period, early seventeenth century. Bronze, gilt and silvered, each 8 x 9 3/4" (20.3 x 24.8 cm). Collection of Mr. and Mrs. James W. Alsdorf, Winnetka, Ill.

During the Momoyama and into the Edo period, there was a great boom in castle and villa construction in Japan. In the late sixteenth and early seventeenth centuries communities were enlarged, old towns grew, and new ones were founded. All this was related to the sudden spurt in economic growth in the country and its reorganization and reunification under the successive rule of three powerful military leaders, Oda Nobunaga (1534–1582), Toyotomi Hideyoshi (1536–1598), and Tokugawa Ieyasu (1542–1616), after a long period of civil strife.

The many new homes of the feudal aristocracy and their retainers required decoration and furnishing. The two butterflies illustrated here are elegant examples of the type of ornamentation used architecturally to embellish the simple woodwork in a grand villa, or as a stud to cover joints or places where nails had been used. The butterflies are large in scale, which tells us that they were intended for an imposing structure. They were cast of bronze and then details defining the lepidopteran form and markings were chased and hammered into the metal. Finally, specified areas were gilt and silvered. The butterflies have a sculptural quality and the artist who created the design placed their heads at an angle so that both eyes are visible. One can visualize these great butterflies high up against the natural wood of a room lined with wall panels, or *fusuma*, of birds and flowers or landscape. They are a reminder of the height of sumptuous refinement of the Momoyama period.

21. *Horses Romping at the Beach*. Eclectic style. Late Momoyama–early Edo period; early seventeenth century. Twofold screen, ink, color, and gold leaf on paper, 67 x 71" (170.1 x 180.2 cm). Shinenkan Collection

There is a delightful freshness and naivety about the eight horses which romp and play in the beachside setting of this twofold screen. The theme of horses at play or being trained was not an uncommon one in the art of Japan and, prior to that, China. On the painted doors of the eleventh-century Hōō-dō at the Byōdō-in in Uji, a similar group of horses is portrayed at pasture, while in the thirteenth-century *Zuishin Teiki Emaki* (*Handscroll of the Imperial Guard Cavalry*), horses are shown in procession. A third type of horse painting is represented by the handscroll attributed to Tosa Hirochika (active 1459–1492) in the Freer Gallery of Art, Washington, D.C., which depicts the animal being trained by nobles and grooms. This last theme is believed to be based on an early Kamakura period prototype; however, the original has not survived. In China the horse theme had been popular at a very early date; evidence is given by paintings such as that of a horse lashed to a post in the collection of Mrs. John D. Riddell, London, attributed to the eighth-century artist Han Kan, and the *Horse and Groom* by Chao Yung, born 1289, in the Freer Gallery of Art. An even closer parallel can be seen in the *Horses Crossing a River* in the style of Chao Meng-fu, also in the Freer Gallery of Art. In fact an examination of paintings in the manner of Chao Meng-fu reveals a number of works that would fall into this category. It is highly likely that some of these reached Japan and influenced painters there.

The artist of this horse screen is not known. On many paintings produced in the Momoyama and the early Edo periods signatures were not applied. There were a great number of competent artists who traveled about producing paintings and decorations for the nobility, influential retainers, and the ever more prosperous merchant class. These painters were often attached to no particular school and merged many styles to create designs that would please them and their patrons. The style is eclectic, as in this work, where Kanō and Tosa, as well as innovative elements, intermingle. The horses resemble some that appear in Yamato-e painting of the Kamakura period and indicate the strength of the Tosa artists in keeping that tradition alive. The same is true of the sprinkled gold and cut gold leaf floated on the painted surface to create patterns. This device harks back to the Heian period and paintings such as the Heike sutras done for the family of Taira no Kiyomori (1118–1181) between 1164 and 1167 and still kept at the Itsukushima shrine. The trees and their treatment resemble those that appear in Yamato-e, Tosa, and even some Kanō school paintings. One must keep in mind that styles often merged.

The eight horses that romp here without any evidence of human presence are placed on a flattened-out abstract segment of beach. They are painted on a ground that has been prepared with sheets of square-cut gold leaf. Gold leaf was commonly employed by artists in the Momoyama period, for the precious material not only was decorative and reflected light to brighten interiors but also was indicative of the wealth and position of the owner. The horses stand out against the background and, save for the three that pause to drink at the edge of the beach, are very animated. In terms of composition, the horses are well contained, with the prancing one on the left moving toward the group of seven on the right. Scattered here and there in the water and on the hills in the background are small growths of bamboo, other plants, and trees. These are executed in a rather solid Tosa manner, whereas a Kanōish fluffy golden cloud band at the bottom and another near the top of the screen serve as cushions for the central theme. The rich color and bright gold leaf, along with the sprinkled accents of small irregularly shaped flakes of gold, are now much altered by the ravages of time. The quality of this fine, spirited painting continues to show and one can only envy being in its presence daily.

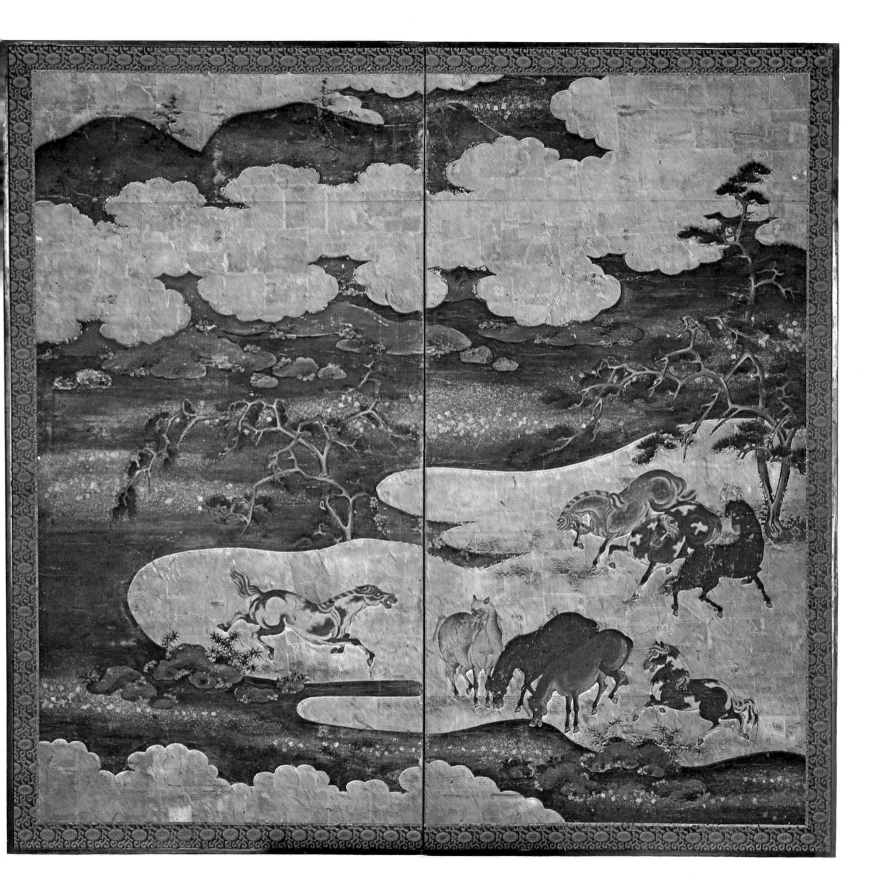

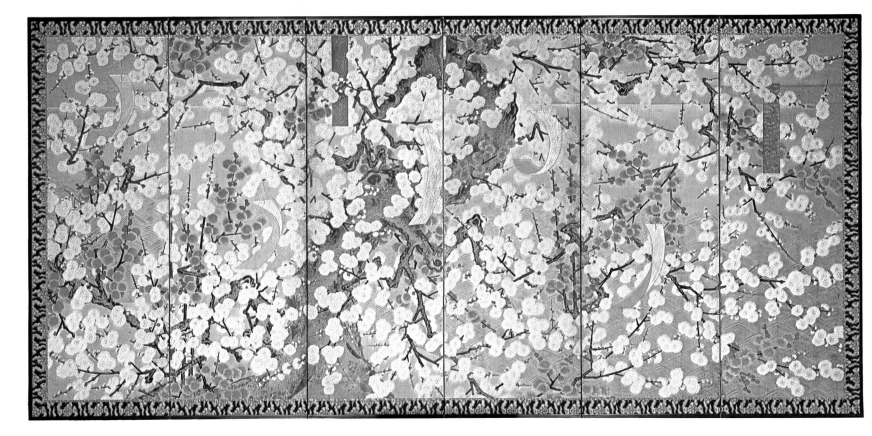

22. *Plum Blossoms and Poem Papers*. Artist unknown. Momoyama period, early seventeenth century. Pair of sixfold screens, ink, color, and gold on paper, each 67″ x 12′ 1/2″ (170.1 x 367 cm). Shinenkan Collection

I remember many years ago looking at a volume by Minamoto Hōshū titled *Nihon Meihō Momoyama Byōbu Taikan* (*A Compendium of Momoyama Screen Masterpieces*). As I glanced through the book, my eyes came upon a screen depicting plum blossoms and poem papers and I was struck by the very ornate yet beautiful design. That particular pair of screens remained in my mind for many years. I hoped that

someday I would have the opportunity of viewing them and if the circumstances were correct, of considering the screens for the Freer Gallery of Art. I was therefore pleasantly startled to learn that they had found a good home in the United States and that the new owners, the Shinenkan Collection, encouraged students and scholars to study and examine the objects in their collection, and took great pains in the proper maintenance and care of these treasures.

One may ask what made this pair of screens remain in my mind over these many years. The answer is evident as soon as one views them. In contrast to most Japanese screen paintings with floral or bird motifs, this example is totally covered with an overall design. The design of two old plum trees, one on each screen, in full blossom, with

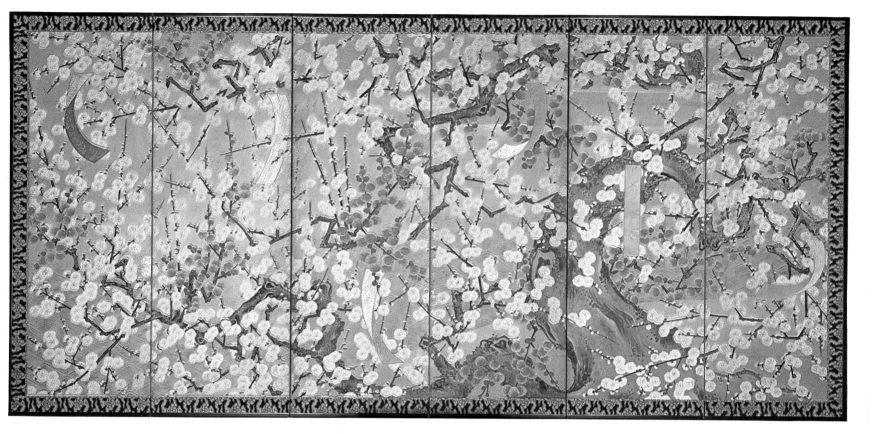

hundreds of white, red, and pink flowers filling virtually the entire surface of the painting, is most unusual. Poem papers in various colors hang from the blossom-laden branches, adding a sense of reality and movement. We know that it was the practice to tie verses onto trees, and as shown here they have twisted and turned in the breeze.

The branches and blossoms form a fragrantly colorful curtain through which we can peer to see a stylized lozenge pattern that probably equates with waves. The flowers were done in a gesso-like technique called *moriage*, which consists of building up the pattern in relief with a mixture of very finely powdered shell white combined with water and a binder. It is a most painstaking technique that was pop-

ularized in the Momoyama period. The *moriage* device was another means the artists of the early seventeenth century had to display the growing wealth of the land and to fulfill their patrons' desire to show it off. The entire background, including the waves, is painted with gold. Different tonalities have been applied to suggest the ground on which the trees stand as well as the bands of mist in the sky.

The tree trunk and branches indicate that the unknown artist had either trained in or been influenced by the Kanō tradition. The blossoms that explode over the surface of the screens are most decorative. Their rich array of color and pattern brings joy to the viewer, telling that winter is on the wane and presaging spring, life, and new growth.

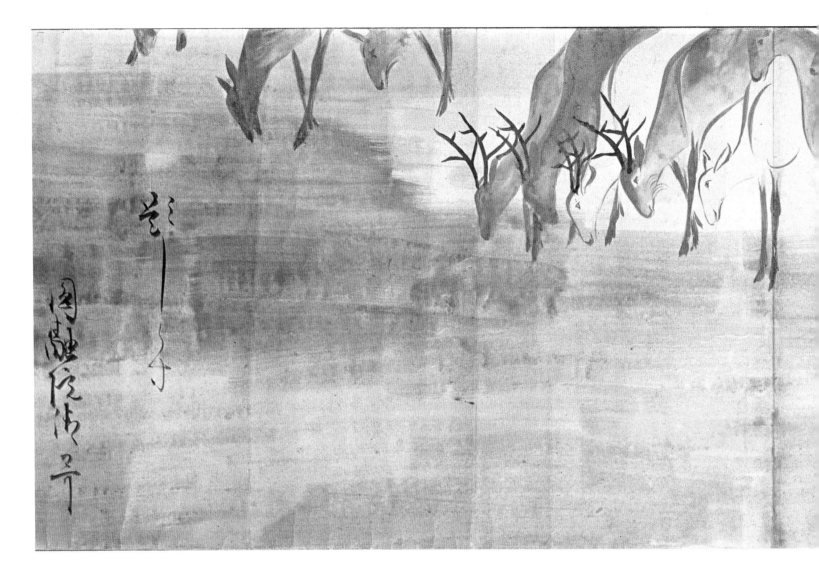

23. *Deer and Poems*. Underpainting by Nonomura Sōtatsu (first half of the seventeenth century); calligraphy by Hon'ami Kōetsu (1558–1637). Momoyama period. Handscroll, gold, silver, and ink on paper, 13 3/8″ x 34′ 2 1/2″ (34 x 1,043.3 cm). Seattle Art Museum. Gift of Mrs. Donald E. Frederick

This striking and highly decorative painting was the product of two artists of great talent who, working harmoniously together, greatly enriched the art of Japan. The style which they developed took firm root and is known today as the Rimpa school. The founder of the school—the calligrapher who with beautiful hand wrote the poems on the scroll illustrated here—was Hon'ami Kōetsu. His collaborator, the painter Nonomura Sōtatsu, is thought to have been related to Kōetsu through marriage. The work that came about as a result of their joint effort is some of the most refined, elegant, restrained, and decorative ever produced in Japan.

Kōetsu's position in the development of the Rimpa school appears to stem from his talent of serving as a catalyst and inspirational source for many great designs. The Hon'ami family into which he was born was noted for their skill in cleaning, polishing, and judging swords. These weapons were in vital demand, and those trained in keeping them both physically and symbolically perfect were treated with favor and came in contact with the powerful forces of the late Muromachi and Momoyama ages. Kōetsu's father, Kōji, had been adopted into the Hon'ami family and later set up his own branch. His eldest son, Kōetsu, though skilled in the family profession, manifested an even greater interest in the creative arts, and this was recognized. In fact, his interests were catholic, including painting, calligraphy, pottery, metalwork, chanting, and lacquer, and he displayed superior talent in all of this these. His great skill was recognized by the military ruler of the day, Tokugawa Ieyasu, who bestowed upon Kōetsu a plot of land at Takagamine, slightly north of Kyoto. Here Kōetsu established an art colony where his circle could work undisturbed.

Very little is known or documented about Sōtatsu. It is believed that he was the son of a wealthy merchant who operated a shop under the trade name Tawaraya. There is confusion as to what his true family name was. Some scholars report it to be Kitagawa or Hasuike, though the surname more often associated with him was Nonomura. Since he also often used the Tawaraya name, it is frequently concluded that somehow he was linked to the Hasuike family, who operated a tex-

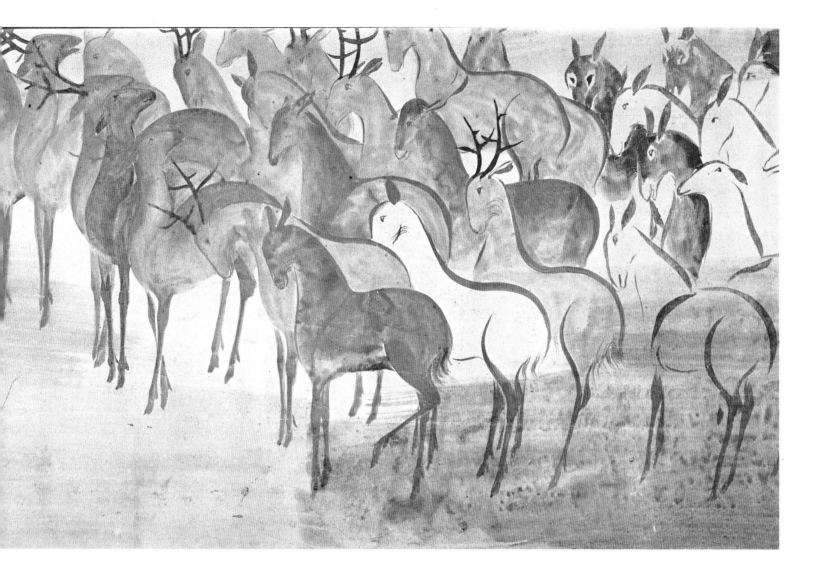

tile factory in Kyoto bearing the same name.

Reflected in Sōtatsu's work is his study and understanding of traditional Yamato-e painting. Thus in 1630 he copied the *Saigyō Monogatari* (*Biography of Priest Saigyō* [1118-1195]). He also understood the Kanō, Tosa, and Muromachi *suiboku* (ink) traditions, and this last one he enhanced with frequent use of *tarashikomi* (the technique discussed in relation to the Sanraku painting of wagtails, No. 18). Sōtatsu's skill did not go unrecognized, for sometime prior to 1639 he was awarded the honorary and prized title of Hokkyō.

The *Deer and Poems* handscroll illustrated here, belonging to the Seattle Art Museum, is one of the finest examples of the Sōtatsu-Kōetsu union. The original handscroll of which this is but a large section was divided in 1935 by the late Baron Masuda. It was later subdivided even further, and portions can be found in the Atami Art Museum, the Goto Art Museum, and private collections. The portion which was wisely and fortunately acquired by the Seattle Art Museum contains some of the most exciting passages. The drawing by Sōtatsu is all that is shown here, but we must always keep in mind that it was wedded with Kōetsu's strong, distinctive calligraphy.

The entire scroll is composed of deer in various groupings painted in gold, silver, or combinations thereof. They leap through the air or just stop to graze. Sōtatsu assembled the deer and he interrelated them. He also depicted bucks and does, so that the characteristics of both male and female are shown. Very often he used outlines, as did the Yamato-e artists of the Heian and Kamakura periods, but this was not always the case. He also brushed the ground with broad, irregular, horizontal strokes in silver or gold, adding to the decorative effect of the paper. Topping all this was the beautiful calligraphy of Kōetsu. It is almost miraculous the way the calligraphy and painting support each other.

The poems in this particular scroll are taken from the *Shin Kokinshū* (*New Anthology of Ancient and Modern Poetry*), which was originally compiled in the early thirteenth century. Kōetsu makes his calligraphy sing, and just by looking at it one can sense rhythm. Some passages are heavy and the ink is dark, whereas other portions appear to leap as gracefully as the deer portrayed in the scroll. The calligraphy never intrudes upon our enjoyment of the painting, and the reverse is also true. The scroll is a great masterpiece. It carries Sōtatsu's frequently used seal, read Inen, and bears Kōetsu's signature.

59

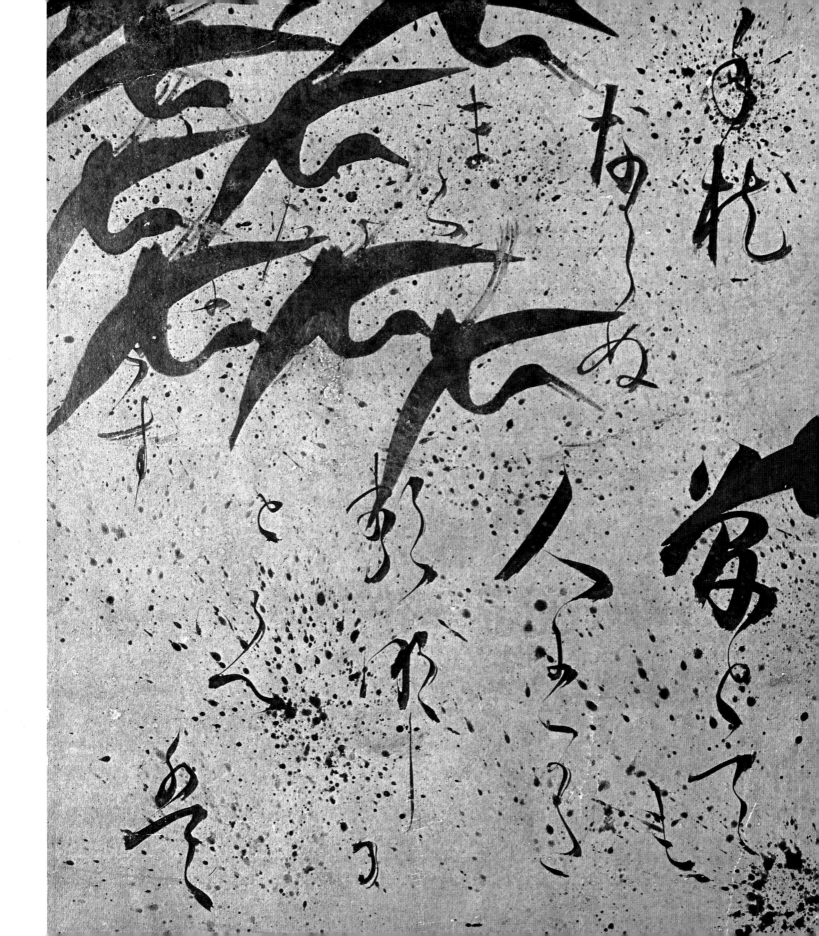

24. *Flying Cranes and Poetry*. Underpainting by Nonomura Sōtatsu (first half of the seventeenth century); calligraphy by Hon'ami Kōetsu (1558–1637). Momoyama period, seventeenth century. Poem paper mounted as kakemono, ink on gold flecked gray-blue paper, 50 1/2 x 14 3/8″ (128.3 x 36.5 cm). Nelson Gallery–Atkins Museum, Kansas City, Mo. Gift of Mrs. George H. Bunting, Jr.

On this poem paper the brilliant combined talents of Sōtatsu and Kōetsu are displayed much as in No. 23. Very often prior to executing a design the artist would select or commission that special papers be made by such talented artisans as Sōji, who resided in Takagamine, Kōetsu's art colony. The paper in this instance is dyed a soft gray-blue. It provides a beautiful sky in which Sōtatsu's cranes fly. They are highly stylized and appear to be painted in ink to which a slight amount of silver has been added. This imparts an added sheen to the cranes. At the end of their long narrow necks the artist painted relatively large heads and long beaks. The wings, which are widespread in flight, roughly resemble crescent moons.

The calligraphy is generally accepted as being by Kōetsu and is applied over almost the entire surface of the paper, adding to the pattern. Neither the poem nor the anthology it was copied from is presently known.

The style of calligraphy is without doubt that of Kōetsu; however, there are marked variations from much of the accepted Kōetsu calligraphy, such as No. 23. In *Flying Cranes and Poetry* the brush frequently divides and produces a more delicate stroke, which parallels the principal one. This peculiarity can be found in Kōetsu's · writing, though more often to a lesser extent than seen here. This fact by no means reduces the importance of this excitingly decorated poem paper.

I do hope, however, that as the years advance scholars will learn more about Kōetsu's calligraphy, and that many of the problems that perplex us today will be resolved.

Neither Sōtatsu nor Kōetsu was content with the design as it stood at this point. Thus, as a final touch, one of the artists flecked gold paint from the end of his brush over random areas of the paper's surface. The impression given the viewer is one of great beauty.

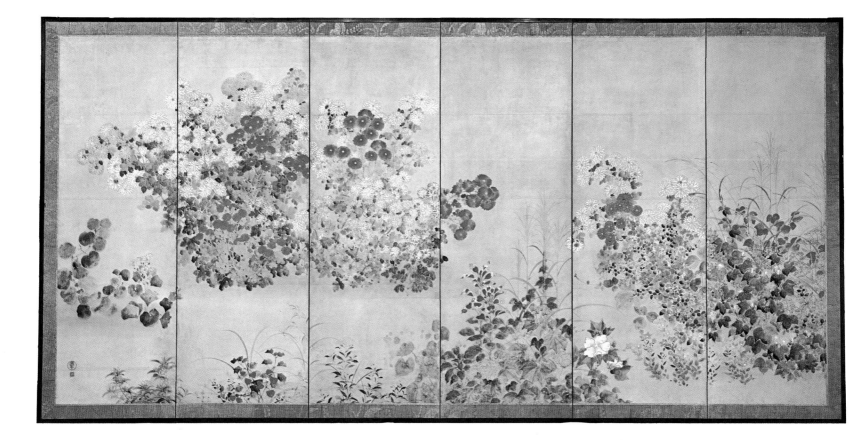

25. *Flowers of the Four Seasons.* By
Kitagawa Sōsetsu (mid-seventeenth
century). Late Momoyama–early Edo
periods. Pair of sixfold screens, ink and
color on paper, each 67″ x 10′ 10 3/8″
(170.1 x 331.2 cm). The Cleveland
Museum of Art. Purchase, Leonard C.
Hanna, Jr. Bequest

There is nothing in Western art, or for
that matter in Chinese art, that quite
equals the Japanese approach to gather-
ing together the flowers of the seasons
and presenting them as a unified com-
position. We have seen that combina-
tions of birds and flowers existed in

works such as No. 10, attributed to
Sesshū. It was not until Sōtatsu and his
followers, however, that the flowers of
all the seasons were assembled into a
simple design and represented alone
without the benefit of cheery bird
songs. Paintings of this nature became
extremely popular, and because of their
universal appeal and highly decorative
nature many artists, especially those of
the Rimpa school, produced them. One
of the earliest and most successful
masters was Kitagawa Sōsetsu.

We know very little of the artist
Kitagawa Sōsetsu. There is a minimal
amount of biographical data available
and even his birth and death dates are
not known. In fact, the name Sōsetsu

appears on paintings of a similar nature
with three different combinations of
characters used in the signature, and
often bearing the Sōtatsu studio Inen
seal. Thus we are not certain whether
we are dealing with one, two, or even
three artists. The generally accepted
theory at the present time is that
Kitagawa Sōsetsu was a blood relative
of Sōtatsu. Supporters of this theory are
encouraged by the fact (reported in dis-
cussing No. 23) that some scholars
believe that Sōtatsu was also descended
from the Kitagawa family. One of the
only other incontrovertible facts known
is that Sōsetsu received the honorary
title of Hokkyō prior to 1642, though
probably not until after Sōtatsu's death.

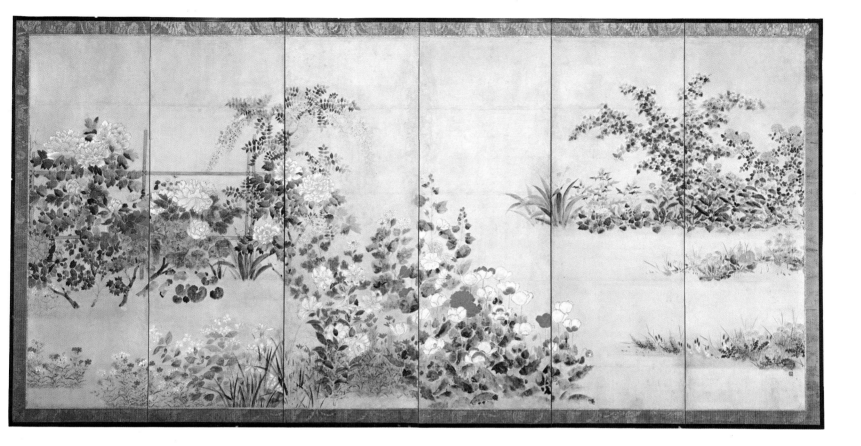

The pair of sixfold screens shown here are superior in execution, although they are typical examples of Kitagawa Sōsetsu's work. On them are represented a veritable garden of the favorite blossoms which appealed to the Japanese during the flowering season. Actually this raises a problem, for they are usually titled "Flowers of the Four Seasons," yet winter is truly not represented. One might claim facetiously that winter is symbolized by the void areas in the composition. Actually, on some four-seasons floral paintings, the plum or camellia equate with winter. In the Cleveland Museum of Art screen, spring and summer appear on the right, and the list of flowering plants is for-midable. Among the blooms portrayed are the rose, dandelion, orchid, kerria, iris, pink, peony, wisteria, poppy, daisy, hollyhock, and thistle. Sōsetsu painted a simple stake fence into this half of the composition, and it helps to support the wisteria and the plants, such as the peony, with its heavy full blossoms. The left-hand screen is dedicated to autumn and contains among other flowers, ivy, chrysanthemums, ballflowers, mallow, bush clover, and eulalia. In both screens the floral offerings are organized into horizontal bands which extend as har-monious groupings across the surface of the composition.

In his paintings Sōsetsu treats the viewer to a bountiful harvest and floral feast. A careful examination of his treatment of the plants reveals that he was a keen observer of nature. He re-laxed some of the formal elements of Rimpa composition, and introduced into his work a miraculous and delicate sense of color, also employing translu-cent washes and *tarashikomi*. It is dif-ficult to evaluate fully the original color, for screens of this nature were much loved and used. Almost all of them have suffered damage and have been repaired, remounted, and washed a number of times. This has bleached out the colors and altered their rela-tionship to the paper ground. Despite all this, Sōsetsu's skill and the magic of his brushwork remain alive.

DETAIL OF PLATE 25 ▶

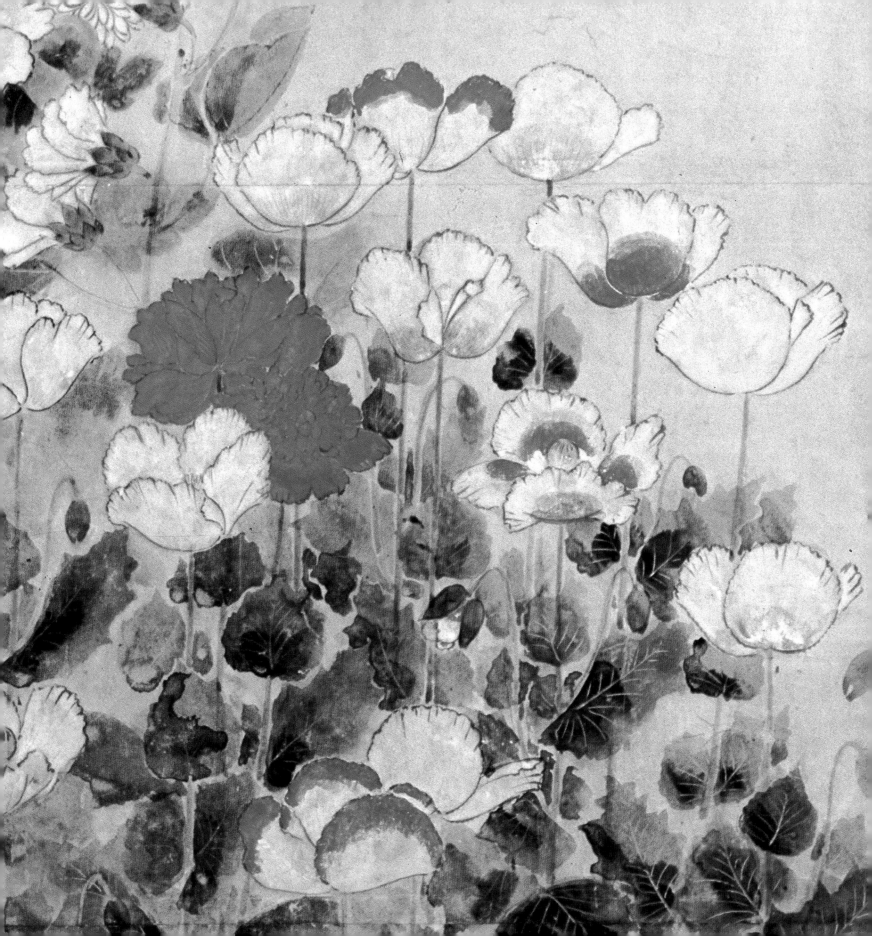

Edo and Modern Periods

IT IS ALMOST IMPOSSIBLE to sum up the aesthetic achievements of the Edo period (1615–1868) with brevity. One must remember that during the two hundred and fifty-odd years that comprise it, the entire social structure of Japan underwent great change. Nobunaga, Hideyoshi, and Ieyasu had brought comparative tranquility. The Tokugawa, a strong central authority based in Edo, governed in the name of the emperor and all the provinces were subservient to their rule. Economically the middle class had gained. Merchants and men in the street not only began to possess money, they also expressed great interest in using it for symbols reflecting their newly found place in the sun. Fortunately, art was one of the symbols that appealed to them. To meet this demand, artists and draftsmen adapted to popular desires and pleasures. Thus, in the Edo period, there developed a whole range of subject matter, styles, materials, and techniques. The formula seemed to be: more people–greater need, greater need–more artists, more artists–more variation of themes, more variation of themes–new styles and techniques, new styles and techniques–growth of interest.

As was to be expected, in painting the traditional styles continued to flourish. Thus the academic Kanō (No. 32) and Tosa (No. 30), as well as the Yamato-e, Muromachi Suiboku, Kaihō, Unkoku (No. 35), Hasegawa, and Rimpa schools never vanished. Offshoots developed from them in the Edo period. A genre style known as *ukiyo-e* came into being. The Soga manner (No. 31), with Muromachi

Suiboku and Kanō touches, had its moment of glory. The scholar literati, or Nanga, tradition became very important, and it shines as one of the bright lights in the Edo period's aesthetic sky. Artists such as Nankai (1677–1751; No. 42), Gyokuran (1728–1784; No. 51), Chikutō (1776–1853; No. 71), Buson (1716–1783; No. 45), and Taiga (1723–1776) are but a tiny number of those who contributed to Nanga's development.

The Rimpa school was revitalized by the personalities of Kōrin (1658–1716; No. 27), and his brother Kenzan (1663–1743; Nos. 28 and 29), and new pulsations of vitality by Hōitsu (1761–1828; No. 66) and Kiitsu (1796–1858; Nos. 78, 79, 80, and 81) carried the tradition into the nineteenth century. Rimpa had special appeal for those with sophisticated taste, and, because costly materials in the form of gold, silver, fine mineral pigments, and inlays were often used in the creation of Rimpa, for the wealthy.

Among the new schools to develop, one of great importance was the Maruyama, named for Maruyama Ōkyo (1733–1795; Nos. 44 and 45). This school was ideally suited to the representation of nature, for Ōkyo believed in the reasonable attainment of realism. He called upon artists to sketch directly from nature and to capture the essence of what they represented. Ōkyo's works were often carefully detailed, and he produced numbers of exquisite studies of birds, beasts, blossoms, and bugs which impress viewers by their scientific accuracy. Ōkyo's followers and pupils were

many, among them Rosetsu (1755–1799; Nos. 60, 61, and 62), Kirei (1770–1835; No. 70), Tetsuzan (1775–1841; No. 69), and Genki (1747–1797; No. 57). They were anything but mimics, and although the work of each displays Ōkyo's concern for realism, each artist also made his personal contribution.

An incredibly talented individualist, who worked in the Edo period in what I would term a decorative realistic style, was Jakuchū (1716–1800; Nos. 46, 47, 48, and 49). His nature studies are brilliant exercises in pattern and color. So often in the West he is thought of as merely a painter of ink studies of roosters. When we see his skillful applications of color and his meticulous concern for delineating patterns, we are almost struck speechless.

We must keep in mind that the Japanese love of nature was complemented by the presence of Chinese and Western influences in Japan during the late sixteenth, seventeenth, and eighteenth centuries. The grass is always greener elsewhere, and Western perspective permitted the representation of lifelike spatial relationships. Such realism appealed to many Japanese artists and scholars, who reflected in treatises on the backwardness of their homeland and the cleverness of the foreigners who could truly capture nature. The Rangakusha (Dutch Scholars) provided a noisy and persistent chorus which, at times, aroused the fears of the rulers that dangerous revolutionary elements were at hand.

There were also individualists like Sosen (1747–1821; Nos. 55 and 56), who produced such detailed and charming studies of monkeys that he was even accused of being one. Others, such as Goshun (1752–1811; No. 45) and

Keibun (1779–1843; No. 73), broke away from the Maruyama school by combining Nanga mannerisms and subject matter derived from Buson with Ōkyo's precepts. The new style Goshun formulated was called Shijō after the location in Kyoto of his studio. Another artist who rivaled Kōetsu's legendary feats in versatility was Zeshin (1807–1891; Nos. 82, 83, 84, 85, 86, 121, 122, 123, and 124). He was a master of lacquer and painting, and his devotion to nature themes was constant. We must keep in mind that throughout Japanese art most accomplished masters were versatile. They not only often worked in other manners; they also tried their hand at other arts, be it painting, sculpture, ceramics, pottery, textiles, lacquer, or music.

As time passed in the Edo period, lesser creatures, such as insects, had their moment of glory. Zeshin's representations of ants (No. 121), crickets (No. 86), and grasshoppers (No. 84) all appear capable of movement.

In the decorative arts—ceramics, metalwork, lacquer, ivory carving, and textile patterns—the same themes, talent, and concerns displayed by Edo pictorial artists were repeated. Floral designs dominated the painted surfaces of porcelains and pottery. The metal tsuba (sword guards), lacquer inro (seal cases), and a variety of boxes for various uses all relied on nature themes. The range of subject matter was almost as catholic as that employed by the carvers of the netsuke toggles. In the decorative arts, the total encyclopedia of nature was utilized.

I have mentioned earlier that many schools and artists appeared in the Edo period. The patterns established by them continued into modern times. Each artist and school

contributed to the picture of Japanese nature as represented in art. The contributions made by each of these artists are recorded in the pages of this volume. Formal, decorative, expressive, spontaneous, realistic, and impressionistic approaches are all part of that story.

A love of nature remains constant. In the modern age, the human has done much by selfish misunderstanding and outright destruction to alter the balance of nature. We are indeed fortunate that an aesthetic chronicle exists. The works of art are an archive. They are living things gently preserved by artists for their beauty and interest. That is also our goal within the pages of this volume. Let us hope that in this way we may add impetus to the preservation of nature's species, life, and beauty.

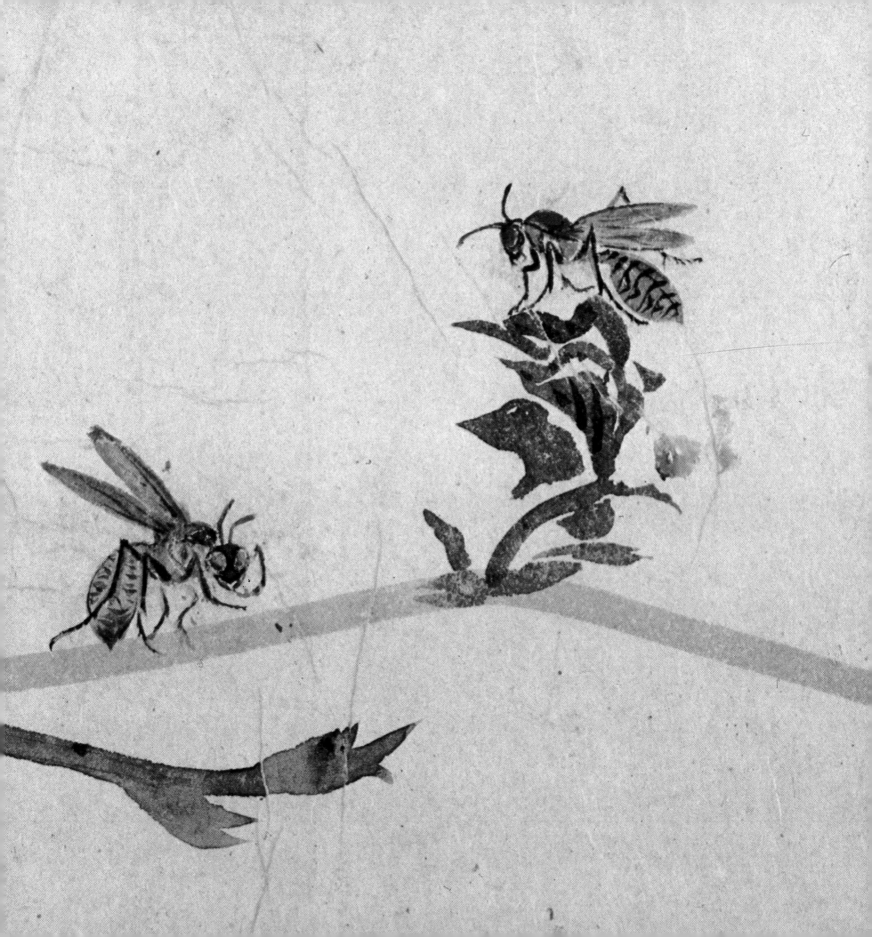

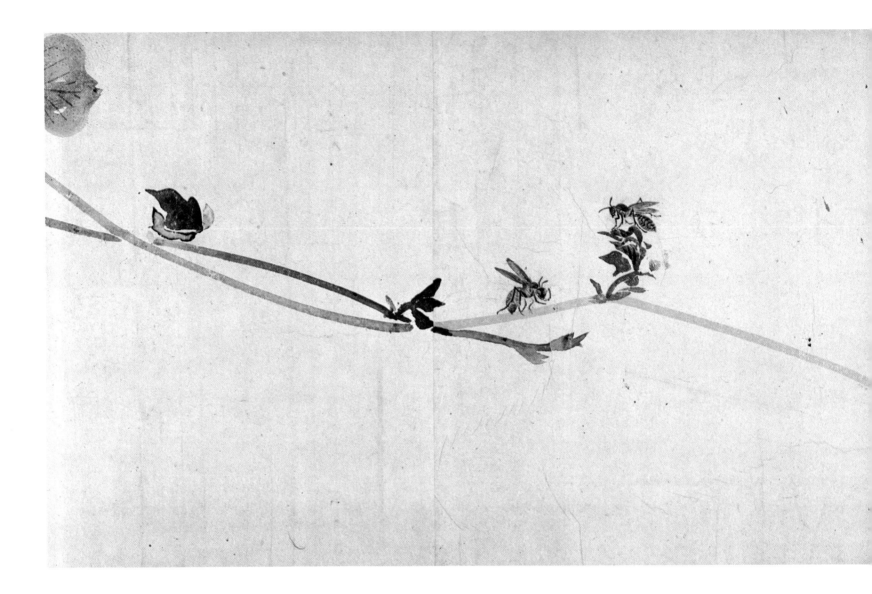

◀ DETAIL OF PLATE 26

26. *Flowers of the Four Seasons*. By Sosen (seventeenth century). Late Momoyama-early Edo periods. Handscroll, ink and color on paper, 11 1/2″ x 22′ 3″ (29.2 x 678.2 cm). Philadelphia Museum of Art. Gift of Mrs. John C. Atwood, Jr.

This work by Sosen, a very slightly known artist, continues the floral tradition so successfully refined by Kitagawa Sōsetsu. There is almost a total vacuum in the biographical data we know about Sosen. There was a later artist who used this name, Mori Sosen (1747–1821), but the two have no relationship either stylistically or in time. We do not know Sosen's birth or death dates; all we have

are reports that he was talented at floral and figure painting, and is believed to have been active in the Kan'ei era, 1624–43. The only concrete information we possess is in the form of the name and a number of seals which appear in the *Kōrin Impu* (*Record of Kōrin Seals*). A seal reproduced in that volume reads Sosen, and it is shown in combination with the Inen seal. This does not enlighten us very much, for we know that the Inen seal was used by many followers of Sōtatsu. A signature and seal, read Juntei, are also reproduced there, and it is conjectured that this was Sosen's studio name. In the scanty biographical data recorded

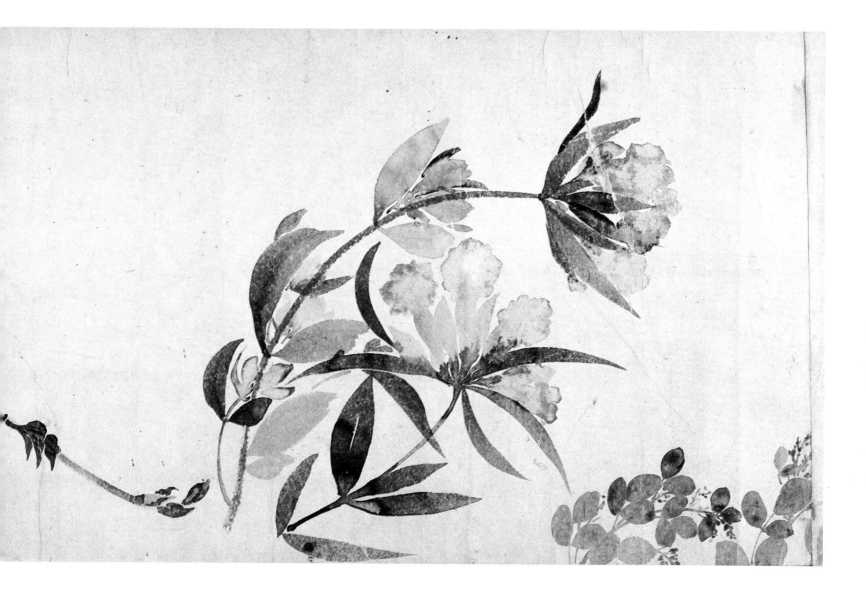

about this artist, it is mentioned that he was also honored with the title Hokkyō.

The competence of Sosen as a painter is attested to by his handscroll of the *Flowers of the Four Seasons* shown here. This work is delicately and superbly painted, and as a result of its being in handscroll format, the colors are fresh and give us a better understanding of what the Sōsetsu screens, such as No. 25, must have looked like originally. As one unwinds the scroll, an uncrowded parade of flowers passes before the viewer's eyes. Much of it is standard fare, for the artist used plum blossoms, wisteria, iris, water plantain, autumn grasses, vines, and morning glories.

Sosen was not a copyist, and this is clearly revealed in the passage reproduced here. In it he has painted a vine that may well be jasmine. With great skill and use of *tarashikomi* he has captured the essence of the plant's horizontal and downward sloping branches, and then as a surprise placed two finely drawn wasps on a branch. One wasp is about to sup off the flower's sweet nectar. Gracefully linked to the jasmine-like vine is another flowering plant. On the right, bush clover in autumnal flower bends under the weight of its leaves and blossoms to carry along the general movement to the right found in this passage.

27. *Morning Glories*. By Ogata Kōrin (1658-1716). Edo period. Incense wrapper mounted as kakemono, ink, color, and gold on silk, 53 1/2 x 17 3/4" (135.9 x 45 cm). The Art Institute of Chicago. Russell Tyson Collection

One of the greatest, most creative, and fascinating masters of the Rimpa school of painting was Ogata Kōrin. The founders of this school, Kōetsu and Sōtatsu, had set high standards, and Kōrin equaled and at times surpassed these in producing works of haunting beauty. He greatly enriched the tradition of designs utilizing blossoms and birds with innovations that sparkle with originality. These were often executed in materials of the finest quality and the completed works of art are rich and sumptuous though never vulgar.

We are fortunate in that Kōrin's life and background are quite well documented. How rare this is in the case of Japanese artists, for usually only the minimal facts are known. Kōrin's antecedents moved in influential circles in the Momoyama and early Edo periods. A man named Ogata Koreharu, who originally had resided in Bungo (Ōita) province in Kyushu, moved during the late sixteenth century to Kyoto, where he entered the service of Yoshiaki (1537-1597), the last Ashikaga shogun. When Oda Nobunaga replaced Yoshiaki as shogun, the latter went into retirement, but Koreharu did not follow him, staying instead in Kyoto. Upon Koreharu's death, Dōhaku took over the leadership of the Ogata family. This man, Dōhaku, provided the link between the Ogata and Hon'ami families, by selecting Hōshu, Kōetsu's elder sister, as his bride. Aiding the Ogata family fortunes, Dōhaku became the purveyor of silk textiles for the three daughters of the influential Asai Nagamasa (1545-1573). These three women had all married prominent men. Yodo-gimi, Nagamasa's eldest

daughter, married the second military shogun of the Edo period, Toyotomi Hideyoshi. The second daughter became the wife of Kyōgoku Takatsugu (1560-1609), a Christian, who was daimyo of the Ōtsu and Obama fiefs. Nagamasa's third daughter married Hidetada (1579-1632), the son of Tokugawa Ieyasu, founder of the Tokugawa shogunate. Hidetada, in turn, followed his father as military ruler of the land. The shop that Dōhaku set up was called the Kariganeya, and it flourished and the Ogata family prospered. Upon Dōhaku's death, control of the shop was passed on to Sōhaku, who greatly benefited by the patronage of Tōfukumon-in, the shogun's daughter. Her position was one of great power, for she had become the consort of Emperor Gomizunoo, who reigned from 1612 to 1629. Sōhaku became a member of Kōetsu's art community at Takagamine, and when he died in 1631, Sōho, his eldest son, inherited the Kariganeya business. Upon Sōho's death in 1660, his stepbrother, Kōrin's father Sōken, inherited the shop.

Sōken produced a large family and quite obviously he tried to instill in them an interest in the arts. Kōrin and his younger brother Kenzan (1663-1743), were so favorably indoctrinated by their father that they both became excellent artists.

Kōrin is reported to have studied painting with Yamamoto Sōken (d. 1706), and also Kanō Tsunenobu (1636-1713) and Sumiyoshi Gukei (1631-1705). The strongest influences on him were by his relatives Kōetsu and Sōtatsu. Kōrin was quite obviously a playboy and a superb dilettante. He rapidly squandered his sizable inheritance and was forced to sell his father's home. Like Kōetsu, he tried his hand at lacquer and ceramics, as well as painting and textiles, with notable success. He also kept up with important theatrical, literary, and social functions.

His decline in fortune was a force in bringing about his collaboration, about 1699, with his brother, Kenzan, at the Narutaki kiln. Though he suffered from a serious cash-flow dilemma, Kōrin's reputation as an artist was not affected. Thus in about 1701 he was awarded the honorary title of Hokkyō. His fortune rose and declined in a seesaw manner depending on which patron had come to his defense. Thinking that a change of scene would be valuable, he left Kyoto for Edo, where prominent merchants such as the Fuyuki family and the daimyos of Tsugaru and Sakai gave him commissions. The lure and love of Kyoto remained too strong, however, and he abandoned Edo and in 1709 returned there to a new home on Shimmachidōri near Nijō-kudaru. Toward the end of his life, it is reported, he took the tonsure and became an ardent Buddhist of the Nichiren sect. Kōrin died on the second day of the sixth month of 1716 and was buried in the compound of the Hongyō-in of the Myōken-ji.

The incense wrapper illustrated here is a fascinating representative of Kōrin's talent. It is not as large or as impressive as a full-scale scroll painting, screen, or lacquer; however, it reveals much about the artist. The incense wrapper is a fairly small rectangle of silk which Kōrin painted gold, and then decorated with morning glories in costly, brilliant azurite and malachite pigments. Actually Kōrin had produced at least seven such incense wrappers; they may have been commissioned for an elegant scent identification contest, or as grand gifts to please a wealthy patron. The other incense wrappers include designs of cranes, ivy, a willow tree, pinks, and white plum trees. The designs are all windows revealing themes treasured by Kōrin. Each one is compositionally exciting and evokes a desire to see more.

Kōrin's talents were great. His work in lacquer can be seen and studied in the superb inrō No. 97.

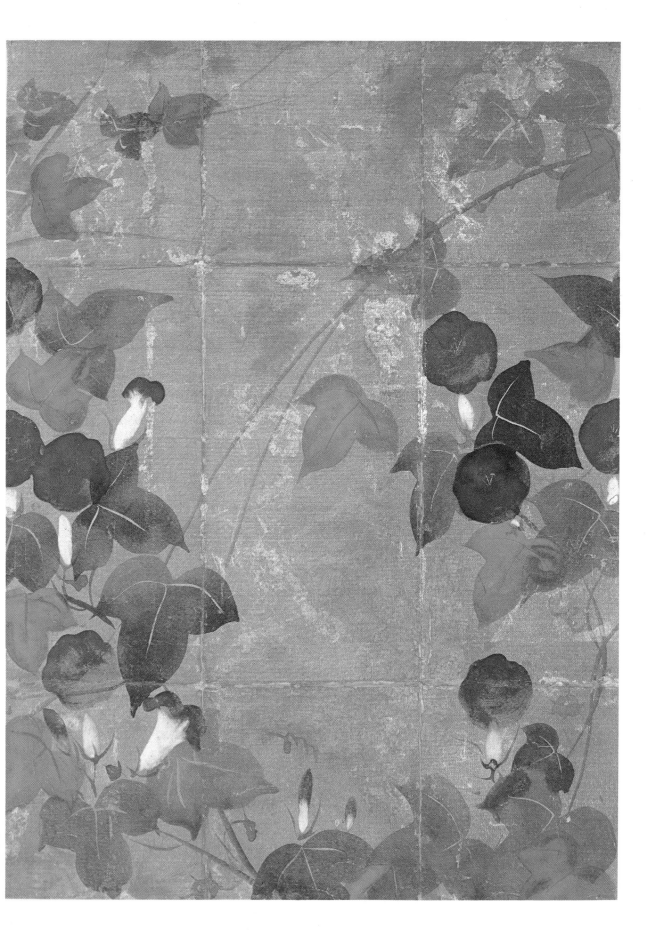

28. *Cake Trays.* Attributed to Ogata Kenzan (1663-1743). Edo period, eighteenth century. Stoneware, creamy transparent glaze over brown slip decoration, each 5 3/4 x 5 3/4 x 7/8″ (14.6 x 14.6 x 2.2 cm). Seattle Art Museum. Eugene Fuller Memorial Collection

The four cake trays shown here are all characteristic, both in shape and execution, of the work which is now generically called Kenzan-yaki (Kenzan wares). Some of the ware was actually made by Kenzan, while an even larger body of it was the work of assistants, pupils, or later followers. Often the pieces carry the Kenzan signature and this has produced much confusion, for in many instances it is but an interpolation.

Sets of ceramics in Japan normally come in five pieces or multiples thereof, so it is possible that one tray of the Seattle set has been lost. Floral motifs were very popular and had been in common use from the Kamakura period on. In the Momoyama era, decorators of ceramics made great use of flower themes on wares such as Shino, Karatsu, Seto, and Oribe. With the use of enamels and further advances in pottery-decorating techniques, the Edo period ceramics relied even more heavily on these motifs.

Kenzan, as was mentioned in No. 27, was the younger brother of Kōrin. Though brought up with the same advantages and exposure to Edo society and culture, Kenzan was a more introspective being. He carried the same spirit of creative talent, though certainly he must have been much shyer than his brother. He was content to look on and learn and to create wares that bore a semblance of sophistication and humility. Kenzan was aided in this by the very nature of Japanese ceramics, which until that time had shunned flamboyance and overdecoration. Thus Kenzan's pottery, or that attributed to his hand, is basically simple ware made to be used and treasured. Kenzan's early training was much like that of his brother, with education in Zen, literature, poetry, calligraphy, drama, the tea ceremony, and ceramics. He befriended his relative, Kōetsu's grandson, Hon'ami Kōho (1601-1682), and studied pottery-making with him. He also tried to learn what he could from Ichinyū (d. 1696), the fourth-generation master of the Raku tradition that had been sponsored by Toyotomi Hideyoshi.

Kenzan is also reported to have studied pottery techniques employed by the great master potter Ninsei, who had introduced the use of gold, silver, and colored enamels on his wares. He set up a kiln about 1688 at his home in Omuro, which was close to the site of Ninsei's kiln. After ten years there, Kenzan moved in 1699 to Narutaki, where he set up a new kiln on land given to him by Prince Tsunahira Nijō. It was during this general time that he established close rapport with Ninsei's son, Seiemon, and a potter called Magobei, who had his kiln at Oshikoji; both assisted Kenzan in his work. His brother Kōrin also came to the kiln to decorate wares, and many of the pieces are a joint effort, resembling in a way the Kōetsu-Sōtatsu union. Prior to Kōrin's death in 1712, Kenzan moved his kiln again. This time he established himself in the city of Kyoto at Chōjiyamachi, where he appears to have remained until 1731, when he moved to Edo and set up a kiln at Iriya. Here he not only produced pottery but sought to document his techniques and wrote the *Tōkō Hitsuyō* (*Potter's Memorandum*). As his age advanced, his fortune declined, and this restrained artist, who was fully indoctrinated both in his craft and in Zen notions, died in 1743 almost a pauper.

Each of the four trays illustrated here is signed Kenzan Sei-zu and carries two

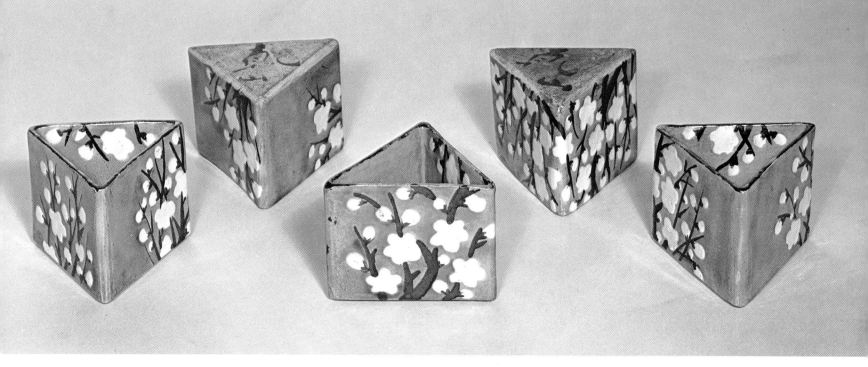

seols; the upper one reads Kenzan, whereas the lower is not fully deciphered, though the second character is read *shin*, which is believed by some scholars to have been substituted by Kenzan for another character read the same way and used in his name Shinsei. On each of the four dishes a different plant is painted. The first has a stalk of bamboo, and along the right edge of the tray is a brief inscription which roughly translated reads, "The approaching wind as though there are voices." The second tray is decorated with a pine tree, and has an inscription which translates as, "This branch disdains frost and snow." The third tray has an orchid plant painted in slip on the right, and its inscription may be translated as, "The jade and purple orchid is pulled and slanted like a hair ornament." The design on the fourth tray is a camellia, and its inscription may be translated as, "Always prospers in frost and snow." All of the slip painting is spontaneously done and the trays are bold and handsome. They vary somewhat from wares which can be assigned with relative certainty to Kenzan's hand and thus are only attributed to him.

29. *Enameled Cups With White Plum Blossoms.* By Ogata Kenzan (1663–1743). Edo period, eighteenth century. Stoneware, white and black over green enamel glaze, each, h. 2 5/8" (6.5 cm); diam. 3 3/8" (8.5 cm). Collection of Kimiko and John Powers

These five triangular-shaped cups with their emerald enamel glaze are gemlike and are considered to have actually been executed by Kenzan (No. 28). The use of enamel and the decoration of ceramics with overall patterns were in all likelihood the result of Ninsei's influence on Kenzan. Showing his originality, Kenzan made the plum-blossom design continue onto the insides of the cups. The application of patterns in this manner was a device not uncommonly used by lacquer artists, and we know that Kenzan's brother, Kōrin, and earlier artists of the Rimpa school, such as Kōetsu, were familiar with its application. In lacquer, the design flows continuously around the sides and over the cover of a box.

The painting of the white plum blossoms and the branches which support them is brilliant. They form a delightful contrast to the translucent green enamel glaze. Though sets of Japanese wares normally consist of five pieces, triangular-shaped cups such as the one shown here came in six pieces, so that when their tips were joined they would form a hexagon.

Each of the cups carries Kenzan's signature on its unglazed bottom.

30. *Battle of the Chickens and Rats.* Attributed to Tosa Mitsunari (1646–1710). Edo period, late seventeenth century. Two handscrolls, ink, pigment, and gold leaf on paper, h. 13″ (33 cm); h. 13 3/4″ (34.9 cm). Anonymous loan through the Fogg Art Museum, Harvard University, Cambridge, Mass.

We have already seen in the fragment from the *Frolicking Animal Handscroll*, No. 5, that in the Heian and Kamakura periods birds and animals were at times substituted for humans in acting out the narrative theme portrayed in a painting. Such paintings had immediate appeal, for the human has always been entertained by watching the cleverness as well as the clumsiness of birds and beasts trained to mimic human achievement while dressed in male and female costume. When applied to painting, this substitution permitted artists to work with additional freedom, for the very stringent restraints of Edo period censorship were not applied with as much vehemence to birds and beasts as to the human figure. There came about a kind of story illustration known as the *irui-monogatari* (tales of nonhuman beings). In our study of this genre of painting we find that the Tosa school utilized it fairly often, and we also find partial uses in stories such as the *Tsuru no Zōshi* (*Tale of a Crane*) in the collection of the Freer Gallery of Art.

The story told in the illustrations of the scrolls shown here occurred in autumn, 1636. The tale is a lampoon on court and military life, and the chickens and rats are made to copy the pettiness of humankind. The names of the animals in the text are simple enough, for they are called *niwatori* (chicken), *nezumi* (rat), *kōmori* (bat), and *kaeru* (frog). They also have pompous titles such as Court Master of Music, Lord of Chikugo, Minister of Justice, and Master of Ceremonies. The two factions, the chickens and the rats, are on the verge of war; each refuses to relinquish claim to the spillings left from the tribute rice during harvest time. The Minister of Justice and Master of Ceremonies intercede and arbitrate the disagreement with a banquet. The vignettes are filled with lively action and humor and are brilliantly painted.

The *Battle of the Chickens and Rats* handscrolls are attributed to a slightly known painter, Mitsunari, who was the eldest son of Tosa Mitsuoki (1617–1691). Mitsunari had followed his father as head of the Imperial Painting Bureau and had been given official court rank. Thus his observations of the squabbling found in politics and the military must have come from keen firsthand observation.

These two narrative handscrolls are classic examples of the Tosa tradition when it was applied with Yamato-e techniques. Outlines define almost everything, and they vary little and carry no feeling of calligraphic movement. Instead, the action in the scenes is captured by the relationship of the participants in the story along with their posturing. In keeping with the Tosa–Yamato-e style, Mitsunari used vivid opaque pigments with textile patterns, the diagonals and verticals of interior settings, and gold-flecked bands of clouds at the top and bottom, as important decorative features. In one scene the two camps in court costume confront each other; it is obvious that tempers have flared. In another scene the participants have donned armor and girded for battle, as a solitary rat appears before the commander-in-chief of the bird forces and his military council.

The application of birds and animals to the painted narrative tradition of Japan is one of the refreshing and charming aspects of Japanese art.

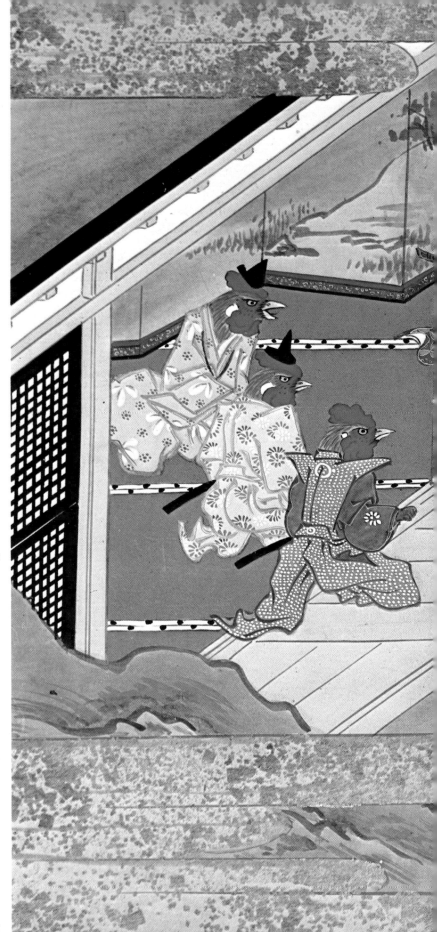

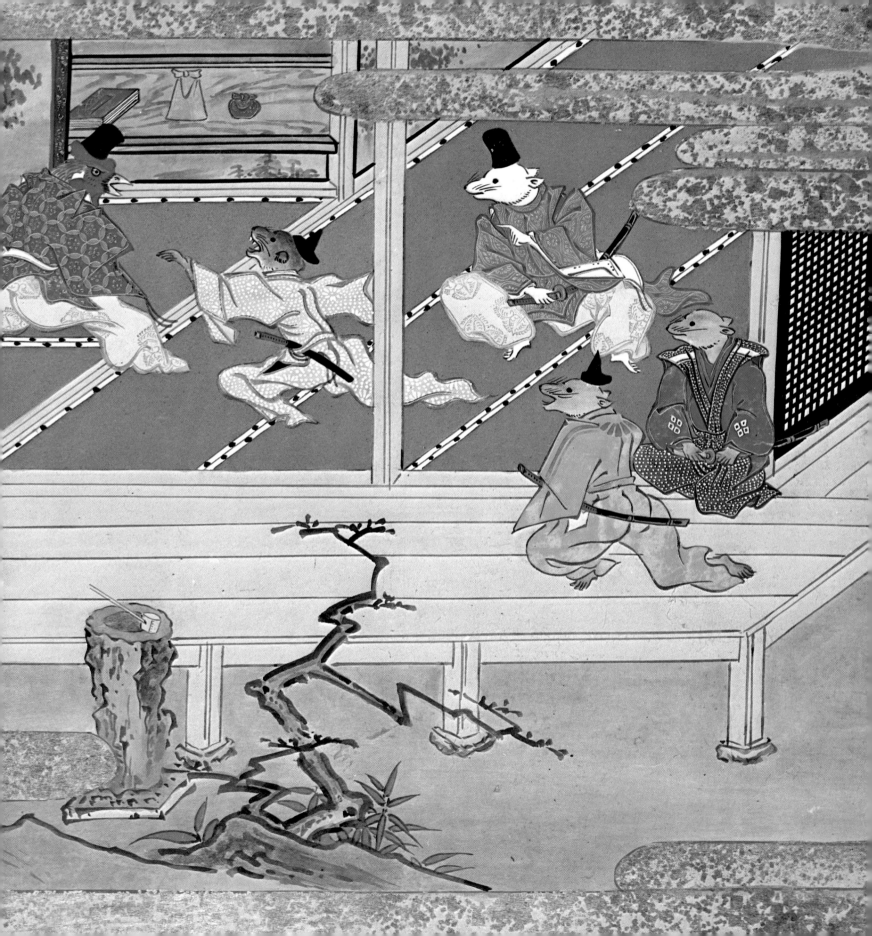

31. *Hawk.* By Soga Nichokuan (active c. 1656), Edo period, seventeenth century. Kakemono, ink on paper, 82 1/8 x 28 3/4" (208.6 x 73 cm). Asian Art Museum of San Francisco. The Avery Brundage Collection

Certain artists concentrated on a singular theme; such a man was Nichokuan, who, we might say, was the hawk and eagle painter of seventeenth-century Japan. These paintings stand apart from the works of other schools and are very competently done. Nichokuan was the son of Chokuan (active 1596–1614). Both artists lived in Sakai, the bustling port facility just outside Osaka, and used the Soga family name. In doing this they claimed a relationship to the fifteenth-century artist Soga Jasoku, who was associated with the Daitoku-ji and linked with the Zen priest Ikkyū. The actual familial link between Jasoku and Chokuan is impossible to trace. Nichokuan, the artist of the hawk painting shown here, carried the genealogical fantasy even further. He claimed to represent the sixth generation descended from Jasoku. In this, at least, he shared a family name. He also fancifully claimed lineage to Shūbun. Such claims, I feel, fall into the area of artists' promotional efforts.

The hawk painted by Nichokuan is characteristic of the work of the Soga school. Actually it would be rather difficult to distinguish these were a whole group of *suiboku* (ink) paintings of hawks placed together without signatures or seals. They resemble Muromachi paintings such as the Shūkō hawk in the Freer Gallery of Art. In many ways they also resemble academic Kanō school treatments of the theme. A distinguishing Soga feature is that the birds are not merely stylized compilations of an idealized bird; instead, they have character and life. They are birds of prey and as such are hunters, alert and ready to move with great swiftness; there is no saccharine quality about them. Typical of Soga brushwork, and especially that of Chokuan and his son, Nichokuan, is the careful concern with which they delineate the plumage, beak, eye, and talons of the bird. Rather than just using outlines and washes, the Soga artists applied additional strokes to distinguish feathers with different qualities. The hawk rests on a thick branch of an old oak tree. Portions of the branch are outlined with bold strokes, and the large oak leaves create a foil for the bird's head, leading the viewer to concentrate on this feature and the hawk's wing. Soga works are often criticized as being stiff and mechanical, but actually they are not so, for they are the result of the artist's direct study of nature.

This painting bears all three seals used by Nichokuan. The upper one probably reads Soga, though the second character is not fully decipherable. The middle square-shaped seal with rounded edges reads Nichokuan. The bottom square seal appears on many of Nichokuan's paintings and reads In (Lineage).

DETAIL OF PLATE 31 ▶

32. *Bamboo and Poppies*. By Kanō Shigenobu (active second quarter of the seventeenth century). Edo period. Pair of sixfold screens, ink, color, and gold leaf on paper, each 68 3/8″ x 12′ (173.7 x 365.8 cm). Seattle Art Museum. Margaret E. Fuller Purchase Fund

One of the most beautiful, realistic, and decorative floral designs to survive in Japanese art is the pair of screens illustrated here on which an almost unknown Kanō school artist has painted bamboo and poppies. The entire design was worked out with almost mathematical precision and the artist achieved perfection. He continued the traditional characteristics of screen composition which by this time had become so ingrained as to be natural. These characteristics first took root in the Muromachi period, and from that time on were repeated again and again, especially by artists of the academic Kanō school. The most obvious feature was a tendency to place the tallest and most monumental elements, other than the distant landscape, at the outer edges of the screen. These served as fences within which the remaining composition would be contained. A second feature was the use of voids and bands of mist or clouds which would float across the surface. In the screens shown here, two stands of bamboo perform the service of the aforementioned fence. On

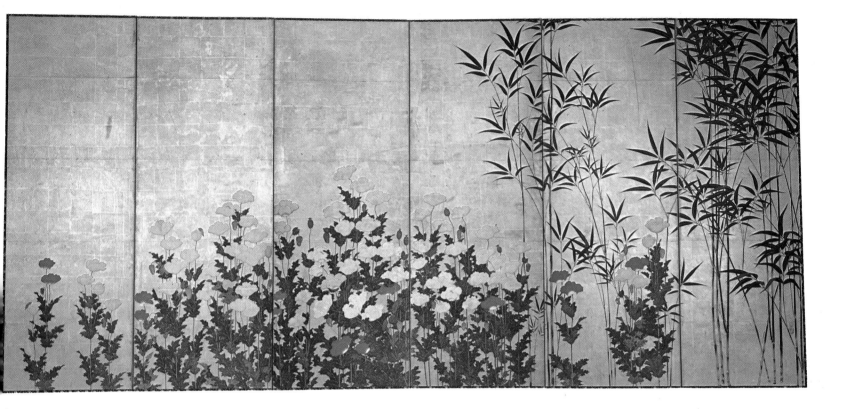

the right-hand screen the bamboo oc-
cupies the two end panels and just the
edge of the proximate one. The bamboo
extends over a wider area of the left-
hand screen, for here it is part of four
panels commencing from the left outer
edge. To compensate for the uneven dis-
tribution of bamboo, the artist crowded
poppies into the remaining panels of the
right-hand screen, whereas he spread
them out much more sparsely on its
mate. This device creates interest in
turn, for pockets of color are formed,
and the poppies and bamboo appear
almost as silhouettes against the gold-
leafed background. The artist has
painted his bamboo thin with spiky
bladelike leaves. The delicate stalks
appear stringy and capable of movement.
The lovely poppies, by contrast, have a

fragility imparted partially by the fresh
colors of their blossoms, but also by the
density and vertical nature of their
growth. One can sense that they could
easily snap off.

This great design was the creation of
a very slightly known artist of the Kanō
school called Shigenobu, who dwelt in
Kyoto. The biographical dictionaries
tell little if anything about him other
than that he was active in the second
quarter of the seventeenth century and
was also called Sōken. He is reported to
have been a pupil of Sōshū. There are
two seals on the screens: the upper one
appears to read Ji, and the second is
indecipherable. A screen with a very
similar design is in the collection of the
Kimbell Art Museum in Fort Worth,
Texas.

33. *Horse*. Edo period, dated the fifth month 1682. *Ema* (wooden votive panel), carved in low relief, painted with ink and color, 21 3/4 x 33" (55.2 x 83.8 cm). Collection of Mr. and Mrs. James W. Alsdorf, Winnetka, Ill.

Paintings of horses done on wooden panels and presented to Shinto shrines as votive offerings are an old custom in Japan. Originally the donor actually presented a horse as an offering of thanks for the presence or absence of rain. As these animals were highly prized, such a gift signified the sincerity of one's devotion and faith. Painted panels of this sort became very popular in the Edo period, and with the passage of time the subject matter varied and a range of themes was employed. The use of *ema* was expanded to thanksgiving for any favor the gods had granted, as well as for prayers yet to be fulfilled.

Many artists of note produced *ema*, such as Kanō Sanraku's horses in the Kaizu Tenjin Shrine in Shiga prefecture. The practice continues even to the present, with votive pictures of all sizes periodically appearing at shrines. Normally such works are painted on panels and framed to hang at the shrine. Usually the elements have weathered the wood badly and the paintings have all but vanished. There are also instances where almost miraculously the heavily pigmented surfaces have protected the wood, and while the background areas have deteriorated, the rest appears to be sculptural, as though carved out in low relief.

On the panel shown here, a very spirited horse with saddle appears to have suddenly stopped its forward movement, and lowers its head to indicate that decision. The colors were once brilliant, and even today this is one of the rare instances where an *ema*'s color is very well preserved. Having been created with particular intent, *ema* normally carry inscriptions. Across the top is the formula, "All requests answered, all prayers fulfilled." Along the left edge of the panel the date it was offered is given as an auspicious day in the fifth month of 1682. Below and to the right of this is written "Respectfully Hiroyuki." Although in the past it has been suggested that this is the name of the artist who painted the *ema*, it is more likely the name of the donor.

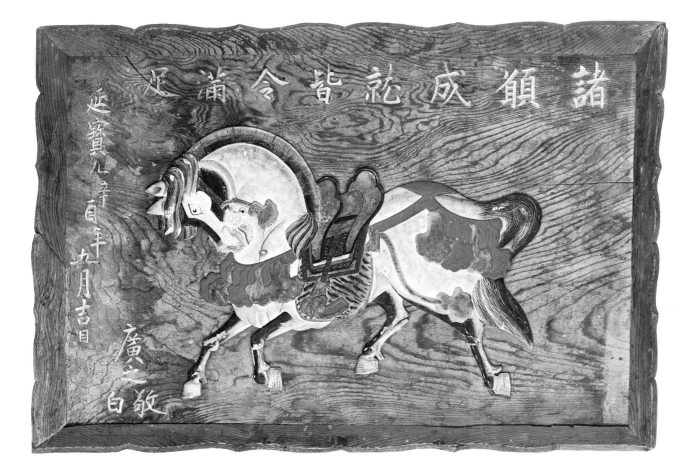

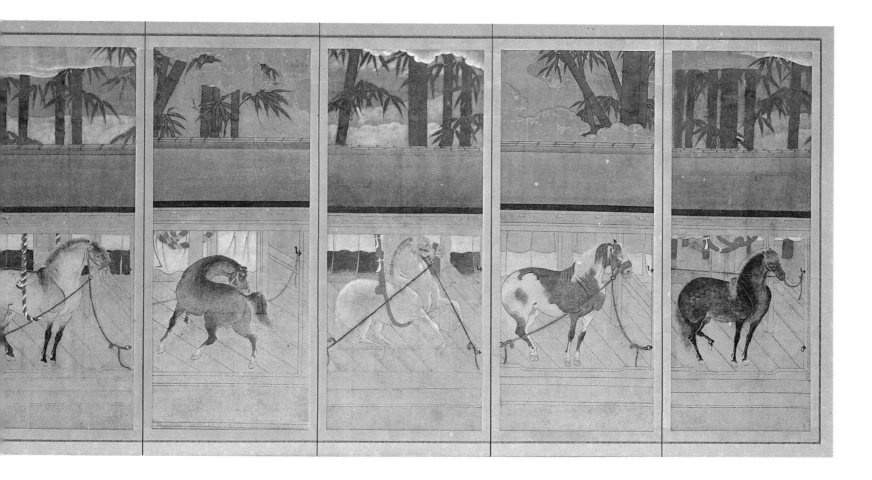

4. *Umaya Zu* (*Stable Painting*). Artist unknown. Edo period, seventeenth century. Sixfold screen, ink and color on paper, 47 5/8″ x 9′10″ (120.7 x 301 cm). Asian Art Museum of San Francisco. The Avery Brundage Collection

Interest in using horses as themes for paintings has already been seen in Nos. 21 and 33, and mention was made of their earlier employment as subject matter. In the late sixteenth and the early seventeenth century, pairs of screens representing these noble beasts in the stalls of their stables (*umaya*) grew in vogue. Usually the horses are associated with their grooms or with riders who have come to admire them. In these instances the works are without question genre paintings. The paintings are usually without signature, although there is strong stylistic evidence of Yamato-e and Tosa influence. Most screen paintings of *umaya* bear witness to heavy usage; much like the bird and flower screens of the four seasons, they were very popular and as a result were displayed often and occasionally damaged and repaired. In many instances the panels link neatly together; in others, the horses are painted one to a panel, and the panels in turn have been trimmed prior to being mounted onto the folds of the screen. Thus, at times, variations in the positioning of the panels create juxtapositions which cause speculation on the authenticity of the suggested order.

The *umaya* screen shown here is a very fine example, though unfortunately only one half of the pair is known. It is hoped that with future research the right-hand screen may be located. The horses, which are shown without the presence of humans, are all tethered, and three are also in slings. The edges of the stalls and the roofs of the stable are also shown. Rising behind the stalls to the upper edge of the composition is a grove of large, thick bamboo, whose stalks vanish into the gold-leafed clouds of the sky. In this particular variety of *umaya* screen, one also finds a seasonal tree background using plum, cherry, or maples instead of the bamboo shown here. At times the screens are not as tall, and the grove background is absent. I have often wondered if such backgrounds were not affixed in later restorations to add height. This would be very difficult to detect even by cautious examination. The screen from the Avery Brundage Collection illustrated here is a case in point. If one examines the bamboo grove one discovers that even allowing for the trimmed-away areas, the panels would not join together easily. The third panel from the left is in many ways different from the others. In the ridges of the roofs, two basic variations of tile placement are evident, and actually additional differences exist if one takes scale into account. Three architectural treatments are found at the edges of the stalls: four have a channeled beam, one is flush to the edge, and one terminates at a straight horizontal beam. Many questions remain to be answered. Stylistically the third horse from the left, though equally active, is a stallion of more delicate proportions. These questions can all be resolved by assuming that the variations are the result of remounting. Though I honestly do not know, I would accept that theory. I would also hazard the possibility that the painting is the result of a salvage project in which panels from a similar screen, or the missing half of the present one, were rescued, joined, and given a new life in this vigorous and handsome work of art.

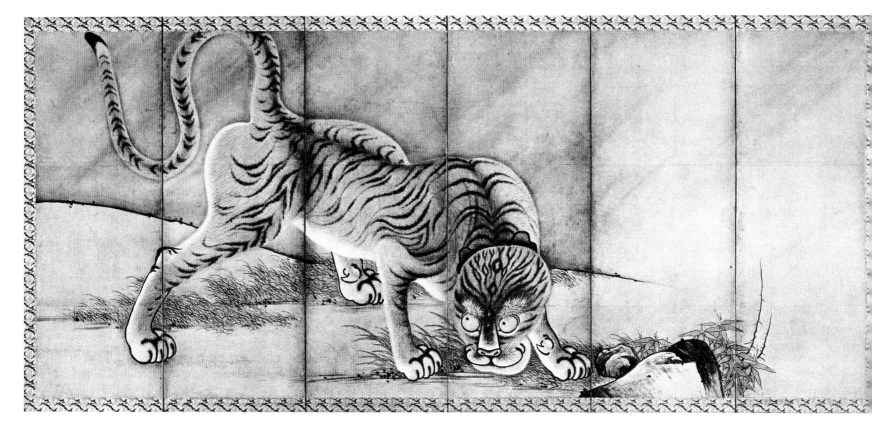

35. *Tiger and Dragon*. Attributed to
Unkoku Tōgan (1547–1618). Edo
period, seventeenth century. Pair of six-
fold screens, ink and slight color on
paper, each 65″ x 12′2″ (165 x
372 cm). Asian Art Museum of San
Francisco. The Avery Brundage
Collection

Tigers and dragons appear in the art of
the Orient at a very early date. One has
only to glance at the bronzes of the an-
cient Shang and Chou dynasties of
China to establish their popularity.
From that point on, the dragon and
tiger as themes were repeatedly used,
whether in metal, ceramics, lacquer,
textiles, or painting. From China their
vogue was carried to Korea and then to
Japan.

The development of this genre in
Japan was probably most stimulated by
the presence of numbers of Sung, Yüan,
and Ming dynasty paintings brought
back to the island kingdom from the
mainland by returning priests and en-
voys during the revival of interest in
things Chinese in the Muromachi
period. Thus Japanese artists saw,
copied, and reinterpreted fine paintings
of these beasts.

One of the favorite methods
employed by the Japanese in portraying
the dragon and the tiger was to paint
them on pairs of sixfold screens with a
single beast reigning on each half. One
need not go to Japan to see fine ex-
amples; the Cleveland Museum of Art
has a noteworthy specimen by Sesson
(1504–1589) and the Nelson Gallery-
Atkins Museum, Kansas City, Mo., has
a slightly later example by the Edo
period artist Kanō Tanyū (1602–
1674). There are additional examples
in other collections in the United States.
Perhaps the most unusual and puzzling
are the screens shown here. Although
traditionally attributed to Unkoku
Tōgan (1547–1618), few would accept
that attribution. Both the dragon and
the tiger are executed in a very bold and
daring manner. They have an academic
appearance and also show traces of
naive originality. The dragon rushing
along over the water in the right-hand
screen does not really seem ferocious, or
in that much of a hurry; it is a

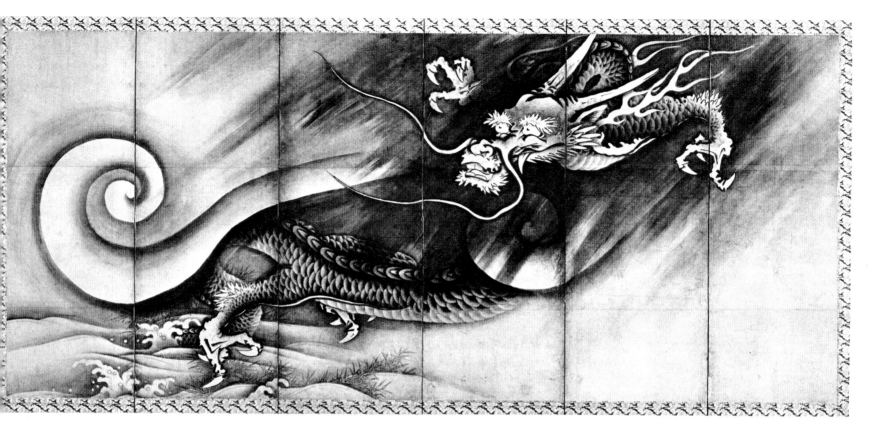

benevolent beast. The air about the dragon is stirred up by its front legs, and its claws appear turned in, as though braking its movement. The brushed line stands out, and this also applies to the softer treatment of the scales covering the dragon's body. There is little that is subtle, although the unknown artist painted the few clumps of grass, or young bamboo, and waves with a much finer controlled line. The tiger on the left-hand screen appears to be miscast, as is often the case in Japanese art. He is painted on a very large scale so that his curved, raised tail vanishes, only to reappear elsewhere in the picture. The proportions of the body are all wrong and indicate a flattened-out tiger skin rather than a live beast. The head resembles a Halloween mask with

peculiar ears, popeyes, a nose like a celery stalk, bushy, brushlike eyebrows, and an accented mouth. The fur markings only vaguely resemble natural ones, and the tiger, like the dragon, is not very sinister. It certainly could never spring from the stance it takes.

The Unkoku school, to which this work is attributed, was founded by Tōgan, who claimed to be the legitimate heir to Sesshū's manner, as did many other late-sixteenth- and seventeenth-century masters. Tōgan felt he was the third generation, whereas Hasegawa Tōhaku (1539–1610) claimed to be the fifth. The Unkoku style is normally formal and stiff, and in Tōgan, and other Unkoku school landscapes, a reliance on Sesshū can be seen. For the school he established, Tōgan

took the name Unkoku from Sesshū's studio, which was called Unkoku-an. He also borrowed the character Tō in his name from Sesshū's name Tōyō. In addition, he served the Mōri family, which had idolized Sesshū, and he copied the magnificent long Sesshū landscape handscroll of 1486 for Mōri Terumoto (1553–1625).

I recall the first time the late Avery Brundage showed me, and very kindly permitted me to study, the fascinating screens shown here. He was well aware that the attribution to Tōgan was but a traditional one, yet he remained enchanted by the screens. I continue to be charmed by them. The scale and treatment are unusual and the paintings are imbued with humor, subtle though it be, that is so important in Japanese art.

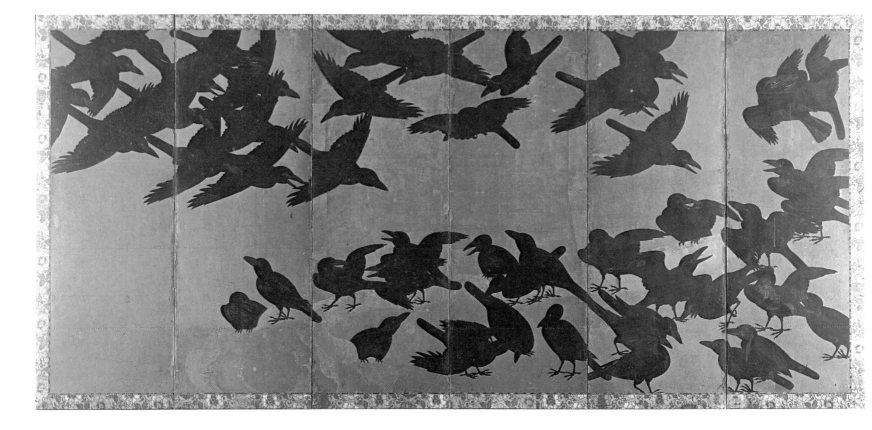

36. *Crows.* Artist unknown. Edo period, early seventeenth century. Pair of six-fold screens, ink, lacquer, and gold leaf on paper, each 68 1/2″ x 11′7″ (173.9 x 353.1 cm). Seattle Art Museum. Eugene Fuller Memorial Collection

The crow plays a mixed role in the art of Japan. In early handscrolls a three-legged crow was depicted at times, because it was considered to dwell in, and thus be symbolic of, the sun. Such a bird appears in the handscrolls of the founding and establishment of the Geppō-ji, dating from the early Muromachi period, and now in the collection of the Freer Gallery of Art. This mystical usage can be traced back to China, where the crow is also emblematic of filial piety, for the younger birds are said to care for their

disabled elders. On the other hand, crows are considered a nuisance both in Japan and in China; they are raucous, quarrelsome, and raid the fields of crops. They are thus pests and are often equated with bleakness, winter, darkness, and ill fortune.

Assembled on this pair of sixfold screens are slightly fewer than one hundred crows. The design is amazing and memorable, for the black birds stand out in sharp contrast against the gold-leafed background. In reproduction they usually appear to be silhouettes, but they are not. The unknown artist has quite clearly defined the various areas of their bodies and their plumage by a device that dates back at least to the Kamakura period. It is a technique of painting in black upon black. The tonalities of the ink vary slightly, and

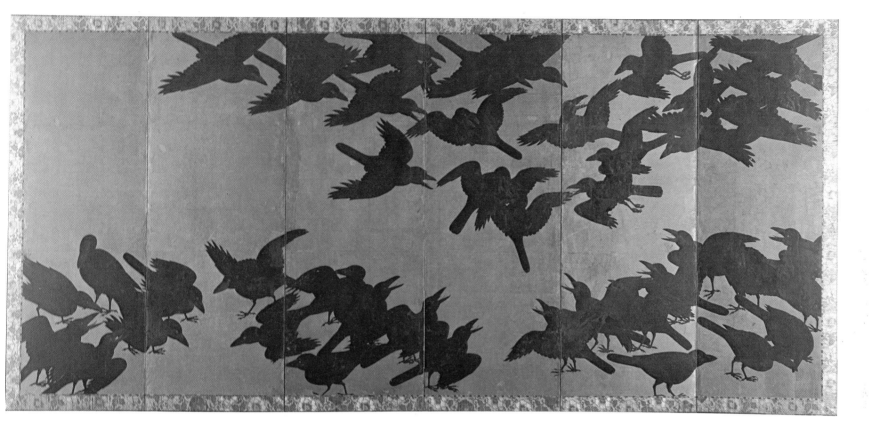

silver was mixed at times with the ink to create a sheen, or areas would be built up in low gesso relief and then ink applied over these areas, creating a three-dimensional effect. It is also reported that lacquer was used and mixed with the ink to create another tonality; however, without further scientific evidence I would question this. Instead it is likely that glue was mixed with the ink; we know that in early *ukiyo-e* prints this was thought to resemble lacquer and such prints were called *urushi-e* (lacquer prints).

The crows are very animated and make me think of the pesky starlings that descend upon many of our cities on wintry evenings. The sky of the right-hand screen shows two flights of crows diving from opposite ends and meeting in V formation to fight for air

supremacy. On the ground, groups of crows follow the general V outline, and "caw" away at the battlers. On the left-hand screen two less obvious or dramatic V's are used, representing attackers and defenders, while on the ground the general assembled audience creates pandemonium as a few pacifists ignore the whole scene.

It is a brilliant, decorative composition, and in its boldness and novelty we are reminded of the creativity of the Rimpa school. It has also been considered by some a Kanō school work. Actually it is very unlike most Kanō school art. In all probability this superb design is the work of an itinerant painter who probably had exposure to many traditions. Because he was not allied to a fixed academic style he was able to bring about this magic.

37. *Covered Bowl with Chrysanthemums and Plover*. Kakiemon ware. Edo period, early eighteenth century. Porcelain, h. 5″ with lid (12.7 cm); diam. 8 1/4″ (21 cm). The Cleveland Museum of Art. James Parmelee Fund and Various Donors by Exchange

Porcelain was probably first made in Japan in 1616 by a captive Korean immigrant named Ri Sampei, who set up a kiln at Tengudani, Kamishirakawa, in the Arita district of Hizen province (modern Saga prefecture). Ri Sampei was evidently brought to Japan at the end of the second Korean campaign by a lesser noble who served the mighty Lord Nabeshima Naoshige (1538–1618). It is reported that the first wares he made were utilitarian pieces resembling Karatsu pottery. Because of his exposure to porcelain making in Korea Ri Sampei sought the proper raw materials in Japan. After much searching, he came upon the superb kaolin deposits at Izumiyama, located along the Arita River. It was here, at Tengudani, that he joined eighteen other Korean potters and built their kiln and dwellings. Their first porcelain pieces very closely resembled Yi dynasty Korean wares, being either plain undecorated pieces or else ornamented with underglaze blue designs. Once established, the roots of the porcelain industry in Japan flourished, and many kilns came into being as native Japanese learned the profession. One of these appears to have been a Hizen potter named Sakaida Kakiemon, who is believed to have been the son of Sakaida Ensei, a lesser-known potter. The Sakaida family are said to have commenced their work at Minami Kawahara, in the Arita region, by producing wares in the Karatsu manner. Later they turned to producing underglaze blue decorated porcelains and celadons, and even later they learned the secret of decorating porcelains with colored, vitrifiable enamels. It was reported by the late eminent ceramic historian and potter Koyama Fujio, in his book *The Heritage of Japanese Ceramics*, that their knowledge of the use of enamel decoration was passed along to Kakiemon by one Toshima Tokuzaemon, a ceramic merchant. Tokuzaemon is credited with having learned the techniques from a Chinese at Nagasaki. The tale cannot be verified; and it is likely that even if Tokuzaemon knew the basics it took a great deal of experimentation on the part of Kakiemon before the technique was learned and perfected. Since the pieces were highly prized, the method of production was kept as a carefully guarded secret and passed along only to the heir of the family. Fortunately for lovers of enamel-decorated porcelain the secret leaked, and before long a good number of potters were producing this type of ware.

There is a charming legend told of how, while making a pair of *kaki* (persimmons) for the Lord of Nabeshima, the potter first achieved the rich orangish-red that matched the fruit's natural color. He henceforth used its name as part of his own, Kakiemon.

The covered bowl shown here is a superb example of an early eighteenth-century Kakiemon potter's skill. The pattern of plover flying over the waves should recall to our minds the earlier use of this theme on lacquer (see No. 7). The elegantly shaped bowl of fine white porcelain was made with an incised and modeled band of waves on the body and cover. Undulating over these surfaces and scattered among the waves are plover in flight, while chrysanthemum blossoms and their leaves float as they are carried along by the water. The cover of the bowl, which is delicately and perfectly fashioned, has a gently curving, bridgelike handle. The Kakiemon potter who produced this work had obviously mastered the use of red, blue, and green enamels, as well as gold. The colors are fresh and jewel-like. Even the interior of the piece is decorated with great taste and restraint: the interior of the cover has a sprig of plum blossoms, and painted on the bottom of the bowl are two showy legendary phoenixes confronting each other, with two flaming jewels separating them; their tail feathers curve behind them to follow the roundness of the bowl.

It is quite apparent that this piece was popular; in addition to the bowl shown here, there is an example in an American private collection, and one in the National Museum in Tokyo. In all likelihood there are still other examples. They attest to the incredible mastery of the Kakiemon potters.

A.

B.

C.

D.

38. *A. Dish with Chrysanthemums, Leaves, and Tendrils; B. Dish with Gourds and Vines; C. Dish with Maple Leaves on a Spider's Web; D. Dish with Fern Frond Border.* Nabeshima ware. Edo period, eighteenth and nineteenth centuries. Porcelain with underglaze blue and overglaze enamel decoration, *A.* h.1 7/8" (4.8 cm); diam. 6" (15.2 cm); *B.* h. 1 1/2" (3.8 cm); diam. 5 1/2" (13.9 cm); *C.* h. 1 7/8" (4.8 cm); diam. 5 3/8" (13.5 cm); *D.* h. 1 1/2" (3.8 cm); diam. 5 1/2" (13.9 cm). The University of Michigan Museum of Art. Margaret Watson Parker Art Collection

It was toward the end of the fifteenth century that the Nabeshima clan established themselves firmly in Hizen. When porcelain production commenced, they supported and encouraged it, and in a very real sense they were the catalysts and patrons who made possible the development of what is today Saga prefecture into the leading porcelain center of Japan. Imari, Kakiemon, Hizen, and Nabeshima wares are all a result of the intercession of the Nabeshima daimyo.

Although the lords of Nabeshima favored porcelain in general, they considered the products of one kiln superior and jealously protected and guarded them. The ceramics from this site are simply called Nabeshima ware. In 1628 a kiln was built at Iwayakawachi under direct clan management to produce porcelains of the finest quality, to be used either as presentation pieces or for the Nabeshima family's own use and appreciation. To protect the kiln and also supervise its operation, the daimyo even brought in Fukuda Kizaemon, a highly skilled specialist from Kyoto. The Nabeshima clan rapidly recognized the great economic value of porcelain as an article of trade. In 1661 the Nabeshima kiln was transferred to Minami Kawahara, and in 1675 it was transferred to Okawachi, where it remained for approximately two hundred years. Okawachi was a distant and not easily accessible site, and the kiln's location in a remote valley thus served as a protective measure. Very strict controls were applied to the production at

the Nabeshima kilns. Not only was anything that failed to meet the standards not marketed; it was destroyed and the shards buried.

The four small dishes illustrated here are worthy examples of the creative genius of Nabeshima potters. They are all made of a paste which in fineness and purity surpasses that of other wares such as Imari and Kakiemon. Each stands on a raised foot that is comparatively high. The white of the body shows little discoloration; one might term it a true white. Finally, the patterns and the quality of drawing are very fine, and the vitrifiable colored enamels that are applied over the glaze are clear. They are juxtaposed with sensitivity, and the glazed body glistens and adds light to the patterns.

Floral or geometric designs were favorites of the Nabeshima artists. Thus, a highly stylized plant, which has been called both a chrysanthemum and a wild rose, cleverly fills the space. In dish *A*, the leaves, blossoms, and tendrils, depicted as curlicues, are arranged to suit the space. The enamels are applied with great control and subtly carry the viewer's—or should one say diner's—eyes along the pattern. Another dish with this same design can be found in the St. Louis Art Museum. In the second dish, *B*, the design follows the rim of the plate but does not reach all the way in to fill the entire surface. Gourds and their vines are the decorative motif, and one has the impression of lying on one's back beneath a circular arbor. The gourds are small, whereas the leaves of the vines are large. The drawing is most accomplished, and again the enamels enhance and increase our appreciation of this dish. Nabeshima designs were often novel; thus, on *C*, the artist has executed a spider's web which is stretched taut over the surface of the dish. Fallen maple leaves are caught and supported by the web. The brilliance and freshness of the color of the leaves contrast wonderfully with the web. Other dishes utilizing variations on the maple-leaf theme can be found in the collections of Mr. and Mrs. Henry Trubner of Bellevue, Wash., and Mrs. George H. Bunting, Sr., of Shawnee Mission,

Kans. These three dishes appear to be eighteenth-century in date. The fourth one, *D*, is in all likelihood a little later. The design is a very formal one and consists of a broad band ringing the rim of the dish. Two stylized flowers, geometrical motifs, and what appear to be ferns fill the band. Once again, the dish is tastefully and meticulously executed.

As was mentioned, all four dishes shown here stand on raised feet. It was common in Nabeshima ware to decorate the raised foot with a band resembling the teeth of a comb in underglaze blue. Other formal stylized decorations in underglaze blue, such as a "coin" pattern or floral arabesque, were commonly painted on the exterior rim of Nabeshima dishes.

39. *Dish, Kiri* (Paulownia Leaf Cluster Shape). Nabeshima ware. Edo period, early eighteenth century. Porcelain, underglaze blue with overglaze enamel decoration, h. 5 1/4″ (13.3 cm); diam. 6 1/2″ (16.5 cm). Collection of Mr. and Mrs. James W. Alsdorf, Winnetka, Ill.

Another worthy example of Nabeshima ware (see No. 38) is this unusual dish molded into the shape of a *kiri* (paulownia leaf). It is very easily identifiable by its carefully indicated veins. Completing the dish shape is an edge on which the stylized blossoms, in slight relief, are placed against what is usually termed a "coin," or *shippo*, pattern. The background for the blossoms is rather busy but probably intentionally so, since it contrasts with the simple form of the leaves and the flowers.

The Nabeshima artists often crowded blossoms onto abstract or leaf shapes. The Imari potters also made use of molded shapes, but never with as much success as the potters from the Nabeshima kiln. There are many factors to keep in mind when using or viewing Japanese ceramics. Probably most important are the intended use of the piece and the aesthetics of Japanese food. The placement and arrangement of food on a dish is treated as a fine art.

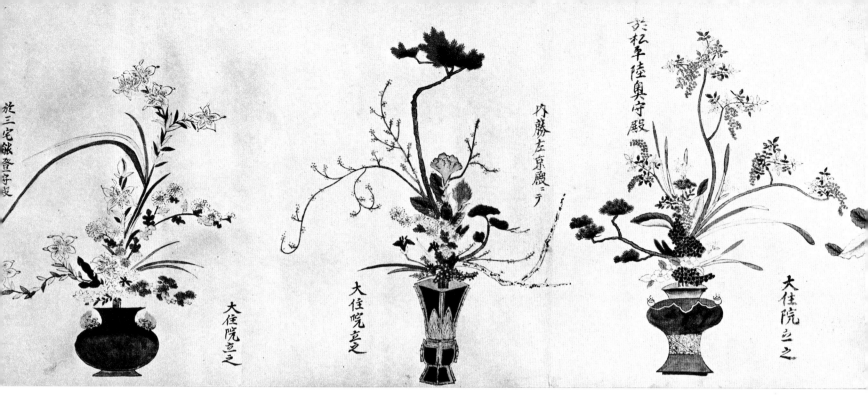

40. *Flower Arrangement Studies*. Artist unknown. Edo period. Handscroll, ink and color on paper, portions printed, 13 3/8" x 29'2" (34 x 889 cm). The Art Institute of Chicago. Frederick W. Gookin Collection

The art of *ikebana* (flower arrangement) is a prized talent in Japan, and can be traced back in history to the introduction of Buddhism. The great Prince Regent Shōtoku Taishi (572–621) sent a number of envoys to China to study Buddhism and the arts it had engendered. One of these emissaries happened to be his cousin Ono-no-Imoko, who manifested a great interest in flowers and gardens. It was from China that the concept of a garden with a pond or lake came to Japan. When Shōtoku Taishi died, Ono-no-Imoko is reported to have gone into seclusion in a small rustic hut beside one of these garden lakes. Here he prayed for the soul of Shōtoku Taishi, and the name given to his retreat was Ike-no-Bō (Hermitage by the Lake). This same name was given to the first school of flower arrangement in Japan. As Ono-no-Imoko came to be more and more interested in flower arrangement, he took

a new name, Senmu, and since that time the prefix Sen has been associated with the name of those continuing the *ikebana* tradition.

With the passage of time, the art of floral arrangement grew, and different styles and schools of specialists were established. The formal style was known as Rikka, whereas the freer style was called Nageire. The Japanese devotees through the centuries have developed *ikebana* into a manner of displaying both their love of nature and their talent for organizing its elements into refined displays.

Still-life representations of arranged flowers did not appear in Japan much prior to the Muromachi period (see No. 16). Such depictions did not become fully popular until the late seventeenth and the eighteenth centuries. The handscroll shown here is typical in many ways of these later works. On it are depicted some thirty-five different arrangements in the Rikka manner. The flowers are all placed in carefully drawn vessels of metal, ceramic, or other materials, and appear as though set out for display, with great attention being paid to the basic properties of the flowers in the arrangements.

During the Edo period, it had become a custom for *ikebana* buffs to copy, or have copied, favorite designs.

These samples were usually gathered into volumes or books so that the *ikebana* devotee could refer to them as he tried to recreate them, or reinterpret them into original designs. At times the floral paintings were done with simple ink outline with color to be added to them either shortly thereafter, or in the distant future. The popularity of the flower-arrangement craze was such that often the designs would be carved into wood blocks from which they could be printed in quantity, rebound into books, and disseminated to the masses.

Though basically typical, the Art Institute of Chicago handscroll is also atypical, since it combines both painting and printing. Portions of the scroll are quite clearly drawn with a brush, and all the color was applied in that manner. On the other hand, most of the calligraphy was done with wood blocks. It appears as though the inscriptions were stamped beside the arrangements. The unusual element is that, without rhyme or reason, portions of the floral assemblages also appear to have been done with wood blocks. It is very difficult to isolate these areas with surety. The branches and flowers are quite competently portrayed; the combinations are often creative, and the variety of designs is exciting.

Though two indications of dating can

be found on this scroll, it is impossible to document them without some question arising. One given date refers to the fiftieth anniversary of the mourning at the Tōshōgū at Nikko. One might assume that to be 1667, fifty years after Tokugawa Ieyasu was officially interred there. However, since construction of the mausoleum was not started until 1624, the date could be 1674, and as work was not completed until 1636, the fiftieth anniversary might be considered by some to be 1686. Carrying the confusion one step further, the shrine was not called Tōshōgū until 1644, so the date we seek may be 1694. The second reference date found in the inscriptions appears twice. It is a cyclical date (based on the traditional Japanese sixty-year calendar cycle) and could equate with 1654, 1714, or 1774. In reviewing these facts, I am led to conclude that the artist who produced this scroll relied on a number of sources, and thus we cannot accept the printed dating as the year in which the scroll was painted.

The artist applied his color with great skill, and the inscriptions in most instances make reference to a subtemple or shrine called Daijū-in, where the arrangements were displayed. The names of those who commissioned these scrolls (usually the nobility) are also given.

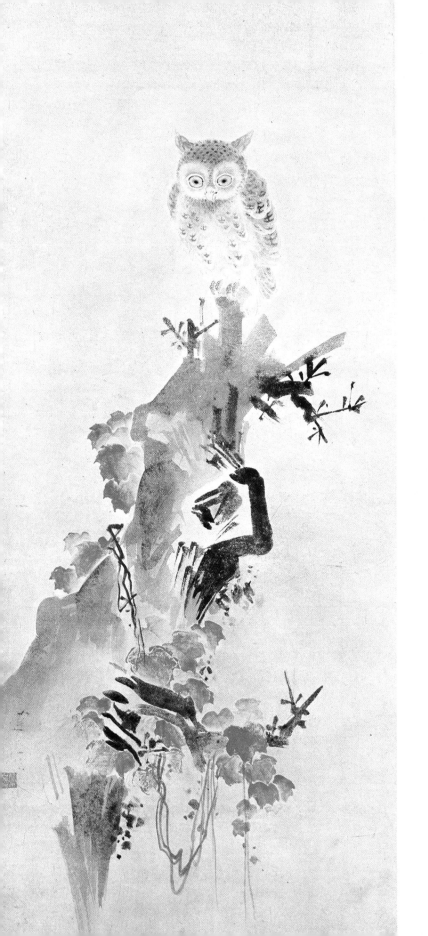

41. *Owl.* By Watanabe Shikō (1683–1755). Edo period. Kakemono, ink and slight color on paper, 71 1/4 x 16 7/8″ (181 x 43 cm). The Detroit Institute of Arts. Mary Martin Semmes Fund

There is a fine sense of spontaneity as well as naturalism in this sympathetic painting of an owl by Watanabe Shikō. Once again we find little biographical data recorded about the artist, but from his work we can readily ascertain that he was well versed in the Kanō school painting tradition. There is a close resemblance between his work and that of Kanō Naonobu (1607–1650). One can almost assume that he saw some of· Naonobu's work or was acquainted with his pupils. Shikō, as he matured, became a very close follower of Kōrin, and one can speculate that they had met. One of the obvious channels through which Shikō's interest in Kōrin in particular, and in the Rimpa school, may have been encouraged was the powerful Konoe family. Shikō served them as a retainer, and we know how freely Kōrin moved in, and was idolized by, those fashionable circles.

It is obvious in Shikō's work that he had a great love for nature. The owl shown here sits with eyes wide open atop the stumplike remains of an old tree. His broad shoulders and large head lead us to concentrate on his perceiving eyes. How different he is from the somewhat menacing *Hawk* by Nichokuan (see No. 31). The owl is depicted as a rather soft, downy creature in contrast to the old tree. To achieve this contrast, the tonality of ink used for the owl is softer and lighter than that applied for the tree. The trunk is indicated by an array of broad, slashing, Kanō-like strokes applied to create a sturdy perch for the bird. Winding about the tree's trunk is an ivy vine; its leaves show traces of Rimpa influence. Accents in dark ink on the trunk and leaves aid in creating a sense of depth.

The artist's seal found on this painting appears to read Shikō no in (Seal of Shikō). A painting by Sakai Hōitsu (1761–1828), which appears to be almost a rear view of this work, is in the Shinenkan Collection (see No. 66). Shikō's skill in the pure Rimpa tradition can be seen in the magnificent iris screens in the Cleveland Museum of Art and in the twofold flower screen in the Freer Gallery of Art.

DETAIL OF PLATE 41 ▶

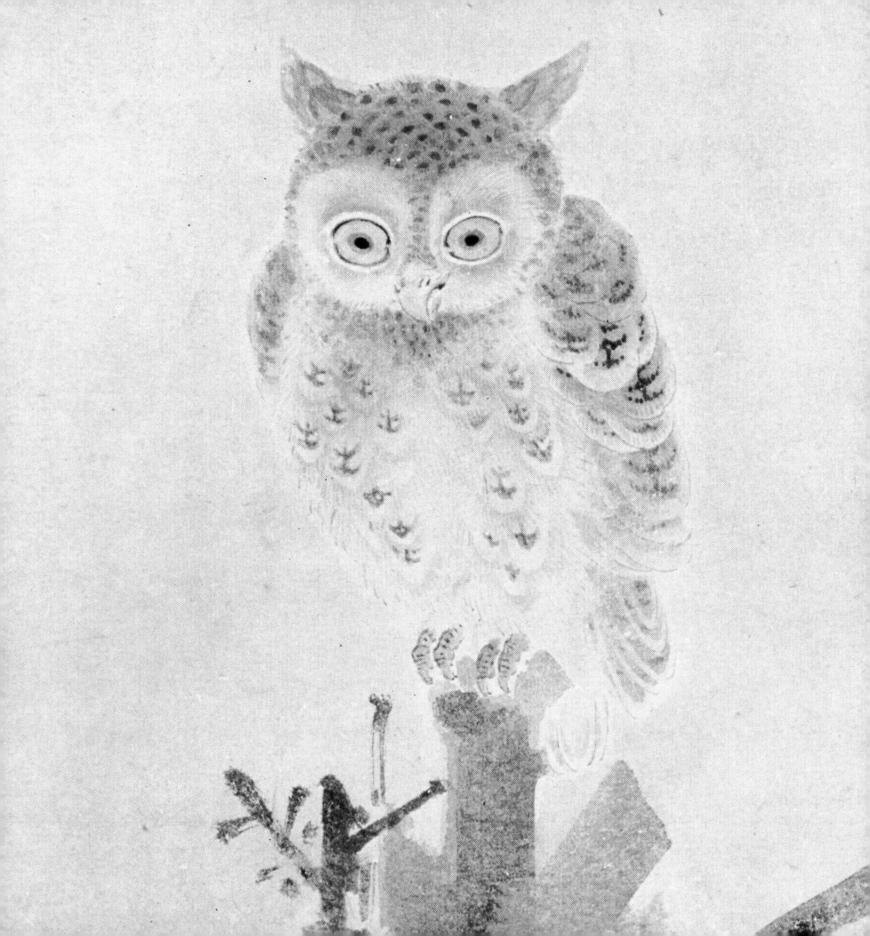

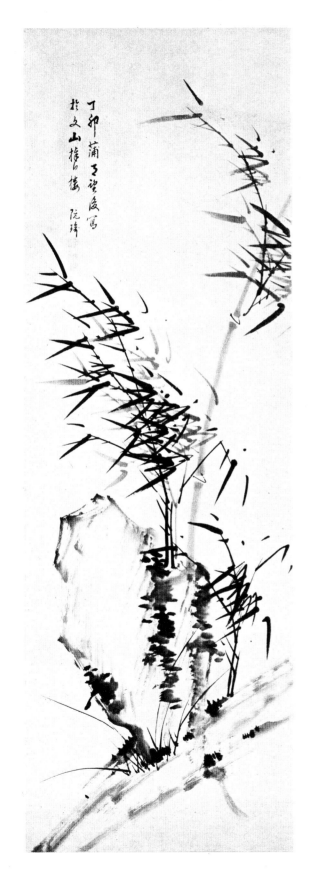

42. *Bamboo and Rock*. By Gion Nankai (1676–1751). Edo period, dated 1748. Kakemono, ink on paper, 74 x 20 7/8″ (188 x 53 cm). Shōka Collection

This distinctive painting of bamboo growing behind a rock is a typical work of Gion Nankai, who is generally considered to be the founder of the important Nanga, or Bunjinga, school of painting in Japanese art. Nanga literally means Southern painting, and Bunjinga means scholar literati painting. Specialists generally concede that they are one and the same, although there are those who seek to draw a fine distinction between the two. The source of inspiration was Chinese painting by the artists who are considered masters of the *wen-jen-hua* (scholar literati painting) style. The formalization of the *wen-jen-hua* style is an outgrowth of the Chinese Nan-tsung hua (Southern school painting) concept which had been originated and formulated by the Chinese artist and theorist Tung Ch'i-ch'ang (1555–1636). Paintings of this school are generally considered to be less formal, more individualistic, and more natural than that of the Northern school, which was steeped in academic tradition.

Nankai was born into a family of moderate means and social status. His father was a doctor who served the lord of Kii province, present-day Wakayama prefecture. Actually the daimyo of Kii was a descendant of the powerful Tokugawa clan; in 1619 his eighth son, Yorinobu, had been assigned the fief, and the family retained control until the Meiji restoration of 1868.

Nankai had been born in Edo, and as a young man studied Confucianism under the noted scholar Kinoshita Jun'an (1621–1698). Nankai soon distinguished himself as a writer. When his father died, Nankai, as the eldest son, assumed his privileges as a retainer of the daimyo. His success story was rather brief; in 1700 he was sent into exile to Nagahara for a period of ten years. The cause for this is unknown, but usually it is stated that it was for excessive indulgences and dissipation. Upon receiving

his pardon, in 1710, Nankai returned to Wakayama City; the following year he was reinstated as a Confucian teacher with a stipend, and he was placed in charge of the clan school in 1713. His painting style was much influenced by the *Pa-chung Hua-p'u (Eight Different Picture Albums)*, which was published in China in the 1620s, and the more noted *Chieh-tzu-yüan hua-chüan (Mustard Seed Garden Manual of Painting)*, sections of which appeared in 1679 and 1701. Nankai commented in a letter on his familiarity with this later work. Both sources for his response were in the form of woodblock prints, but it is believed that Nankai also had the opportunity to see Chinese paintings.

Nankai's paintings vary a great deal. The bamboo and rock shown here was a common enough theme. It had been utilized often by Muromachi period artists, although in the case of Gyokuen Bompō (1344–c. 1420), orchids were used instead of bamboo to form similar compositions. Bamboo paintings were very popular in the Yüan as well as the Ming dynasty of China, and Nankai's work resembles those. The brushwork is spontaneous, the strokes are decisive, and Nankai employs a relatively dry brush, which adds crispness to the bamboo. By using different values of ink, he creates a spatial play between the stalks. The rock is somewhat precariously placed on a hill that slopes sharply. In an eccentric manner, Nankai adds outline and depth to the rock by means of numerous small, informal, horizontal strokes. The bamboo leaves generally point to the left, as though driven by a brisk wind.

On the upper left of the painting, Nankai placed an inscription which informs us that the painting was done in 1748 on the fifteenth day of the fifth lunar month, when the artist was seventy-two years old. He also mentions that he painted it at the Tōhakurō in Bunzan. He signed the inscription with one of his names, Genyu, and beneath it placed two seals; the upper one has not been deciphered, whereas the lower one reads Nankai.

43. *A Bonseki (Tray Garden)*. By Hakuin Ekaku (1685-1768). Edo period, eighteenth century. Kakemono, ink on paper, 42 1/2 x 21 3/4″ (108 x 55.2 cm). Collection of Dr. and Mrs. Kurt A. Gitter, New Orleans, La.

A group of rocks spotted with moss and placed within a simple tray of sand is the subject of this painting. To the Japanese moss is a much loved plant, and gardens devoted to it, such as that of the Saihō-ji on the outskirts of Kyoto, dating from the Muromachi period, are indeed beautiful. The artists of this great land also had a penchant for arranging things in a tasteful manner; thus, miniature gardens of sand and stones placed in trays became a highly sophisticated form of aesthetic expression. These tray arrangements usually evoked thoughts of some favorite setting or literary theme, or just a pleasant memory. By their very nature they also related to simple Zen ideals.

Hakuin Ekaku, the creator of this painting, was steeped in the Zen tradition. He was born in the village of Hara, in Suruga province, which equates with present-day Shizuoka prefecture. The son of a samurai, he joined the priesthood when he was only fifteen years old. With much zeal Hakuin traveled throughout the country seeking enlightenment; once he felt he had achieved that, he sought to carry the message of Zen to the masses. His goal was to reach out and awaken the common people to the importance of this teaching. During the last fifty years of his life he maintained very close ties with the Shōin-ji at Hara, his birthplace.

Hakuin's skills are not manifested solely in his paintings; he was also talented in calligraphy, prose, and popular songs. He helped bring about a revival of Zen Buddhism in the Edo period, and was one of the most important painters of Zenga (Zen paintings). These were unspoiled by formality;

they were intentionally painted in a most relaxed manner and without subservience to tradition. As such, they appear amateurish, as well as naive; often they are entertaining and humorous. Apparently Hakuin and other Zenga masters realized that in the difficult Edo world people were attracted by an opportunity to relax. His paintings were meant to appeal to the masses as a means of instruction. To reach this goal, he often turned away from the formal vocabulary of brushstrokes and developed a free style in allowing his ink to puddle and bleed. These devices would also add interest and novelty to his work.

This *bonseki* painting is a case in point. It is done with a minimum of strokes with a very wet brush, and without great concern for outline. The suggestion of the tray, rock, and moss are there and that is what truly counts. At times the ink appears to have been sized with glue, which caused it to form

bubbles and patches. Hakuin's inscription on this painting may be freely translated as follows: "Does the priest come to the Ishiyama-dera?" The two forms of rocks depicted in the tray are said to be symbolic of the Ishiyama-dera. There is also a play on words, for the natural word for priest is *Bō*. Here Hakuin used the character for tray, read *Bon*. Thus the inscription would literally read, "Does the tray come to the Ishiyama-dera?"

Hakuin placed three of his seals on the painting. The one in the upper right corner reads Kokantei. On the left-hand side of the painting, the upper seal reads Hakuin no in (Seal of Hakuin), and the lower one appears to read Ekaku. The painting has been trimmed.

It may be of interest to note that two other versions of this painting exist in Japan: one is in the Kitaori Kiichirō collection in Kyoto, and the other is in the Nohara Saburō collection in Iida. Both carry the same inscription.

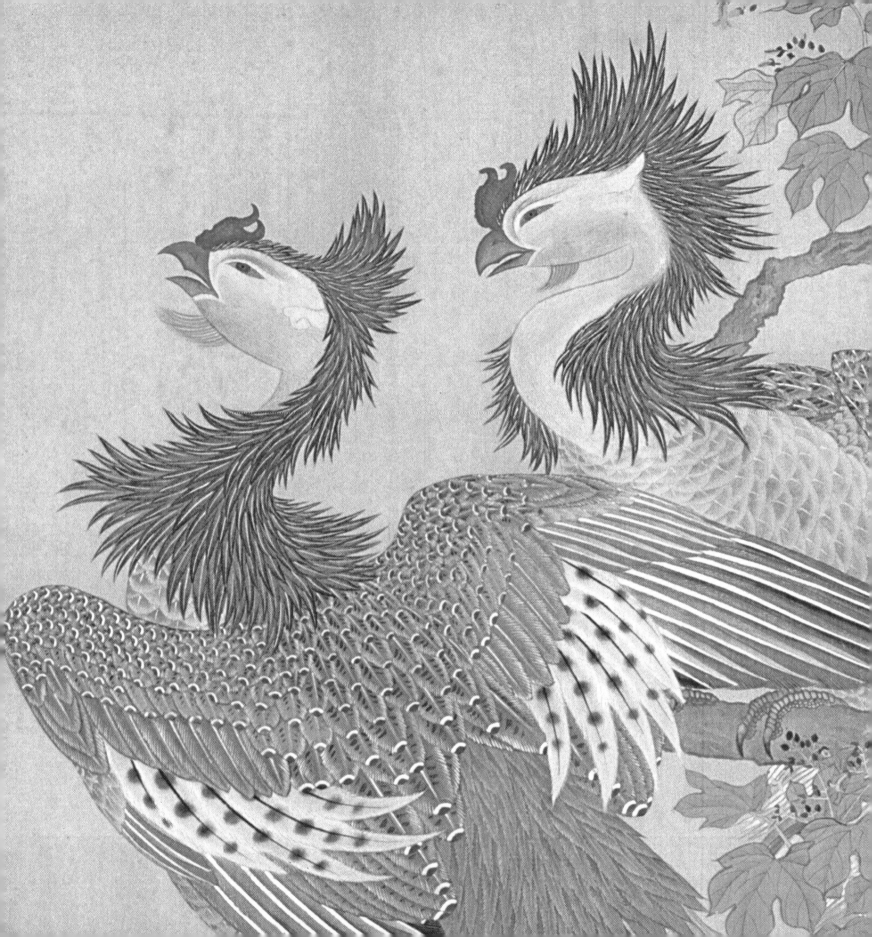

4. *Phoenixes*. By Maruyama Ōkyo (1733–1795). Edo period, dated 1783. Kakemono, ink, color, and gold on silk, 90 7/8 x 33″ (230.8 x 83.8 cm). Shinenkan Collection

Maruyama Ōkyo was the founder of a distinctive style of realistic painting based on the direct study of nature. The Maruyama style was named for him. Ōkyo was born in 1733 into the family of a farmer named Maruyama Kurazaemon, and they lived at Anao in Tamba province. The family was anything but affluent, and stories are related of their unsuccessful attempts to interest Ōkyo in farming. Ōkyo studied for the priesthood and also rejected that. Subsequently he was sent to Kyoto where he was apprenticed to a dry goods shop called the Iwakiya and later transferred to a shop owned by Nakajima Kambei, which specialized in producing dolls. The budding artist, in all likelihood, assisted in painting the dolls. Ōkyo's family moved to Kyoto in about 1750 and at that point the young man's serious art training began. He studied with a Kanō school painter called Ishida Yūtei (1721–1786), discovered other Kyoto artists, and made a study of popular Yüan and Ming dynasty styles of painting. He also became acquainted with the work of Ch'en Nan-p'in, a Chinese artist who had settled in Nagasaki about 1731. Ch'en Nan-p'in favored realistically executed bird and flower paintings done in bright colors, and Ōkyo's mature style is partially a development of this. Western influence was very strong in scholarly artistic circles in the eighteenth century, and its concern for realism and perspective also influenced Ōkyo. He undertook studies in which he copied Western works. As a result of these influences, Ōkyo determined that sketching directly from nature and realistic accuracy of the sketch were vital to his aesthetic style. Thus, Ōkyo produced great numbers of nature studies which were similar to those attributed to Satake Shozan (see No. 59).

The Maruyama style produced by Ōkyo had great popular appeal, for his clients were not the scholar literati. Those who purchased from Ōkyo desired beautiful, charming, and easily identifiable pictures. That is what he gave them.

In recent years, it has become popular to downgrade Ōkyo's impact on the art scene by claiming he lacked originality or sophistication. Such criticisms can be refuted when one studies his work. His wonderful *Pine Trees in the Snow* in the Mitsui Collection and his *Geese in Flight* in the Freer Gallery of Art are only two examples of his competence and originality. We must also consider the fact that he modestly accepted and helped train great numbers of pupils who swarmed to him. The list of his ten greatest disciples is imposing. It is interesting to note that included among his pupils are four artists represented in this volume: Rosetsu (see Nos. 60, 61, and 62), Genki (see No. 57), Tetsuzan (see No. 69), and Kirei (see No. 70). Also he took Goshun (see No. 45) into his studio as an equal rather than a pupil.

In 1790 Ōkyo was asked to paint a screen for the Imperial Household and was offered court status, but he refused the honor. His life was painting and he gave it all his energy. When he died in 1795, he was buried in Kyoto at the Goshin-ji in Shijō.

In the painting shown here, Ōkyo has portrayed two phoenixes seated in a paulownia tree. It is amusing that Ōkyo, who was the champion of realism in art, should have chosen this mythological bird for a theme. The phoenix is said to appear at times of peace and prosperity and thus symbolizes good fortune. This legendary phoenix is a composite of all that is beautiful in birds; its plumage of five colors is splendid and elegant. Displaying a painstaking concern for detail Ōkyo produced one of the most colorful and decorative representations of phoenixes I have ever seen. Pattern was all important, as can be seen in the juxtaposition of colors and the tessera-like squares that line the spine of the tail feathers. This treatment reminds me of Gustav Klimt (1862–1918), who used a similar device in many of his works in Western art over a century later.

The phoenix painting may well have been produced on special commission. It is dated early winter of 1782. Next to this, the artist placed his signature, read Ōkyo. He also placed two seals on the painting. The upper one reads Ōkyo no in (Seal of Ōkyo), and the lower one reads Chūsen, another of his names.

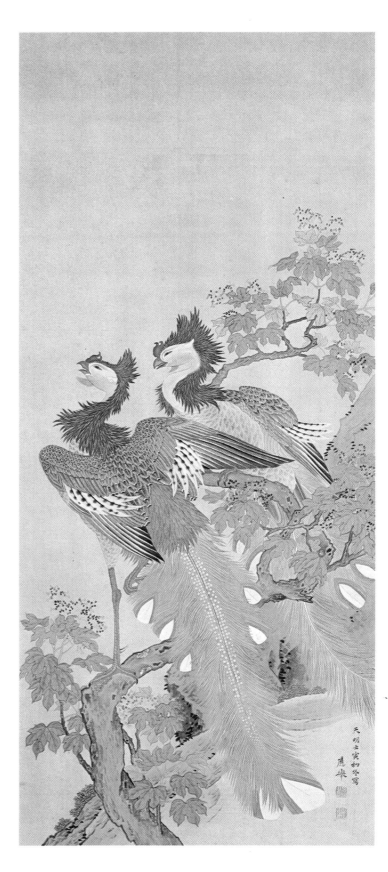

45. *A Triptych: Setsugekka (Snow, Moon and Flowers): Crow on a Snow-covered Rooftop.* By Yosa Buson (1716-1783). *Crow in Flight Before the Moon.* By Maruyama Ōkyo (1733-1795). *Crow on a Plum Branch.* By Matsumura Goshun (1752-1811). Edo period, dated 1768. Kakemono, ink and wash on paper, each 75 x 16 7/8″ (190.5 x 42.9 cm). Collection of Mr. and Mrs. James W. Alsdorf, Winnetka, Ill.

These three paintings are generally considered to form a triptych although I question that they were painted with that intention. The Ōkyo painting, the moon sequence, is dated 1768. If the others were done at the same time, it would mean Goshun was only sixteen. As his work here is mature and accomplished, I doubt that it was done at that young age. It is possible that the Goshun painting, the flower sequence, replaced a work by another artist which had become lost or destroyed. Some support for this theory is that the treatment of the crow theme by Goshun does not match the other two works. Usually the relationship in triptychs is quite close. A second explanation would be that the three paintings were assembled at a later date by an avid collector.

 The crow painting by Buson is entertaining. The bird appears gigantic as it perches on the ridgepole of a snow-covered thatched roof. The bird, formed of bold wet strokes, was consciously made too large for the structure. The crow appears to be cold and by representing it as somewhat squarish in form, the artist emphasizes its compactness as it huddles with wings down to keep warm. The crow has the alert characteristics of Buson's usual treatment of this theme, although it seems less miserable and nasty than his customary portrayal. The artist signed this work Buson and placed two seals on it. I have been unable to decipher the lower one from the available photographs; at times it appears to read Chikuden, which would be out of order.

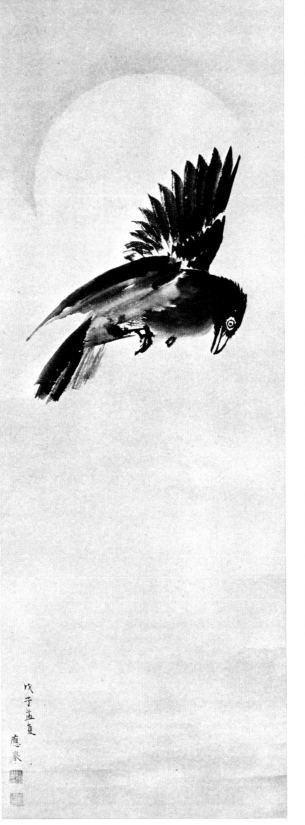

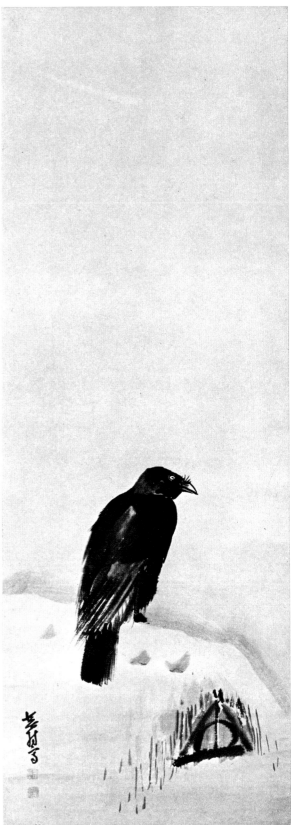

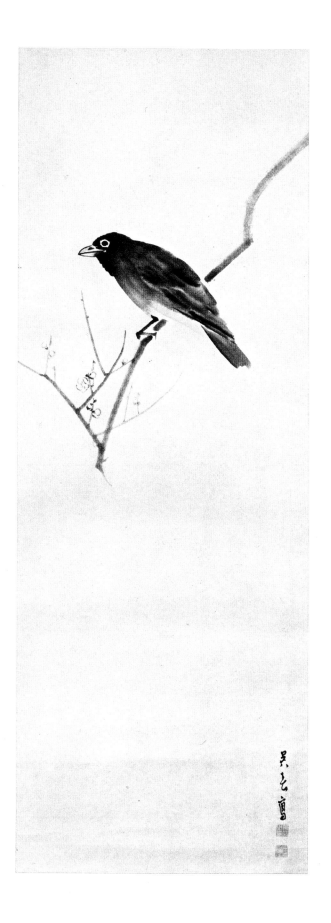

The upper seal reads Sanka Koji and is one Buson used between 1760 and 1782.

Yosa Buson is one of the major Nanga school painters. It is believed that he was born into a family of farmers and that in 1735 he moved to Edo. He studied *haiku* poetry there under Uchida Senzan (d. 1758) and also with the accomplished Hayano Hajin (1677-1742). Buson soon gained recognition and he was then attracted to his idol, the great poet Matsuo Bashō (1644-1694). During his stay in Edo, Buson also studied painting and obviously he came in contact with Kanō and Tosa school art. When his poetry master Hajin died in 1742, Buson took to wandering, but finally settled in Kyoto and then in the village of Yosa in the outskirts, from which comes his name. It is believed that many artists, including Sakaki Hyakusen (1697-1752), influenced Buson's development into a full-fledged Nanga artist. He also studied Chinese art, including works like the *Mustard Seed Garden Manual*. Buson was known for the Zen flavor in his work, and in 1771 he collaborated with Ikeno Taiga to produce the magnificent album, *Ten Pleasures and Ten Conveniences*. He was an able master, and when he died in 1783 he left behind him a great number of pupils, including Goshun, Baitei, and Kinkoku.

Maruyama Ōkyo painted the center or moon sequence of this triptych. His crow is shown in flight and it flaps one wing in odd fashion against the moon; the opposite wing is not outstretched. The crow's feet are contracted and its body curves like the moon. The head is lowered and it seems to have its eye on a tasty morsel below. Ōkyo's crow is painted with the same use of broad wet strokes, yet because he shows the outstretched wing and the underside of the crow, there is more textural development of the feathers. On the painting Ōkyo placed a cyclical date equating with 1768 in the summer at the time of Bon (the memorial Festival for the Dead). He signed the painting Ōkyo and placed on it the same two seals as seen in No. 44.

The final painting that forms this *setsugekka* triptych, the crow on a branch of flowering plum, is by Matsumura Goshun and is a milder work than the two other paintings. Goshun was born in 1752 into a very large family in Kyoto, and while still a youth he earned a reputation as an imbiber of sake and also as a scribe. To earn a living, he wrote letters for the courtesans in the Shimabara licensed quarter. Buson was Goshun's primary teacher of painting and also of the composition of *haiku* poetry. Later he studied with Ōkyo and then synthesized the Nanga literati style with the realism of the Maruyama school. The new style he formed came to be called the Shijō school. Like many artists of his time, Goshun painted for the Imperial Household and trained many pupils, including his brother Keibun (see No. 73). Goshun was a versatile artist and his paintings show his sensitive understanding of nature. He was also an accomplished poet and well versed in literature, music, and the life of his age. When he died in 1811 Japan lost a very competent artist. Goshun's remains were later removed from the Daitsū-ji and were placed beside those of Buson, the man he idolized.

In contrast to the other two, Goshun's crow is at rest in the plum tree. Actually in some ways the Buson and Goshun paintings frame the larger Ōkyo crow. Goshun's brushwork is softer and his washes and ink are not as intense as those used by the others. This imparts a feeling of peace. The bird's eye is a larger dark dot and this makes the crow appear less aggressive than the others. Using a minimum of line Goshun drew the plum branch to slope downward in two graceful curved stages. Springing out near the end of the branch is a shoot and from this sprouts blossoms. On the painting Goshun placed his signature, read "Painted by Goshun," and two seals. The upper one reads Goshun no in (Seal of Goshun). The bottom one appears to read Hakubō.

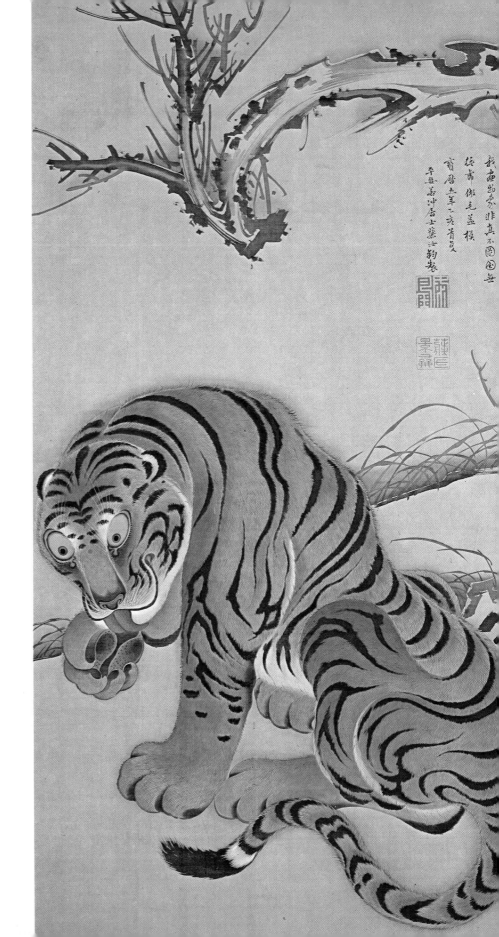

46. *Tiger*. By Itō Jakuchū (1716–1800). Edo period, dated 1755. Kakemono, ink and color on silk, 83 1/3 x 37 3/8" (211.5 x 95 cm). Shinenkan Collection

Itō Jakuchū was an artist who devoted the major portion of his long life to setting down on paper and silk the animals, water life, flowers, and insects of Japan.

Jakuchū was born on February 8, 1716, the eldest son of a greengrocer in Kyoto. He appears to have studied painting first with a Kanō school artist. Most of our knowledge of Jakuchū's training is found in the inscription on the stele at his grave, which was composed by a close friend, the monk Daiten (1719–1801). It tells us of Jakuchū's adventure in the study of Sung and Yüan dynasty Chinese paintings, and how they awoke in him an interest in painting directly from nature.

During his late thirties Jakuchū began to develop a distinctive style. He gathered barnyard fowl about him and spent his time studying and sketching them almost as though obsessed. Jakuchū's catholic observations of nature were almost scientific; however, he was a professional artist, and design and composition played a great role in his creative effort. He also displayed individualistic mannerisms which distinguish his work and at the same time relate it to Kōrin's work (see No. 27), which he admired. In his forties he painted and produced the noted thirty-scroll set titled *Colorful Realm of Living Beings*. This he gave to the Shōkaku-ji, but in 1889 it was given by the temple to the Imperial Household, where it is treasured.

Following the spurt of activity in his forties, Jakuchū's production appears to have slowed, though we find that in his fifties and sixties he did naive-like, folk-art designs for many Buddhist reliefs, which were incised by artisans onto stones at the Sekihō-ji at Fukakusa, in Kyoto. Unfortunately, tragedy struck Kyoto in 1778 when a large portion of the city was leveled by flame. Jakuchū's home and business went up in smoke, and as a result he returned to painting, but this time with the avowed purpose of supporting himself. Thus, late in his life he became a competitive artist. His vigor had not diminished, and though he worked in Osaka for a short time, he returned to Kyoto where he continued

to paint almost up to his death, on September 8, 1800.

We are fortunate that a number of superb examples of Jakuchū's work survive. An early example is this humorous tiger dated 1755. It is a bold and entertaining painting. The tiger almost fills the silk as, preening, he licks his paw. The animal is well rounded when compared with the tree in the background. Jakuchū was clearly fascinated by the tiger, yet we know he had never seen one. On the painting he placed an inscription translated by Dr. Yoshiaki Shimizu, who catalogued this painting upon its exhibition at the Nelson Gallery–Atkins Museum of Kansas City, Mo. His translation is as follows: "I paint only what is real and true. The ferocious tiger does not exist in this country. [Thus] I have emulated the work of Mao I. Done in the fourth month of the fifth year of Hōreki (1755)." He signed the painting "Made by Tō Jokin, the hermit Jakuchū of Heian (Kyoto)." It also carries two of his seals; the upper one may be read Jokin and the lower one Tōshi Keiwa.

Careful examination of Jakuchū's tiger establishes the artist's patience and meticulous care. The individual hairs of the tiger's pelt form a network of crosshatching which one can but admire. I can only speculate on how interesting it would have been had Jakuchū had the opportunity to see and observe a live tiger.

47. *Rooster and Hen Before Hydrangeas.* By Itō Jakuchū (1716–1800). Edo period, eighteenth century. Kakemono, ink and color on silk, 88 3/4 x 44 1/2" (225.3 x 113 cm). Shinenkan Collection

In all likelihood, this painting was done early in Jakuchū's career as an artist. Somewhat later than the *Tiger* (No. 46), however, it dates approximately from 1759, when Jakuchū was already embarked on the *Colorful Realm of Living Beings* series. In fact, a painting from the set, now in the Imperial Household Collection, and the Shinenkan Collection painting shown here are compositionally very close. In this painting Jakuchū placed two of the barnyard fowl on which he lavished so much attention. He was obviously fascinated by them and studied their appearance and actions almost with the vigor of a professional taxonomist.

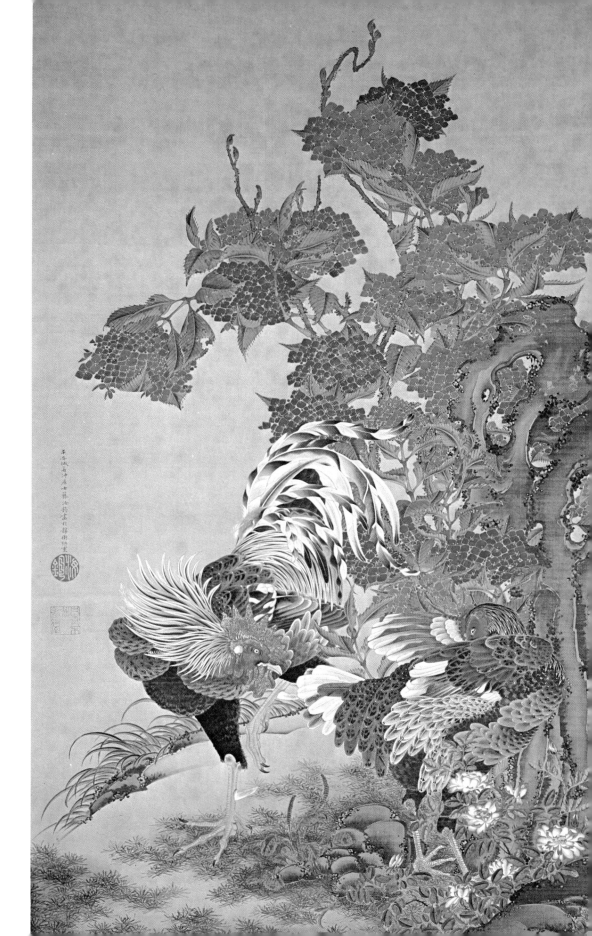

Classical postures are shown as the rooster, with long black-and-white tail feathers, raises a leg and turns to stare at the hen, who coyly turns her head to observe him, raises her wings slightly, and shows moderate interest in her suitor. The rooster's spurs are sharp and project outward, while the long feathers at the back of his head are raised and curl upward in anticipation.

A fascinating feature of Jakuchū's birds is that though basically anatomically correct, he was too much of a pure artist to produce what today we term magic realism. Jakuchū wanted his fowl to be authentic, but he was equally interested in design and pattern. Thus an important part of his talent was the arrangement of the rooster and hen, and the organization of their feathers into groupings which heighten the design. In life the feathers on the rooster's breast would not form such a series of rounded clusters. To Jakuchū they helped accent the diagonal formed by the neck feathers and the sense of movement toward the hen. The two fowl stand on a fernlike carpet of ground cover, while weeds sprout forth from a small cluster of rocks. A handsome rose plant flowers in the lower right of the painting. Running along the right edge are rocks that have clearly found their way out of a Chinese painting. The holes found in the rocks apparently intrigued Jakuchū and aided in his buildup of the pattern. A large blue hydrangea plant wraps around a rock, and its blossoms and leaves can be seen through the holes. The hydrangea, like the rooster and hen, appears to be very true to nature yet when one observes it with care, Jakuchū's stylization and interpretation of nature can be seen. The petals are separated from one another to form an intricate pattern rather than mimic reality. Even the placement of his seals and inscription on this painting aid in heightening the feeling of confrontation and action. The blue and green of the hydrangea, and the white, black, and brown of the feathers lead us to the intense red of the fowls' combs and of the seals. These hot spots of color stand forth on the same general plane.

On the left edge of the painting Jakuchū signed it as follows: "Painted in the humble room on Nishiki Street by Tō Jokin, the hermit Jakuchū of Heian (Kyoto)." The round upper seal reads Jokin while the square lower seal reads Tansei Fuchi Rōshō Shi.

48. *Mandarin Ducks and Snow-covered Reeds*. By Itō Jakuchū (1716–1800). Edo period, eighteenth century. Kakemono, ink and color on silk, 81 1/4 x 28 1/4" (206.3 x 71.5 cm). Shinenkan Collection

There is lyricism to be found in the work of Jakuchū. The cold of winter is very evident in this painting of a mandarin drake and his mate swimming in a frosty pond; the snow-laden reeds set the time. Winter has stolen the summery green from the reeds and dried them until they are tan. Jakuchū adds a glimmer of hope, for spotted here and there along the stalks are faint suggestions of the green that will return to the plants when sunlight and warmth come back.

The sense of chill is somewhat tempered by the mandarin ducks. They are symbolic of conjugal happiness, and their presence, especially the color of the drake's plumage, adds warmth to the scene. The male floats placidly on the water, apparently unruffled by the female, who twists in the water to paddle toward him. In this painting Jakuchū once again displays his keen observation of natural phenomenon. The transparency of the water is shown, and the head and one foot of the duck and one foot of the drake are seen through the water.

In this work Jakuchū exhibits his talent for design, and one can detect lessons learned from a study of Kōrin and the decorative Rimpa tradition. Jakuchū balances the angular reeds shown along the side and at the top and bottom of the composition with the oval-like form of the ducks and the movement of the water, and the female's paddling echoes this shape. The reeds in this painting are similar to those in the *White Fronted Goose and Reeds* in the *Colorful Realm of Living Beings* series of kakemono, and the mandarin ducks resemble those in the *Mandarin Ducks in the Snow* from the same series.

On this painting, which was probably executed during his early forties, Jakuchū placed the same inscription with his signature and seals as found on No. 46. It reads: "Painted in the humble room on Nishiki Street by Tō Jokin, the hermit Jakuchū of Heian (Kyoto)." The seals read Jokin and Tansei Fuchi Rōshō Shi. The snows have fallen and the mandarin ducks remain united. Jakuchū has triumphed once again.

49. *Eagle in the Snow*. By Itō Jakuchū (1716–1800). Edo period, eighteenth century. Kakemono, ink on paper, 81 3/8 x 24 5/8" (206.6 x 62.5 cm). Shinenkan Collection

This eagle, another painting by Jakuchū, was done in his eighty-fourth year near the end of his life. It is a startling painting, for it is so very strong in terms of both composition and brushwork. Although Jakuchū is by now an old man, his control of line remains sure and firm. The eagle clings to a snow-covered rock which slopes rather precipitously and overhangs the sea. The sea churns away as the water breaks against the rock and curls inward, forming the stylized convention for waves later borrowed from Japan by the Western Art Nouveau movement. Jakuchū used slashing brushstrokes of intense ink to outline the lower edges of the rock. These make the snow seem even whiter and colder; it is a bleak scene. The eagle, which appears to be of the type called crested serpent eagle, cuts the composition in two. Its head is lowered and its alert eye peers out as it waits for any movement. The eagle's right foot is raised to its wing, while the left one is stretched out with spread talons gripping the snow.

Jakuchū once again displays his talent at observing and capturing nature. One is reminded of the Nichokuan *Hawk* (see No. 31), although Jakuchū's eagle is less menacing. The lack of color heightens the somber setting. It is cold and windy, and to accentuate this feeling, Jakuchū brushed ink into the background silk, making the sky dark and gloomy.

One might interpret the eagle painting as Jakuchū's vision of himself. He was now an old man faced with the hardships of illness. Like the snow, his hair had turned white. Though the challenges were many, he was alert. He fought to continue to paint and to devote his energy to art. It was at this point in his life that Jakuchū returned to accepting but one *to* (approximately four gallons) of rice as payment for his paintings. Thus he signed this work, "A Painting by Beitoō (The Old Man of One *To* of Rice) aged eighty-five." He also placed on it two seals. The upper one reads Tō Jokin in (Seal of Tō Jokin), and the lower round one reads Jakuchū Koji (Retired Jakuchū).

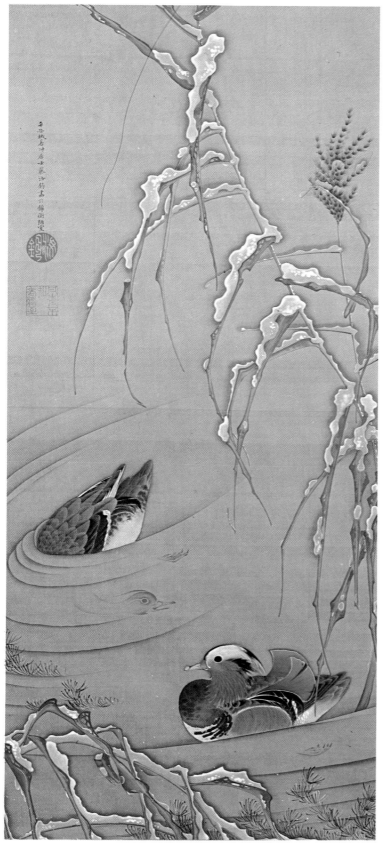

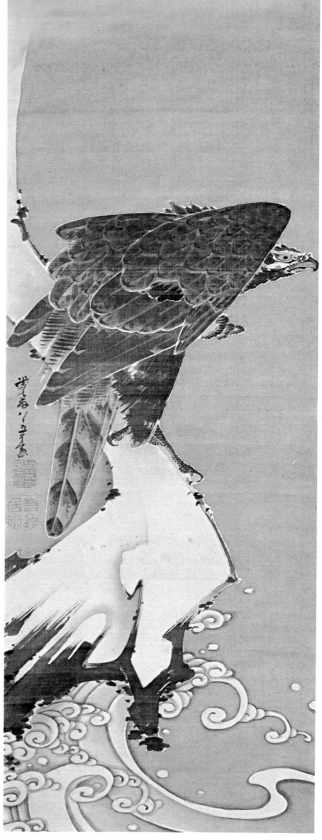

48

49

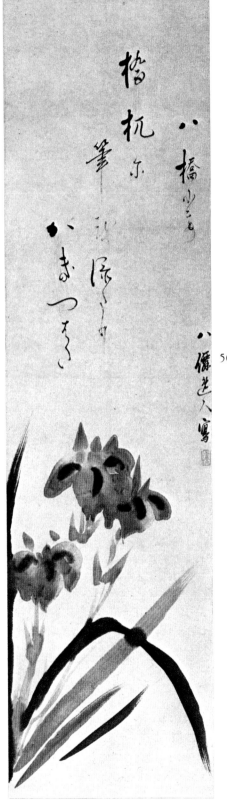

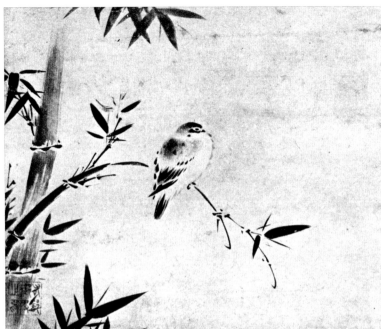

50. *Iris.* By Sakaki Hyakusen (1697-1752). Edo period, eighteenth century. Kake mono, ink on paper, 70 3/8 x 11 5/8″ (178.8 x 29.5 cm). The University of Michigan Museum of Art. Margaret Watson Parker Art Collection

In this painting we are introduced to *haiga*, another variety of Japanese pictorial depiction. These were rather hastily and/or spontaneously executed sketches done to accompany *haiku*, seventeen-syllable poems. Actually, it is likely that the paintings were done first and then the poems were written to occupy the remaining space.

An iris is the subject of the painting shown here. The blades of its leaves and its blossoms enter the composition from the lower left. The brushstrokes that compose these elements were very hastily applied, and a fair amount of water accompanied the ink. Thus, the *tarashikomi* technique is evident in areas where the buds are formed, and also on the flowers. The petals are very full, and the transparency of the wetly applied ink prevents the flowers from appearing flat. In this painting we are also made aware of the degree of spontaneity characterizing *haiga*. Normally, Japanese artists are meticulous, but here the artist did not wait for the lighter ink to dry before he brushed on the dark iris leaf. This lack of concern was

quite characteristic of *haiga* painters.

Sakaki Hyakusen, the artist who painted this picture, was one of the early Nanga masters, as well as a pioneer in *haiga*. His father was a successful pharmacist in Nagoya. We know little about Hyakusen's early life except that it is believed he studied with a Kanō school master, and had professional academic instruction. In this sense he differs from Nankai and Hakuin (see Nos. 42 and 43), who represented more truly the *bunjin* (scholar literati). Hyakusen painted as a vocation, and he undertook large commissions such as screens and panels. The first of his dated works to survive is from 1720, and we know that at that time he was pursuing a mastery of *haiku* poetry. In 1728, Hyakusen traveled to Kyoto where he painted many fine works and displayed his ability not only in *haiga* but also in *nanga*.

On the iris painting he placed a signature, read Hassen Itsujin, and his seal, read Hōkkyō. He also wrote on this *haiga* a *haiku* which he titled ''At Yatsuhashi.'' The poem may be translated as:

> ''On the bridge posts,
> I laid down my brush,
> the iris.''

Overwhelmed by the iris at this scenic spot, Hyakusen paused, and then returned to paint.

51. *Sparrow on a Bamboo Branch.* By Ikeno Gyokuran (1728-1784). Edo period, eighteenth century. Kakemono ink on paper, 46 x 19 1/8″ (116.8 x 48.6 cm). The University of Michigan Museum of Art. Margaret Watson Parker Art Collection

One of the greatest masters of the Nanga school was Ikeno Taiga (1723-1776). Taiga had married a girl from Kyoto called Machi, who later became known as Gyokuran. Her father, Tokuyama, had been a samurai, and her mother, Yuriko, was a talented *haiku* poetess. Gyokuran proved to be a good and loyal wife. She had talent as a poet and turned her efforts toward complement her husband's skill. While still in her twenties, she studied painting with him and also with another of the early Nanga pioneers, Yanagisawa Kien (1706-1758).

Gyokuran and her husband must have been a fairly unusual couple, for they were included in the *Kinsei Kijin Den (Lives of Eccentrics of Modern Times)*, which was published in 1790 in Kyoto, and illustrated by Mikuma Katen. The Iken family is shown playing musical instruments in a cluttered room.

This painting of a plump sparrow seated on a branch of a bamboo plant typical of her work. The painting has spontaneity; the bamboo displays a good degree of virtuosity, and the sparrow is also drawn with skill. Its breast is defined by a series of dots or tiny brushstrokes. This was a device employed both by Muromachi ink painters and by artists of the Kanō school. Thus we can see that academic techniques had influenced the Nanga style. The thin bamboo bends under the weight of the bird. The sparrow's head is sunk into its breast feathers, and one senses that it is about to nap. In this work Gyokuran drew her brush back the end of the stroke to indicate the thinnest bamboo sprigs. By this device hooklike stroke is formed, which in a delicate and subtle manner makes one concentrate on the sparrow.

In the lower-left corner of the paint ing there is a seal. It is not one of the typical seals used by Gyokuran, and it true role vis-à-vis the painting is not a yet established.

52. *Plum Tree in Moonlight*. By Tani Buncho (1763–1840). Edo period, late eighteenth – early nineteenth centuries. Kakemono, ink on paper, 86 x 36 1/4" (218.4 x 92.1 cm). Private collection

An old, weathered plum tree at the height of blossoming is the subject of this spirited ink painting by an artist who is considered by many to be one of the three great masters of the Tokugawa period. The two other artists singled out for this praise were Kanō Tanyū (1602–1674) and Maruyama Ōkyō (1733–1795) (see Nos. 44 and 45). The tree fills almost the entire space as the broad trunk twists in from the left and moves diagonally to the right until about a third of the way up. At this point it alters direction and turns back toward the left side of the composition. As is so often the case, the tree has either rotted or suffered some other natural or unnatural catastrophe, and the primary branch terminates. A secondary branch almost parallels the trunk; it is flourishing and is the source of the many blossoms. Sucker shoots also come forth from the old trunk, and they rise with a gentle curve, almost hesitatingly, as they search for light and air. Bunchō's construction of the tree is well disciplined, but it is by no means academic. He uses a very free, spontaneous, almost eccentric mixture of a vast variety of brush techniques. The old trunk is shaped by a series of blobs of ink that link together, giving the impression of *tarashikomi*, and creating the illusion of the soft, deteriorated bark of the trunk. The white paper areas remaining between the two edges of the trunk's outline serve as spatial indicators. The flowering branch growing from the trunk was painted with lighter ink, though here and there dark ink was applied as accents. The plum blossoms were all outlined by a few brushstrokes, and Bunchō quite successfully kept them in reserve white, the natural tonality of the paper, against the night sky. The young sucker shoots were formed by Bunchō with what we might term as pulsating, or "on again, off again," brush-strokes. He loaded his brush heavily with ink, lifted it almost away from the paper, leaving only the edges, then reapplied it rhythmically in a heavy manner to form the shoots. As a back-ground for the tree, Bunchō created a moonlit sky. To accomplish this he applied light ink with a very wet brush, making the areas run together to create the impression of a night sky. In keeping with the energetic spirit of the painting, he left uneven areas of the background in reserve. They appear as patches of moonlight on clouds floating in the sky.

Bunchō was a master of many styles. More than most artists of the period, he had an opportunity to be fully exposed to the full range of the aesthetics of the Tokugawa era. In this work it is clear that he was influenced by scholar literati Chinese paintings which the Japanese were to reinterpret as Nanga. The painting also reveals a decorative quality and the *tarashikomi*-like effect manifests Bunchō's understanding of the Rimpa tradition, which in turn was steeped in Yamato-e. Most of all, in this work Bunchō reveals his versatility and an independence of spirit. Much like Jakuchū (see Nos. 46, 47, 48, 49), Shōhaku (see No. 58), and Hakuin (see No. 43), Bunchō was master of his brush, and it performed as he desired.

Tani Bunchō was born into the Ōtomo family, with roots in Ōmi province. His background was one of comparative security and wealth, for his father was in the service of the trusted Tayasu daimyo. While still a young man, only twenty-six, Bunchō followed in his father's footsteps and was employed by the Tayasu branch of the Tokugawa on a trial basis. In 1792, when only thirty, he became a full retainer.

A complete biography of Bunchō's life is recounted in that most valuable book by Charles H. Mitchell, assisted by Osamu Ueda, titled *The Illustrated Books of the Nanga, Maruyama, Shijo and Other Related Schools of Japan: A Biobibliography* (Los Angeles: Dawson's Book Shop, 1972). This biography gathers and summarizes much that can be gleaned from Japanese sources as well as Bunchō's own comments on his career. The impression one gets is that Bunchō was a brilliant, talented, witty, and accommodating man. He is listed as having studied with Kato Bunrei, Kitayama Kangen, Watanabe Gentai, Suzuki Fuyo, and Kushiro Unsen. He was also acquainted with the Chinese Che school and scholar literati paintings, as well as with works by earlier

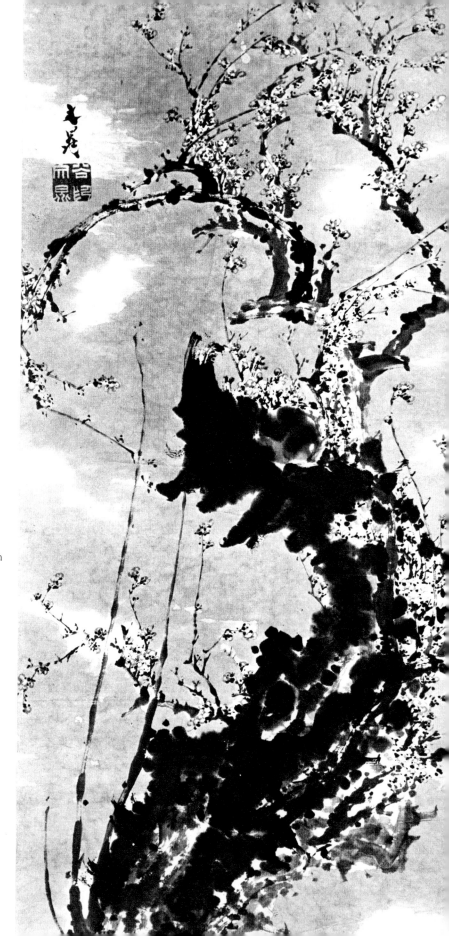

Sung dynasty masters. To round this off, he studied traditional Japanese painting styles such as the Yamato-e, Kanō, Tosa, Rimpa, the newly emerging Nanga, and the even later Maruyama manner. He had a catholic interest in painting and a devotion to it. Although he is recorded as having partaken of the usual carousing and pleasures of his age, the Yoshiwara and sake, his approach was one of moderation, and followed the same tenets as our Anglo-American folk saying "Early to bed, early to rise, makes a man healthy, wealthy, and wise." Bunchō appears to have been all of these.

He is reported to have assisted artists such as Katsushika Hokusai (1760–1849) and his entire family—wife, children, sisters, brothers, son-in-law, and grandchildren—and approximately two thousand other people are listed as his students. He is said to have set up a regular curriculum of painting lessons on established days of the month, with approximately three hundred students attending these sessions. It is difficult to imagine anything on this scale even in terms of today's *ikebana* schools in Japan. I can only imagine how pleased Bunchō would have been with educa-

tional television had it existed then. It would have made it possible for him to reach and assist even more students.

The tremendous popularity that surrounded Bunchō made him a very wealthy man, and he enjoyed the comforts of life. He even displayed vanity; it is said that his sake was a special brand named for him. One wonders whether or not he may have sold the advertising rights. The total picture of Bunchō is that of a most active and fascinating human being. His association with Shirakawa Rakuo (1758–1829), the seventh son of Tokugawa Munetake, made his successful career possible. Rakuo later changed his name to Matsudaira Sadanobu, and served as chief minister of state to the shogun Tokugawa Ienari (1773–1841).

The plum tree on a moonlit night is but one flowering from Bunchō's brush. It carries his signature, read Bunchō, and his seal, read Tani Bunchō no in (Seal of Tani Bunchō). He left behind him a great number of paintings that would defy placement if unsigned and if the viewer were unaware of the artist's versatility. Bunchō greatly enriched the enjoyment and practice of art in Japan.

53. *Tiger*. By Katayama Yōkoku (1762–1803). Edo period, late eighteenth century. Kakemono, ink, color, and gold on paper, 74 3/4 x 22 5/8" (189.8 x 57.4 cm). Shinenkan Collection

An incredible beast is this tiger by Katayama Yōkoku. He is often termed an angry tiger, and perhaps that is so, for his head is turned alertly and his mouth is open, baring his very sharp teeth. A ruffled coat and bristling whiskers and eyebrows add to his wrathful appearance. At the same time, showing his very broad snout, the tiger seems to be rather foolish; one senses that he is moving cautiously or just sneaking about. Actually, the tiger might be compared to a kabuki actor making his appearance on the stage in the dramatic *Shibaraku* sequence. It's like a pop art impression "Pow! Zam! Grrr!! I'm here!"

This painting was produced by an artist of whom little is known. Yōkoku was born in Nagasaki in 1762 and his forebears are believed to have been doctors. His father is said to have been Chinese, whereas his mother was

Japanese. In 1792, his father died, and when his mother died shortly thereafter, he traveled about and ended up in Tottori at the home of Nakayama Tōsen. His paintings came to the attention of the Lord of Inabo, who assigned him to the home of a tea master, Katayama Sōhi. His proficiency in painting developed and he traveled extensively, going to Edo and Kyoto, where one of his paintings was shown to the emperor. As a result, Yōkoku was honored and given court rank. He was noted for his skill at bird and flower paintings. Unfortunately, he died while still young, at the age of forty-two.

Yōkoku's treatment of this tiger is markedly different from the other tiger paintings discussed in this volume (see Nos. 35, 57, 61, and 70). This tiger totally dominates and fills the composition. Actually, if all of him were shown, he could not fit into the space. But he is distinctive and has great character; even his curving tail adds movement. Yōkoku signed this work Tōyō Yōkoku and placed on it two seals. The upper one reads Dōkan while the lower one reads Yōkoku.

DETAIL OF PLATE 53 ▶

54. *Rabbits and Crows in the Night Snow.*
By Dagyoku Sanjin (Hidehara) (1733–
1778). Edo period, dated 1775. Pair of
sixfold screens, ink and white pigment
on paper, each 67 3/8″ x 12′ 2 1/4″
(171 x 371.4 cm). Shinenkan Collection

This is an unusual and probably unique
painting in Japanese art. I do not know
of another that quite matches it, for it
was produced by utilizing techniques
that certainly were uncommon for the
Edo period. A curious note is that its
artist, although recorded in the bio-
graphical registers of artists, is
otherwise virtually unknown. All we
have are four names, Dagyoku Sanjin,
Hidehara, Komyō, and Kazuragi, and
the statement that he was from Osaka.
I have never seen another work by his

hand, and this painting of rabbits and
crows in a night snowfall may be the
only complete existing document
relating to him.

The daring composition is somewhat
reminiscent of Bunchō's treatment of
the snowy sky (see No. 52). Dagyoku
Sanjin has painted the sky a dark gray;
in fact it appears almost black. He used
long horizontal strokes made with a
broad brush to attain an evenness of the
night sky, which thereby takes on a
velvety appearance. Very cleverly and
carefully he held the areas for his design
in reserve. Thus they remain paper-
white and stand in sharp contrast to the
dark sky. On the right-hand screen, in
the reserved area, he constructed the
trunks of three sturdy pine trees. Their
branches dip into the painting at the
top. To identify these as pines, Dagyoku
Sanjin indicated with ink the charac-
teristic pine bark and the brushlike
needles covering the ends of the

branches. With great skill, alternating
from reserved to inked areas, he por-
trayed a vine which tangles in the trees.
There was little margin for error, and
one wonders how this relative unknown
was able to achieve these effects. The
startling feature of the composition of
the right-hand screen is the delineation
of the rabbits. Composed of reserved
areas, they were merely outlined and
their features added. One races along
on the ground while, to our amaze-
ment, the second rabbit has climbed
halfway up into a tree and looks back at
the one chasing it. I must admit that I
have never observed or heard of a tree-
climbing rabbit, and I find Dagyoku
Sanjin's representation a wonderful
flight into fancy. The reserved areas of
the white paper are thus used to create
the snow that clings to the tree trunks,
pine needles, and vines, as well as to the
furry white rabbits. In the upper left of
this screen the artist has placed the

110

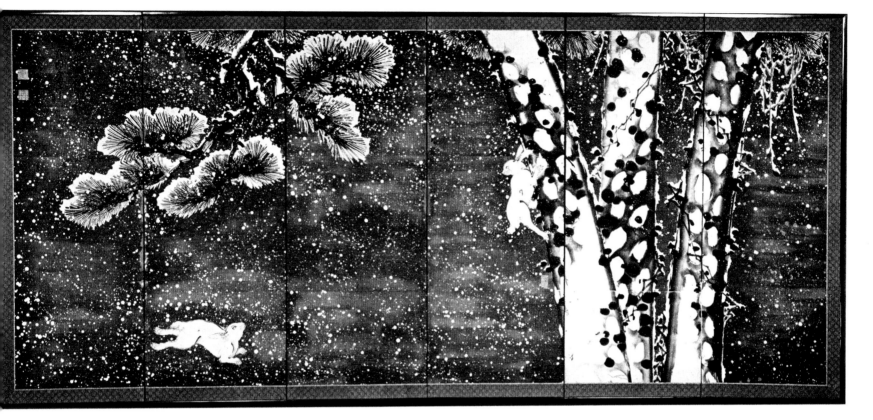

cyclical date, which equates with 1775, the fourth year of An'ei. He also placed three seals on the painting. Dagyoku Sanjin must have been rather proud of his name, for the regular red seal would not have shown up well against the sky. Therefore, he stamped them onto white paper, cut them out, and pasted them onto the screen. They have not been deciphered, although the name Hidehara, which he used, appears in the upper square seal along with characters that may form Komyō, another of his names. A peculiar feature is the placement of the third seal, which he affixed alongside the trunk of a pine on the third panel from the right. Over the entire surface he spattered white pigment quite thickly to indicate the heavily falling snow.

An old plum tree already in blossom and two crows are the subjects of the left-hand screen. The tree trunk, in one of Dagyoku Sanjin's few adherences to

convention, occupies the left of the composition. The same velvety night sky provides the background for the tree, and much as he handled the pines, the plum tree and its blossoms are left in reserve. Dagyoku Sanjin outlined the trunk and branches with broad, sure strokes of dark ink, and the petals of the blossoms with fine oval strokes. The white of the paper becomes the wet snow clinging to the tree. He painted a mischievous-looking crow perched on a limb, which gazes slightly downward at the other crow which, with beak open, flies near the tree, obviously trying to catch the first bird's attention. The two crows were also painted in reserved areas and were done with great skill. Dagyoku Sanjin indicated the many kinds of feathers and, although the painting is stylized, one senses reality. This work probably reflects the growing trend to observe and paint directly from nature. We have already seen it in

Jakuchū (see Nos. 46, 47, 48, and 49). We also know that Bunchō (see No. 52), Ōkyo (see Nos. 44 and 45), and Mori Sosen (see Nos. 55 and 56) had a keen interest in it. The night sky of the left-hand screen, like its mate, is speckled with heavy white snow which has been spattered. The illusion it creates as it almost weightlessly floats to earth is wonderful.

The left-hand screen bears the same seals, including their unusual presentation and placement, as found on its mate. The painting carries an inscription that again dates it to the fourth year of An'ei, 1775, and calls it a snow scene. This screen is signed Dagyoku Sanjin Hidehara, whereas the right one is signed Dagyoku Hidehara. It is tragic that we know so little about this artist; one keeps hoping to discover other works from his hand. Unquestionably, he had great talent and was a creative genius.

55. *Monkey and Grasshopper*. By Mori Sosen (1747–1821). Edo period, late eighteenth–early nineteenth centuries. Kakemono, ink and color on silk, 70 1/4 x 20 3/8″ (178.3 x 51.7 cm). Shinenkan Collection

Sosen was born in 1747 and died in 1821. There are many tales told about him, but the basic facts of his biography may be summed up as follows: His family name was Mori and his personal name was Shushō. He also used the name Oga as well as the *gō* (pseudonym) of Sosen, Jokansai, Reimyoan, and Reibyōan. Sosen, as he is commonly referred to, was born in Nagasaki, but lived most of his life in Naniwa which is the present-day Osaka. It is reported that, together with his brothers, he studied painting of the Kanō school. His Kanō school teacher was Yamamoto Jushunsai. Sosen, however, was not satisfied with working in the Kanō style, and he combined it with realism similar to that found in the works of the Maruyama and Shijō schools. He specialized in painting animals, particularly monkeys, and many stories exist about his relationship to them.

It is related that one day Sosen, while still living in Nagasaki, sent hunters out to secure a monkey for him to sketch. This they succeeded in doing; the artist placed the animal in a tree in his garden and proceeded to draw it many times. Some foreigners saw these sketches and the completed paintings, and commented that they were unrealistic. Sosen thereupon went into the mountains to capture the true spirit of the monkey in its natural habitat.

Another story deals with the legend that Sosen was actually only painting his ancestors for he was in truth a monkey. Although the complete text is unclear due to missing characters, it is reported in *Koga Bikō (Notes on Old Paintings*, p. 1206) that the teacher Ritsuzan composed a poem which he presented to the artist Sosen. In it he questioned the artist's ancestry. He acknowledged that Sosen's ancestors were hermits, but wondered which hermits. He claimed that the method of painting monkeys was transmitted from Yang-chou. He then told the story of a group of monkeys who were being laughed at by their keeper. Among the group was one very old and clever one who did not join the intrigues of the rest of the group. Instead, he ate some mystic medicine and flew up to heaven. Later, he flew down to Japan and landed in the vicinity of Naniwa where he established himself in a small house. He took up the art of painting in order to remember his former friends, and was happily engaged in making money. However, he was ashamed of the fact that he was not truly a man but a monkey, and therefore falsely claimed that his ancestors emerged from hermits. A man of knowledge questioned the truth of this statement, but Sosen denied its falsehood. Master Ritsu, however, looked further into the matter and found that the claims of ancestry were false. Sosen finally could no longer dodge the issue and recognized that he was in truth a monkey hermit and not a man descended from hermits.

It is reported that at the age of sixty Sosen changed the character *so* of his name, from ancestor to monkey.

The two monkeys in this painting are alert and are engaged in a favorite pastime, catching insects, a theme that Sosen repeated many times. The elder monkey has climbed a plum tree and braces himself with one foot against the trunk. He swings way out and clasps a thin branch with one hand for support as he reaches into the air and snatches what appears to be a grasshopper in flight. A mischievous young monkey is on the elder's arm where he views the feat with open-mouthed awe and perhaps with hunger.

Both monkeys are done in Sosen's typical fashion. They are soft furry balls, yet one can easily detect the presence of bone structure under the fluffy coat. The monkeys painted by Sosen are always endowed with character and personality. Also they are usually engaged in action or pursuing the objects of their curiosity.

The furry softness of the monkeys contrasts with the tree which enters the composition at the lower right, vanishes, and reappears as flowering branches near the top. The tree is done with bold and decisive brushstrokes. The ink was rather wet and there is evidence of touches of *tarashikomi*. To strengthen the trunk and branches, Sosen added a few strokes in darker ink and pointillistic dots to indicate lichen. The blossoms and buds are fresh and meticulously done. Sosen's paintings radiate a humanism, personal curiosity, and warmth. This painting is signed Sosen and carries one of his seals, read Mori Shushō.

56. *Monkey and Wasp.* By Mori Sosen
(1747–1821). Edo period, late
eighteenth–early nineteenth centuries.
Kakemono, ink and slight color on
paper, 73 x 14 1/8″ (185.4 x 36 cm).
Shinenkan Collection

This second monkey painting by Sosen
is endowed with the same
mischievousness and inquisitiveness that
we saw in No. 55. Sosen deleted all
background and used only the two
elements essential to his story—a
monkey and a wasp. Seated on the
ground the monkey's furry body is
composed of a limited number of
carefully placed broad brushstrokes and
many softer strokes over those to
indicate the long-haired fur. The
monkey's head is constructed of a great
number of hairlike lines. The ear, eye,
nose, mouth, hands, and feet are
accented by darker brushwork.

In the sky a wasp circles above the
monkey's head; it is the center of
attention. The monkey's eye is on the
wasp, as though mesmerized, and its
clenched fists indicate that before long
it will try to catch the curious flying
insect.

Sosen's treatment of monkeys on
paper varies slightly from those on silk,
which have greater softness, partially
imparted by the physical properties of
the material. As in No. 55, the artist
placed on this painting his signature,
read Sosen, and his seal, read Mori
Shushō.

DETAIL OF PLATE 56 ▶

57. *Tiger Licking Its Leg.* By Komai Genki
(1747–1797). Edo period, late
eighteenth century. Kakemono, ink and
color on paper, 67 1/2 x 45 5/8"
(171.4 x 115.9 cm). Shinenkan
Collection

Little is known about the artist Genki
other than that, along with Rosetsu (see
Nos. 60, 61, and 62), he was one of
Maruyama Ōkyo's (see Nos. 44 and
45) finest pupils. He was a resident of
Kyoto and was noted for his fine paint-
ings of beautiful women. Although this
book is devoted to nature themes, we
must keep in mind that most of the
artists considered here also had
competence in representing the human
form, objects, and landscape. Genki was
born in 1747 and during his lifetime he
used a number of names including Ki,
Yukinosuke, and Shion. Among his
pupils he had the artist Watanabe
Nangaku (1767–1813; see No. 67).
Genki died in 1797 and was buried in
Kyoto at the Myōsen-in.
 A meticulously drawn tiger preening
and licking its foreleg is the subject of
this painting. Obviously Genki had seen
a tiger skin and with thousands of fine
short strokes he sought to capture the
true nature of its coat. These strokes
give the animal's fur the appearance of
a thick pile. Genki also tried to indicate
the dark banded striations of the tiger.
In this he was less successful, because
although they do indicate form and
help define depth, they are not true to
nature. Once again the tiger is not
represented in a fierce pose prior to
attacking. Instead, it is at ease as it
washes itself in front of an outcropping
of rocks and an unusual leafy plant. As al-
ready seen in Nos. 35 and 53, the animal is
too big for the space, so part of its
haunch and tail vanish and then
reappear in the composition. Genki's
treatment of this beast often favored in
Japanese art is observant and precisely
detailed. The painting is signed Genki
Utsusu (Drawn by Genki) and carries a
small square seal, read Genki no in
(Seal of Genki).

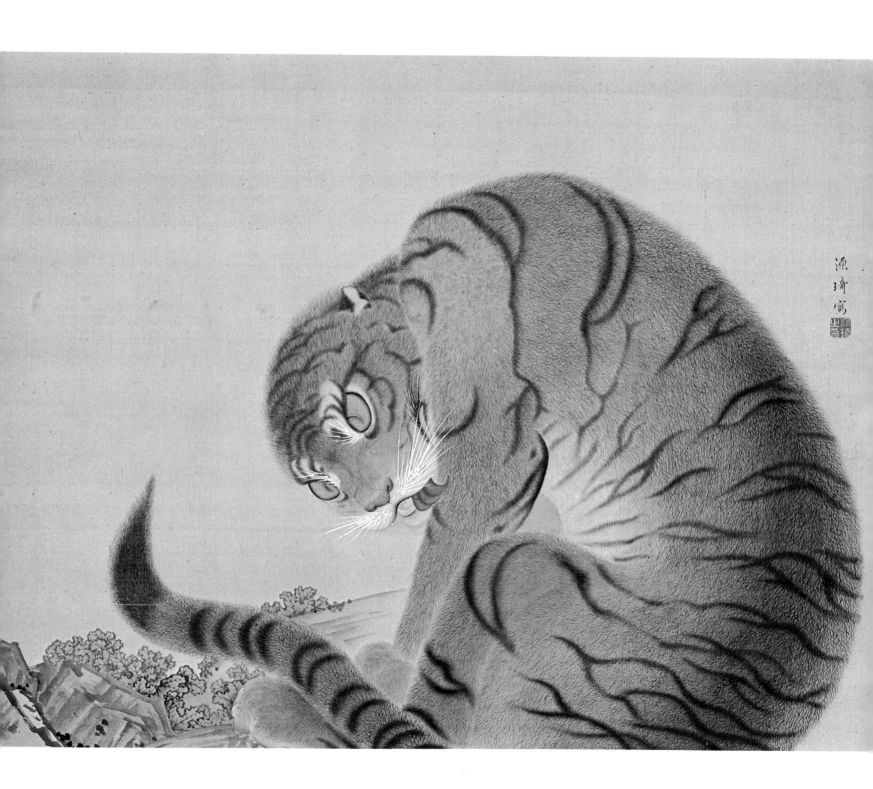

117

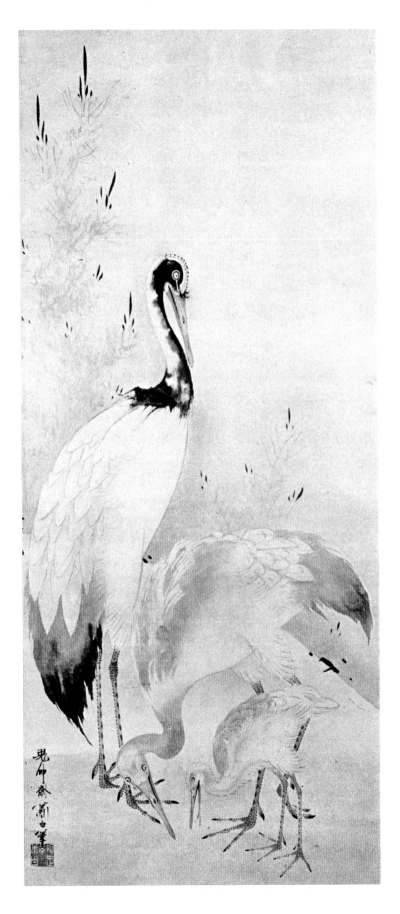

58. *Cranes and Pines*. By Soga Shōhaku (1730–1781). Edo period, eighteenth century. Kakemono, ink, and slight color on paper, 87 1/2 x 28 5/8" (222.2 x 72.7 cm). Shinenkan Collection

Japanese art in the mid-eighteenth century was blessed by a great deal of freedom and eccentricity. Like Shōhaku Taiga (1723–1776), Rosetsu (1755–1799; Nos. 60, 61, and 62), Buson (1716–1783; No. 45), Hakuin (1685–1768; No. 43), and Jakuchū (1716–1800; Nos. 46, 47, 48, and 49), this artist, Soga Shōhaku, flourished. Many amazing and amusing stories have been woven about the lives of each of these men. Undoubtedly, Shōhaku, the one who was most eccentric, remains the least understood or documented. For a number of years Money Hickman of the Museum of Fine Arts in Boston has been engaged in research on this fascinating artist. It is hoped that his study will be completed soon, and that it will enlighten all of us.

A number of places have been suggested as Shōhaku's birthplace. Among them Kyoto or Ise are considered the most likely. It is believed that Shōhaku began painting as a young man and was taught by Takada Keihō (1673–1755), who worked in the Kanō style. Though there is no question that Kanō features are present in his work, they are usually masked by Shōhaku's very personal and eccentric mannerisms. His paintings are often explosive and burst with energy. There is really little explanation for this except that it is reported that he drank excessively. Perhaps when Shōhaku was possessed, the sake demon took control of his hand and moved it brilliantly to create wildly expressive works. Shōhaku thought of himself as the tenth generation heir to the painting style of Soga Jasoku, the Muromachi ink painter who flourished in the latter half of the fifteenth century. It is folly to believe that a direct relationship will ever be established, and it is sufficient to know that in Shōhaku we have an artist who formulated his own dramatic and dynamic style. It is reported he quarreled with his fellow artists and moreover was opinionated and an egoist. He had no love for Ōkyo (see Nos. 44 and 45) and reportedly suggested that if one sought true paintings, Shōhaku was the one to come to, whereas if one wished mere sketches then Ōkyo was the man to seek out. Certainly his remarks did not endear him to the popular favorites of the time though, as so often happens, he was odd enough to inspire admiration. His popularity among collectors fell into a decline, and only recently has it been on the upsurge. He was a prolific artist and, in addition, numbers of forgeries or paintings done in his manner are in existence. His dissipation may have accounted for his early demise when he was only fifty-one years old.

This painting could be humorously titled *The Crane Family*. Shōhaku represented the father, mother, and child on it. In contrast to many of his works, it is calm and serene not only in subject matter but also in brushwork. The composition is well organized as the male crane towers over and keeps a watchful eye on his family. The mother stoops, perhaps to guide the youngster in a lesson in bug hunting. The male's plumage is showy, the female's soft and unobtrusive, while the fledgling's feathers are rather spiky and without sheen. Behind the family group, Shōhaku painted a soft and lyrical impression of pine trees.

In all likelihood, this is an early painting by Shōhaku. The mannerisms of his most active period are not apparent. The subject matter is tranquil, as is the handling of his brush. Shōhaku placed on this painting one of his signatures, read Kishinsai Shōhaku, and his seal, read Jasoku-ken Shōhaku.

Birds. Attributed to Satake Shozan (1748–1785). Mid-Edo period, c. 1780. Handscroll, ink and slight color on paper, h. 19 5/8" (49.8 cm). Fogg Art Museum, Harvard University, Cambridge, Mass. Anonymous loan

The handscroll to which this section belongs is an ornithological study which appealed to the non-academic Japanese artists of the eighteenth century. Kōrin, the artist who painted the *Morning Glories* incense wrapper (see No. 27), had made such studies, and Maruyama Ōkyo, who is represented in this volume by *Phoenixes* (see No. 44) and *Crow in Flight Before the Moon* (see No. 45), filled sketchbooks and a handscroll with very precise, labeled studies of birds, beasts, blossoms, and bugs. The Japanese love of sketching was always strong, and if one were to search bookshops dealing in manuscripts or art materials numerous sketchbooks crammed full of nature studies would be easily found. At times the compilers of these works even gathered feathers or

pressed blossoms and leaves as scientific aids to the creation and documentation of these nature studies.

The interest in Western studies called *Rangaku* (Dutch studies) had influenced many walks of Japanese life. Its effect on art is evident in this scroll of bird studies in which the artist placed the birds about an old maple tree which serves as a perch for many of them. The tree is merely the artist's acknowledgment of academic training; he had no concern for scale relationships between the tree and birds. Thus the former is tiny and narrow whereas the latter are large and have fairly accurate proportional relationships. The artist shows either a knowledge of ornithology or an ability to copy scientific studies of birds with much care. He has drawn them with great detail and identifies each so that the viewer would have no difficulty in using this scroll as a guide on nature walks. In cataloguing this painting for the exhibition *The Courtly Tradition in Japanese Art and Literature*, Professor

John M. Rosenfield and his co-authors discuss it in great detail on pages 297 and 298 of the scholarly volume published by the Fogg Art Museum, Harvard University, in 1973. The section dealing with the identification of the birds is as follows:

In the section of the scroll illustrated here, the birds are all said to be island (*shima*) species and are a fairly routine group. The bird to the left of the tree trunk, standing on the ground is labeled *muku* (gray starling). The two on the tree trunk are a pair of *ikaru* (grosbeak; as in the Ikaruga-no-miya, the palace of Shōtoku Taishi where Hōryū-ji was built). The three birds on the upper branch to the right are *hitaki* (fly catcher), *isuka* (grossbill), and to the far right, *hōjiro* (meadow bunting). The largest bird is a *karasu* (a crow). Directly beneath it is a pair of *koma* (robin), and to the far right on the ground is a pair of *nojiko* (yellow bunting).

On the branch of the tree to the left of the trunk is a bird called the *shitoto*.
In all likelihood Satake Shozan (1748–

1785) is the artist who painted this handscroll and whose signature appears on it. Shozan was lord of the remote Akita region. He was obsessed with the importance of truth and realism in art and felt that Japanese and Chinese art had failed because they were lacking in those properties. Traditional art was therefore of little value or use and Shozan encouraged the development of a school of Western-style painting. When Shozan traveled, he sought the company of those exposed to Western (Dutch) thought and art styles. Thus, in 1773, he had a pioneer of Western studies, Hiraga Gennai (1726–1779), come to Akita for seven months. Gennai trained Odano Naotake (1749–1780), one of Shozan's retainers, in the Western manner of painting. Naotake in turn is believed to have relayed this style to others.

This handscroll is done with great taste. There is evidence that the artist was a man of refinement, with knowledge that extended beyond that of a copier or decorator. The artist's investigative study of birds is keen and it is generally felt that this is a work by Shozan.

60. *Peacock*. By Nagasawa Rosetsu (1755–1799). Edo period, dated 1782. Twofold screen, ink, color, and gold on paper, 67 1/4 x 74″ (170.8 x 188 cm). Shinenkan Collection

It was common practice for a pupil to copy his teacher and, in fact, almost mimic him as he progressed on the orderly course of development into a full-fledged professional artist. Along the way, he would at times depart from the tradition in which he had studied in order to formulate a manner and style of his own. Such was the case of Nagasawa Rosetsu, a most competent painter, who produced the peacock shown here.

As is so often true for Japanese artists, we do not have an abundance of biographical information about Rosetsu. He was born in 1755. His father is said to have been a man named Uesugi Hikoemon, a samurai of lesser rank in the service of the Aoyama family, who were Lords of Shimotsuke in Tamba province. Like his father, Rosetsu also served a feudal lord, becoming a retainer of Inaba, Lord of Tango of Yodo province. It was at this time that it is believed he changed his family name from Uesugi to Nagasawa. The exact year has not been established, but it is known that Rosetsu moved to Kyoto prior to the spring of 1781. This year can be fixed by his dated painting *Fierce Tiger* in the Okabashi Collection. On it he also wrote that it was done at Raku, a term commonly applied to Kyoto. In fact, pairs of screens depicting scenes of everyday life in and about Kyoto done in the *ukiyo-e* genre are commonly known as *Rakuchū Rakugai Byōbu* (*Screens of Scenes In and Outside of Kyoto*). It was the practice in late-eighteenth-century Japan to publish lists of selected residents in various towns. Registers of this nature exist for Kyoto, Osaka, and Nagasaki. They were by no means a comprehensive census or even a partial one. It would be erroneous to think of them as a *Who's Who*, since we really do not know how inclusion was determined. The lists are valuable to us because often they include the names of artists and serve as added documentation. In 1782, when he was only twenty-nine, Rosetsu appeared in the *Heian Jinbutsu Shi* (*A Record of Kyoto Personalities*).

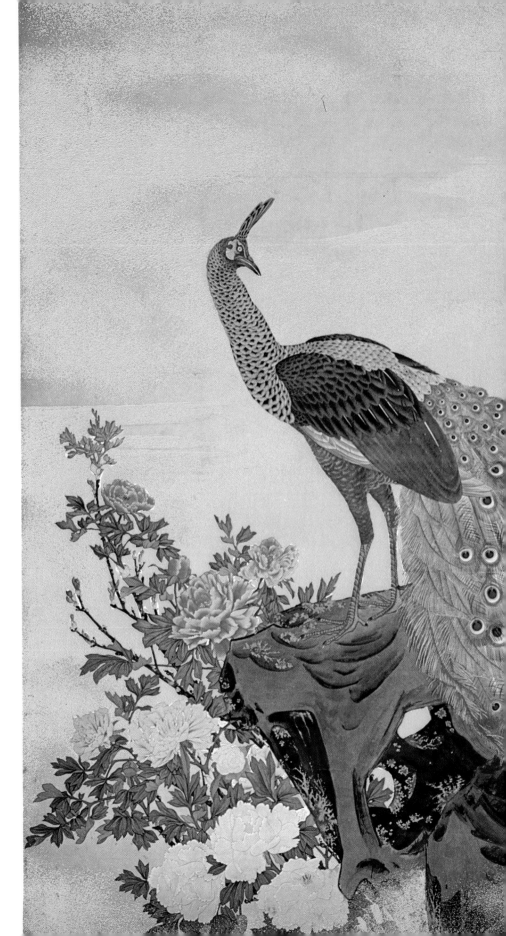

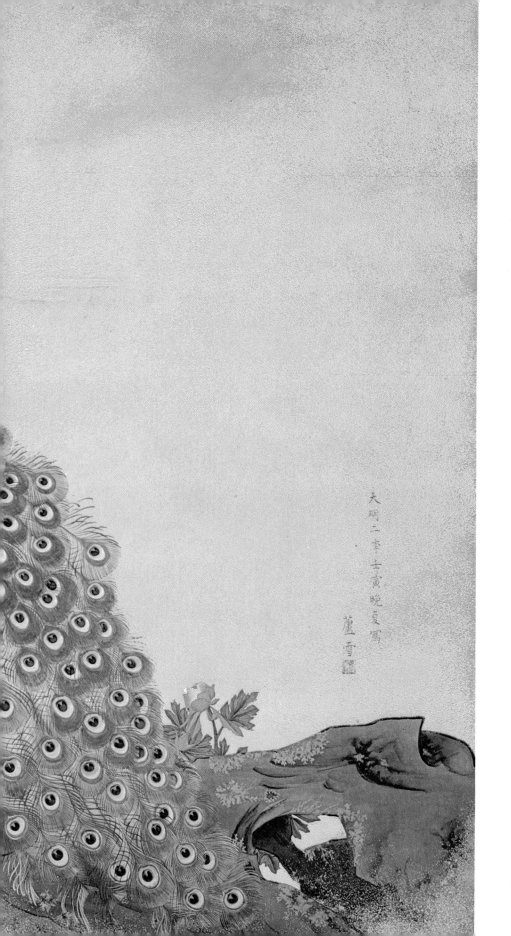

天明二年壬寅晩夏寫

蘆雪圖

From this we can conclude either that Rosetsu knew the compiler of the list or that his accomplishments were known by that time. His residence is listed as being at Miike Kudarumachi Miyuki-chō.

Maruyama Ōkyo (see Nos. 44 and 45) was Rosetsu's principal teacher of painting. Ōkyo was both talented and highly respected, and the fact that Rosetsu was accepted by him as a pupil again speaks favorably of the younger artist's ability. Often skilled pupils would be called upon to assist an accomplished master, and there is the distinct possibility that the pupil would even execute preparatory work. It was in this period in 1782, when he was strongly under Ōkyo's influence, that Rosetsu executed the *Queen Mother of the West*. This was followed by a number of commissions, including the *Peacock* shown here, done in the same year, and a dragon painted on the walls of the Kaifuku-in, a subtemple of the Myōshin-ji. Other important commissions of this time were the *fusuma* for the Sōdō-ji, which Rosetsu produced in 1787 for his friend the abbot Kankei who had assisted him in his Zen studies. The Sōdō-ji is located in Nanki, and while there Rosetsu also painted for the Muryō-ji and the Jōfu-ji. He also visited the Kōzan-ji and did some painting there. We know that he was in Kyoto in 1790, for he joined with many academic school artists as well as his own teacher, Ōkyo, in helping to redecorate the Imperial Palace. Rosetsu's career remained an active one, and he exhibited in 1796 in a show known as the Higashiyama Exhibition of New Calligraphy and Painting which had been organized by Minagawa Kien. Such exhibitions were held twice a year during 1788–1801; they introduced talented artists to the public, and, in fact, may have been the first public exhibitions held in Japan. Rosetsu produced a votive painting for the Itsukushima Shrine in 1797. He died two years later under somewhat clouded circumstances while visiting Osaka.

Rosetsu made a distinguished contribution to Japanese painting. The *Peacock* shown here is an early work and it is in fact a reinterpretation of a design done by Ōkyo, his teacher. The Ōkyo painting is in the Denver Museum of Art (The J. D. Hatch Collection of Japanese Art, In Memory of the Reverend Anson Phelps Stokes);

121

it is more delicate than the Rosetsu rendering, and a peahen standing on the rock at the right was part of the composition. By deleting the peahen and by his use of brushwork, Rosetsu made the composition more a design of pattern and contrast than an attempt to achieve the accuracy of a nature study. The paper background contributes to this effect, for its surface is harder than the silk used by Ōkyo. Rosetsu also used gold wash and clouds made up of minute flecks of gold. These devices add to the contrast between the painting and background. When one studies the Rosetsu peacock with care, it is immediately evident that it is more than a mere copy of Ōkyo's work. Rosetsu's peacock is beautifully painted with the nuances, sheen, and color of the feathers, all meticulously executed. The tail feathers form a network of lines and the entire painting gives an effect of great gorgeousness.

Rosetsu placed an early variety of signature and seal on the painting. It carries the date *Temmei Niki Jin-in*, which corresponds with 1782; Rosetsu stated that he painted it during the late summer. He signed it simply Rosetsu and added an unusual variety of seal, also read Rosetsu.

61. *Fierce Tiger.* By Nagasawa Rosetsu (1755–1799). Edo period, late eighteenth century. Kakemono, ink and slight color on silk, 96 1/4 x 63 3/4" (244.6 x 161.9 cm). Shinenkan Collection

The tiger climbing up onto a rock, portrayed here by Rosetsu, appears to be grumpy rather than fierce. He displays signs of anger but is not shown snarling or about to spring. In fact, the beast appears to stare directly at the viewer and almost challenges him with a "This is my rock" attitude. It is obvious that the breeze is very strong, for the hair of the tiger's coat stands on end as though raised and ruffled by the wind rather than by anger. The small bamboo clumps rising from behind the rocks verify the intensity of the wind's movement. They bend and are blown in one direction.

As in his *Peacock* (No. 60) and *Elephant and Bullock* pair of screens (No. 62), Rosetsu here again displays his competence and mastery of compositional organization. The tiger is stretched out on a diagonal and fills the space superbly. His body is somewhat contorted, so that we concentrate on the head with its sharply slanted eyes and needle-pointed whiskers as well as on the much softer contours of the snout and mouth. By combining many short strokes of lighter ink with a background wash, Rosetsu created the pelt and an illusion of modeling. No tiger ever really looked this way, but then Rosetsu did not seek to copy nature exactly. Instead he sought to capture its essence with a high degree of accuracy. Rosetsu often used the device of repeating a shape in

creating the forms of the creatures he was depicting. Thus the tiger's rounded, squarish left shoulder is echoed by the curving tail accented by dark ink applied to its tip. The rear right foot is echoed in a similar manner by the general shape of the edge of the rock onto which the tiger climbs. The right foreleg of the tiger repeats this shape on an even larger scale.

In this painting Rosetsu also displays his mastery of the use of washes. The rocks have definite form and on examining them with care, one discovers that they are composed of very skillfully applied ink washes which have puddled, thus giving shape and definition. The tiger is a very successful Rosetsu design; it was formerly in the collection of the Hengan-ji in Kyoto. Rosetsu obviously thought highly of the design since he used it in a twofold screen of the same subject now in the Joe Brotherton Collection in San Francisco.

Along the left edge of the painting, Rosetsu wrote an inscription from which the title was taken. It may be freely translated as "A fierce tiger with one roar is noisier than both dragons." In truth, there are three varieties of the legendary dragon: one that was horned and dwelt in the heavens, one without horns that lived in the sea, and one with scales that resided in marshy locales and in the mountains. To Rosetsu, the tiger was much more real than a never-materialized dragon. He signed the painting with his signature, read Rosetsu, and placed on it two seals. The upper, square one contains two characters which may be read Naga Gyo, and the lower, round-shaped one contains the single character read Gyo.

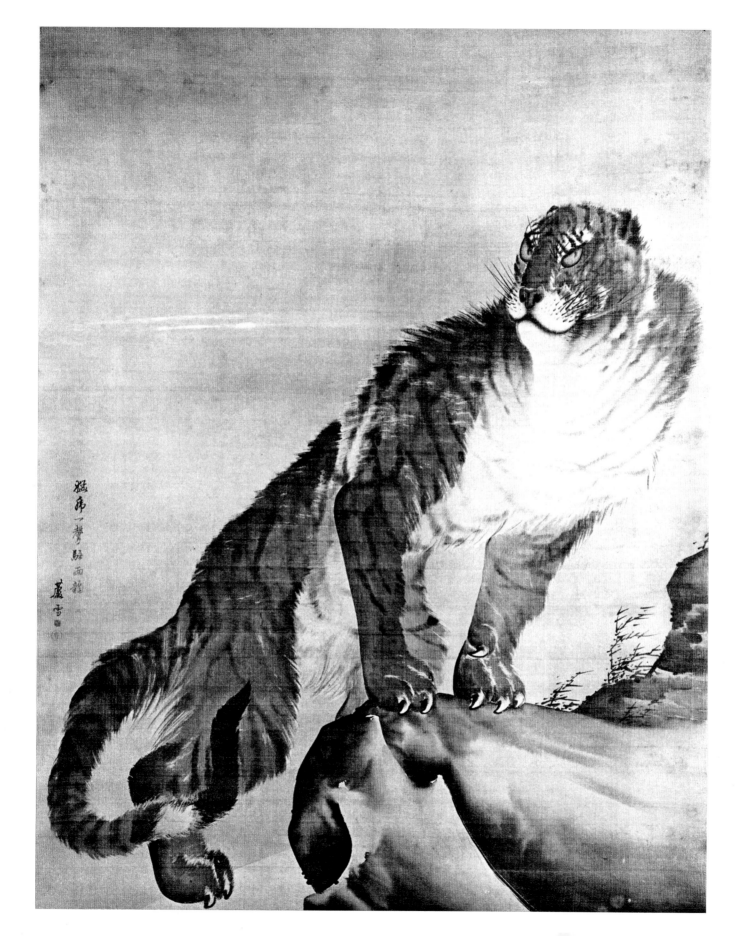

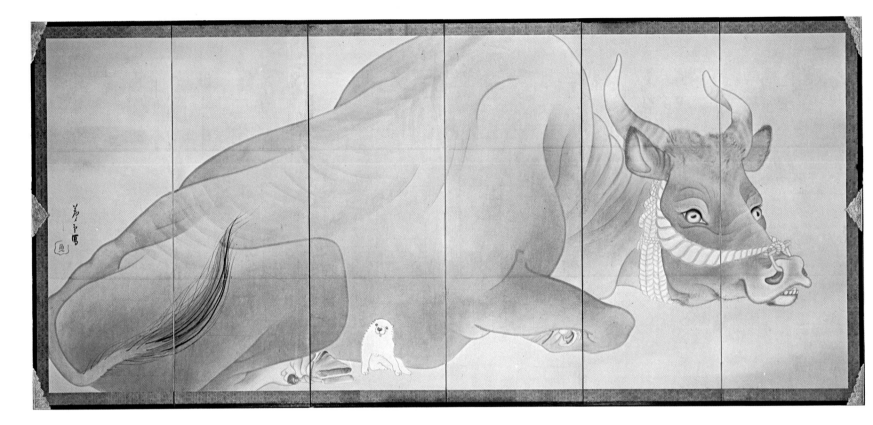

62. *Bullock with Puppy, Elephant with Crows.* By Nagasawa Rosetsu (1755–1799). Edo period, late eighteenth century. Pair of sixfold screens, ink and gold wash on paper, each 67 1/4″ x 12′ 3 3/4″ (170.8 x 375.3 cm). Shinenkan Collection

With this pair of screens Rosetsu triumphs in the creation of compositions of great originality and wit. He constantly sought out new designs that had not become hackneyed by repeated use. Even a cursory study of his work reveals the freshness and ingenuity of his com-positions. Often they were also imbued with humor or a touch of whimsy. Here, with the minimum use of line Rosetsu painted a huge elephant at rest and a contented bullock. Each animal occupies almost the entire paper expanse of a screen. The elephant, the subject of the right-hand screen, is drawn with an economy, or what we might even go so far as to term a rationing of line, used only to indicate the boundary of the rather happy beast and the stylized folds of elephant flesh. Its massive body spreads over the folds of the screen. The tusks protrude from a spot near the floppy ears and quite to the rear of the head which is not true to nature—but then one wonders how many live elephants Rosetsu was privileged to see. The trunk curves gently inward, and the elephant has crossed its feet as it patiently tolerates the two visiting crows that have paused to explore it and rest on its back. Though much smaller, the crows are composed of at least as many brushstrokes as the elephant. The small black birds contrast wonderfully with the bulk of the beast. They appear to be busybodies, or one might characterize them as tourists aboard the elephant.

Undoubtedly they serve a purpose, possibly scratching about and picking at parasites that might be irritating to the elephant. Rosetsu's sense of humor can also be seen in his depiction of the elephant's tail, which enters the composition from the bottom right looking like a fly whisk or stalk of wheat.

On the left screen, Rosetsu has portrayed a huge bullock contentedly at rest with its fore hooves folded under. Once again he has employed an economy of line, but there is much more of a sense of depth and three-dimensionality in the depiction of the

bullock than in that of the elephant. This was accomplished by using a carefully applied grayish wash with broad brushstrokes that impart depth and spatial relationships. Once again Rosetsu added his own personal touch of humor and contrast; between the fore and hind legs of the bullock he placed a winsome white puppy done in the manner of his teacher, Ōkyo. The puppy sits sprawled out awkwardly, looking almost ill at ease, while the large bullock is shown totally at rest. Rosetsu often used puppies in his paintings. Frequently they were as stylized as

the one shown here and were painted in the manner of Ōkyo. The furry, tiny puppy contrasts with the short-haired bullock. Much smaller than the living mountain in whose shadow it reclines, the puppy almost appears to be inviting the viewer to meet its friend.

The backgrounds behind both beasts in this superb pair of screens are done with a slight wash. On each screen Rosetsu placed his signature, read Rosetsu Sha (Painted by Rosetsu) and his irregularly bounded seal, in which the character, read Gyo (Fish), is placed.

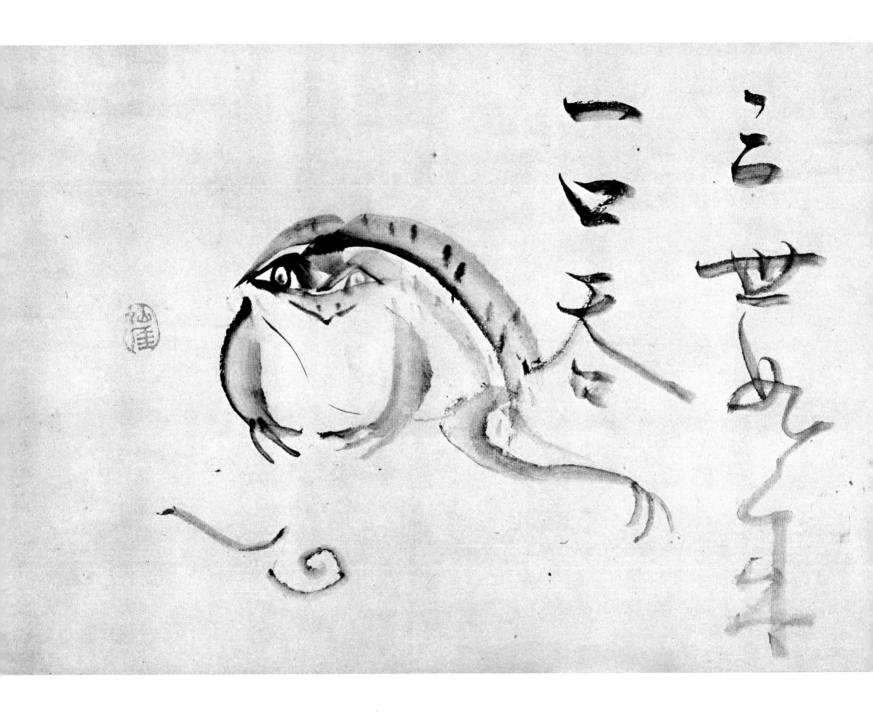

63. *Frog and Snail*. By Sengai (1750–1837). Edo period, late eighteenth century. Kakemono, ink on paper, 50 x 22 1/4″ (127 x 56.5 cm). Private collection

There is a simplicity and unprofessional naivety and charm to be found in the paintings and calligraphy of Sengai. He was born in 1750 into the family of a simple farmer from Mino (present-day Gifu prefecture). When only eleven he had joined a religious order, and his devotion to Zen and his proselytizing for it became the reason for his existence. He set forth on his religious pilgrimage, and at nineteen he met the great monk Gessen Zenji. He joined Gessen and studied with him for some thirteen years. When Gessen died, Sengai set out once again on his peregrinations in search of a master. He finally settled in 1788 at the Shōfuku-ji in Hakata which had been founded by Eisai in 1195 and was the earliest Zen monastery in Japan. Sengai rose to become abbot of this monastery and only retired at age sixty-two in order to spread the teachings of Zen through his paintings and calligraphy until his death in 1837.

Sengai was blessed by a fine talent and sense of unselfconscious awareness. His paintings are truly in the Zenga tradition, and in general conception they follow those created by Hakuin (see No. 43). Many of Sengai's works have warmth and humor, and one can sense the humility of the man.

In this painting Sengai depicts a frog and a snail. One can count the few brushstrokes he used, because economy and lack of distraction are basic to the Zen tradition. The frog is carelessly drawn and yet each line is essential and nothing is lacking. Its body is like a hillock and its eyes resemble inverted V's. It smiles as it watches the snail's progress, while at the same time it places its forelegs and stretches one rear leg in readiness to leap. The frog's upturned mouth expresses anticipatory joy at the meal that crawls along so slowly. The snail is composed of only two brushstrokes; they are perfectly placed and yet also consciously drawn to express a lack of skill or the need of it. On the painting, Sengai wrote a seven-character inscription. It may be freely translated as

"Three generations,
Nine years,
Gobbled up, in one mouthful."

On the left side of the painting, he placed his often-used seal, read Sengai.

64. *Chrysanthemums*. By Sengai (1750–1837). Edo period, late eighteenth century. Kakemono, ink on paper, 56 x 15″ (142.2 x 38.1 cm). Private collection

Sengai's genius and ability to capture nature without realism or pretense is visible again in this second work from his brush (see No. 63). The sprig of chrysanthemum with two blossoms is a fascinating exercise. One might ask, "What is necessary to a chrysanthemum?" The answer would be "petals, leaves, and buds."

Sengai suggests the petals with a series of loops and strokes clustered tightly together to form the flowers. He just drew his brush along the paper in a formless manner for the leaves. The brush seems to start nowhere and go anywhere. However, one could not mistake the design for anything but leaves. The same is true of the buds at the end of the curving stalk of chrysanthemums. The simplicity and spontaneity of Sengai's paintings are most appealing. On the painting he wrote a poem, the first half of which may be freely translated as follows:

"In the ikebana
Though we say *kiku*
There are no ears."

The word *kiku* is a play on words, for it means *to hear*, as well as *chrysanthemum*, the subject of the painting. Sengai also affixed his seal, read Sengai, to the work.

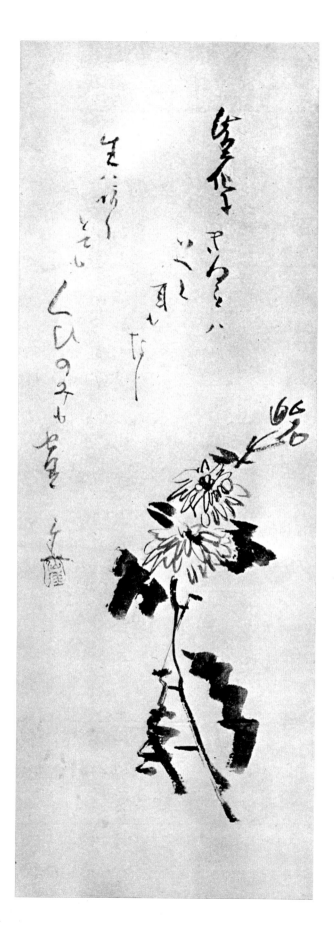

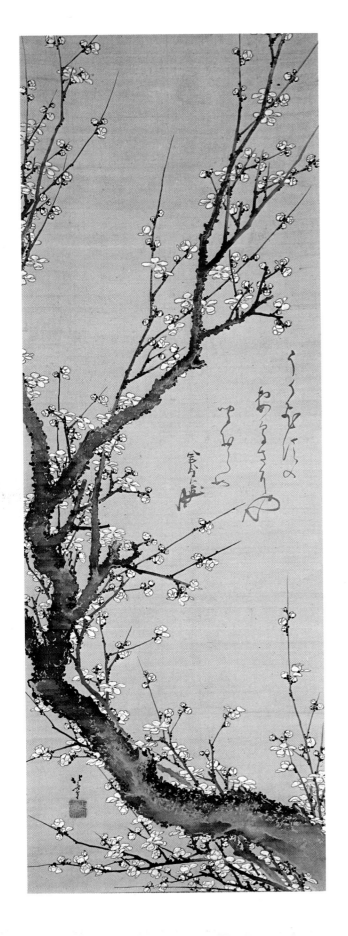

65. *Flowering Plum.* By Katsushika Hokusai (1760–1849). Edo period, early nineteenth century. Kakemono, ink and color on silk, 80 1/2 x 20 3/8″ (204.5 x 51.7 cm). Nelson Gallery-Atkins Museum, Kansas City, Mo.

The theme of a flowering plum is a favorite in Japanese art. In the Namboku-chō period, the fourteenth century, artists had already sought to capture its beauty (see No. 9). With each succeeding generation that interest continued, and though the theme is fairly constant, the variations on it are many.

A branch of plum from the upper reaches of a tree in full bloom fills most of the silk allotted for this painting. It enters the composition from the right, reaches over to the left edge of the silk, climbs a little, and then divides with one branch reaching for the right upper edge. Only a portion of a tree is shown and the trunk and roots from which the bough springs are not visible, nor are the ends of the branches which soar into the sky. The painting was done with great sureness of hand; the drawing is crisp and hard, and there is no evidence of hesitancy in the brushwork. The painting is an accomplished work by Katsushika Hokusai. In creating the main branch, Hokusai first drew its general shape and then over this applied numerous small wet strokes that give the impression of the rough bark of the tree. The heavy branch acts as a broad river into which the many tributaries feed. Hokusai used outlines to define the blossoms in all stages of development, and their whiteness and purity contrasts with the somber darkness of the branch. To make them stand out, the artist applied a slight tint to the background silk. The entire composition is quite formal, especially when we compare Hokusai's statement with that of Tani Bunchō (see No. 52). We must keep in mind that paintings such as these, and wood-block prints, were later to influence deeply Impressionist and Post-Impressionist artists in the West. Van Gogh actually

DETAIL OF PLATE 65 ▶

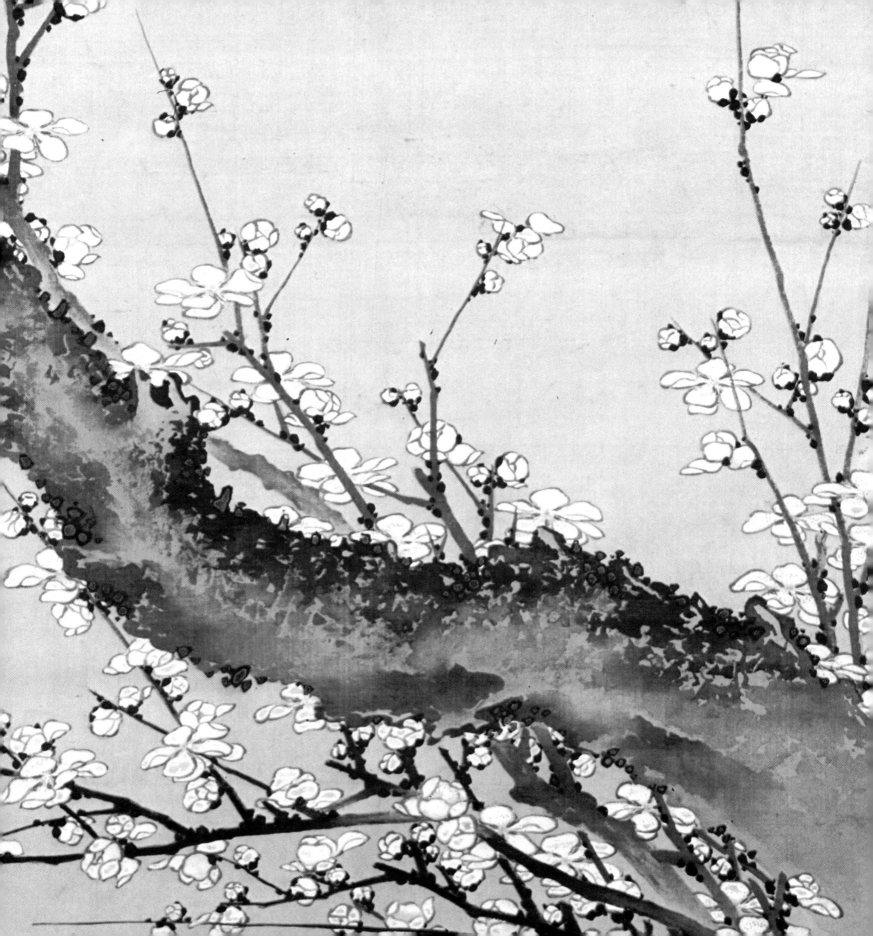

copied a print of a flowering plum grove by Hiroshige (1797–1858).

Katsushika Hokusai, who produced this lovely plum blossom, was a great artist and is probably one of the Japanese artists best known in the West. He was born in 1760 into the Kawamura family at Honjō Warigesui, part of the Katsushika district of Edo. When he was only four or five years old, he was adopted into the family of a mirror-maker, Nakajima Ise. In his apprenticeship there, Hokusai became exposed to the world of design and craftsmanship. At about the age of fourteen, Hokusai became apprenticed to an engraver of wood blocks for prints and this experience was also invaluable to him in his later career as a print designer. His first major advance occurred in 1778 when he became a pupil at the studio of Katsukawa Shunshō (1726–1792). During this period, he used the name Shunrō and, during his lifetime, he changed his name and residence many times. Some seven years later, in 1785, it is reported that he quarreled with his teacher and left his studio. Though he was working in the *ukiyo-e* (floating-world genre) manner, during his twenties and thirties, he also studied the academic Kanō style with Kanō Yūsen as well as the Tosa manner of painting. Because he was also deeply impressed by the work of the Rimpa school and artists such as Kōrin, he took to copying the basic form of the seal used by those masters. Hokusai is generally known to Japanese art historians as "The Old Man Mad About Painting." He started using this name without the "Old" about 1800. In 1804, he produced a gigantic portrait (some eighteen yards long and eleven yards wide) of Daruma in the compound of the Otowa Gokoku-ji. He entered a painting competition with Tani Bunchō (see No. 52) and was successful with a composition of the prints made by a rooster after its feet had been dipped in red paint and it was released to walk across a broad blue-painted surface. The footprints resembled maple leaves and Hokusai's ingenuity was praised. In the early part of the nineteenth century, he fought with his friend, the great author Kyokutei Bakin (1767–1848). About 1818, he suffered severe financial reverses and traveled to the Kyoto-Osaka region. Once again he came in contact with Bunchō, who was well established. Bunchō praised his work and assisted him.

Hokusai's love for his art was intense. In 1828, he suffered and overcame a severe attack of palsy, and then went on to publish and praise the Chinese healing recipe. Hokusai traveled a good deal in the 1820's, and appeared in Uraga in 1834. He married, had children and grandchildren, and was constantly plagued with financial worries. His brush never stopped, for painting was his source of revitalizing energy. He was a fantastically prolific artist and there are many tales about him that alone could fill a volume. Hokusai felt that he would not become a competent artist until he was seventy-five, and called upon his admirers to stay alive until he reached the age of one hundred and ten. In a note at the end of the *Fugaku Hyakkei (A Hundred Views of Fuji)* print series, he wrote, "At one hundred and ten every dot and every line from my brush will be alive." Unfortunately he did not attain that great age and died in 1849 at age eighty-nine.

Hokusai loved all things and had a curiosity about everything. His treatment of nature was sensitive and accurate and his brush was deft. The combination of these elements enabled him to produce beautiful compositions such as this plum branch. On the painting there is a poem and Hokusai signed the work with his signature, read Hokusai, and placed on it a seal, read Raishin, which he used primarily between 1812 and 1815.

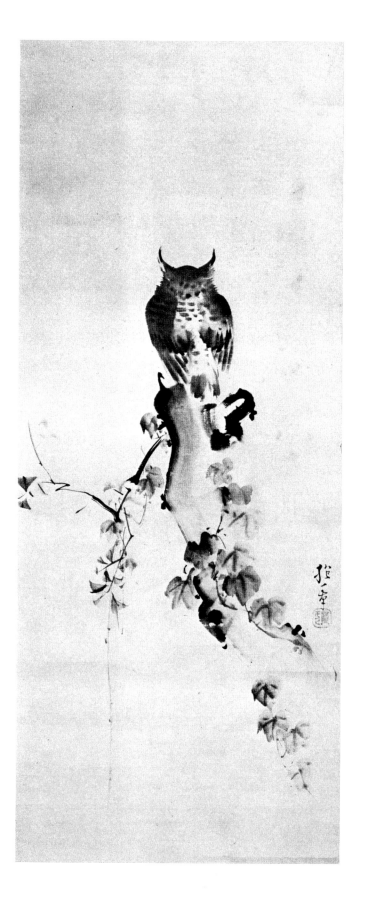

66. *Owl*. By Sakai Hōitsu (1761–1828).
Edo period, late eighteenth century.
Kakemono, ink and color on paper, 84
x 26 5/8″ (213.4 x 67.6 cm).
Shinenkan Collection

Sakai Hōitsu heralded the start of the
last flowering of the Rimpa school. He
idolized Kōrin (see No. 27)
and was steeped in the entire tradition
of this school. He was a member of the
Sakai family, which ruled Himeji castle,
and was ranked among the wealthier
daimyo of the age. Hōitsu was born in
Edo and as a young man was called
Tadazane. Like so many young
gentlemen of the time, he was trained in
the Chinese classics and Confucian
thought. Augmenting these highly
moralistic philosophies was his firm
adherence to Buddhism. At an early age
Hōitsu expressed his desire and talent
for art. Being a member of the Sakai
family was most fortunate, for that
family had manifested a great interest
in contemporary artistic talent, and in
the early eighteenth century had acted
as patrons to Kōrin. Thus Hōitsu was
exposed early to the work of this major
Rimpa master. Although at the time of
Hōitsu's birth Kōrin had been dead for
forty-five years, Hōitsu had only adula-
tion for Kōrin as an artist and source of
inspiration. Prior to determining that he
would be a Rimpa artist, Hōitsu sam-
pled the work of other popular schools
of the age. He studied Bunjinga, the
Kanō school techniques, *ukiyo-e* under
Utagawa Toyoharu (1735–1814), the
Nagasaki school established by Sō
Shiseki (1712–1786), and is even in-
cluded by some scholars among the
pupils of Ōkyo's son, Maruyama Ōzui
(1766–1829). Like his idol and other
predecessors of the Rimpa school, he
also had a great interest in the tea
ceremony and was talented in designing
lacquers, especially inro (seal or
medicine cases). Hōitsu's devotion to
Kōrin was so strong that he became a

chronicler of his work and in 1815
published the *Kōrin Hyakuzu* (*One
Hundred Paintings of Kōrin*) and the
Ogata Ryakū Impu (*Collected Seals of
the Ogata School*). In 1797 he took the
tonsure and moved to Kyoto, only to
return in 1809 to Edo, his home town,
where he died in 1828.

Hōitsu was richly endowed and
copied much from Kōrin. He produced
figure studies of the great poets and
literary giants in the traditional stylized
Rimpa manner, which was ultimately
derived from Yamato-e. Hōitsu also
mastered the characteristic Rimpa
technique of *tarashikomi*. He was a
brilliant colorist and able to indulge his
talent, for he had the wealth necessary
to afford costly pigments and materials
of the finest quality.

In this charming painting of an owl,
Hōitsu has depicted the bird from the
rear. It should immediately call to mind
Watanabe Shiko's frontal treatment of
a similar theme (see No. 41). It is
known that Hōitsu also painted the owl
from the front. The owl is perched
solidly at the top of a branch of an old
tree. The principal portion of the trunk
is formed by a broad brushstroke, and
an ivy-like vine is entwined about the
trunk and branch of the tree. In paint-
ing the leaves, Hōitsu employed
tarashikomi, and the entire composition
was done with great spontaneity. The
rear view given of the owl somehow in-
spires sympathy for it and also is amus-
ing. The owl is composed of a number
of deftly applied wet brushstrokes
which create its roundish shape. Hōitsu
in this work also shows his skill at
knowing when to stop; there is just
enough form and shape to tell the story.
He does not overwhelm us with detail
or line. The owl reveals one aspect of
Hōitsu's great talent.

The painting carries the artist's
signature, read Hōitsu Hitsu (Painted
by Hōitsu), and a seal which has not
been adequately deciphered.

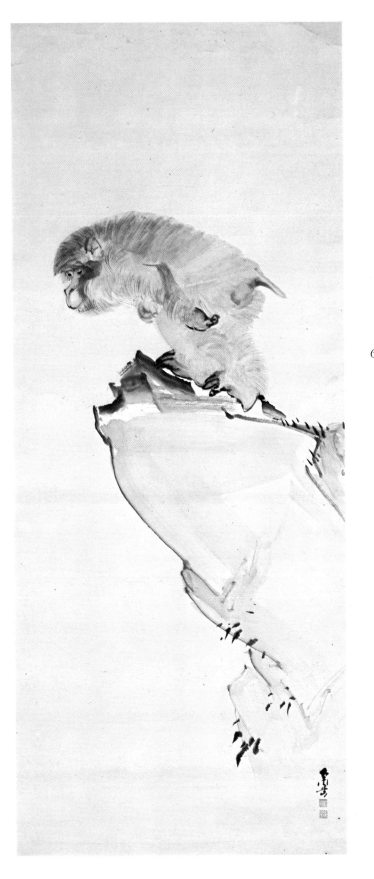

67. *Monkey Peering Over a Cliff.* By Watanabe Nangaku (1767–1813). Edo period, late eighteenth century. Kakemono, ink and slight color on paper, 84 1/4 x 27 3/4″ (214 x 70.5 cm). Shinenkan Collection

The artists of Japan were fascinated by monkeys; they were able to view them firsthand and the variety found in Japan was relatively tame and domesticated. Shrewd observations of monkeys were made and set down on paper or silk, especially by artists such as Mori Sosen (see Nos. 55 and 56). Perhaps it is the nature of man to be entertained by these animals so similar to us in action and, at times, in appearance.

The monkey shown here has rushed out onto a cliff and twists its head sideways to peer down at some interesting event outside our vision. The cliff is constructed of a narrow brushed outline, and within this boundary are a number of very light broad wash strokes which indicate its texture and form. Standing on top of the cliff is what we might term a miniature and docile King Kong. The monkey is drawn with a few light, broad brushstrokes to suggest its form and then hundreds of light curving strokes are superimposed to represent the fur. Hunched over as he bends to peer over the cliff, the position of the monkey is accented by the curving fur which adds to the impression of haste and movement. The monkey's face is very expressive and his soft, almost closed eyes are gentle. Oddly, the artist placed the monkey's feet in an awkward position; the right foot crosses behind the left leg. Perhaps this was done intentionally to add to the immediacy of the moment.

This wonderful monkey was painted by Watanabe Nangaku, another of the ten most noted pupils of Ōkyo and clearly very much influenced by his teacher. He is also said to have studied with Komai Genki (see No. 57) and to have had contact with Mori Tetsuzan (see No. 69). In addition to the name Nangaku, he used Iwao, Iseki, Isaburō, and Kozaemon. Though Nangaku was devoted to Ōkyo, it is reported he liked Kōrin's work and studied that as well. As a result, a decorative element appears in some of his later paintings. Late in his life Nangaku determined to carry the message of Ōkyo's greatness to Edo, and therefore he left Kyoto and spent three years in Edo as the first teacher of the Maruyama style in that city. He gathered about him a number of distinguished pupils, including Suzuki Nanrei (1775–1844) and Tani Bunchō's son, Bun'ichi (1787–1818). Following his stay in Edo, Nangaku returned to Kyoto and died in 1813.

On the delightful monkey painting illustrated here, he wrote his signature Nangaku and affixed two seals. The upper one reads Iwao no in (Seal of Iwao), and the lower one reads Iseki.

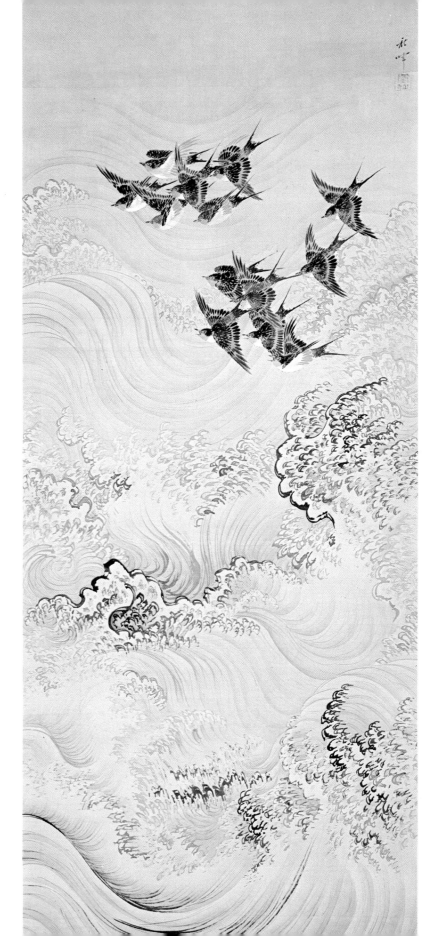

68. *Swallows and Waves*. By Okamoto Shūki (1785–1862). Edo period, nineteenth century. Kakemono, ink and color on paper, 78 1/4 x 32 1/4″ (198.8 x 81.9 cm). Shinenkan Collection

In this painting we return to a familiar subject (see No. 7). Birds flying over waves was a constantly repeated theme in all periods of Japanese art.

The artist who painted this work was Okamoto Shūki. It is generally believed he was born in 1785, though some scholars opt for 1807. Among the names used by Shūki were Sukenojō, Shūō, and Fujiwara Ryūsen. He served as a retainer of Lord Okubo of the Odawara castle. His first teacher of painting seems to have been Ōnishi Keisai (c. 1820). When Keisai died, Shūki became acquainted with Watanabe Kazan (1793–1841) and devoted himself to learning painting from his new friend. He was a talented artist whose specialty was bird and flower paintings. His death date is generally accepted as 1862.

Shūki's treatment of the bird-and-wave theme is quite inventive. The waves cover the entire vertical stretch of paper; they move and churn with great action in the foreground, and as they recede into space they soften and are calm, as though touched by some magical force. The waves undulate, those in the front break, and whitecaps reach into the air like nervous fingers. Shūki created the impression of movement by defining the waters with broad light bands which he then accented with dark brushstrokes. Thirteen swallows divided into two groups dart swiftly over the waves. The way they are clustered, and the directness and stability of their flight, makes the water seem even more turbulent. The color of the water is light and cool and it contrasts with the dark plumage of the birds. The swallows' V-shaped tails make them resemble arrows and add to their swift appearance.

In most earlier representations of this theme, the horizon line was kept much lower. Shūki, however, decided to use this approach with perspective. He signed the painting Shūki and placed on it a square seal, read Junsen. I do not question the seal, but have been unable to find Junsen recorded as one of the names he used.

133

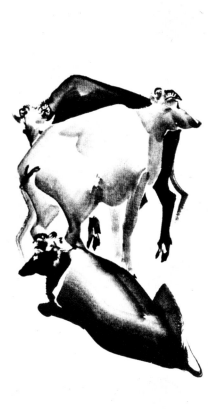

69. *Cows.* By Mori Tetsuzan (1775–1841). Edo period, nineteenth century. Kakemono, ink on paper, 78 x 18 5/8″ (198 x 47.3 cm). Shinenkan Collection

This painting of cows was produced by the nephew of Mori Sosen (see Nos. 55 and 56). Tetsuzan was the son of Sosen's elder brother, Mori Shuhō (1738-1823). Born in Osaka into a family of artists, he soon followed in his father's footsteps. Tetsuzan was adopted by his uncle Sosen although he became a pupil of Maruyama Ōkyo (see Nos. 44 and 45). He soon became a proficient artist and he too was ranked as one of Ōkyo's ten most competent pupils. Although he actually adhered quite strictly to the Maruyama style he also was fascinated by Western paintings. Ōkyo had also shown interest in the newly arrived foreign styles and had experimented with them. Tetsuzan incorporated some of these elements into his own manner of painting. He also transmitted Ōkyo's influence to Sosen. He was so enthusiastic about the Maruyama style that he went to Edo to carry on the proselytizing work begun by Nangaku (see No. 67). He later returned to the Osaka–Kyoto region where he promoted the cause of his teacher's tradition. When he died in 1841, he was buried at the Kimei-in in Kyoto.

Three cows are the subject of this painting by Tetsuzan, and Western influence is immediately evident, for cows are an unusual and, one might well say, foreign theme in Japanese art. There were any number of bullocks represented but few, if any, cows. The animals are done boldly with few broad brushstrokes; the body of the beast lying in the foreground is composed of approximately three strokes. Tetsuzan avoided the use of a confining outline, giving the painting spontaneity. It is a brilliant exercise in the definition of form with economy of line. He also imparted a spatial relationship to his composition by the cow's placement and by his alternation of color. One's eye moves along the back of the lying animal to the light-coated standing one, also diagonally placed, and then to the dark beast in the center. Tetsuzan had mastered his lessons well. He placed on the painting his signature, read Tetsuzan, and his seal, read Shushin, one of the several names he used along with Shigen and Bunzō.

DETAIL OF PLATE 69 ▶

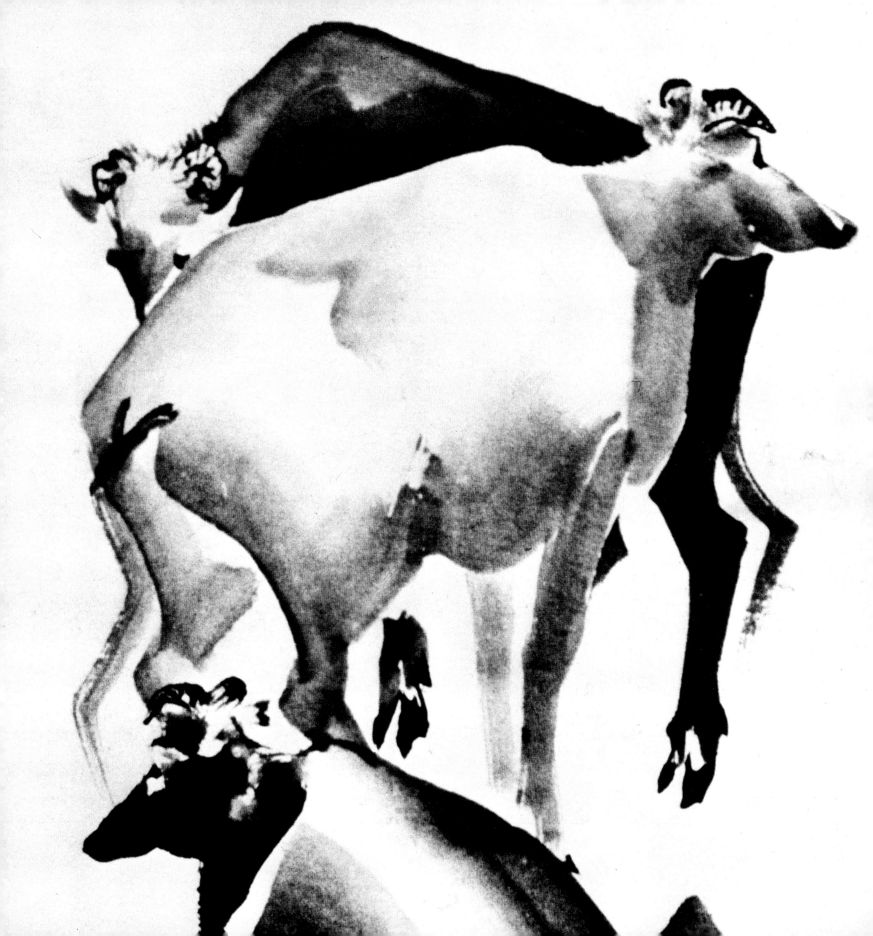

70. *Tiger*. By Kameoka Kirei (1770–1835). Edo period, early nineteenth century. Kakemono, ink and color on paper, 77 1/4 x 23 5/8" (196.2 x 60.1 cm). Shinenkan Collection

Very little is documented about Kameoka Kirei, the artist who created this painting. He appears to have been a native of Kyoto and also was a pupil of Maruyama Ōkyo (see Nos. 44 and 45). He became a distinguished artist and was ranked as one of Ōkyo's ten most competent disciples. In addition to the name of Kirei he used the names Shikyō, Kijūrō, and Mitsushige.

Kirei's *Tiger* shown here contrasts greatly with those depicted by Yōkoku (see No. 53) and Genki (see No. 57). Kirei portrayed all of the tiger, whereas they only showed part of the beast. To get the whole animal onto the paper, Kirei resorted to foreshortening. He probably learned this under Ōkyo, who was fascinated by Western art. Obviously Kirei had never mastered the lesson, because the tiger's forelegs and shoulders are unreasonably broad, and it appears to be squeezed. This may account for its rather grumpy countenance. Though Kirei's attempt is unsuccessful, it is important to realize the Japanese artists' interest and progress in adapting this Western device. As was the case with Genki (see No. 57), Kirei lavished his attention on thousands of thin brushstrokes to indicate the animal's fur. The Japanese artists of this period must have had access to a tiger skin which they avidly studied and copied.

Placed in the upper left corner of this painting is an enigmatic poem done in the Chinese manner which cannot be readily translated. It carries the signature and seal of a Zen priest that seems to read Taizen. Kirei signed the painting with his signature, read Kirei, and an oval seal divided into two parts. The upper half reads Kirei and the lower half reads Shikyō.

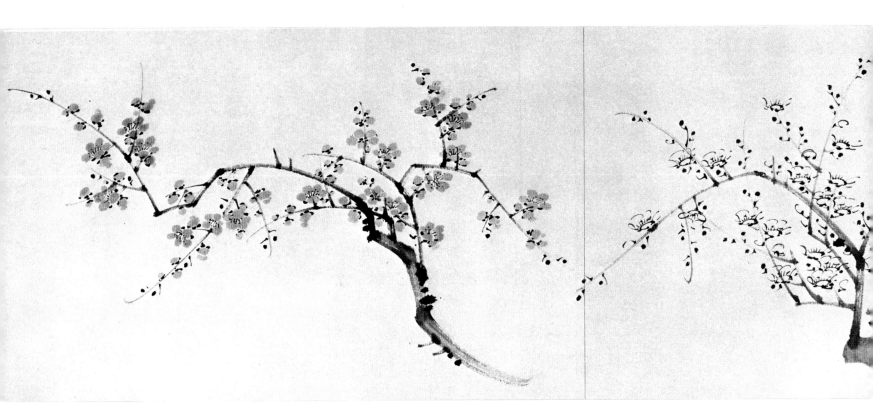

71. *"The Four Gentlemen."* Attributed to
Nakabayashi Chikutō (1776-1853).
Edo period, nineteenth century.
Handscroll, ink on paper, 11 1/4"
x 12' 1" (28.6 x 368.3 cm). Shōka
Collection

The title of this handscroll may be
somewhat obscure and confusing to the
uninitiated. "The Four Gentlemen"
actually refers to four noble and
dignified plants which are compared to
men of virtue—thus, gentlemen. The
plants are also seasonal: the plum tree
usually stands for winter, the orchid is
symbolic of spring, the bamboo equates
with summer, and the chrysanthemum
typifies autumn. The basic principle is
of Chinese derivation and numerical
combinations of this type were not at all
unusual.

 In this painting the artist took license
to rearrange the plants. As one unrolls
the scroll the bamboo is revealed first,
followed by the orchid, two varieties of

plum—white first and then red—and
then a repeat of the bamboo. The
brushwork is very competent and
controlled; there are no misplaced
strokes and the plants have the barest of
background. The first bamboo grows
freely while the orchid springs forth
from behind a rock. The white plum is
heavily laden with blossoms and
appears to represent a young tree. The
red plum is merely a branch sadly
broken from a tree and is much more
angular than its white counterpart. The
second bamboo resembles the first and
grows from a rocky outcropping. The
artist presents us with a fine vocabulary
of brushstrokes and a wide range of ink
values. Although no color is employed,
one almost senses its presence because
the ink is so deftly and subtly handled.

 This handscroll of "The Four
Gentlemen" is believed to be by the
hand of Nakabayashi Chikutō. It bears
no signature but the brushwork is very
much in Chikutō's manner and is

therefore attributed to him.
Nakabayashi Chikutō was a most able
late master of the Nanga school. He was
born in 1776 in Nagoya where his
father was a physician. It is reported
that his father was not successful, and
Chikutō moved at age eleven to another
part of Nagoya to live with his aunt. In
this environment he began his study of
painting. His first teacher was Yamada
Kyūjo (1747–1793), the man who
taught his friend Baiitsu (see No. 72).
After this, Chikutō came under the
influence of Kamiya Tenyū, a wealthy
Nagoya collector and connoisseur also
known to Baiitsu. Tenyū had a sizable
collection of Chinese paintings and the
two young artists studied them and met
others interested in the arts who
participated in what we might call
Tenyū's salon. The story is told that
Tenyū gave Chikutō and Baiitsu their
names. This occurred when he invited
them to a temple to view two Chinese
paintings. One was of a bamboo and he

thereafter called the artist *Chikutō*
(Bamboo Grotto); the other was called
Baiitsu (Plum Leisure) after the plum
painting.

In 1802, both Chikutō and Baiitsu
went to Kyoto. They lived and worked
together and were acquainted with the
scholar and literati painter Rai San'yo
(1780–1832) and his circle. Though
the two young artists went back to
Nagoya, Chikutō returned to Kyoto in
1815 and settled there permanently.
The early nineteenth century was a
period when artists were also expressing
themselves in a literary vein. Chikutō
published numerous treatises on his
theoretical approach to art and his
criticism of other styles. In these essays
he constantly alludes to the Chinese
masters although, when one studies
Chikutō's work, one notices the
limitations in his approach. His style
does not vary much and is rather
academic. Before he died in 1853 he
had attracted many pupils.

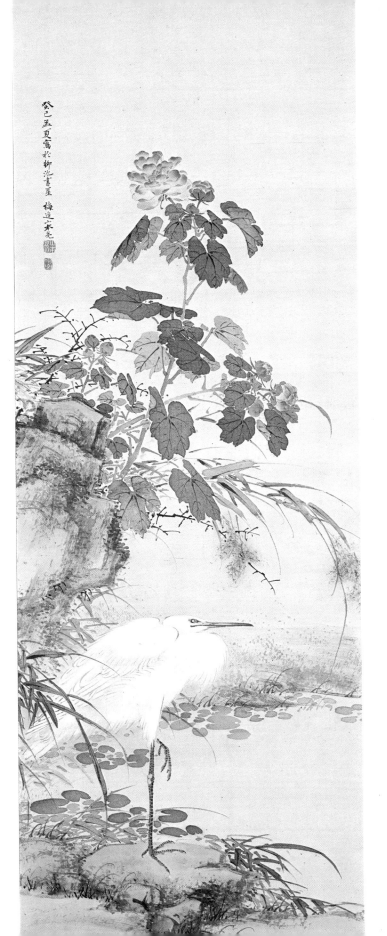

72. *Egret and Mallow Plants.* By Yamamoto Baiitsu (1783-1856). Edo period, nineteenth century. Kakemono, ink and color on silk, 73 x 21 1/2" (185.4 x 54.6 cm). Dr. and Mrs. Kurt A. Gitter, New Orleans

An egret standing on a rock beside a pond is the subject of this delicate painting done in a style reminiscent of the Shijō school. Behind the egret is a large rocky mass from which springs flowering branches of a mallow plant and pampas grass. Because of the plants, the painting is symbolic of late summer or autumn. The color is delicate, and even the brilliance of the blossoms is contained. It forms a peaceful, lyrical statement of nature.

The artist who painted this work, Yamamoto Baiitsu, was born in Nagoya in 1783. He trained in painting with a number of masters including a slightly known Shijō artist named Chō Gesshō, and also with Yamada Kyūjo (1747-1793), and Nukaya Rantei. During his youth Baiitsu became acquainted with Nakabayashi Chikutō and their friendship flourished. They traveled together in 1802 to Kyoto, and while there Baiitsu became well indoctrinated in the Nanga manner of painting. Some thirteen years later he traveled to Edo, where he continued to paint and also became acquainted with the literati and art circles of Japan. Approximately two years prior to his death Baiitsu returned to Nagoya.

Baiitsu loved to paint birds and flowers, frequently with a touch of originality. His brushwork was always delicate and he achieved perfection. The egret and setting, including the plants of this painting, are adroitly handled. Baiitsu had mastered the use of *tarashikomi* and that is evident here in the leaves of the mallow and those that float in the pond. The snowy white egret stands on one thin leg which almost forms a ruler line and thus provides a vertical accent which is repeated by the tall mallows. These elements are in the Shijō manner, whereas the rocks are in the Nanga tradition.

This painting is characteristic of Baiitsu's delicate touch. A very similar work titled *Autumn Flowers* is in the Mary and Jackson Burke Collection. Though the composition is different, the feeling and touch are such that the two might have been produced for a suite of paintings.

On the painting shown Baiitsu placed a cyclical date which corresponds to 1833. He also mentions that the work was done in the summer at the time of Bon, the festival for the dead. In the inscription, he tells us that he painted the work in what was probably his Kyoto studio, Ryūchi Shoya. He also signed the painting Baiitsu Yamamoto Ryō and placed on it two seals. The squarish one repeats the signature and reads Yamamoto Ryō, whereas the rectangular bottom one reads Meikei, another of his names.

73. *Flowers and Other Studies*. By Matsumura Keibun (1779–1843). Edo period, nineteenth century. Handscroll, ink and color on paper, 11 3/8″ x 28′ 1 1/2″ (28.9 x 857.3 cm). The University of Michigan Museum of Art. Margaret Watson Parker Art Collection

One of the pioneer artists of the Shijō school was Matsumura Keibun, the younger brother of Goshun (see No. 45). In fact Keibun was some twenty-seven years younger than Goshun and thus their relationship was more like that of father and son than of brothers. Keibun studied painting with his brother and became thoroughly indoctrinated in the principles of the Shijō school. He also became interested in Confucian thought and toward this end he associated with Koishi Genzui, a knowledgeable scholar. It was fashionable for Shijō as well as Nanga artists to study the aesthetic theories of the Ming and Ch'ing dynasties of China, and during Keibun's lifetime the quest for foreign knowledge became the vogue. Some scholars and artists turned to Dutch or Western studies, but more of them preferred Chinese studies, probably because of the relative ease of mastering the language. Also, China was closer, and ties had existed historically for many centuries. Keibun's keen interest in foreign thought emphasizes his curiosity and receptivity. He used a number of names including Shisō, Kaname, Yōjin, and Kakei.

When one examines Keibun's paintings, one is struck by their tranquility and evenness. As statements of art, these works avoid controversy, and

perhaps for this reason some art historians consider Keibun closer in style to Ōkyo than to Goshun. He loved to paint flower and bird studies and was very skilled at these. When he died in 1843, he was buried at the Daitsū-ji in Kyoto.

This handscroll is typical of Keibun's work. There is a delicacy and a pretty quality about the painting, and the ink and colors have a transparency that makes them appear light and soft. The artist used washes and avoided the use of outlines. In the portion shown here we see Keibun's rendition of a peony, a chrysanthemum, and a vine, although the last also resembles a branch of weeping willow. The paintings are done with great competence and adherence to Shijō tradition. The peony's petals are rich and the values remind me of a much toned-down watercolor by Nolde (1867–1956). There is a spontaneous quality to the drawing; realism bows to impressionism in the flowers. It is only by selecting and treating the vine in an abstract manner that Keibun displays a talent for originality. Other portions of this scroll are devoted to figures, other plants, a fish, a bird, and an insect. Each study is perfect. At the end of this handscroll the artist placed his signature, read Keibun, and his seal, read Keibun no in (Seal of Keibun).

74. *Lotus and Willow in Moonlight*. By Tsubaki Chinzan (1801-1854). Edo period, dated 1852. Kakemono, ink and color on silk, 92 1/2 x 40" (235 x 101.6 cm). Dr. and Mrs. Kurt A. Gitter Collection, New Orleans

The Nanga artist who produced this work, Tsubaki Chinzan, was born in 1801 at Koishikawa in Edo. His father died when Chinzan was seven, and his mother had to struggle to maintain her family. When Chinzan matured, he selected the military arts as his profession and became a spearman for the shogunate. It is said he was highly skilled at his work but he yearned to paint and to earn more money because the military was a low-paid profession. Thus, Chinzan became a pupil of the Nanga artist, Kaneko Kinryō (d. 1817) When Kinryō died, Chinzan studied with Tani Bunchō (1764-1840; see No. 52) and later became a pupil in the studio of Watanabe Kazan (1793-1841). It was Kazan who made the greatest impression on Chinzan and a very close personal relationship existed between the two artists. Chinzan's true skill lay in his bird and flower studies, although he also followed Kazan's lead and did portrait studies and landscapes. It seems paradoxical that this man, who was known for his modesty and gentleness, was so highly skilled in the use of the lance and pike. He also had developed a knowledge of literature, including that of China. In addition, he was reportedly a talented musician on the *sho* (reed pipes) and the *koto*. His teacher, Kazan, thought so highly of Chinzan that he let him train his son, Shōka (1835-1887). Chinzan helped support Shōka after Kazan's death. He used a number of names in addition to Chinzan, including Tokuho, Tsubaki Hitsu, Chūta, Kyūan, Takukadō, Shikyūan, and Hekiin-sambō. When he died in 1854, he left behind a number of pupils including the talented late Nanga artist, Yamamoto Kinkoku (1811-1873).

This large painting by Chinzan depicts a lotus pond over which hang willow trees as seen by the light of the silvery moon. The colors are accordingly light and delicate, and there is no trace of night's darkness, for the moon is full. Chinzan used both washes and *tarashikomi*. The painting seems executed with much spontaneity, especially if one contrasts it with the waterside setting by Baiitsu (see No. 72). There is a romantic quality about the setting and Chinzan treated both the lotus plants and willows with grace. The silk background was also toned, which increases the lyrical tranquility of the scene.

Chinzan had been much influenced by the Chinese art he had seen and he wrote a poem in the Chinese manner in the upper right of the painting. The poem may be freely translated as follows: "I'm ecstatic of the time when lotus blossoms ornament the river. As the moon moves through the willow, casting shadows, I can enjoy the cool breeze."

Next to the poem, Chinzan wrote that he had painted this work when weak and unwell during the summer of 1852. He placed on it one of his signatures, read Chinsei, and two seals. The upper one reads Hitsu no in (Seal of Hitsu), and the lower one reads Chinzan. Near the bottom left corner of the painting there is a third seal which Chinzan occasionally used. It reads Tsubaki Uji Aokage Sambō (The Tsubaki Family, Mountain Room in the Blue Shadows).

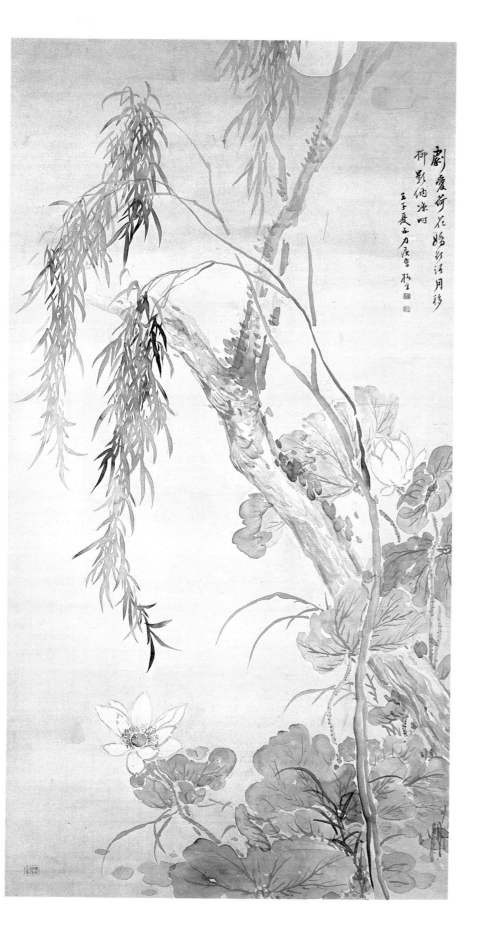

劇愛荷花嬌紅沼月移
柳影納凉呵
壬子夏五月庚午極生

145

75. *Bottle with Rabbits and Plants*. Hizen ware. Edo period, late seventeenth century. Porcelain, underglaze blue decoration, h. 5 3/4″ (14.6 cm). The Art Institute of Chicago. S. M. Nickerson Collection

As was mentioned in discussing No. 37, it was in Hizen province that Japanese porcelain manufacturing first took root in the early seventeenth century. A great number of kilns flourished there and it became the center for Imari (Arita), Kakiemon, and Nabeshima wares. Simple underglaze blue was often used in the decoration of these pieces as well as overglaze enamels and gold. Pieces that were relatively simple in form and decoration, and on which designs were painted spontaneously in underglaze cobalt blue, usually are categorized as early Hizen wares. The specific kilns from which these pieces come cannot always be determined.

This small bottle is in the Hizen tradition. The porcelain body is composed of the typical fine white clay. One could also refer to the bottle as an example of Arita blue-and-white porcelain. Painted on the vase in underglaze cobalt blue are rabbits and plants done with utmost freedom. The rabbits are shown head on and resemble puffy clouds onto which are attached circular heads with long ears and features like caricatures. The plants, like the animals, are drawn with a great amount of freedom and it would be impossible to identify them. The body, shape, foot, and decoration are consistent with ceramics from the Hizen region.

76. *Two Sake Bottles with Bamboo and Wisteria.* Hirado ware. Edo period, eighteenth century. Porcelain, underglaze blue decoration, each h. 8 1/8″ (20.6 cm); foot, 3 1/4″ (8.3 cm). The Joseph and Helen Regenstein Foundation

Hirado, near Nagasaki, was very important to Japan's early relationship with the Western world. It was here that the Portuguese merchantmen came to trade in the sixteenth century. In 1609 when the Dutch received permission to trade in Japan, they selected Hirado as their headquarters. The English soon followed the Dutch, and in 1613 their East India Company sent a ship, the *Clove*, to the same port, where they also established a trade center. But ten years later the center failed economically and the English withdrew. The Dutch remained at Hirado until 1641 when they were confined to Deshima and only allowed to trade from there.

Porcelain ware of excellent quality was produced at Mikawachi in Hirado. Actually it was Korean potters, their descendants, and their pupils who had made ceramics there since the seventeenth century. They are reported first to have turned to the manufacture of porcelain in the eighteenth century. In 1751 the kilns were taken over by the ruling Lord of Hirado. The porcelain produced at these kilns was distinguished by the exceptionally fine quality of both paste and glaze. In addition, Hirado potters tended to decorate their wares with delicate designs in a very pale blue. Hirado ware is easily recognized by these features as well as for the number of pierced, carved, and molded pieces that were produced.

These two sake bottles are very sophisticated. They are thinly potted and the body is pinched in, a practice often employed by Japanese potters. This was purely utilitarian as it gave the pourer a better grip. At the same time, the "dimpling" gives each piece its own personality. One bottle has a spray of wisteria painted on it; the other is decorated with bamboo. The areas of decoration are very limited and the carefully controlled, pale blue brushwork stands out against the larger areas of white porcelain.

77. *River Landscape with Fireflies*. By
Shiokawa Bunrin (1808-1877). Early
Meiji period, dated 1875. Pair of
sixfold screens, ink, color, and gold on
paper, each 68″ x 12′ 4 1/2″ (172.7 x
377.1 cm). Nelson Gallery–Atkins
Museum, Kansas City, Mo.

The subject of this pair of screens is
truly lyrical and romantic. A stream
meanders and moves with swift current
through the composition. The setting is
night and the sky is dark though
moonlight adds a soft tint which reflects
off the mist that hugs the river bank
and cloaks the distance. With great
novelty the artist portrayed fireflies
moving through the silvery air and
clustering in the reeds beside the
stream. Their glow flashes softly, add-
ing light and movement to the peaceful
setting.

On the right screen Bunrin depicts a
narrow stream emptying into a broader
body of water. By careful use of lines
creating splashing waves as the water
cascades over rocks to a lower level, the
artist indicates the swiftness of the
current. On this screen he placed a

cyclical date *kinoe-inu*, which corresponds with 1875. He also states that it was painted in summer during the fifth month, and signed it Bunrin. He also affixed two seals; the upper one reads Bunrin and the lower Shion, another of his names. The composition continues onto the left-hand screen. Here the stream is wider and it flows past some pilings and a willow tree which grows on the bank. On this screen Bunrin simply placed his signature and the same two seals he used on its mate.

Shiokawa Bunrin was a very popular and highly esteemed artist in his day. He was a pupil of the Shijō school artist Okamoto Toyohiko (1773–1845), and like his teacher, Bunrin favored romantic landscapes. His work is very atmospheric. Bunrin is reported to have been a sinophile and it is said he often turned to Chinese classics for solace. To assist him in inspiration, he also turned to sake. The beauty and success of compositions such as this pair of screens are evidence that his talent grew and did not dissolve into the waters of the river. Bunrin died in 1877 and his remains were interred in Kyoto.

78. *Cranes*. By Suzuki Kiitsu (1796–1858). Edo period, nineteenth century. Pair of sixfold screens, ink, color, and gold on paper, each 71 7/8" x 12'10 1/4" (182 x 392.4 cm). Shinenkan Collection

A very competent artist of the Rimpa school was Suzuki Kiitsu. In many ways one might consider him the last truly great master of the school. I have found, however, that dogmatic statements such as this really do not hold up well under examination, and thus would prefer considering Kiitsu as one of the important late Rimpa masters.

Born into a family called Shien, Kiitsu's success as an artist was very closely related to his employment by the Sakai, Hōitsu's family, and the patronage he received from them. Kiitsu's father was trained as a professional textile dyer who brought his family with him to Edo from Ōmi province. He became noted for having perfected a new method of dying cloth purple. His father's profession stimulated Kiitsu's interest in the arts, and at the age of eighteen he was fortunate to be accepted by Hōitsu as a pupil. From that point on Hōitsu kept an eye on his young disciple. He trained him, and even arranged for his marriage and adoption into the Suzuki family, which was evidently an advantageous move. Kiitsu became a samurai in the Sakai household and was appointed as a chamberlain. This position permitted him to continue his art studies.

Kiitsu was a most versatile artist whose subject matter varied widely, though birds and flowers were the predominant theme. In his treatment of figures and color, one detects the influence of the *ukiyo-e* school. We can also find traces of his study of Maruyama and Tosa traditions in his painting. Kiitsu worked in the classical Rimpa tradition but he also contributed originality. His works are bolder in design and less busy than the usual work of his Rimpa predecessors. It is known that a close bond of friendship united Kiitsu with his master, Hōitsu; they sought insight together in the arts of poetry and tea ceremony. Kiitsu's

loyalty to the Sakai family continued even after Hōitsu's death. His later years were spent in training others to follow the Rimpa tradition.

This pair of sixfold screens on which cranes are depicted establishes Kiitsu's reliance on traditional Rimpa themes and especially his devotion to the work of Ogata Kōrin whom Hōitsu idolized. Kiitsu must have been indoctrinated in Kōrin's work, and actually may have been assigned to copy Kōrin's crane screen as an exercise. Copying an earlier master's work was accepted procedure and especially common among members of the Rimpa school. The original Kōrin crane screen is in the Freer Gallery of Art in Washington, D.C.

Kiitsu's copy gives us a wonderful opportunity to compare the two masters. Actually there is little variation in the composition of the two paintings. The major change is that whereas the Kōrin is placed against a gold-leaf background, the Kiitsu is painted on a paper ground against which flecks of gold have been sprinkled. The Kiitsu painting is stiffer and the contrasts are sharper. This is to be expected in a copy. In comparing the two works, we must keep in mind that the Kōrin example is much repainted and thus it cannot be fully evaluated.

The design of cranes parading stiff-legged from the outer edges of both screens across the expanse of paper is

brilliant. The cranes' general lack of flexibility and their awkwardness accentuates the decorative impact of the design. I've always thought of them as musical notes that could be played or sung if one could superimpose scoring marks on the paper. Just as in the Kōrin screen, simple values of black, gray, and white were used. In both paintings, a stylized band of water, done in a manner typical of Kōrin, cuts into the background. Even though the painting was intended to be nothing more than a clear copy, it is an important work from Kiitsu's hand. He signed both screens Seisei Kiitsu and placed beneath each of his signatures one of his seals, read Teihakushi.

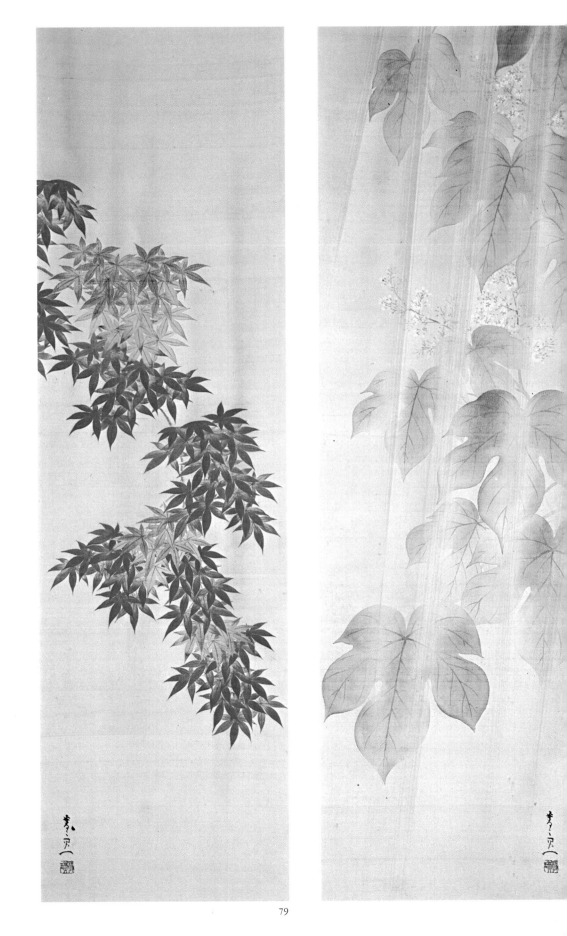

79. *Maples*. By Suzuki Kiitsu (1796–1858). Edo period, nineteenth century. Kakemono, ink and color on silk, 83 x 47 1/8″ (210.8 x 119.7 cm). Shinenkan Collection

This branch of green, red, and yellow maple probably was painted as a mate to No. 80. Kiitsu, in full Rimpa tradition, utilized the rich color to heighten the pattern he created. The branch enters the composition from the left and zigzags across the silk while the crisp maple leaves help to hide the obviousness of the direction of the branch. The maple, like the *Paulownia*, is also caught in a shower. Instead of slanting diagonally, the rain falls straight down, as is so often the case in autumn. The rain is very fine and is indicated by a few delicate vertical strokes composed of washes of light ink. Kiitsu has once again revealed his ability to capture atmospheric effects. This technique was probably learned by Kiitsu when he studied the realism of the Maruyama school.

In both this painting and in No. 80 Kiitsu has isolated the plant. His counterparts in the Rimpa school more likely would have combined them with other elements. The result of Kiitsu's singular treatment of the theme is to aid the viewer's concentration and to suggest loneliness. Kiitsu placed and signed the same seal on this work as on the paulownia painting.

80. *Paulownia*. By Suzuki Kiitsu (1796–1858). Edo period, nineteenth century. Kakemono, ink and color on silk, 83 x 47 1/8″ (210.8 x 119.7 cm). Shinenkan Collection

Another facet of Kiitsu's great talent, atmospheric effects, is revealed in this painting of leaves and flowers of a paulownia tree bathed by the water of a sudden shower. I believe that Kiitsu's study of Maruyama school painting aided him to set natural elements down on paper or silk with a good deal of accuracy. However, Kiitsu was not content merely to copy nature. He arranged elements to form lovely, delicate patterns or designs. He was not frozen by the style of a single school; instead his work shows a great deal of flexibility, though the Rimpa interest in decorative qualities is almost always present.

This painting is composed of beautifully drawn paulownia leaves and very delicate blossom spikes. As a palette, in addition to his ink, Kiitsu used very light washes of green and white as well as gradations of green mixed with ink. The leaves and blossoms appear almost transparent as a heavy rain cascades down upon them. The water moves in sheets and though it is obvious that it is heavy, nowhere does it appear mechanical or unnatural. The rain is applied as a gray wash, and the paulownia which remains visible under it seems to quench its thirst and regain strength. This moment in nature is preserved for us by Kiitsu. In all likelihood, this painting was intended as the mate of No. 79. It is possible that Kiitsu's original intent was to create a series of nature studies representing the four seasons, or even to paint a nature study symbolic of each of the twelve months. Such formulas were often followed by Japanese artists.

Kiitsu placed on this painting and its mate, No. 79, one of his signatures, read Seisei Kiitsu. On each of them he also placed his seal which reads Shūrin Ga (Painted by Shūrin). This was another of the studio names Kiitsu employed.

81. *Willow and Egret.* By Suzuki Kiitsu
(1796–1858). Edo period, nineteenth
century. Twofold screen, ink and color
on silk, 58 1/4 x 61 3/8" (147.8 x
156 cm). Shinenkan Collection

This twofold screen on which Kiitsu
depicted a willow tree and an egret in
flight is a painting that is breathtaking
in its lyrical purity and competence. In
traditional Rimpa fashion, the artist
used his elements of design to form an
exciting pattern, although at the same
time he did not close his eyes to the
realities of nature. The snowy egret is
splendidly drawn; the whiteness and
almost weightlessness of the many
layers of feathers are captured by Kiitsu,
and the egret seems to be soaring
into the sky. Obviously, there was much
stylization in the positioning of the bird
but that is by no means disturbing. The
virginal-looking white feathers stand
out against the much more highly
repetitive formula Kiitsu used for the
leaf-laden branches of the weeping
willow tree. The egret is prominent
against the leafy background in which
subtle tonalities of green and gray are
brought into play. Lighter tones are
used in the background to impart a
sense of depth.

Kiitsu's great talent is further evident
from his manner of defining the tree's
trunk. He outlined it and then tried to
mask the outline by filling the area with
tarashikomi which, through the flow of
the ink and color, gives form and depth
to the trunk. Although strangely subtle,
I am certain this painting was done with
a high level of consciousness; perhaps
the subtlety resides in the gentleness of
his intent.

The briefest glance at this screen
evokes thoughts of the summer. Anyone
who has lived in Japan knows that
season can be very hot and humid. Yet
Kiitsu's painting cools one and, with the
freedom of the egret in flight, sets one's
mind at ease. Though the air seems to
barely move, the willow branches are
fanned by a refreshing breeze from the
egret's fluttering wings.

Paintings like this one establish
Kiitsu as a great artist. On the trunk
of the tree, in a large circle, he painted
one of his seals which reads Isandō.

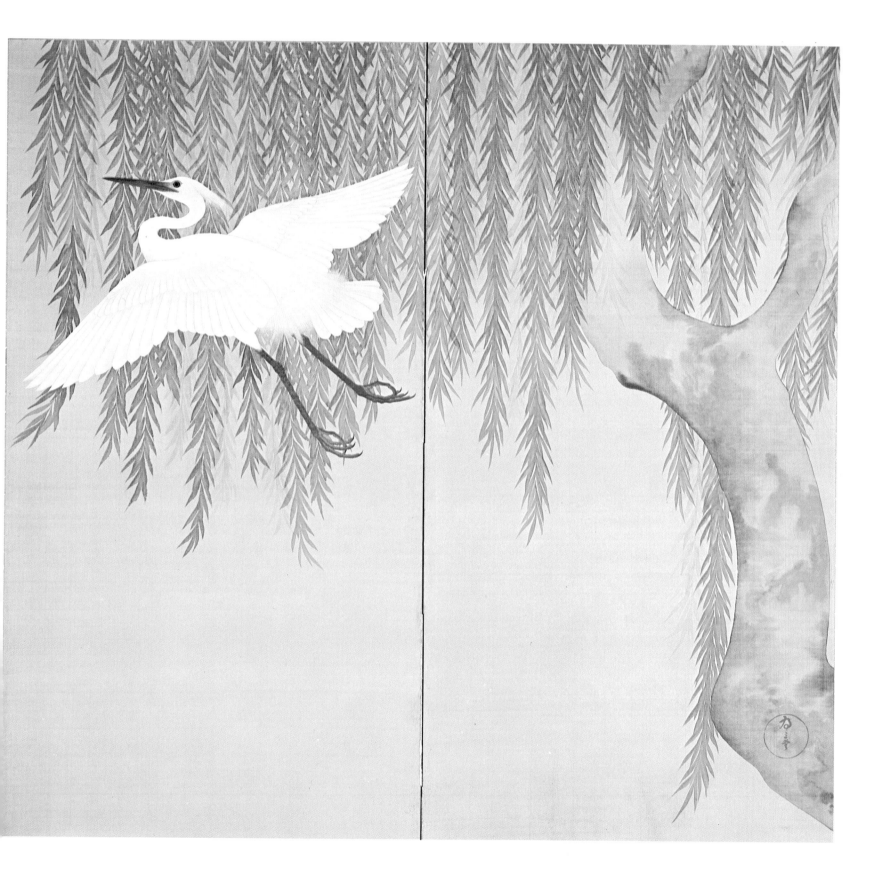

82. *Deer and Bat.* By Shibata Zeshin
(1807–1891). Edo period, nineteenth
century. Twofold screen, lacquer and
gold leaf on paper, 55 x 54″ (139.7 x
137.2 cm). Asian Art Museum of San
Francisco. The Avery Brundage
Collection

Shibata Zeshin was versed in many arts;
he was accomplished, versatile, and
blessed with great productive energy.
Zeshin was born as Shibata Kametaro
in the second month of 1807. His
father, Shibata Ichigorō, was employed
by the court as a sculptor. When only
eleven, Zeshin turned to the study of
lacquering. His teacher at that time was
the very talented Koma Kansai II
(1767–1835), who produced the
beautiful iris-patterned inro, No. 103.
Zeshin mastered the lacquerer's craft
with a degree of excellence that
surpassed that of most of his colleagues.
He traveled to Kyoto a number of times
and while there he studied painting
under Maruyama-Shijō artists, such as
Suzuki Nanrei (1775–1844) and
Okamoto Toyohiko (1773–1845).
Thus Zeshin was exposed to that school
of artists' great interest in, and rather
realistic portrayal of, nature. There is
little doubt that Zeshin learned to
sketch from life. His art is fasci-
nating for the combination of his
talent as a painter with his skill in the
use of lacquer. Thus he not only
produced objects decorated with
lacquer, but also paintings on paper and
silk, utilizing lacquer as the base
pigment. This was a known technique
which had fallen into disuse. Actually
no artist prior to his time mastered the
technique with Zeshin's skill. His paint-
ings ranged from large works, such
as this screen, to miniature-like albums.
In addition to this, he created large
numbers of more standard lacquer ob-
jects. He was indeed a most prolific
artist.

In many ways Zeshin stands at the
summit of Japanese lacquer artists. He
employed most of the known tech-
niques but showed a special taste for
the more somber lacquers, such as
black, brown, and green. Also he often
tried to simulate other materials in lac-
quer, and his themes were usually taken

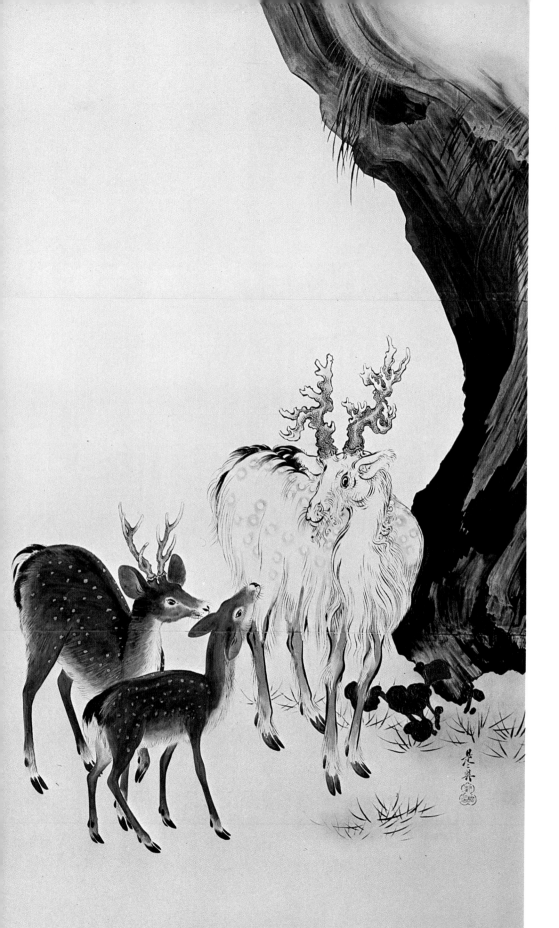

from nature. Zeshin's designs, whether
in the normal ink and pigment
medium or lacquer, were superbly
thought out. He had great ability to
relate objects, as well as part of his
compositions, to the other elements in
them. His materials indicate that
he was an artist of understated
sophistication. In his own lifetime
Zeshin was ranked with the leading
lacquer masters of the age. Emperor
Meiji (1868–1912) appointed
him a court artist in 1890 and his
highly respected talents were employed
in the decoration of the Imperial
Palace. One year later, in 1891, Zeshin
died. He left behind him three sons,
many masterpieces, and many
professional admirers.

On this twofold screen Zeshin
painted both sides with handsome
designs. A stag and two young deer are
the focal point of the right half of one
screen; they stand before what appears
to be a rocky outcropping. The elder
white deer and the two young are
painted with lacquer as are all the other
elements of the composition. In
contrast, the left half of the screen is
covered with a fine gold-leafed ground
and includes only a solitary white bat.
The deer, bat, and fungus are symbols
of longevity and happiness in the Far
East. Probably the screen was
commissioned as a gift and invocation
of good fortune. This is even more
strongly suggested by the pine and
bamboo painted on the reverse side of
the screen, because they also equate with
longevity.

The brushwork of this screen is
magnificently accomplished. The
lacquer has its own special sheen and
texture, and Zeshin easily overcame the
problems of working in lacquer on large
areas of paper. On the lower right of
the panel with the deer and the rock,
Zeshin placed his signature, read
Zeshin, and a gourd-shaped seal
containing the name Tairyūkyo, one of
the several he employed. To study
Zeshin's paintings done in lacquer, one
would be well advised to visit the Asian
Art Museum of San Francisco. The late
Avery Brundage was very fond of
Zeshin's work and his collection is rich
in the treasures of that great artist's
hand.

83. *Five Plates with Floral Designs*. By
Shibata Zeshin (1807–1891). Edo
period, nineteenth century. Papier-
mâché, lacquer, gold, and colors, each
h. 1/4″ (0.6 cm); diam. 3 3/4″ (9.5
cm). The University of Michigan
Museum of Art. Margaret Watson
Parker Art Collection

These five small plates done in papier-
mâché reveal Zeshin's great interest in
experimenting with various materials
and his success with almost anything he
touched (see Nos. 82, 84, 85, 86, 121,
122, 123, and 124). These humble and
lightweight plates were given elegance
by Zeshin. They were treated as
lacquers of the finest quality; their
surfaces were covered with gold and a
different autumnal plant was painted on
each plate. The five designs include
lespedeza, *kikyō* (balloon flower), au-
tumnal grass, chrysanthemums, and
ominaeshi (Patrinia scabiosaefolia);
possibly they were commissioned for a
special autumnal dinner party. The
colors Zeshin used are bright and fresh,
and the designs are painted to enhance
the space they occupy. Each plate carries
the artist's signature, read Zeshin, and a
squarish seal in the form of the
character *shin*, the last half of his name.

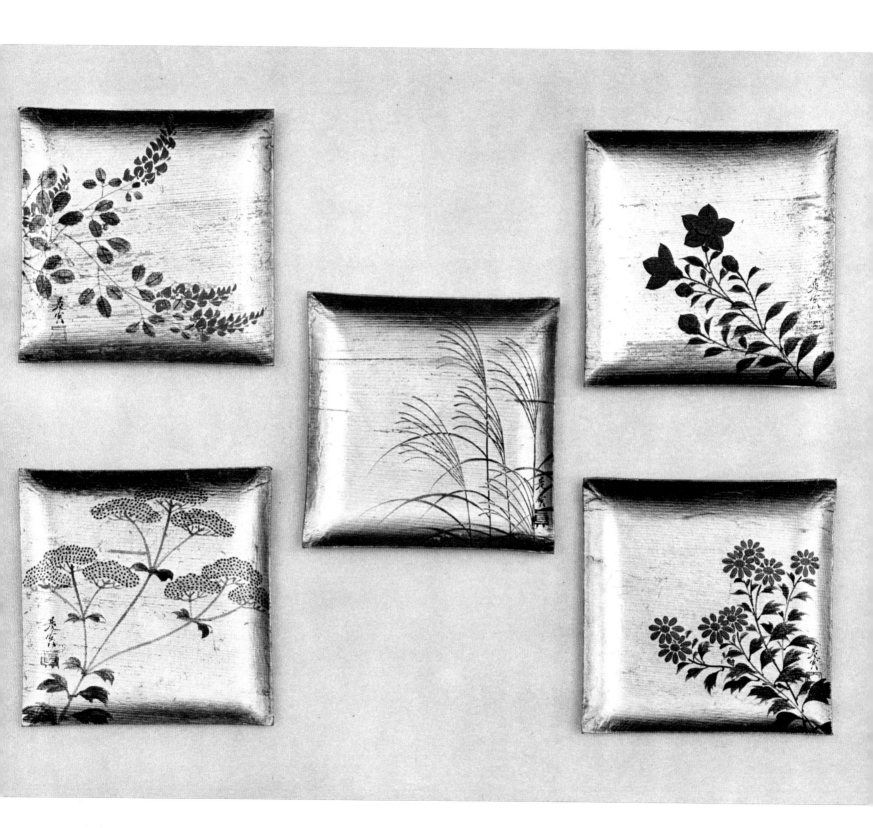

84. *Grasshopper and Gourd Vine.* By Shibata Zeshin (1807–1891). Edo period, nineteenth century. Kakemono, ink and color on silk, 44 7/8 x 17 1/8" (114 x 43.4 cm). Joseph P. Ryan, Jr. Collection, Oakland, Calif.

Zeshin's ability was great, and he excelled not only in paintings done in lacquer, but also in those using standard materials. This composition on silk shows skill and reveals just how facile an artist he was. In this realistic composition, Zeshin painted a gourd vine which cuts diagonally from the upper right to the lower left of the silk. The tendrils, stalks, and leaves of the vine interweave to form an interesting pattern. The leaves are shown in two tonalities of green; the interior is dark, the exterior is lighter. The white blossoms are extremely delicate and detailed, whereas the gourds have a textured surface resembling the *iji-iji-nuri* lacquer ground often used by Zeshin.

Resting in the vine is a most realistic grasshopper. His back is to the viewer and his delicate wings and angular spring-like legs are carefully executed. The larger, twining forms that surround the grasshopper are generally softer than the insect and seem capable of bending. The grasshopper, though at rest, seems prepared to jump and be airborne any second; the vine is only a temporary perch.

Zeshin's choice of colors are natural and lovely. The gourd vine and insect are both humble, but the attention Zeshin lavished on them reveals his love of nature and of precise delineation.

Other works by Zeshin in both the painted and lacquer forms can be seen in Nos. 82, 83, 85, 86, 121, 122, 123, and 124. Zeshin signed this work with his signature, read Zeshin, and the Tairyūkyo gourd-shaped seal is similar to the one found on No. 85.

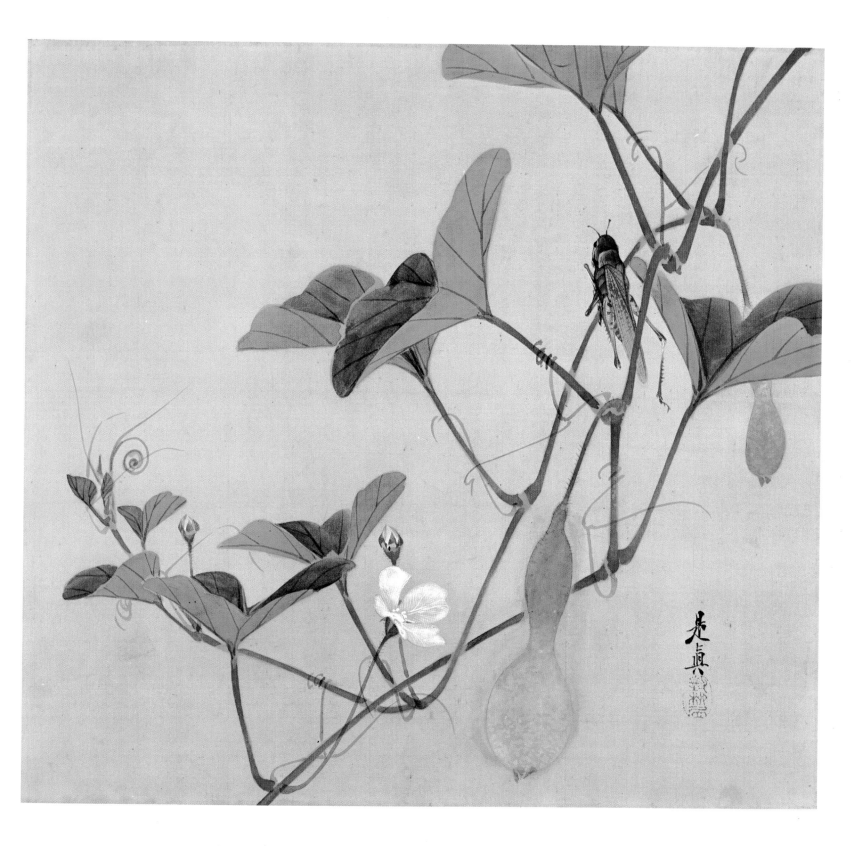

163

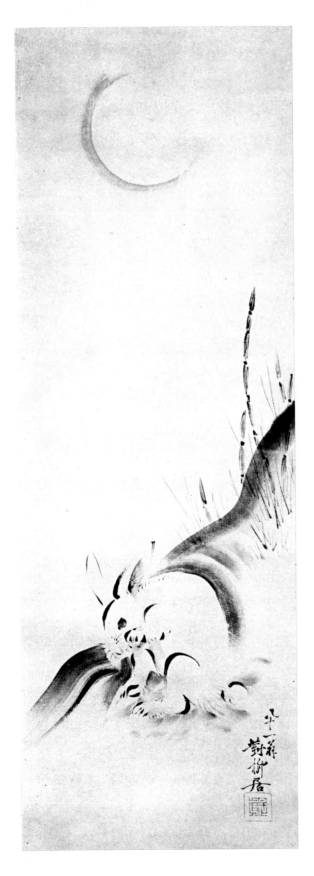

85. *Moon and Rabbit*. By Shibata Zeshin (1807–1891). Meiji period, dated 1887. Kakemono, ink and slight color on paper, 85 1/4 x 25 1/2″ (216.5 x 64.8 cm). Shinenkan Collection

Only four years before his death Shibata Zeshin painted this endearing rabbit sitting and grooming himself with his forepaws raised to his face. White and furry, formed from only a few brushstrokes, the rabbit is painted with great spontaneity in a manner not usually associated with Zeshin. In many ways, the technique resembles that used many centuries earlier in the segment from the *Frolicking Animals Handscroll*, No. 5. The rabbit is huddled over and his body forms a roundish mass that echoes the full moon hanging in the sky. Zeshin uses broad brushstrokes to accentuate both the rabbit and the hill on which the animal sits. A much lighter and wetter ink was used in these areas. *Tokusa (Equisetum hiemale)* in its greenish-brown sheath and grass grow on the hillside.

The rabbit and moon were associated in Far Eastern art. The rabbit was often shown pounding rice flour in a mortar and making rice cakes under a full moon. The hare is said to inhabit the moon as a reward for offering its body in sacrifice for Buddha. As portrayed here, it is a lovable creature.

Zeshin signed this painting as follows: "The eighty-one year old man." According to the Japanese system, one is considered a year old at the time of birth. Thus, Zeshin was actually eighty, and the date of the painting is 1887. The signature he placed on this painting reads Tairyūkyo. He also placed below the signature a large square seal, read Zeshin. Other works by the artist are Nos. 82, 83, 84, 86, 121, 122, 123, and 124.

86. *Crickets, Cage, and Flowers*. By Shibata Zeshin (1807–1891). Edo period, nineteenth century. Kakemono, pigmented lacquer, ink, and colors on paper, 50 1/2 x 16 1/8″ (128.3 x 41 cm). Harold P. Stern Collection, Washington, D.C.

In this small painting Zeshin again reveals his skill in painting with lacquer on paper to produce a delightful design. One must always keep in mind that lacquer is an extremely difficult material to work with, and the slowness and special circumstances under which it dries must have created many problems for Zeshin.

In the Asian Art Museum of San Francisco, The Avery Brundage Collection, there is a second painting by Zeshin with almost this same design. This is not unusual, for artists of Zeshin's period and talent were often called upon to copy their work for an eager client.

The cricket cage painted in lacquer here is a most elegant one. It has short scroll-like legs, and the lower sides have a pattern using a rock and a meandering stream. The top has a red lacquered disk and the bars are delicately drawn so that the rear ones in a lighter shade create the illusion of space. A cricket seems to move in the cage. Zeshin painted four stalks of flowering plants behind the cage and their silhouettes appear through its wires. The plants are *kikyō* (balloon flower), *susuki* (pampas grass), *ominaeshi (Patrinia scabiosaefolia)* with its yellow blossoms, and an unidentified variety of autumn blossom. A sensitively painted cricket crawls along one of the blades of pampas grass. The entire composition forms a distinctive still life, but considering the insects, perhaps all is not that still. On this work, the artist placed his signature, read Zeshin, and used a square seal which reads Koma, another of his names. Other works by Zeshin can be studied in Nos. 82, 83, 84, 85, 121, 122, 123, and 124.

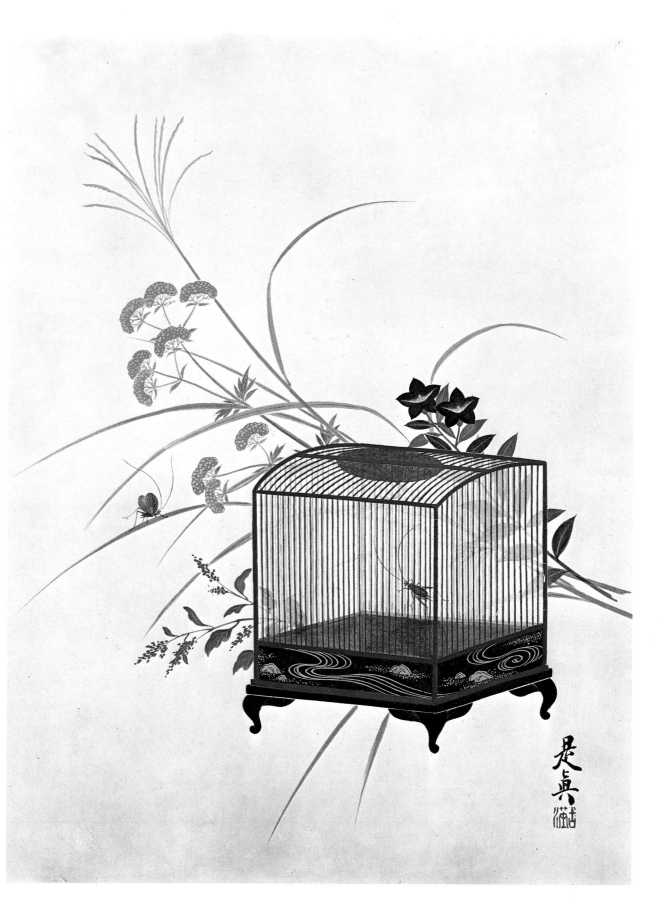

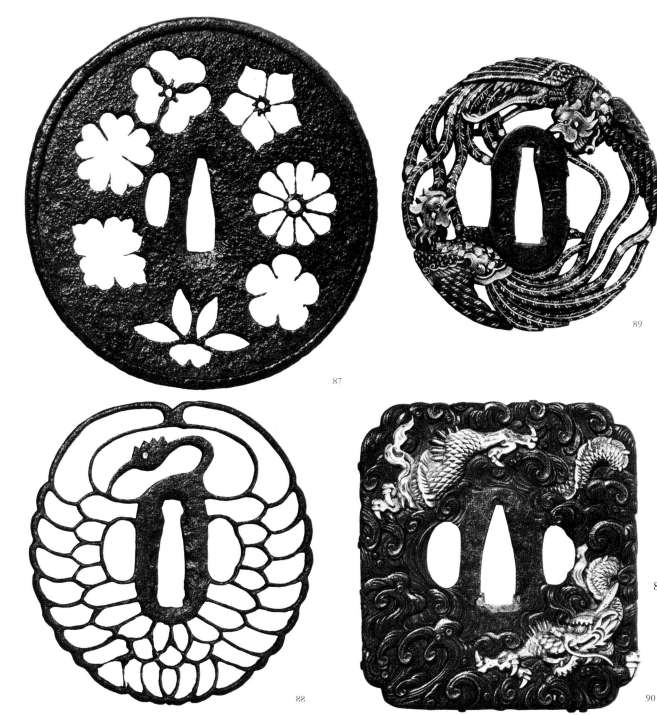

87

88

89

90

therefore, in the late fourteenth and the fifteenth centuries, their surfaces were perforated to lighten them. With the innate Japanese sense for good design, it was a simple step to fashion the perforations into patterns. At first these were simple, but as relative peace returned to Japan following the Battle of Sekigahara in 1600, the decoration of *tsuba* grew and eventually overwhelmed the sword guard. Blades became more and more ceremonial and, proportionately, so did the ornamentation of a good sword.

The *tsuba* shown here is a superb fourteenth-century example. It is made of a comparatively thin piece of iron with a narrow, raised outer rim. Actually the thinness of the metal is deceptive, for anyone familiar with Japanese metalwork can attest to the many layers of specially tempered and hammered metal that form the body of the *tsuba*. In typical fashion for the period, the *tsuba* is large in diameter. The perforations forming the pattern are crisply and beautifully executed. Seven blossoms have been pierced through the metal; among them are included plum, cherry, peach, lotus, and chrysanthemum. Though unsigned, the piece has been attributed to Munemasa, who was the ninth generation of the Myōchin family. This school of metalworkers was a most distinguished one, and the artist has fabricated a *tsuba* of great delicacy by welding the floral motif with the strength of the raw material. They nobly complement each other.

88. *Tsuba*, Early Higo: Stylized Crane. Artist unknown. Late Muromachi-Momoyama periods, late sixteenth century. Iron, diam. 3 1/4″ (8.3 cm). Charles A. Greenfield Collection, New York

Pierced tsuba fashioned very much in the manner of the Japan Air Lines logo were very popular in Japan. The theme appears to have been used from the sixteenth century on, and reached its greatest popularity during the early Edo period. It was in Kyushu in the region of Higo, today's Kumamoto prefecture, that this variety of swordguard developed and was especially prevalent.

There is a wonderful sense of elegance in the design. The crane's neck and head are surrounded by a delicate roundel formed by the bird's outspread wings. The entire conception is a very

87. *Tsuba*, pierced with seven floral roundels. Attributed to Myōchin IX (Munemasa). Late fourteenth century. Iron, diam. 4 1/2″ (11.6 cm). Collection Charles A. Greenfield, New York (formerly D. Bess Collection)

The sword guard, known in Japan as the *tsuba*, served to separate the haft of the sword from the blade. It was thus quite utilitarian, for it prevented the

wielder from accidently being cut by the blade should his hand slip down upon it. Since it projected as a cuff, the *tsuba* also gave a small degree of protection against blows directed to the hand. Stylistically, sword guards underwent a number of changes. Most of these variations related to the development of new fighting techniques and to regional preferences. By the twelfth century the sword had developed into the gracefully

carved blade we generally know today. It was intended for hand-to-hand combat, and the curving design allowed for great flexibility in combat. The *tsuba* served a very important additional function: as it projected, it helped to protect the blade from fracture by being struck heavy blows. Until the Nambokuchō and early Muromachi periods, *tsuba* were quite heavy and solid. They somewhat hampered one in combat and,

fluid one and the plumage and tips of the wings which curve gracefully and join above the crane's head create a handsome pattern. It is quite obvious that such designs influenced the Art Nouveau artists in the Western world. Tsuba of this early variety were usually unsigned.

9. *Tsuba*, Two Phoenixes. By Nomura Kanenori. Edo period, early eighteenth century. Iron with metal inlays, diam. 3 1/4″ (7.9 cm). Previous Collections: S. Bing, and Louis Gonse. Charles A. Greenfield Collection, New York

Two phoenixes confronting each other form the design of this handsome and meticulously executed *tsuba*. The basic metal of the guard is iron, and after the design was cast the artist used his chisel to further enhance it with etching and inlays of various metals, including gold. The inlays add life to the already active design and there is dynamic movement. The artist shows great control, for the wings and tail feathers of the birds curve to create the round shape. The design is like the painted roundels found on the ceilings of temples and villas of the Edo period. This was a very popular design and its origins go back to the early history of Japanese painting. It is evident from its well-preserved condition that this *tsuba*'s use was decoration rather than combat.

This particular example is by Nomura Kanenori, a very fine designer of metalwork. He signed this *tsuba* on one side with his name, Kaneishi Nomura Kanenori. On the reverse he inscribed where he dwelt, Kōshū Hikone ni Sumu (Resided in Hikone in Kōshū Province). Kōshū was another name for Kai province.

0. *Tsuba*, A Dragon Swirling Through Waves. By Yatabe Michinaga. Edo period, eighteenth century. Iron inlaid with gold and brass, diam. 3 1/2″ (8.9 cm). Previous Collections: Louis Gonse, and D. Bess. Charles A. Greenfield Collection, New York

This square *tsuba* was executed in high relief by the talented artist Yatabe Michinaga. As so often for workers in metal and lacquer, biographical data are almost nil. Birth and death dates are usually unknown, and usually all we have is a signature and the name of the province in which the master worked.

In this *tsuba* the waves through which the dragon moves are very agitated and resemble those used by the artist Sesson (see text, No. 16) or the artists of the Rimpa school. Accented by inlays of gold and brass, the dragon's head, a portion of its body, and the tail break through the turbulent water. The entire design was chiseled in high relief. On the obverse side the artist placed his signature which reads Mito ni Sumu Michinaga Saku (Made by Michinaga who dwelt in Mito). He was Yatabe Michinaga, a member of the Kōami school and a pupil of Toshinaga I, the famous master who died in 1768.

91. *Tsuba*, Maple Leaves Against a Chrysanthemum. Artist unknown. Edo period, nineteenth century. *Shakudō* with gold and silver inlay, diam. 3 3/8″ (8.6 cm). Charles A. Greenfield Collection, New York

A sixteen-petal chrysanthemum forms the background on which the unknown artist of this beautiful *tsuba* placed maple leaves executed in gold and silver inlay. The design is one of great richness and sophisticated refinement. The maples curve unobtrusively over and around the edges of the sword guard. The sheen of the rich materials which define the leaves contrasts beautifully with the properties of the *shakudō* ground. *Shakudō* is an alloy of copper formed by adding a percentage of gold to a base comprised of copper, tin, lead traces, and occasionally silver. This amalgam would then be boiled with a pickling solution and the result would be the deep blue-black color seen here. Again this *tsuba* obviously was intended for display.

92. *Tsuba*, Wild Horses. Signed, Shiba Takechika. Edo period, nineteenth century. Silver, diam. 3 3/8″ (8.6 cm). Previous Collections: Brayton Ives, and H. R. Bishop. Charles A. Greenfield Collection, New York

Two horses executed in relief on silver are the theme of this very energetic *tsuba*. The use of silver as the base metal informs us at once that this sword guard was intended solely for decorative purposes, since silver is certainly too soft to stand the rigors of combat. In addition, we know from the design and the maker that it is a work dating roughly from the middle of the nineteenth century.

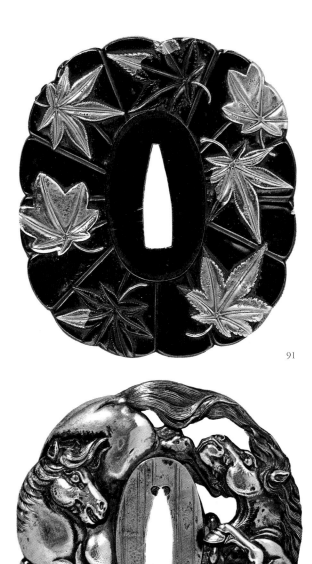

91

92

The artist who signed himself here as Shiba Takechika appears to have been descended from Yasuchika VI. The family of Yasuchika masters were noted for their well-formed relief pieces and the originality of their designs. Takechika seems to have resided in Kyoto and was officially honored as a master metalworker.

The two horses are arranged to form the rough circular shape of the *tsuba*.

One seems to be chasing the other, and their manes and tails in movement give an added sense of vitality. The silver relief catches glints of reflected light and the highlights add to the three-dimensionality of the intense horses. The design is, without question, one of great novelty and beauty. It should remind any Japanese art historian of Kanō Tsunenobu's paintings of galloping horses.

93. *Inro*: lacquer; three cases; *nashiji* ground decorated with a black horse tied to a red post with a mother-of-pearl inlaid finial, 2 5/8 x 2" (6.6 x 5.1 cm). Inside: black lacquer. Edo period, seventeenth century. Previous Collections: Louis Gonse, and D. Bess. *Netsuke*: ivory; cat seated on a mat nursing kittens, h. 1 5/8" (4.2 cm). *Ojime*: coral bead. Charles A. Greenfield Collection, New York

Inro are small tiered cases originally designed to hold the seals and ink which were and still are essential to the transaction of business in Japan. As time passed, they also served as containers for medicines, powders, or other

small items which would fit inside the small trays that join to form the overall case. The original source of inspiration was China, although the Japanese elaborated on the Chinese formula, adding variety and an amazing originality of decoration. One must keep in mind the fact that traditional Japanese clothing does not have pockets. Thus, inro served as miniature containers for the necessaries needed on one's person. These elegant personal cases were attached to the carriers' robes by means of a toggle, known as a netsuke, affixed to one end of the cord on which the individual trays were strung. The netsuke would serve as an anchor and would be drawn under the obi, or an obi cord, and then hang over, thus securing the inro in place. The carpentry, or one might say engineering, of inro is fascinating and miraculous. Their cores were usually composed of wood, though examples exist of leather, paper, metal, silk, or other cloths. The cores were cut and shaped to form the traylike pieces that join to create the body. It was essential that the parts fit together perfectly because they were subjected to extensive daily use.

Inro were popular from roughly the seventeenth through the mid-nineteenth centuries. The cases, once fashioned, were very highly decorated and lacquer was the material most often used for this. The range of themes, techniques, color, and additional embellishment of these small carrying cases is phenomenal. They were highly personal and thus, though the shapes were roughly standardized, the ornamentation ranged through the entire gamut of Japanese art history. To prevent the individual trays from moving about, a cord was looped through a specially drilled channel. This joined them loosely; however, a third element called the *ojime* was made to serve as a keeper. Normally the *ojime* is very small, a bead which can be slid up and down on the cord linking the cases and thus easing or increasing tension upon them. The union of inro, netsuke, and *ojime* provides a magnificent marriage of materials and design joined for a common utilitarian purpose.

The tethered horse which decorates this inro skillfully fills the space. The lacquer master turned the horse's head to one side, depicted all four feet, and executed its body in slight relief. These devices help to create spatial relationships. He also selected his lac-

quers so that the three major elements—background, horse, and the post to which it is tied—stand out. The horse is black, the post is red with a mother-of-pearl finial inlay, and the background is a gold *nashiji* (pear skin) lacquer. The *nashiji* technique involves the application of flakes or dust of gold or silver in layers, embedding them in a coating of transparent lacquer. The overall appearance is that of the skin of a golden pear and thus explains the origin of the name. Four elements compose this basic inro: three trays and a cover which caps the ensemble, a fine coral *ojime*, and the charming small sculpture, the netsuke. Although often netsuke bore signatures, this one is unsigned. The carver of this ivory toggle represented a cat and its litter on a straw mat. The reverse side of the inro is undecorated save for the lacquer ground.

94. *Inro*: lacquer; four cases; dark *rogin* (waxy silver) ground; five crows and a tree at night with a slight suggestion of a full moon; the rare technique is employed of *yozakura-nuri* (black on black through which the underpainted design is revealed), created by Sōtetsu III (1699–1776), 3 1/2 x 2 3/8" (8.9 x 6.1 cm). Inside: *nashiji* lacquer. Signed: Kanshōsai, by Iizuka Tōyō, eighteenth century. Previous Collections: S. S. Davies, and D. Bess. *Netsuke*: *rogin* lacquer; a sparrow with the character *kotobuki* (good fortune) written in gold on its back, l. 2 1/8" (5.4 cm). *Ojime*: *shibuichi* cylinder striped with *shakudō* and silver. Charles A. Greenfield Collection, New York

The lacquer master who produced this inro, Iizuka Tōyō, was active in the mid-eighteenth century. He worked primarily in the field of inro although, like many fine lacquer artists, he also produced other items, including furniture. His talent was recognized by Lord Hachizuka of Awa province whom he served as a samurai. Although he used a number of names, including Tōyōsai, Kōsai, and Genroku, his mature pieces carried the Kanshōsai signature.

Iizuka Tōyō was especially noted for his competence in the *togidashi* technique which involved the building up and then polishing of layer upon layer of a design with the formula repeated over and over again. This imparted a wonderful sense of depth and subtlety to the pattern. In the example shown here

he also displays his skill in the very complicated *yozakura-nuri* technique. The term literally means night cherry blossoms and, as applied, it was normally a black-on-black decorative process involving the application of a black or dark design on a highly polished black background. The slight variation in values makes the design stand out, though it appears cloaked by the velvet of night. The true *yozakura-nuri* technique is a most difficult one to achieve.

Tōyō became the founder of a school of lacquer masters that used his name.

93

94

On this inro, he painted a design of crows in a tree. On one side three birds are seated on the same branch, and on the reverse two birds are represented. The arrangement of the birds is quite original and displays Tōyō's talent as an artist. The netsuke and *ojime* affixed to this piece are unsigned.

95. *Inro*: lacquer; four cases; *roiro* ground. Toy dog in white and lavender *mitsudasō* technique; dog's coat a mosaic of green, purple, and blue *raden*; collar inlaid in very fine *gyōbu* lacquer; "lovers knot" of gold *takamakie*, 3 1/8 x 2 3/8" (7.9 x 6.1 cm). Inside: gold and red lacquer. Signed: Koma Sadahisa,

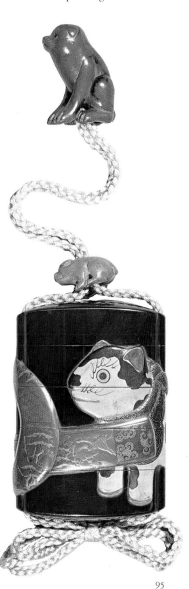

95

eighteenth century. Previous Collections: S. Ambrose Lee, and D. Bess. *Netsuke*: wood, toy dog, h. 1 1/2" (3.8 cm). Signed: Tadayoshi, eighteenth century. *Ojime*: wood, a puppy. Charles A. Greenfield Collection, New York

The Koma school of artists was one of the major ones in the history of Japanese lacquer. The founder was Kyūi, who lived from 1600 to 1663. There were twelve generations of the school, plus collateral branches and their descendants and pupils, including Shibata Zeshin (1807–1891) (see Nos. 82, 83, 84, 85, 86, 121, 122, 123, and 124).

Inro made by artists of the Koma school were generally of very fine quality and were usually fairly wide and flat. The design on this inro of a dog and "lovers knot" uses a number of techniques. The basic ground is deep black with a high polish known as *roiro* (wax color). The toy spotted dog is done in *mitsudasō*, a painterly technique with lead oxide, oil, and colored lacquers mixed and applied to create a design. On its back the naive-like dog wears a coat or blanket composed of exquisitely inlaid pieces of *raden* (mother-of-pearl), and its collar is composed of irregular flakes of gold set into a relief band. This process is termed *gyōbu-nashiji*. The "lovers knot" is done in raised gold lacquer known as *takamakie* with a pattern of the "Three Friends," the pine, plum, and bamboo. These are all symbols of longevity, as are the cranes painted on this band.

I have been unable to find anything recorded about Koma Sadahisa. Stylistically the piece belongs in the eighteenth century and resembles some of the decorative designs so favored by artists of the Rimpa school.

The wooden netsuke is a realistic representation of a Japanese puppy. Its artist, Tadayoshi, was highly skilled in the carving of animals from wood. The *ojime* is unsigned and is also shaped like a puppy.

96. *Inro*: lacquer; two cases; *roiro* ground encrusted with a gray lizard in imitation of *same-nuri* (lacquered sharkskin), 2 1/8 x 3" (5.4 x 7.6 cm). Inside: black and gold lacquer. Signed in *chinkinbori* (incised lines into which powder or lacquer is brushed, making the design or inscription readily visible): Koma Yasuaki, late eighteenth century. Previous Collection: W. L.

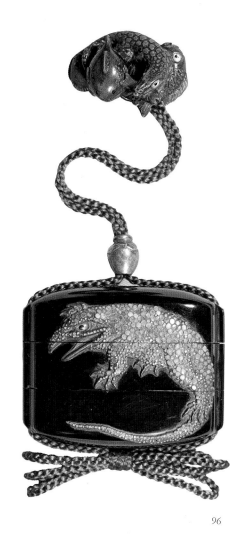

96

Behrens. *Netsuke*: wood, crocodile, and fish, eyes inlaid. w. 1 3/4" (4.5 cm). Signed Ikkyū, nineteenth century. *Ojime*: silver jar. Charles A. Greenfield Collection, New York

This inro is especially unusual because of the nature of the design. The lizard-like creature is very effectively represented in relief on its surface; the technique of *same-nuri* captures its rough, pebbly skin. The Japanese were well equipped to do this since they had used sharkskin on their swords and its translation into lacquer is very competently achieved. On the reverse of the inro is a design of waves highlighted by

gold lacquer. The entire ensemble is one of great novelty and skill.

The inro is signed Koma Yasuaki. There are three artists recorded who used this name: one was the second-generation Koma, Kyūzō I; the second was Kyūzō III, who also was Koma IV (d. 1732); the third appears to be an independent Koma master who also used this name.

The water theme of the inro is carried a step further in the wood-carved netsuke of fish and a crocodile, and in the silver *ojime* fashioned like a water jar. The netsuke-maker was Ikkyū, a talented, little-documented, nineteenth-century master.

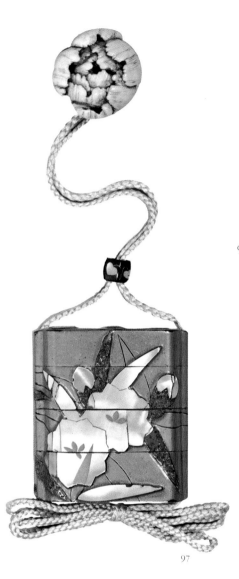

painter, he was also a very talented designer of lacquers. This piece, combining large areas of fine mother-of-pearl with pewter inlays, is typical of his work. Kōrin loved this interplay between the textures of rich and humble materials. Set in an elegant gold-lacquered ground, areas of light and dark are in contrast. The design is simple and pure using little involvement with relief or three-dimensionality, for pattern is what really counted to Kōrin. The unsigned netsuke and ojime continue the floral theme.

The lacquer designers of the Rimpa school were very fond of using pewter as an inlay material. Kōetsu (see Nos. 23 and 24), the founder of the school, was probably the first master to use this material in relation to lacquer.

98. *Inro*: lacquer; four cases; *roiro* ground with some *mura-nashiji* (the use of metallic powder to form irregular, and at times dense, masses such as clouds or mist). Sleeping goose in ceramic of seven colors with gourds, flowers, and foliage in gold and red lacquer, green ceramic, mother-of-pearl, and lead, 3 x 3 ″ (7.6 x 7.6 cm). Inside: *nashiji* lacquer. Signed: ceramic seal, Kan, by Ritsuō (1663–1747). Previous Collections: Louis Gonse, and D. Bess. *Netsuke*: pottery, a goose, w. 1 1/2″ (3.8 cm). Signed: Makuzu. *Ojime*: agate bead. Charles A. Greenfield Collection, New York

Ritsuō—also known by his other names, Ogawa Haritsu, Kan, Naoyuki, and Kanshi—was a very talented, major, master lacquer artist. He is known not only for lacquer, but also for his paintings, wood carvings, and pottery. In addition to this, he trained with and was a friend of the great Edo-period poet, Bashō. Being a samurai he was also instructed in the use of weapons.

Ritsuō was born in Ise province. We know that he must have come to Kyoto because he was much influenced by Kōrin and his brother, Kenzan. That influence is clearly reflected in the use of inlays in his lacquers. Ritsuō also studied lacquer with Ogawa Kyokoku. To prove his own skill and originality, Ritsuō introduced the use of ceramic inlays. This technique serves almost as a trademark of his work.

The story is related that Ritsuō, though endowed with great talent, was not always able to market his work. Thus, for periods he was very poor and

at one point, to make ends meet was reduced to the production and sale of inexpensive clay dolls.

More than any artist of the age, Ritsuō embellished his lacquers with inlays of all sorts of material. In doing this he employed ceramics, jade, ivory, mother-of-pearl, tortoiseshell, carved cinnabar, mica, and metal. Delighting in capturing the essence of old and worn materials, he often cleverly imitated them in lacquer. Thus, he made many inro in the form of old, treasured ink sticks. Another characteristic of his work was to keep the ground simple and natural so that it would contrast with the lacquer and inlays. His work, in a manner of speaking, is a form of collage.

The peaceful scene of a goose at rest on this inro is characteristic of his work.

The ground is simple; ceramic, lead, and mother-of-pearl inlays were used. I has great simplicity as well as elegance. and the design could easily translate to a painting. The piece also carries the ceramic inlaid seal with which he signed most of his pieces. It reads Kan. We must keep in mind that his able pupil, Haritsu II, Mochizuki Hanzan (c.1743–1790) (see No. 128), also use his Kan seal, and it was often copied and forged. The sleeping ceramic goose of the netsuke and *ojime* continues the bucolic nature theme.

99. *Inro*: lacquer; two cases; *roiro* ground with a porcelain owl perched among gilded and mother-of-pearl posts strung with rattle boards, 2 5/8 x 2 3/4″ (6. x 7 cm). Inside: gold and red lacquer Signed: Ritsuō; and green ceramic seal.

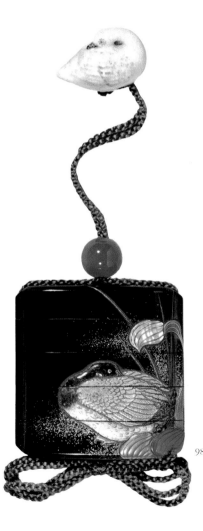

97. *Inro*: lacquer; three cases; *kinji* (gold lacquer) ground containing minute specks of metallic gold, mallow plants in mother-of-pearl and lead, 2 3/8 x 2 1/8″ (6.1 x 5.4 cm). Inside: gold lacquer. Inscribed inside lid: Hokkyō Kōrin *kakihan* (cipher), by Ogata Kōrin (1658–1716). Previous Collection: Louis Comfort Tiffany Foundation. *Netsuke*: ivory, peony blossom, diam. 1 1/4″ (3.2 cm). *Ojime*: ebony, with leaf design in mother-of-pearl inlay. Charles A. Greenfield Collection, New York

Kōrin's biography has already been discussed in No. 27. In addition to being a

suō's ceramic production is highly skilled, and he must have maintained special facilities in which to fire the small detailed pieces used in his lacquers. Actually, since as yet no scholar has come to grips with this problem, it presents a challenge for future researchers. An analysis of Ritsuō's materials would be very useful. At present one is tempted to think of him as a scavenger saving scraps and bits of unusual materials to use in his work.

The owl is well fashioned, with carefully detailed plumage and features. It perches on a post, part of a fence from which are suspended rattle boards used as a scarecrow device. The netsuke by Ikkyū continues the theme of the owl; the eyes of the bird are inlaid with ivory. It is a tiny animated carving of a young owl nesting in the hollow trees. When the netsuke is moved the bird pokes its body out through the opening to announce its presence. The naturalistic cicada which decorates the *ojime*, though later in date than the inro, harmonizes superbly with it.

100. *Inro*: lacquer; three cases; *kinji* (gold ground), *sumie* (ink painting) design of a dragon in a cloud over a wave. Inside: *ginji* (silver ground) with scattered *hirame* (flattened gold or metal filings) set into the lacquer, 3 3/8 x 3″ (8.6 x 7.6 cm). Signed: Hōgen Jotekisai Ga Jōkasai (by Yamada Jōkasai after a design by Hōgen Jotekisai), late seventeenth-early eighteenth centuries. Previous Collection: Moslé. *Netsuke*: ivory, dragon, l. 2″ (5.1 cm). Signed: Shōunsai, nineteenth century. *Ojime*: amber bead. Charles A. Greenfield Collection, New York

The Yamada school of inro artists was an offshoot of the large and talented Kajikawa school. The founder of the Yamada style was Jōkasai, who lived in Edo. His skill was such that he was appointed to be inro-maker to the Tokugawa shogunate. Jōkasai's lacquers are all of high quality and very well executed. On some of his work he used relief metal to embellish the design. This inro on which he painted a dragon in black lacquer is much more painterly. It actually represents the transfer of a painting design into lacquer by Kanō Terunobu, who died in 1763. Jotekisai was one of the studio names of Terunobu. Though

inro often reflected the influence of designs by other artists, few were copied with as much care as this one. One actually is aware of the brushwork of the painting as the dragon moves above the wave.

The dragon-shaped netsuke is splendidly carved. It was done by Maeda Shōunsai, a nineteenth-century Edo master, who was the father of Shōmin (born in 1841).

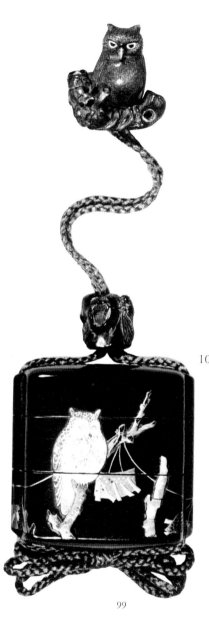

99

Kan, by Ritsuō (1663–1747). *Netsuke*: wood and ivory; owl with young on a tree stump, h. 1 1/2″ (3.8 cm). Signed: Ikkyū, nineteenth century. *Ojime*: *umimatsu*, pine; cicada on a tree stump. Signed: Rensai; nineteenth century. Charles A. Greenfield Collection, New York

Ritsuō's penchant for using a variety of materials to embellish his lacquers is evident here again in his treatment of this inro. The ceramic owl stands out in contrast to the rich black ground. Rit-

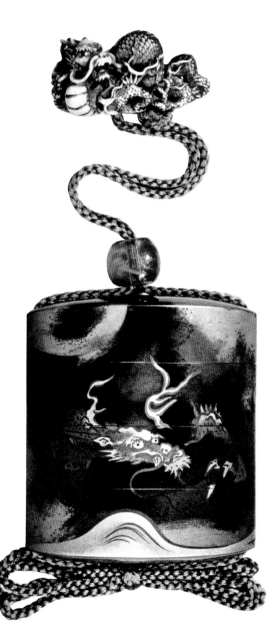

100

101. *Inro*: lacquer; five cases; *roiro* ground, decorated with a basket of flowers in carved lacquer of various colors in high relief, 3 5/8 x 2 1/4" (9.2 x 5.7 cm). Inside: gold lacquer. Signed in *chinkinbori*: Yōsei (probably Yōsei XI, d. 1735), eighteenth century. Previous Collections: E. Gilbertson, and H. C. Clifford. *Manju netsuke*: lacquer, olive-green ground with three carved red dragonflies, *chinkinbori* rims, diam. 1 1/2" (3.8 cm). Signed inside: Yōsei. Previous Collections: W. L. Behrens, and H. C. Clifford. *Ojime*: ivory. carved coral. Charles A. Greenfield Collection, New York

The still life arranged in a woven basket depicted on this inro should recall work by Eii and also the references made to still life in discussing No. 16 by Sesson. Basically, the flowers appear to be chrysanthemums and rose mallows, thus setting the time as autumn. Since it is also a very free arrangement, it is not typical of the highly stylized formulas used in *ikebana*.

There were nineteen generations of artists who used the Yōsei name. The founder was active from about 1356 to 1361; the last master died in 1952. The artists who were part of the Yōsei school were especially talented in the production of *tsuishu* (carved red lacquer) and *tsuikoku* (carved black lacquer). The technique was derived from China where magnificent works carved from cinnabar lacquer were produced in the Ming dynasty. The Yōsei school artists were also talented in producing *guri* lacquers. In this technique, layers of colored lacquer are alternated and, by using a V-shaped cut, the artist incised them to reveal the various layers.

The Yōsei master who produced this inro was in all likelihood Yōsei XI, who was also known as Chōsei and Nagamori. He was a very talented artist who died in Edo in 1735. On this piece he employed a rare combination of colored lacquers to indicate the flowers in the basket. The netsuke is of a button type commonly called *manju*; it was also created by the maker of the inro. The dragonflies found on the netsuke and the plum blossom carved into the coral *ojime* harmonize well with the inro's nature theme.

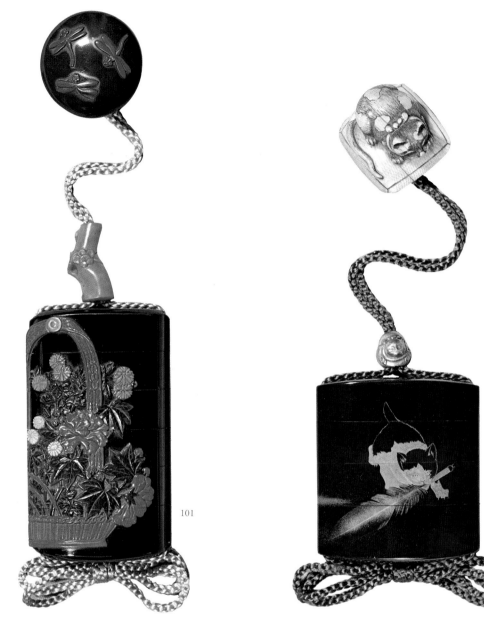

101

102

102. *Inro*: lacquer; three cases; *roiro* ground, a black and silver kitten carrying in its mouth a green and blue feather, in color *togidashi*; on reverse, a basket of flowers in green, gold, and silver *togidashi*, 2 3/4 x 2 5/8" (7 x 6.6 cm). Inside: *nashiji* lacquer. Signed: Katsunobu, nineteenth century. Previous Collections: Louis Gonse, and D. Bess. *Netsuke*: Ivory, cat on a pillow. *Ojime*: metal, a cat. Charles A. Greenfield Collection, New York

Katsunobu, the artist who produced this inro, obviously had a great understanding and sensitivity for cats. Unfortunately, nothing is really known about him.

The kitten he has depicted on this inro carries a large feather in its mouth. Such themes were common in Yi dynasty Korean art. Korean artists displayed a great deal of affection for cats, and in a like manner Katsunobu's statement is warm, charming, and humorous, with a feather that is almost larger than the cat. To lighten it Katsunobu executed the feather in a *togidashi* technique, which gives it an airy effect. On the reverse he drew a finely composed basket of flowers with a path—also done in *togidashi*—leading to it. The netsuke and inro repeat the use of a feline as the theme.

103. *Inro*: lacquer; three cases; *roiro* ground, decorated in *togidashi*, an iris plant with green leaves and white and cobalt blue flowers; on reverse, wild goose on a stream with lotus-like flower in green and gold *togidashi*, 2 3/4 x 2 3/4" (7 x 7 cm). Inside: red and gold lacquer. Signed: Kansai; by Koma Kansai II (1767–1835). Previous Collections: W. L. Behrens, and D. Bess. *Manju netsuke* lacquered wood; encrusted with painted crystal leaves and ants, diam. 1 1/2" (3.8 cm). Signed: Meiseki. *Ojime*: bronze metal; bead decorated with silver iris. Signed: Tomoyuki (active 1861–1863). Charles A. Greenfield Collection, New York

The use of colbalt blue as a color on an inro is extremely rare. In this example, it is employed for the well-drawn irises which decorate one side, along with the leaves of the plant and the very fine vertical shoots of grass. The intensely rich blue stands out against the black ground and harmonizes well with the green and gold of the leaves. On the reverse side a wild goose floats in a pond with flowers. This side is much less dramatic and it seems as though the artist purposely sought to create a contrast between the two principal surfaces of the inro.

This inro is signed Kansai and it is believed to be by the second-generation Koma Kansai, who was also known as Sakanouchi Jūbei II. He was a highly respected lacquer artist employed by the shogun Tokugawa Ienari. The Koma school which Kansai II represents was a collateral branch descended from Koryū, also known as Kimura Shichiemon, an eighteenth-century master and follower of Kyūzō III. Koma Kansai II is also important because he served as the teacher of Shibata Zeshin (1807–1891; Nos. 82, 83, 84, 85, 86, 121, 122, 123, 124, and 125).

104. *Inro*: lacquer; four cases; *roiro* ground, a dragonfly, with body of green *takamakie*, and wings of extreme delicacy and transparency in opalescent *hiramakie*, alighting on a stalk of golden bamboo, 3 x 2 3/8" (7.6 x 6.1 cm). Inside: *nashiji* lacquer. Signed inside lid: Shiomi Masakage, and seal: by Shiomi Masakage, early eighteenth century. Previous Collections: Louis Gonse, and D. Bess. *Netsuke*: wood, piece of broken bamboo with folded bamboo leaf in which is concealed a spider, part of whose web is seen in impressed lines (done by steaming the wood), h. 1 1/2" (3.8 cm). Signature: unread. Previous Collections: W. W. Winkworth, and D. Bess. *Ojime*: agate bead. Charles A. Greenfield Collection, New York

The inro artists of Japan had a great love for natural themes, and many would combine realistic elements with decorative elements to create distinguished pieces. Such an artist was Shiomi Masakage, who produced this very elegant inro. Little is known

about Masakage except that he was a member of the Shiomi family of artists. He was in all likelihood a descendant or pupil of Shiomi Masanari (c. 1647– c. 1725).

Painted in different tonalities of gold, the bamboo stands out richly against the *roiro* ground in this piece. Masakage magically captures the nature of a dragonfly alighting momentarily on a bamboo stalk. It is difficult to believe that the wings of the insect are not real; they have the

sheen and transparency of the live dragonfly. One almost expects to see them flutter.

The difficulty of working with the vexing quality of raw lacquer material must have perplexed many artists though obviously Masakage mastered the problems. The bamboo-shaped netsuke added to this inro continues the theme and suits the piece well. Actually, the combination of the elements in an ensemble of inro case, netsuke, *ojime*, and cord is a fine art in itself.

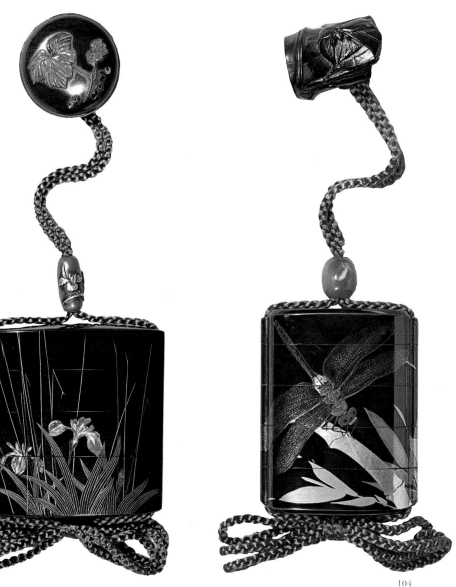

103

104

173

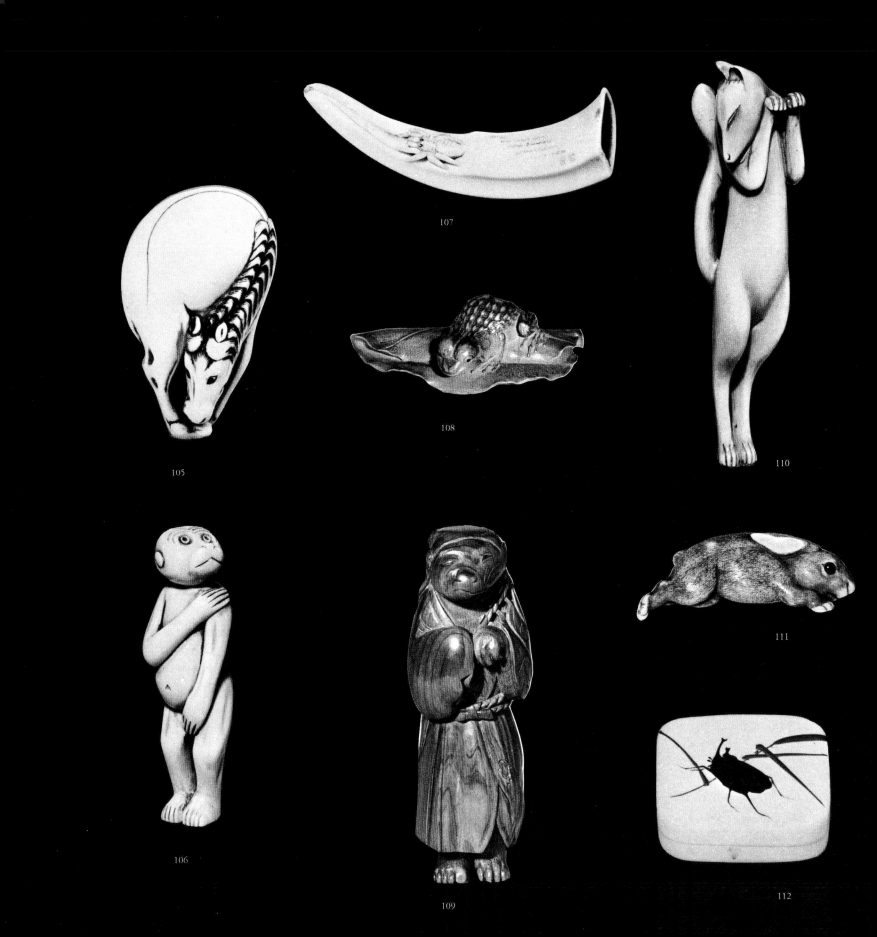

105

106

107

108

109

110

111

112

113

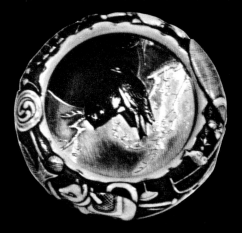

114

115

116

117

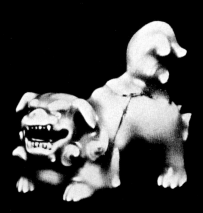

118

119

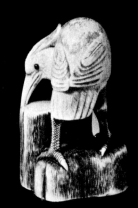

120

105. *Netsuke*: ivory; horse; pupils of eyes inlaid, eighteenth century. L. 2 1/2" (6.4 cm). Charles A. Greenfield Collection, New York

Netsuke, as already mentioned in discussing No. 93, are toggles that were used to attach inro cases to one's clothing. They are small sculptures carved with great care and attention to detail. They were made by a special group of artists who fashioned them from a wide range of materials, including wood, ivory, bone, ceramics, narwhal, metal, glass, amber, lacquer, and papier-mâché. Two holes would be drilled or carved into the netsuke, and the cord that bound the cases of the inro together would be knotted through them. The netsuke would thus become the finial and toggle of the inro ensemble.

Simple pieces of wood probably served as the first form of netsuke. The earliest carved pieces were unsigned, though a number of relatively large examples made of wood are attributed to Yoshimura Shūzan, who died in 1776. These usually portrayed mythological beings. As time passed the netsuke carvers turned to the same range of subject matter that appealed to the painters; nature served as one of the most important themes.

For this netsuke, the artist has carved a horse. Its graceful form follows the curve of the ivory and utilizes the raw material to its best advantage. The stylized treatment of the mane and the lively expression of the horse add to the charm of this small sculpture. The legs are drawn together to form a base. With age and natural handling, the netsuke has taken on a worn and warm appearance. In addition to being skillfully carved, a fine netsuke feels good in one's hand. Owners of pieces such as this one must have cherished their favorites and competed keenly with each other.

106. *Netsuke*: ivory; bashful monkey, eighteenth century. L. 2 7/8" (7.3 cm). Previous Collections: W. W. Winkworth, and D. Bess. Charles A. Greenfield Collection, New York

Often great humor is found in

netsuke. This monkey is one of the most appealing I have ever seen. Its eyes are wide open and innocent. One arm is bent and the hand rests on the shoulder as though to shield its breast, while the other modestly covers the genital area. Even the curled-down toes appear to accent the perplexed state of the monkey. There is no great attempt at realism; instead, the netsuke suggests a figure clad in a loose, enveloping monkey suit.

107. *Netsuke*: boar tusk; spider with inscription and seals, inscription reading: "In the neighborhood of Kawai River at Iwami, the daughter of Shimizu Iwanosuke Tomiharu carved this, the second year of Kansei, dog, fifth month of a blue sky, done outside the Tono River." Signed: Carved by Seiyōdō Bunshōjo; by Shimizu Bunshōjo (1764–1838). Charles A. Greenfield Collection, New York

The carvers of a remote area along the Japan Sea in the southwest corner of Honshu formed a school named for Iwami province in which they dwelt. They were very fond of using boars' teeth for their raw material, and this serves to distinguish their work. The Iwami artists also tended to inscribe their pieces with dedications or statements carefully incised with exceptionally fine lines.

On this netsuke the artist has carved a spider, crawling lazily along the length of the tusk. In the inscription, the artist gives her identity. She was Shimizu Onoe, the daughter of the founder of the school, Tomiharu (1723–1811). She was also known as Iwao II and she was a superb master of netsuke carving.

108. *Netsuke*: Boxwood; frog on a curled lotus leaf. Signed in raised characters: Tomiharu and Kawa(i) Seiyōdō; by Shimizu Tomiharu (1723–1811). L. 2 5/8" (6.6 cm). Charles A. Greenfield Collection, New York

The frog seated on a folded lotus leaf, the subject of this great netsuke, appears to be scanning the water on which it floats as it searches for food. The artist Tomiharu has captured

the character of the frog with great ability. By using fine lines and talented chiseling he has also made the lotus leaf seem real.

This netsuke is by the founder of the Iwami school, Shimizu Iwao. Also known as Iwao I, he was the father of Bunshōjo (see No. 107). Tomiharu, who was born in 1723, joined the priesthood in 1745. However, his biography reports that he traveled to Edo, abandoned Buddhism, and subsequently married.

Frogs, such as the one shown here, were one of Tomiharu's favorite themes. He also often portrayed snails, spiders, and crabs.

109. *Netsuke*: wood; badger changing from beast to priest, nineteenth century. L. 3 1/2" (8.9 cm). Charles A. Greenfield Collection, New York

In Japan it was believed that badgers were mischievous and possessed the talent to bewitch people. The artist who carved this relatively large and entertaining netsuke depicted a badger changing from an animal into human form. The metamorphosis is a marked one, and the carver very adroitly indicated the transformation. A wormy leaf raincoat becomes a robe, while the paw vanishes into the sleeve and the whiskers disappear. One-half of the figure is garbed as a mendicant priest who appears to be a humble and simple soul. The other half remains a clever and alert badger.

The artist who carved this netsuke employed relatively bold and broad chisel and knife strokes.

110. *Netsuke*: ivory, stained; dancing fox (*kitsune odori*), nineteenth century. L. 4 1/4" (10.8 cm). Charles A. Greenfield Collection, New York

A number of netsuke carvers selected relatively tall and thin pieces of choice ivory to use for representations of dancing foxes. The subject matter was well suited to the material, and the honey color of the aged ivory suggests the fox's coat. The fox stands on its toes, raising its forelegs and bending its paws. It rests its head on its right shoulder and its long tail curves up behind it, almost as a cushion for the

176

CONTINUED ON PAGE 189

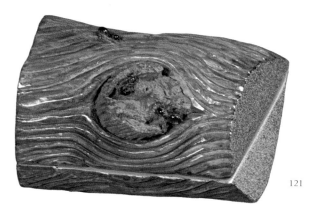

121.

121. *Kōbako* (incense box): wood; carved in form of part of a tree trunk with lacquer ants; sides and inside, gold and *nashiji* lacquer. Bottom, *roiro* with signature Zeshin and seal. Inside cover, *kakihan* by Shibata Zeshin (1807–1891). H. 1 1/2″ (3.8 cm); w. 2″ (5.1 cm); l. 3″ (7.6 cm). Previous Collections: Vignier, and D. Bess. Charles A. Greenfield Collection, New York

We are already familiar with a number of Zeshin's works (Nos. 82, 83, 84, 85, and 86). He was endowed with incredible skill and the mark he left on the art world of Japan is indelible. In this small box created to hold incense, Zeshin again reveals his devotion to natural forms and textures as well as his love for even the tiny ant.

The *kōbako*, which is the name given to such incense containers, is carved to resemble a tree's limb. The wood is grooved and the regularity of these striations is stylized. Zeshin's treatment reveals that although he sought naturalism and realism, design and pattern played an important role in his art. The perfection of the wood is marred by a knothole. To exploit the defect, Zeshin painted it pitted by insect holes and deterioration. He also placed two ants wonderfully fashioned of lacquer in this area and a third ant crawls along a furrow formed by the grooves in the wood.

The two sections of the box fit together very well. Zeshin used a gold *nashiji* lacquer to decorate the ends of the box. Once again, the piece is a triumphant statement of the miracle accomplished by a great lacquer master and artist.

22. *Inro*: lacquer; one case; dark green *iji-iji-nuri* ground imitating a wrinkled surface with chestnut branches on one

side and loquat branches on the other, in *takamakie* of various colors and some carving, 3 1/8 x 2 1/2″ (7.9 x 6.4 cm). Inside: black lacquer. Signed: Zeshin; by Shibata Zeshin (1807–1891). *Netsuke*: wood, chestnut. Signed: Ōuchi Sōsui (1907–1972). *Ojime*: coral bead. Charles A. Greenfield Collection, New York

This lacquer provides us with a superb example of Shibata Zeshin's supreme mastery of the lacquer craft and inro. Zeshin had a great fascination with textures, and much like Ritsuō (see Nos. 98 and 99) was fond of imitating natural materials and forms. In Nos. 82, 83, 84, 85, and 86, evidence was shown of Zeshin's talent at painting. He was wedded to art and his designs have great originality and skillful execution. Zeshin favored the dark green color he used for this inro; it is a very deep color that appears almost black in certain light. The ground was also executed in a technique termed *iji-iji-nuri*, created to imitate aging or well-worn surfaces. To make it, the lacquer artist builds up a network of lines which form low relief patches. The impression created here is one of a scaling or flaking surface. The chestnut, its burr, and its worm-eaten leaf are all beautifully defined. The loquat that Zeshin painted on the reverse side is placed against a much smoother ground.

The chestnut netsuke by Ōuchi Sōsui currently affixed to this inro is realistically executed and harmonizes well with it. It seems to cast the Zeshin drawing into a three-dimensional form. Sōsui was a very talented modern netsuke-carver who lived and worked in Tokyo. His father was Gyokusō who was born in 1879.

123. *Inro*: lacquer; five cases; brown to imitate bamboo, with a spider in raised

lacquer; reverse imitates a natural bamboo surface, 3 x 1 1/2″ (7.6 x 3.8 cm). Inside: gold lacquer. Signed under lid: Shōsai *kakihan*, by Shirayama Shōsai (1853–1923). *Manju netsuke*: brown lacquer, rabbit among flowering plants, diam. 1 5/8″ (4.2 cm). Signed: Zeshin, by Shibata Zeshin (1807–1891). *Ojime*: aventurine bead. Charles A. Greenfield Collection, New York

Shirayama Shōsai, one of the later lacquer artists, was on the faculty of the Tokyo School of Fine Arts. His skill was recognized by the Imperial Household and he was employed at the Imperial Palace. Shōsai was noted for his meticulous work, and his ability in many styles.

This inro case takes the form of a single stalk of bamboo with a spider crawling on it. Only the use of brown lacquer to cover the surface of one side of the inro and the spider destroys the illusion of reality. On the reverse side Shōsai captures with fantastic precision the natural appearance of bamboo. The surface of both sides is rich and sophisticated and conveys the feeling of near perfection that understatement can achieve.

The netsuke is not a typical round form of *manju* but is shaped like a small rectangular box. On it Zeshin executed the humorous and naive rabbit and chrysanthemum design.

In examining an inro like this, one can well understand the striving for originality as well as the desire to be the proud possessor of masterpieces.

122.

123.

124. *Jūbako* (a tier of nested boxes—a picnic box): five sections with two lids; boats laden with rice sheaves on waves with flying *chidori* (plover); in black, brown, and gold lacquer on a dark green *iji-iji-nuri* ground with pewter and shell inlay. Inside, red lacquer. Signed inside both lids: Zeshin; by Shibata Zeshin (1807–1891). H. 16 1/8" (41 cm); w. 9" (22.8 cm); l. 9 5/8" (24.5 cm). Previous Collection: D. Bess. Charles A. Greenfield Collection, New York

Picnics were a very important part of social life in the Edo period and the wealthy daimyo, retainers, and merchants often assembled outdoors to enjoy the warmth of the sun and the beauty of the flowering plum, cherry blossoms, chrysanthemums, and maples. Picnics became almost a ritual, and were conducted with great elegance.

This superb lacquer box was made by Zeshin for use at a grand picnic. It is one of the largest lacquer works he

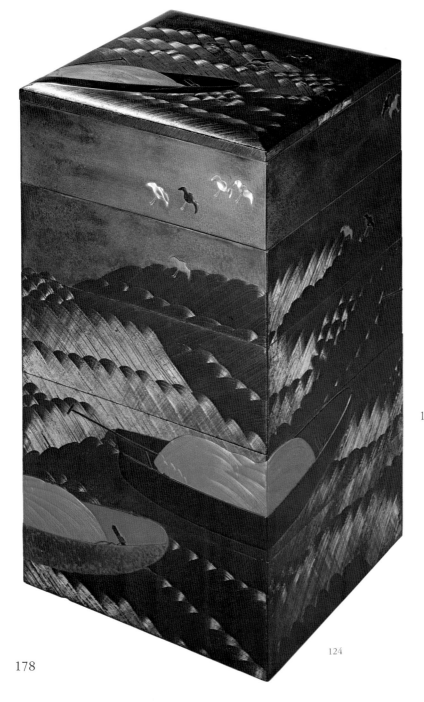

124

made which has survived and it is also one of the most beautiful. Zeshin's lacquer (Nos. 82, 83, 84, 85, 86, 121, and 122) is always distinguished in terms of quality and care of fabrication. His concepts of design were very original and his lacquer work marks him as a genius. On this large nest of boxes he employed a number of favorite themes and techniques. Zeshin was very fond of indicating waves in black or dark brown lacquer. Apparently he built them up in broad bands and then raked through them with a fine-toothed implement to indicate the movements of the water. The light catches in the waves and reflects off them to create a definite sense of movement. At the same time, Zeshin's wave treatment is highly stylized, and a lacquer decorated in this manner is evidence of Zeshin's hand or of his influence. Floating on this churning sea are boats laden with golden sheaves of rice, and the grain is made in the same manner. It contrasts beautifully with the water and boats; the dark water takes on an oxidized, almost silvery sheen while the golden rice radiates a warm glow. The sky above the sea is done in the same weathered, green, *iji-iji-nuri* technique we saw Zeshin use in the chestnut and loquat inro, No. 122. Flying in the darkened sky are plover. These Zeshin produced with inlays of mother-of-pearl, pewter, and forms painted in lacquer. The design continues around the sides and onto the cover of the box. It is a fantastic piece of workmanship.

125. *Suzuribako* (inkstone writing case): lacquered wood; rabbit in tall grass, in gold lacquer on brown ground; inside cover, moon shining through trees, in pewter, mother-of-pearl, and gold lacquer on red ground; inkstone and bronze *mizuire* (water container), sixteenth century. H. 2" (5.1 cm); w. 6 5/8" (16.8 cm); l. 11" (28 cm). Previous Collections: Vicomte de Sartiges, Vignier, and D. Bess. Charles A. Greenfield Collection, New York

China was the source of origin of the inkstone writing case called *suzuribako* by the Japanese. The Chinese did not concentrate greatly on the box but rather on the ink it housed, lavishing great attention on the

decoration of the ink sticks. In contrast the Japanese devoted much attention to the cases and transformed them into objects of great beauty. The *suzuribako* has a basic form: it consist of a covered, rectangular, relatively shallow box. The interior usually was divided into four sections. A division, generally located in the center of the case, consisted of a frame into which was placed a smooth slatelike stone on which to grind ink. This was flanked on either side by a tray intended to hold brushes or sticks of ink. The last division, either above or below the ink stone, held a small container for the water needed for the ink-grinding process. These tiny vessels were made of many materials including metal, ceramic, and lacquered wood. It was standard procedure for lacquer artists to decorate the surface of all these divisions, including the underside of the box's cover.

Few early *suzuribako* of large size have survived. In this one the decoration is quite entertaining. On the cover the unknown artist painted a long-eared rabbit with exceptionally long rear legs. It is about to enter a thicket of tall grass. There is little attempt at the realism which was a feature of later pieces. Instead the artist concentrated on pattern and design. The decoration was flat and bold and the gold contrasts with the brownish ground (early lacquer often had a brownish cast). The interior has a moon and tree design. In China and Japan, the rabbit was often associated with the moon. There are many representations of a rabbit in the moonlight pounding the material for rice cakes in a mortar. The fantastically long legs of this rabbit might provide the needed power to project it to the moon. It is a fine design.

126. *Ryōshibako* (a writing paper or document case): cover and sides with branches of clustered plum blossoms interspersed with the Tokugawa crest in gold and silver *takamakie* and applied sheet gold on *nashiji* ground with gold lacquer border. Inside, *nashiji* lacquer, eighteenth century. H. 2 1/4" (5.7 cm); w. 8 1/2" (21.6 cm); l. 9" (22.8 cm). Previous Collection: Samuel T. Peters. Charles A. Greenfield Collection, New York

125

this instance reminds me of glistening sand rather than pear skin.

The decoration of this box points up the skill of the lacquer masters. The plum blossoms are roughly round and highly stylized. The artist used a number of varieties of gold for the blossoms as well as for the trunks of the trees. The many textures and hues reflect the light in different ways and stimulate one's visual interest in the design.

Because of the presence of the crests, the piece is obviously associated with the Tokugawa shogunate or one of the branches of the family. It may have been commissioned by them but also it may have been ordered as a gift for the Tokugawa or a friend they wished to honor. Because they blossom so early following the winter's cold, the plum trees and their beautiful blossoms are symbolic of rebirth. They are also equated with longevity. One hopes that the rich and beautiful design of this case served as an inspiration for the writer who used the paper it was fashioned to hold.

126

A grove of flowering plum trees is the theme that decorates this sumptuous case intended for holding documents or supplies of beautiful hand-made paper. Four large trees and five smaller ones are used to decorate the cover of the case. Interspersed between the trees are five elegant crests of the Tokugawa family. They are carefully executed in gold and silver lacquer and three of them are placed roughly on a diagonal so that they bisect the cover of the case. The design found on the cover overlays the sides of the case. All of the pattern stands out, for it is set against a fine *nashiji* ground that in

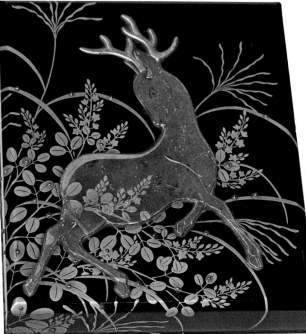

127

127. *Suzuribako*: rectangular form, the cover with beveled edges and decorated in pewter with a stag running among gold *hiramakie* autumn grasses, on a *roiro* ground; the interior with flowers in similar style, fitted with *mizuire* (water container) and inkstone, late seventeenth–early eighteenth centuries. W. 4 5/8″ (11.7 cm); l. 5 1/2″ (14 cm). Charles A. Greenfield Collection, New York

The stag which decorates this *suzuribako* should call to mind the Sotatsu design found on No. 23. Unquestionably the decoration is the work of an artist trained in the Rimpa tradition. This is indicated not only by the simplicity and decorative flatness of the pattern but also by the artists' materials. The Rimpa school favored the use of broad pewter inlays. Here the pewter was incorporated into the pattern before the lespedeza and autumnal grass were added. The deer turns as he daintily moves his legs, and the graceful slope of the stag's body is echoed in the curving plants. Rimpa lacquer artists also tended to use broad areas of contrasting materials to build up their designs as was done here. A floral pattern decorates the interior of the case and small dewdrops in relief are scattered onto the leaves of the

lespedeza plant. There is a restrained elegance found here and in other Rimpa lacquers.

128. *Suzuribako*: natural wood; with edges in black lacquer with gold design, quail among fully ripened millet, in pottery, pewter, mother-of-pearl, and gold lacquer; inside cover, rattle board tied to bamboo pole in gold lacquer on *mura-nashiji* ground; inkstone and *mizuire* of gold-plated copper. Signed inside with seal: Hanzan; by Mochizuki Hanzan (c. 1743–1790). H. 1 3/4″ (4.4 cm); w. 8 1/4″ (21 cm); l. 9 5/8″ (24.4 cm). Previous Collections: M. A. Huc, Mme. Gadiot, and D. Bess. Charles A. Greenfield Collection, New York

An artist who was very skilled in working with both lacquer and ceramics was Mochizuki Hanzan. He is known to us because his work resembles that of Ritsuō (1663–1747; see Nos. 98 and 99). Actually, Hanzan is considered to be the second generation Haritsu (Ritsuō). Obviously he was not a direct pupil since he was a very young child when Ritsuō died. In all likelihood, Hanzan's admiration for Ritsuō's work made him a slave to the manner and techniques he had employed. Hanzan also made use of the Kan seal used by Ritsuō and their works are often confused. Hanzan's lacquers are comparatively sweeter and not as bold in design. They are triumphs of

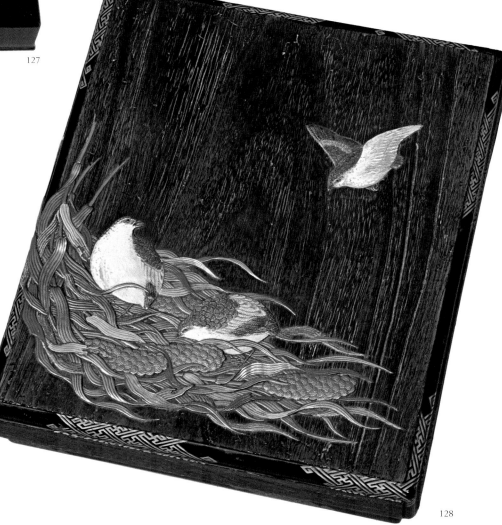

128

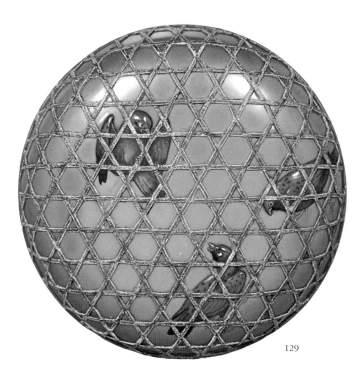

129

execution as is attested by the design of quail in millet seen here.

The composition is a very peaceful one. Two quail have discovered and are enjoying some fully ripened millet. A third quail plummets from the sky to join them. The use of ceramic and other inlays forms a wide range of colors which combine with the gold. The richness of the design and the care with which it was created contrasts with the simple unfinished wood ground. The color of the wood and the grain establish the autumnal nature of the theme. Hanzan was known for his interest in detail and that is evident by the decoration on this *suzuribako*. His skill in ceramics is also established by the quality of the inlays. He learned his craft from his ceramic teacher, who was probably Yōsei XIII, XIV, or XV. The use of quail in this composition may well be derived from paintings by artists such as Tosa Mitsuoki (1617–1691) who often used a similar theme.

129. *Kōbako* (incense box): *fundame* top, *rogin* bottom, *nashiji* interior, and pewter rims; the lid is covered with a network of pewter representing a cage behind which three birds are perched; they have gold lacquer bills and claws,

eyes of crystal, and bodies of shaded brownish red and charcoal lacquer in high relief. Signed: Kanshōsai; by Iizuka Tōyō, eighteenth century. H. 1 5/8″ (4.1 cm); diam. 4 1/4″ (10.8 cm). Previous Collection: D. Bess. Charles A. Greenfield Collection, New York

Iizuka Tōyō, the same artist who made the handsome inro of crows placed in a night setting (No. 94), was the creator of this incense box. Normally, such containers are smaller in scale. The design was used from time to time by lacquer artists but Tōyō's interpretation is novel. He covered the piece with a flat matte ground of gold lacquer; a technique called *fundame*. He then inlaid the cover with a lattice of pewter strips regularly spaced to give the impression of a wire cage. Captured behind this wire he modeled in relief three lively sparrow-like birds. Only one actually clasps the wiring; the other two rest on the golden bottom of the cage.

There is a wonderfully precise quality to the entire arrangement and its execution. In terms of design all is in order, though two of the birds appear to be quarreling. The third one looks at the ground and ignores them. Pieces like this display the lacquer artist's skill in employing various materials and fashioning or treating them to resemble something else. It is also a monument to Tōyō's ability to capture nature.

130. *Case*: two-tiered, in the form of a section of bamboo, carved with a dark green-blue lacquer, the cover showing ladybugs in red and silver *takamakie* with black details, and a gold, silver, and *shakudō* snail shown crawling up the side; the base is *roiro* and the interior, *nashiji*. Signed: Shigesai, nineteenth century. H. 6 1/4″ (15.9 cm); diam. 2 1/4″ (5.7 cm). Charles A. Greenfield Collection, New York

We know actually nothing of the lacquer artist who conceived and brought this handsome case to fruition. From the free design and the manner in which it is interpreted, as well as the quality and greenish-blue

color of the lacquer, we feel the case is nineteenth century. The natural bamboo shape is bold and striking, and the addition of the snail and ladybugs is a whimsical touch. They are beautifully composed and built up of layers of lacquer. One is almost tempted to sit and wait for them to move over the surface. Will the snail dine on the bugs? The love of nature is truly reflected in the lacquers of all periods.

130

131. *Horses and Pines* (Stencil). Artist unknown. Edo period, late nineteenth century. Paper and silk thread, 15 3/4 x 10 1/2″ (40 x 26.5 cm). The Art Institute of Chicago. Frederick W. Gookin Collection

Stencils for the application of designs to textiles were used from at least as early as the Nara period and, through the ages, the Japanese artisans mastered the skills both of their production and their application. Stencil-dyed fabrics appeared in common use in the sixteenth century, but the age in which its employment truly flourished was the Edo period, when stencil-dyed designs became the vogue for cotton *yukata* (lightweight kimono-style robes) or for ordinary household textiles. The stencils used to produce these designs became increasingly complex because with the growth of wealth and fashion consciousness there was keen competition to be the best and most uniquely dressed. The true zenith of stencil-patterned cloth was reached in the nineteenth century when the growing population demanded ever-changing designs.

Stencils were made of paper and were usually sized with persimmon juice to give them added strength. They varied in dimension, but normally were approximately fourteen by fifteen inches. The simpler designs were cut into a single sheet of paper, but as designs became increasingly delicate and complex, the stencil-makers found it wise to cut the design through two sheets of paper and place very fine silk thread between the sheets before joining them. This permitted the use of designs with finer lines and overall patterns. The usual process of dying was to stretch the fabric on a board, place the stencil upon it, and apply color-resist paste to the open or cut-out areas. It was an exacting and tiring procedure. After one side was completed, the patterns already outlined would be traced onto the other side prior to soaking the fabric in dye. For *yukata* the dye was usually indigo.

The men who produced and designed these stencils are often overlooked, though their designs are accomplished works of art. Great numbers of stencils

were destroyed because of heavy use, while others were discarded because no value was placed on them. Those that have survived inform us of the skill and competence of the master stencil-makers, not only as artisans but as artists.

This example depicts two horses frolicking in a grove of young pine trees. Though the design has been cut out, one can detect the sketch or brushwork of the artist who produced the design. The composition is very much in the Tosa school tradition with Kanō school touches also evident. The design is a joyous one and should make us remember the twofold screen of horses in a landscape (see No. 21). The large pattern and the subject indicate that the fabric was intended to be worn by a man.

132. *Cranes and Bamboo* (Stencil). Artist unknown. Edo period, late nineteenth century. Paper and silk thread, 16 3/4 x 10 1/2″ (42.5 x 26.5 cm). The Art Institute of Chicago. Frederick W. Gookin Collection

If one examines this stencil with care, one is struck by the likelihood it was produced by the same hand as No. 131. It could easily be a section from a painting done by any one of the academic bird and flower painters of Japan. Three cranes huddle together in a bamboo thicket, while a fourth stands on one leg looking down at them. The bamboo, tail plumage, and throats of the cranes are executed with a bold and broad cutting technique. In contrast, the legs, heads, beaks, and most of the plumage of the cranes, as well as the delicate stalks of the bamboo, are composed of much more finely cut lines. The birds relate to each other and there is adequate evidence to show that the artist who produced this stencil also had great competence in painting.

133. *Butterflies and a Plant on a Vertically Striped Ground* (Stencil). Artist unknown. Edo period, late nineteenth century. Paper and silk thread, 13 x 16 5/8″ (33 x 42 cm). The Art Institute of Chicago. Frederick W. Gookin Collection

Five lovely butterflies float weightless-

133

134

ly before a plant that resembles the *hagi* (bush clover), which, in turn, is cut into a vertically striped ground. A great number of techniques were employed in creating this most complicated and handsome stencil. In a painterly manner, the plant reaches across the composition. The stems are sturdy and intense while the leaves are executed in a softer manner. This was accomplished by thickening the vertical lines only in the areas which compose the leaves, thus creating for them a soft and shadowy effect. The butterflies vary and are not merely stereotyped symbols. Stencils like this one establish a great respect for the designers and cutters who produced them.

134. *Dragonflies* (Stencil). Artist unknown. Edo period, late nineteenth century. Paper and silk thread, 9 1/2 x 16″ (24 x 40.5 cm). The Art Institute of Chicago. Frederick W. Gookin Collection

Though this stencil has been much used and is damaged in a number of places, it remains an excellent example of the use of an overall pattern with a single theme. The dragonflies fill the entire sheet of paper, and one is not immediately aware of the use of repeats. Actually the composition is made up of panels of thirteen dragonflies which are joined to left and right by the same design. The insects have been cut out from the paper with only the essential elements represented, and it is the lack of finicky detail which makes the pattern so striking. The nature of the subject matter indicates that the finished fabric was intended for summer use.

135. *Sparrows and Pinks (Nadeshiko)*
(Stencil). Artist unknown. Edo period,
late nineteenth century. Paper and silk
thread, 11 1/2 x 16 3/4" (29 x 42.5 cm).
The Art Institute of Chicago.
Clarence Buckingham Collection

The sparrows and pinks form a
lacelike network in this stencil. Five
miniature birds fly among the flowers;
they twist and turn in different direc-
tions and their compact bodies fill
areas where the flowering blossoms
are sparse. Once again the artist
skillfully related the elements of his
design to create a pattern that is
worthy of standing alone or one that
could be repeated over and over again
to form a luxuriant bird-filled garden.
Executing stencils like this one imposes
great difficulties and I am continually
amazed by the lack of patching in the
cutting, as well as the endless variety
of fresh patterns. This stencil is so
delicate that one almost hears the
movements of the sparrows.

136. *Magpies and Flowers* (Stencil). Artist
unknown. Edo period, late nineteenth
century. Paper and silk thread, 11 1/4
x 16 5/8" (28.5 x 42 cm). The Art
Institute of Chicago. Clarence
Buckingham Collection

One rarely feels that stencils are by the
same hand, and nothing is really
known about the individual masters
who produced them. The time taken
to create a single stencil must have
been great and again indicates the
patience of the Japanese in the arts.
The techniques of cut-gold leaf
(kirigane), lacquer production and
decoration, *tarashikomi,* as well as
gesso-like relief *(moriage)* all share
this quality. All these methods re-
quired concentration, time, and in-
credible deftness.
 It is quite possible that this stencil
and No. 135 were done by the same
hand or in the same studio. This is
suggested by the design—magpies
standing on the edge of a stream that
meanders through thickly flowered
banks—and the way it is arranged and
cut out from the paper. The textile art-
ists had a great concern for pattern,
and with miraculous skill the stencil-
maker related the elements of his com-
position to create a rich, ever-changing
design.

137. *Bats on a Honeycombed Ground*
(Stencil). Artist unknown. Edo period,
late nineteenth century. Paper and silk
thread, 17 3/8 x 17 3/8" (44 x 44
cm). The Art Institute of Chicago.
Gift of G. H. Saddard

Incredibly long-winged bats in flight
against a sky of open honeycomb
design form this very elegant and
delicate stencil. One marvels at the
skill of the artist who produced it, for
it took great patience and control to
keep from cutting through the
boundary lines, which would have
destroyed the airiness and balance of
the design. The stencil-makers often
cut designs radiating in many direc-
tions because the patterns were intend-
ed for fabrics that would curve and
mold to the movement of the wearer's
body. Here the artist has beautifully
reduced the bat, symbolic of good for-
tune and longevity, to the bare essen-
tials, and made this often maligned
beast part of a superb pattern.

138. *Mandarin Ducks, Water Plants and
Iris* (Stencil). Artist unknown. Edo
period, late nineteenth century. Paper
and silk thread, 10 1/2 x 16 1/8"
(26.5 x 41 cm). The Art Institute of
Chicago. Frederick W. Gookin
Collection

Seven mandarin ducks swim in the
placid pond that serves as the
background for this stencil. The com-
position is a reserved one, and is
similar in many ways to painted
segments found in bird and flower
screens by artists such as Sesshū (see
No. 10), and Motonobu (see No. 12).
The design is a contained one that fills
the space well. It is a more painterly
stencil than No. 134, in which pattern
was the dominating force. The artist
has barely suggested the movement of
the water and strategically placed the
ducks so that they take shelter in the
plants. In one sense the composition is
a sad one, for traditionally the man-
darin duck is always shown with its
mate, and in this instance, since seven
appear, one must remain alone. The
finished fabric with its relatively
broad, unfilled areas, must have been
an elegant one. It creates a mood of
tranquility, stillness, and ease.

139. *Cat.* By Awashima Chingaku (1822–1888). Late Edo-early Meiji periods, nineteenth century. Kakemono, ink and color on paper, 40 1/2 x 15 3/8″ (102.8 x 39.1 cm). Harold P. Stern Collection, Washington, D.C.

Startled and more annoyed than most of the tigers that appear in this volume is this caricature-like cat by Awashima Chingaku. The cat was drawn with bold expressive brushstrokes and seems almost to move in unconscious haste. Its comically raised ears, wide open eyes, broad nose, bristling whiskers, and downturned mouth all indicate the cat's annoyance and amazement at what it views. The cat's hindquarters are done with a few broad swirling strokes that curve to form a ball shape and the wide tail swishes before it like an exclamation mark. The cat is so ridiculous in appearance that it becomes endearing. It sits against an undefined background.

The artist who painted this work was a strange man, and on learning of his eccentricities I feel at ease, because the painting has come to a proper home and proud possessor. Awashima Chingaku was born in 1822 and lived most of his life in Edo. During his lifetime, he used a number of names including Nampeidō, Jōzō, and Kitsubon. As a young man, he studied painting with the artist Ōnishi Chinnen (1792–1851) who had been a pupil of Nangaku (see No. 67). As a painter Chinnen adopted the Nanga manner and his pupil also roughly worked in that tradition. Chingaku, however, was a great individualist and he also showed a fascination for the painting style developed by Hanabusa Itchō (1652–1724), and Yosa Buson (1716–1783; see No. 45).

Chingaku was fascinated by the increase of foreign influence, and became a comic chronicler of Westerners in Japan during the pre-Meiji and Meiji eras. His sketches of foreign customs, which must have seemed outlandish to him, were published posthumously in 1919 in a work titled *Chingaku Manga (Chingaku's Cartoons)*. Many stories are related about Chingaku. He was said to be obsessed by foreign objects and their novelty. Thus he is supposed to have purchased two pianos although he could not play. He also is said to have suffered from a mania for collecting almost anything. His assemblage of objects grew to such a point that he soon required a warehouse. I am most sympathetic to Chingaku's plight for I also suffer from the same passion. It is for this reason, the comfort of company, as well as for his delightfully naive style, that I take joy in his cat painting which bears the artist's Chingaku seal.

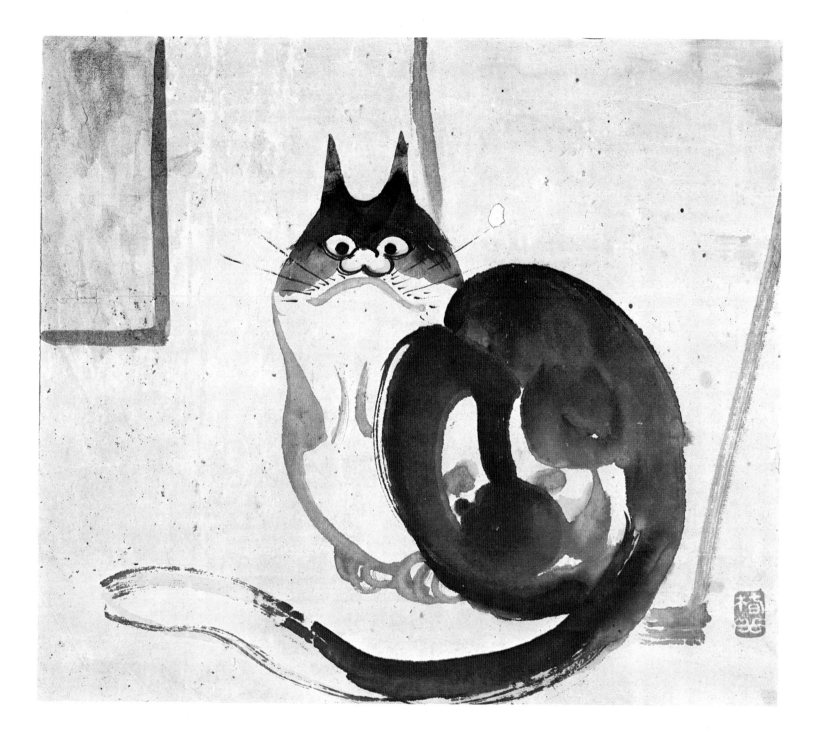

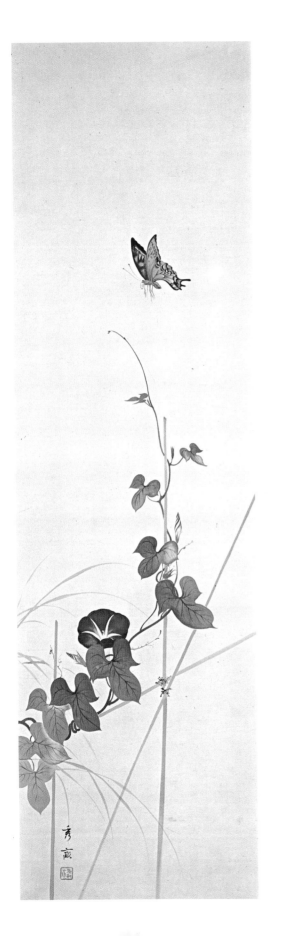

140. *Morning Glories and Butterfly*. By
Ikegami Shūho (1874-1944).
Modern period, twentieth century.
Kakemono, ink and color on silk,
77 1/2 x 18 3/4" (196.9 x 47.6 cm). The
University of Michigan Museum of
Art. Gift of Mr. and Mrs. Frederic R.
Smith

It is always difficult to part from
beauty and yet the transience of life
and nature surrounds us. The tradition
of nature in Japanese art is a long one;
it has not ended with modern times,
and I sincerely pray that it will never
cease to be a part of the Japanese
aesthetic experience. Illustrated in this
volume are works beginning with the
Ishiyama gire poetry page (see No. 1)
of the twelfth century to works of
recent times. Though changes
transpired through the centuries, the
basic theme and love, as well as
understanding, of nature has prevailed
in Japan.

Morning glories supported by stakes
are the subject of this fine painting;
they are painted with great delicacy.
The vine winds about and twists
around the thin stakes that assist its
ascent into the air and toward the sun
which nourishes and gives it energy.
The stylized leaves of the plant serve
as accent marks and create a pattern,
for the artist used different intensities
of tone and hue. There is only one
fully opened blossom on the plant and
we know it will close and fade;
however, four buds in various states of
maturity signify that the morning

glory will continue to live and add
beauty to our world. The artist also
placed several blades of grass in his
composition and these fill the
background unobtrusively and support
the vine.

The morning glory vine, true to
nature, becomes thinner and less
visible as it reaches into the air. Placed
above the delicate finial of the tendril
is a lovely butterfly that floats at ease,
attracted by the beauty of the blossom
and the nectar it contains. Surely it
will alight and then move on to aid
nature in the transmittance of life.
With keen perception and delicacy the
artist delineated all of the butterfly's
salient features.

The artist Shūho, who produced
this work, was born in 1874 in
Nagano prefecture. His father,
Ikegami Shūko, was a Shijō school
artist. Shūho loved painting from a
very early age and he studied with the
artist Araki Kampo (1831-1915). He
also studied the painting styles of the
Nanga and other schools of art. In the
late Meiji period, he began to
participate in the Bunten Exhibitions
and time and again his work was cited
and received awards. Shūho's career
was a long and full one and he died in
1944.

The entire composition of the
master artist speaks of nature's cycle.
The blossom's life is short. It will
perish but new ones will come forth,
and butterflies and other bugs as well
as beasts will come to cherish nature's
beauty.

CONTINUED FROM PAGE 176

head. The ivory in this netsuke is of fine quality. The carvers of these wonderful small sculptures would often search for and discard quantities of material before settling on a natural form that adapted well to the subject they wished to create.

111. *Netsuke*: ivory; running rabbit, eyes inlaid, nineteenth century. L. 2 3/8″ (6 cm). Charles A. Greenfield Collection, New York

This netsuke by an unknown artist illustrates the alertness, action, and vigor the carvers of these fine small sculptures were able to impart to their work. The rabbit appears to be scampering across the ground. Its legs are extended, its nose seems to wiggle, and its ears rest against its body giving it a very streamlined appearance. The carver has carefully etched into the ivory and tinted the many hair lines forming the rabbit's coat. The comparatively large dark eye adds warmth and life to this animal who may well be late for a very important date.

112. *Netsuke*: ivory; a black beetle painted in lacquer, nineteenth century. L. 1 3/8″ (3.5 cm). Charles A. Greenfield Collection, New York

Simple and rather elegant rectangular-shaped ivory plaques form this netsuke. The artist who fashioned and joined them painted on one side a beetle and a blade of grass. The beetle, done in black lacquer, is very well painted. By building up the insect in low relief, the painter gives it a slight sense of three-dimensionality. The dark lacquer also contrasts harmoniously with the ivory. Special skills were essential to painting on ivory.

113. *Netsuke*: narwhal tusk; dog with a bell attached to its collar; pupils of eyes inlaid, nineteenth century. L. 1 3/8″ (3.5 cm). Charles A. Greenfield Collection, New York

The artists who produced netsuke

always searched for rare and unusual materials from which to fashion their pieces. The use of a portion of narwhal tusk for this netsuke is evidence of the appeal of rare raw materials. Narwhal ivory is usually quite dense in structure and of fine quality.

A rather smug and happy puppy is the subject of this netsuke. Except in the Heian- and Kamakura-period handscrolls, Japanese artists rarely portrayed underfed dogs; they tended to represent most of them as plump. This was particularly true of artists like Maruyama Ōkyo and Nagasawa Rosetsu. The short legs, full face, and heavy collar and bell make this a humorous representation. The roly-poly snowball of a puppy seems to wait for someone to play with.

114. *Netsuke*: *kagamibuta*, carved ivory with gold disk; blackbirds on a branch in moonlight; blackbirds in *shakudō* and moon in silver. Signed: Natsuo; by Fushimi Natsuo (1828–1898). Diam. 2 1/4″ (5.7 cm). Charles A. Greenfield Collection, New York

Fushimi Natsuo, a very accomplished metalworker, was born in 1828 and was adopted into the family of a man called Kano Jisuke. When only twelve, he began his training as a metal artisan by studying with a man called Ikeda Kōju who was a member of the Ōtsuki school. Natsuo's talent developed rapidly and he displayed an affinity for the art of the Maruyama-Shijō school. Thus in his metalwork he used a realistic style. Natsuo's versatility was great and, to further his skill, he studied calligraphy and tried his hand at painting. At the age of twenty-five he changed his name to Natsuo, and at this same time he went to Edo, where he shifted from job to job seeking to establish himself. He was employed by the government to design gold coins and to decorate metalwork for the Imperial Household. In his sixties, he joined the faculty of the Tokyo Art School where he passed his great skills along to his pupils.

From time to time Natsuo produced netsuke of a type called *kagamibuta*. These consist of a metal lid covering a bowl of wood, ivory, bone, or horn. In

this example, in brilliant style, Natsuo made the metal plaque of contrasting materials. The ground is gold, as is the vine-covered tree branch fashioned onto it. Two blackbirds, done in *shakudō*, perch on the branch and they are silhouetted against the silver moon behind them. The composition is a fine one. The metal plaque covers a bowl of ivory on which is carved a great variety of toys. Natsuo's netsuke are precision made and extremely choice.

115. *Netsuke*: ivory; cicada emerging from its shell. Signed: Nakajima Kōun (1852–1934). L. 2 1/4″ (5.7 cm). Previous Collection: D. Bess. Charles A. Greenfield Collection, New York

Kōun was born in Tokyo in 1852 and, though originally intended for the architectural profession, he found his interest really lay in producing carvings such as netsuke. Thus it is reported he entered the studio of Tōun when he was only twelve years old. He appears to have been most precocious and rapidly became skilled in many techniques and carved in a variety of materials. His teacher, Tōun, thought so highly of him that he adopted him as a son. Kōun's mature career was spent as a distinguished member of the faculty of the Tokyo Art School, and later he became a member of the Imperial Art Committee.

A cicada emerging from its old shell is the subject matter of this netsuke by Kōun. The design is a rather involved one. Kōun carved the discarded shell as a heavy casing. The ivory of this portion is stained, which also indicates age, whereas the cicada in its new shell is slender and appears alert and active. The theme is an unusual one and the complexity of the carving demonstrates Kōun's great skill.

116. *Netsuke*: amber; chrysanthemum. Signed: Kaigyoku; by Kaigyokusai (1813–1892). L. 1 7/8″ (4.7 cm). Charles A. Greenfield Collection, New York

This chrysanthemum-shaped netsuke was carved of amber. The rich honey color of the amber and the perfection

of the carving combine to produce a jewel-like toggle. The flower's petals curve tightly inward.

Kaigyokusai, the artist who created this netsuke as well as Nos. 117 and 119, was one of the greatest nineteenth-century netsuke masters. Very selective in the quality of the material he used, he became a specialist in locating the best material. His netsuke were very natural and honest, and with great skill he captured the realistic characteristics of his subjects. The pieces he made seem alive and gleam with a special sheen. Obviously a most sensitive master, he was concerned with all the nuances of both his materials and themes.

Kaigyokusai was born into the Shimizu family in Osaka. He was adopted into the Yasunaga family in 1829. It is reported that he used the name Masatsugu early in his life, later adopting those of Kaigyoku and Kaigyokusai. As an artist, it is said he sketched from life, and was a great teacher. Also, it appears he consumed sizable libations of sake which, judging from the beauty of his work, seems to have stimulated his talent.

117. *Netsuke*: ivory; monkey catching a flea, its young sleeping by its side. Signed: Kaigyoku; by Kaigyokusai (1813-1892). L. 1 1/2″ (3.8 cm). Charles A. Greenfield Collection, New York

Another masterpiece produced by Kaigyokusai is this representation of a monkey and its infant. Like No. 116, it is a very sensitive carving. The ivory from which it is made is of incredible quality, pure white and unblemished.

The monkey has just caught what, for convenience's sake, we term a flea. She clasps it in her fist as she turns to examine her conquest. The monkey's coat is defined by thousands of thin lines arranged to symbolize the fur. Her eyes are inlaid and their blackness and focus on the area of action add

greatly to the piece's interest. Resting in the monkey's left arm is a sleeping infant who sags in total relaxation. Kaigyokusai magnificently captured this moment.

118. *Netsuke*: Hirado porcelain; light green celadon lion. Signed with *kakihan*, Masakazu: by Sawaki Masakazu (1839-1891). L. 1 3/4″ (4.4 cm). Charles A. Greenfield Collection, New York

There are a number of ceramic netsuke. Porcelain was especially favored because of its strength and beauty despite its inherent brittleness. When one reflects on the number of failures that precede each properly fired and glazed piece, one's respect for them immediately increases. It must have intrigued a collector to own a miniature porcelain sculpture.

This lion of porcelain with a celadon glaze is a very engaging object. It poses as a fierce lion, though one rapidly senses that it is a pushover. The open mouth and sharp teeth are carefully indicated as is the bushy, almost feathery tail. Though the netsuke has been broken, it has been lovingly repaired with gold lacquer.

The artist who created this netsuke, Sawaki Masakazu, was born in Nagoya but, like many other carvers, lived in Osaka. His father was Sawaki Risuke. Masakazu's brother, Masatoshi, was also a skilled carver of netsuke. Masakazu was very fond of using rats as his theme; thus, this lion is a rare variation. This particular netsuke is considered one of the finest porcelain toggles.

119. *Netsuke*: ivory; stringbeans. Signed: Kaigyoku; by Kaigyokusai (1813-1892). L. 6 1/8″ (15.5 cm). Charles A. Greenfield Collection, New York

Two stringbeans, so lifelike that they appear to be almost miraculously

transformed into ivory, are the subject of this netsuke by Kaigyokusai. Once again the artist's insistence on only the finest material and his sensitivity in capturing the essence of his subject are typical of his concern for perfection. One can almost feel the texture of the pod, taste the flavor of the beans, and feel the toughness of the stalk. The two stringbeans rest together; they touch and separate in an almost erotic embrace. In studying the netsuke of Kaigyokusai, one is immediately struck by how superior his work is to that of a Western artist like Fabergé.

120. *Netsuke*: ivory; heron on a rock, eyes inlaid. Signed: Mitsuhiro and seal Ōhara; by Ōhara Mitsuhiro (1810-1875). L. 1 5/8″ (4.1 cm). Charles A. Greenfield Collection, New York

The carver of this charming netsuke representing a heron on a rock was Mitsuhiro, a rare master. He developed an interest in working with ivory when he was employed in a shop producing samisen plectrums. It is said Mitsuhiro practiced by carving scrap material. The shop was located in Osaka and, in traditional manner, the younger carver was adopted by the owner of the shop. Mitsuhiro evidently was often in ill health and, though his fame as a carver was well known, he eventually returned to Onomichi, his home village. He wrote a manuscript entitled *Takara bukuro (Bag of Treasures)*, and in it told of his great desire to carve and described his training. He also listed his production of some hundred pieces.

One of Mitsuhiro's great talents lay in making his raw material assume the nature of a different substance. Thus, in this netsuke the ivory turns to rock as well as feathers, beak, flesh, and bone. The piece is carved in the round, which was also typical of Mitsuhiro's netsuke. It is a very naturalistic carving and one can sense the heron's next movement.

Bibliography

GENERAL

Joly, Henry L., *Legend in Japanese Art*, John Lane, London, 1908; reprinted, Charles E. Tuttle Company, Inc., Rutland, Vt., and Tokyo, 1967.

Lee, Sherman E., *Japanese Decorative Style*, The Cleveland Museum of Art, Cleveland, Ohio, 1961.

Paine, Robert T., and Soper, Alexander C., *The Art and Architecture of Japan*, Rev. ed., Baltimore, Md., 1975.

Rosenfield, John M., *Japanese Arts of the Heian Period, 794–1185*, Asia Society, Inc., New York, 1967.

Rosenfield, John, and Shimada, Shūjirō, *Traditions of Japanese Art: Selections from the Kimiko and John Powers Collection*, Fogg Art Museum, Harvard University, Cambridge, Mass., 1970.

Sansom, Sir George, *A History of Japan*, 3 vols., Stanford University Press, Stanford, Calif., 1958–63.

Weber, V. F., *Ko-ji Ho-ten*, 2 vols. (privately published), Paris, 1923.

BUDDHIST ART

Seckel, Dietrich, *The Art of Buddhism*, London, 1964.

CALLIGRAPHY

Nakata, Yūjirō, *The Art of Japanese Calligraphy*. Translated by Alan Woodhull and Armins Nikovskis. *The Heibonsha Survey of Japanese Art*, vol. XXVII, New York, 1973.

CERAMICS

Jenyns, Soame, *Japanese Pottery*, London, 1971.

Koyama, Fujio, et al., eds., *Tōji Taikei*, 48 vols., Tokyo, 1972.

Leach, Bernard, *Kenzan and His Tradition: the Lives and Times of Kōetsu, Sōtatsu, Kōrin, and Kenzan*, Transatlantic Arts, Inc., New York, 1966.

Mikami, Tsugio, *The Art of Japanese Ceramics*. Translated by Ann Herring. *The Heibonsha Survey of Japanese Art*, vol. XXIX, New York, 1972.

Seattle Art Museum, *Ceramic Art of Japan: One Hundred Masterpieces from Japanese Collections*, Seattle, Wash., 1972.

———, *International Symposium on Japanese Ceramics*, Seattle, Wash., 1973.

LACQUER

Arakawa, Hirokazu, *Nihon no Bijutsu: Maki-e (Art of Japan: Lacquer)*, vol. 35, Shibundo, Tokyo, 1969 (in Japanese).

Boyer, Martha, *Catalogue of Japanese Lacquers*, The Walters Art Gallery, Baltimore, Md., 1970.

Herberts, K., *Oriental Lacquer: Art and Technique*, New York, 1963.

Jahss, Melvin and Betty, *Inro and Other Miniature Forms of Japanese Lacquer Art*, Charles E. Tuttle Company, Inc., Rutland, Vt., and Tokyo, 1971.

Von Ragué, Beatrix, *Geschichte der Japanischen Lackkunst*, Walter De Gruyter and Co., Berlin, 1967.

NETSUKE

Brockhaus, Albert, *Netsuke*, Duffield and Company, New York, 1924.

Bushell, Raymond, *The Netsuke Handbook of Ueda Reikichi*, Charles E. Tuttle Company, Inc., Rutland, Vt., and Tokyo, 1961.

Jonas, F. M., *Netsuke*, Kegan Paul, Trench, Trubner and Company, London, 1928; reprinted, Charles E. Tuttle Company, Inc., Rutland, Vt., and Tokyo, 1960.

PAINTING

Akiyama, Terukazu, *Japanese Painting*, Skira, Lausanne, 1961.

Cahill, James, *Scholar Painters of Japan: The Nanga School*, Asia Society, Inc., New York, 1972.

Doi, Tsuguyoshi; Tanaka, Ichimatsu; and Yamane, Yūzō, eds., *Shōheki-ga Zenshū*, 10 vols., Tokyo, 1966-72.

Fontein, Jan, and Hickman, Money, *Zen Painting and Calligraphy*, Boston, Mass., 1970.

Kokka Company, *Choice Masterpieces of Kōrin and Kenzan*, The Kokka Co., Tokyo, 1906.

Matsushita, Takaaki, *Muromachi Suiboku-ga (Suiboku Painting of the Muromachi Period)*, Tokyo, 1960.

Mizoguchi, Teijirō, et al., eds., *Nihon Emakimono Shūsei*, 22 vols., Tokyo, 1929-32.

——, *Zoku Nihon Emakimono Shūsei*, 7 vols., Tokyo, 1942-46.

Murase, Miyeko, *Byōbu: Japanese Screens from New York Collections*, Asia Society, Inc., New York, 1971.

Narazaki, Muneshige, ed., *Zaigai Hihō: Japanese Paintings in Western Collections*, Vol. III, Tokyo, 1969.

Rosenfield, John M., and Cranston, Edwin A. and Fumiko, E., *The Courtly Tradition in Japanese Art and Literature*, Cambridge, Mass., 1973.

Shimada, Shūjirō, ed., *Zaigai Hihō: Japanese Paintings in Western Collections*, Vols. I, II, Gakken, Tokyo, 1969.

Tanaka, Ichimatsu, et al., eds., *Nihon Emakimono Zenshū (Japanese Scroll Paintings)*, 24 vols., Tokyo, 1958-69.

TSUBA

Hara, Shinkichi, *Die Meister der Japanischen Schwertzieraten*, Die Reichsdruckerei zu Berlin, Hamburg, 1902.

Joly, Henri L., *Shosankenshū* (list of names, kakihan collected from sword mounts, etc.), Holland Press, London, 1963.

Kawaguchi, Noboru, *Tsuba Taikan (Conspectus of Sword Guards)*, Nanjin-sha, Tokyo, 1935 (in Japanese).

Index

Acknowledgments

Two years ago a very dear friend and lovely lady, Miss Edith Ehrman, was chatting with me. She had assembled a superb collection of Japanese woodblock prints which included one of the finest assemblages of the works of Harunobu. Her prints were primarily devoted to figure studies and human relationships, and the course of our conversation turned to the absence of themes of nature devoid of human involvement. Edith was playing devil's advocate, for usually when I expressed pleasure at a nature study in the print media she would take the opposite position and with great warmth, yet firmness, establish her objections. In one of these discussions Edith said, "I love nature, but not in prints. Why don't we talk about paintings and objects." With this suggestion from her my thoughts turned to the opening phrases of the foreword of this volume. In truth, it was as a result of Edith Ehrman's persistence and support that the theme for this exhibition and volume came into being. This work is dedicated to her loving counsel and spirit. Unfortunately Edith died, though very young, on November 13, 1974. Death had stalked her for many years, yet she never permitted it to alter or lessen her devotion to nature, to Japan, and to educational and political causes. She had a fervent desire that her misfortune should not affect the lives of those who loved her. As the days grew more tiring and the struggle ever more difficult, she would find solace in the seasons and the birds, beasts, blossoms, and bugs of Japan, a country she had learned to adore.

Every exhibition and every book that accompanies it is the result of the collaborative work of a great many people. My debts of gratitude are so great that were I to list them all, I fear this compilation of acknowledgments would never cease. Once the theme had germinated and taken root in my mind, I approached the U.C.L.A. Art Council. When I introduced my thoughts to two members of that Council, Mrs. Sidney F. Brody and Mrs. Herman Weiner, they responded with fantastic support and assistance. How very indebted I am to them, for they reported our discussion to the Art Council, and at a further meeting with Mrs. Franklin D. Murphy, the exhibition's chairman, other council members, and the talented Gerald Nordland, Director of the Frederick S. Wight Art Gallery of the Dickson Art Center at the University of California at Los Angeles, the plans solidified and the exhibition became a project. Since that date, the U.C.L.A. Art Council and Mr. Nordland and his staff have worked tirelessly and with incredible finesse and skill in removing any obstacles to making the exhibition a reality. The staff behind the scenes is huge, and to each and every one I offer my gratitude and blessings.

Once the decision to have an exhibition was reached, the process of securing objects of quality began. I toured the country to view objects and make selections. One must keep in mind that many problems face public institutions as well as private lenders in participating in an exhibition. I was very favored, for the institutions and individuals who were approached responded positively and have gone out of their way to assist us and accommodate our needs. To each and every lender I am eternally thankful.

After the objects were selected, there came the sensitive task of arranging the loans, the insurance, the shipping. Once again, the wonderful members of the U.C.L.A. Art Council carried the burden. At this time I began writing the book and assembling the necessary photographs. These were often supplied; however, in a number of instances new photographs had to be made or additional prints were needed. My own staff at the Freer Gallery of Art, Mr. Raymond Schwartz and Mr. Stanley Turek, patiently spent hours with their cameras, as well as in the dark room developing and printing, to insure that the finished product would be of top quality. In this they were assisted by a third Freer Gallery photographer, Mr. James Hayden. Without their contribution, this volume would not have been possible.

Soon after I began writing the text I was stricken with a debilitating illness. During the tedious days of illness and recovery, the entire staff of the Freer Gallery endeavored to ease my concern and assisted in furthering the goals of this volume. I wish to express my thanks to all of them. A special note of gratitude goes to my secretary, Mrs. Elsie Kronenburg, who won the struggle to decipher my scrawled

manuscript. Mrs. Willa Moore, our Administrative Assistant, Mrs. Harriet McWilliams, and Mrs. Arlene Luskin unstintingly assisted her. I cannot forget the good counsel of Dr. Thomas Lawton, Assistant Director of the Freer Gallery of Art, who daily offered sage suggestions. Mrs. Hin-cheung Lovell contributed information of great value. In addition to these I am indebted to others, who became involved with the mechanics of the exhibition. With skilled artistry, Mr. Takashi Sugiura and Mr. Shigero Mikkaichi repaired and put into condition a number of pieces in the exhibition. Without their loving care and attention, these would have been in danger of perishing and could not have been included. Mrs. Eleanor Radcliffe, our Registrar at the Freer Gallery, Mr. Martin Amt, and Mr. Craig Korr assisted greatly in preparing various objects for shipment and in handling the necessary paper work.

This exhibition was blessed by the personal attention of Mr. Harry N. Abrams, the publisher of this volume, and his staff. They have sailed through a storm of delayed manuscript and missed deadlines caused by my illness. In the face of all those hazards they never lost faith, and proceeded with great sympathy to mask their concern from me for fear that it might worsen my physical condition. I do not know how properly to extend my thanks to these wonderful people. Mr. Nai Y. Chang of Harry N. Abrams took upon his shoulders the task of the design and production of this volume. His skill amounts to true genius, and his wisdom and warmth were a great source of inspiration. The editorial staff also worked tirelessly under difficult conditions, and my applause goes to them.

As can be seen, the numbers who participate in such an endeavor are great. I cannot forget the miracle wrought by the gifted Mr. Jack Carter of the Frederick S. Wight Art Gallery at U.C.L.A. Faced with the monumental challenge of installing an exhibition of this scale in limited space, he cheerfully designed a proper setting for these great treasures, ably assisted by his staff in the execution of the design.

Thanks are also due to the Regents of the University of California, who have made this wonderful art center a reality and have encouraged the Art Council. Without such basic support no venture would be possible.

Last but not least I would like to turn once again in appreciation to the lenders who have cared for and preserved these beautiful works of art. Their concern has made it possible for all of us to participate in the beauty of the various ages these objects represent. Humbly I proffer my gratitude to the many artists who created these works. Even more humbly, I join with the thought of Edith Ehrman to thank the birds, beasts, blossoms, and bugs who have appeared through the ages to inspire man's creation of beauty.

An expression of deep appreciation is due the following museums and private collectors who have so generously allowed their prints to be reproduced herein:

Mr. and Mrs. James W. Alsdorf · Art Institute of Chicago
Asian Art Museum of San Francisco, The Avery Brundage Collection · Brooklyn Museum
Cleveland Museum of Art · Detroit Institute of Arts
Fogg Art Museum, Harvard University · Dr. and Mrs. Kurt A. Gitter
Charles A. Greenfield · Honolulu Academy of Arts
Nelson Gallery-Atkins Museum, Kansas City, Mo.
New Orleans Museum of Art · Philadelphia Museum of Art
Kimiko and John Powers · Joseph P. Ryan, Jr. · Seattle Art Museum
Shinenkan Collection · University of Michigan Museum of Art